# THE CULTURE OF THE STALIN PERIOD

# THE CULTURE OF
# THE STALIN PERIOD

*Edited by*

**Hans Günther**

*Professor of Slavic Literatures*
*University of Bielefeld, West Germany*

St. Martins Press    New York

in association with the School of Slavonic
and East European Studies
University of London

First published in the United States of America in 1990

Printed in Hong Kong

Library of Congress Cataloging–in–Publication Data
The Culture of the Stalin Period/edited by Hans Günther.
p. cm.
"[Published] in association with the School of Slavonic and East
European Studies, University of London."
ISBN 0–312–03993–X
1. Arts, Soviet.   2. National socialism in art–Soviet Union.
3. Arts, Modern–20th century–Soviet Union.   I. Günther, Hans,
1941–
NX556.A1C85   1990
700'.1'03–dc20
                                              89–39232
                                              CIP

# Contents

List of Illustrations                                          vii
List of Figures and Tables                                     ix
Preface                                                        x
Notes on the Contributors                                     xiii
Introduction                                                  xvi

PART I   POPULAR CULTURE, EVERYDAY LIFE,
         IDEOLOGY

1   Working-class Culture and Political Culture in the 1930s    3
    John Barber

2   Stalinism and Popular Culture                               15
    Régine Robin

3   Stalinism and Carnival: Organisation and Aesthetics of      41
    Political Holidays
    Rosalinde Sartorti

4   Stalinism and the Restructuring of Revolutionary            78
    Utopianism
    Richard Stites

PART II   ART

5   Presuppositions of Socialist Realism                        97
    Aleksandar Flaker

6   Problems in the Study of Stalinist Culture                  110
    Igor Golomstock

7   The Birth of Socialist Realism from the Spirit of the       122
    Russian Avant-Garde
    Boris Groys

8   Socialist Realism as Institutional Practice: Observations   149
    on the Interpretation of the Works of Art of the Stalin
    Period
    Jørn Guldberg

9   The Avant-Garde and Art of the Stalinist Era                178
    Vassily Rakitin

PART III   LITERATURE

10   Education and Conversion: The Road to the New Man          193
     in the Totalitarian *Bildungsroman*
     *Hans Günther*

11   Satire under Stalinism: Zoshchenko's *Golubaya kniga*      210
     and M. Bulgakov's *Master i Margarita*
     *Jochen-Ulrich Peters*

PART IV   ARCHITECTURE

12   Moscow in the 1930s and the Emergence of a New City        229
     *Vladimir Paperny*

13   The Ultimate Palladianist, Outliving Revolution and        240
     the Stalin Period: Architect Ivan V. Zholtovsky
     *Adolf Max Vogt*

PART V   FILM

14   From the Avant-Garde to Socialist Realism: Some            251
     Reflections on the Signifying Procedures in Eisenstein's
     *Stachka* and Donskoi's *Raduga*
     *Brenda Bollag*

15   The Annexation of History: Eisenstein and the Ivan         266
     Grozny Cult of the 1940s
     *Bernd Uhlenbruch*

*Index*                                                         288

# List of Illustrations

1. A. I. Vepkhvadze. D. D. Gabitashvili, K. M. Makharadze, G. K. Totivadze: Youth of the World for Peace, 1950–51.
2. A. Gerasimov: The Oath, 1949.
3. A. Deineka: Mosaic to the ceiling of Novokuznetskaya Metro Station, 1940–43.
4. A. Laktionov: In the New Flat, 1951.
5. A. Gerasimov: Portrait of I.V. Stalin, ca. 1942.
6. A. Gerasimov: I.V. Stalin. 1939.
7. I. Brodsky: Portrait of I.V. Stalin, 1932.
8. Z. Volkovinskaya: Stalin's Childhood, 1949.
9. P. Kotov: At Lenin's Death-Bed. ca. 1944.
10. Ivan Leonidov: Lenin-Institute (National Library) 1927.
11. Rudnev and others: Lomonosov University, Moscow, 1952.
12. Shchuko and Gelfreich: Doric Arcade, Smolny Palace, Leningrad, 1922.
13. K. Malevich: The Knife Polisher, Oilpainting.
14. I. I. Zholtovsky: Tarasov House, Moscow, 1909–10.
15. I. A. Fomin: Villa Polovtsev, Petersburg, 1911–13.
16. I. I. Zholtovsky: Bridge over the Moskva, 1921.
17. a) Tatlin: Tower of the 'Third International', 1919.
    b) Vesnin Brothers: Editorial Building for the *Leningrad Pravda*, 1924.
18. I. I. Zholtovsky: State Bank, Moscow, 1927.
19. I. I. Leonidov: Lenin Institute (National Library) Moscow, 1927.
20. I. I. Zholtovsky: Boiler House, Electric Power Plant MOGES near Moscow, 1927.
21. Barshch and Vladimirov: Commune-Building with Maternity Ward (left) and School (right), 1929.
22. I. I. Zholtovsky: Palace of Soviets competition, first design, one of the three First Prizes 1931–32.
23. B. M. Yofan, with Shchuko and Gelfreich: Palace of Soviets competition Phase 1933–35.
24. I. I. Zholtovsky: Palace of Soviets Competition, second design, 1933.
25. B. M. Yofan: Palace of Soviets Competition, model, 1935.

26. I. I. Zholtovsky: Apartmenthouse near the Old University ('Intourist' Building), Moscow, 1933.
27. Palladio: Loggia del Capitaniato, Vicenza, Italy, 1571.
28. I. I. Zholtovsky: Intourist Building, Detail, Moscow, 1933.
29. I. Leonidov: Ministry of Industry, Kremlin, Moscow, 1934.
30. I. I. Zholtovsky: City Hall in Sochi, Black Sea, 1936.
31. Adytum Baalbek (Lebanon) Reconstruction, 150 A.D.
32. Map, Eastern Mediterranean and Black Sea (Sochi: above right, Baalbek near Beirut).

# List of Figures and Tables

1.1 Hours per month spent on cultural and educational activities by working-class families, 1923–36.   5

8.1 The Semiosis of Soviet Pictorial Art   164

# Preface

This book grew out of a conference on 'The Culture of the Stalin Period' which was held at the Zentrum für interdisziplinäre Forschung of the University of Bielefeld, West Germany, 20–23 October 1986. According to the guiding principles of the Centre for Interdisciplinary Research the participants were chosen from different disciplines to unite in the effort to throw light on the phenomenon of Stalinist culture.

Since the beginning of the 1980s there seems to have been a significant rise of interest in various aspects of the Stalin era. This is partly due to new analytical approaches and perspectives, but also to the fact that there seems to be a widespread feeling that this is a culture which is vanishing from our sight and becoming historical. Several participants in the conference mentioned in their papers that works of art and literature or films of the Stalin period have practically disappeared from view in the Soviet Union and are less accessible now than the creations of the Russian avant-garde. Therefore investigations into Stalinist culture are part of the necessary work of *pamyat'* (memory) or, in other words, of what is called in Germany *Vergangenheitsbewältigung*, the mastering of the past. Some Russian artists who belong to the movement of the so called Sots-Art have given numerous examples of making aesthetic use of the emblems of the Stalin period by adopting an ironical standpoint and making them appear in a strange light. They feel that the myths and symbols of this time, obscure as they are, still should not be erased from the collective memory because they are part of Russia's cultural experience. The Sots-Artists' close insiders' view of the functioning of Stalinist cultural symbolism may therefore be something of an inspiration for scholars who are concerned with this period.

As the table of contents shows, the conference focussed on problems from the artistic sphere without excluding, however, popular and political culture. Papers were given by the following participants: John Barber (King's College, Cambridge), Alexis Berelovitch (Sorbonne, Paris), Brenda Bollag (University of Geneva), Christian Borngräber (Berlin), Hans-Jürgen Drengenberg (Freie Universität of Berlin), Aleksandar Flaker (University of

Zagreb), Detlef Gojowy (Unkel am Rhein), Igor Golomstock (London), Boris Groys (Cologne), Hans Günther (University of Bielefeld), Jørn Guldberg (University of Odense), Norbert Hopster (University of Bielefeld), Geoffrey A. Hosking (University of London), Uwe Ketelsen (University of Bochum), Vladimir Paperny (Santa Monica), Jochen-Ulrich Peters (Aachen), Vassily Rakitin (Frankfurt), Régine Robin (Université de Québec à Montréal), Rosalinde Sartorti (New York), Richard Stites (Georgetown University of Washington), Bernd Uhlenbruch (University of Bielefeld), and Adolf Max Vogt (Massachusetts Institute of Technology, Cambridge, Mass.).

I wish to thank the Centre for Interdisciplinary Research of the University of Bielefeld for sponsoring the meeting and for making available its conference building near the Teutoburger Wald. Finally, I should like to express my gratitude to Geoffrey A. Hosking without whom this English edition could not have been brought out.

H.G.

# Notes on the Contributors

**John Barber** is Lecturer in Politics at the University of Cambridge and Fellow of King's College, Cambridge. He has published extensively on Soviet history, historiography and politics.

**Brenda Bollag** teaches film semiotics and the semiotics of artistic communication at the University of Geneva. She has published numerous articles on Soviet and Eastern European cinema.

**Aleksandar Flaker** is Professor at the University of Zagreb, and was educated in Zagreb and Moscow. He has taught at Yale, Munich and Graz. He has published on comparative literature and the Russian avant-garde.

**Igor Golomstock,** art historian, was formerly lecturer at Moscow University and senior researcher at the Museum of Fine Art in Moscow. He has published on Soviet and Western art. Now he is visiting scholar of the Russian Research Center, Harvard University.

**Boris Groys** teaches Russian intellectual history at the University of Münster (W. Germany). He has published numerous articles and the book *Gesamtkunstwerk Stalin* (Munich, 1988) on the Russian art of the twentieth century.

**Jørn Guldberg** is Associate Professor of Art Education at the University of Odense, Denmark. He was educated at the University of Aarhus, where he was Lecturer in art history. He has published on twentieth-century art and design, mainly on Soviet art, on art education and the philosophy of art history.

**Hans Günther,** Professor of Slavic Literatures at the University of Bielefeld (W. Germany), has published on the theory of literature, the Slavic avant-garde and Russian literature. Among his publications on the culture of the Stalin period is his book *Die Verstaatlichung der Literatur* (Stuttgart, 1984).

**Vladimir Paperny** wrote his PhD thesis on Soviet Architecture and Culture under Stalin in 1979 in Moscow. It has been published in the United States under the title *Kul'tura dva* (Ann Arbor, 1985). Currently he is a freelance artist, designer and author in Santa Monica, California.

**Jochen-Ulrich Peters** is Professor of Slavic Literatures at the University of Konstanz. His publications about Soviet Russian Literature and Culture include the book *Russische Satire im 20. Jahrhundert* (Munich/Zürich, 1984).

**Vassily Rakitin** is art historian, critic, connoisseur of Russian art of the twentieth century (during the 1960s and 1970s in Moscow, currently in Frankfurt). He has published on the Russian avant-garde and contemporary Soviet art.

**Régine Robin,** specialist of aesthetics and of the sociology of intellectuals, heads the Cercle d'Etude et de Recherche sur les années Trente at the Université de Québec à Montréal. Among her many publications is *Le Réalisme socialiste, une esthétique impossible* (Paris, 1986), currently being translated into English.

**Rosalinde Sartorti,** specialist in Soviet cultural history, formerly a Research Fellow at the Osteuropa-Institut, Freie Universität Berlin, a Lecturer in Visual Communication and Political Symbolism at the University of Fribourg, Switzerland, and a Visiting Scholar at Columbia University, New York. She has published extensively on Soviet photography.

**Richard Stites** is Professor of History at Georgetown University. He studied Russian History at Harvard and has published books and articles on women's history, revolutionary utopianism and popular culture.

**Bernd Uhlenbruch** is Lecturer in Slavic Literatures at the University of Bielefeld (W. Germany). He has published books on Russian Baroque Literature and essays on Russian music of the nineteenth and twentieth century.

**Adolf Max Vogt,** art critic and architectural historian, founded the Institute for the History and Theory of Architecture at the ETH,

Zurich. He has published on French and Russian revolutionary architecture and on the art of the nineteenth and twentieth century. He divides his activities between Europe and the United States.

# Introduction

The contributions to the present volume, which are concerned with special issues in different spheres of Stalinist culture such as popular culture, art, literature, architecture or film, seem to imply two basic questions: What is the common denominator of the phenomena of this culture? What type of culture does the Stalin period belong to? As for the first question one can say that especially during the last decade some remarkable attempts have been made to explore the complex nature of the Stalin era. For a long time these problems have been approached mainly from a political, ideological or organisational point of view. As the cultural production of this time was looked upon as rather dull and devoid of any deeper interest, research concentrated on its extrinsic sociological aspects, for example on the consequences of Marxism-Leninism in the artistic sphere, on the mechanisms of manipulation and *Gleichschaltung* or on the fate of persecuted artists. The intrinsic approach was restricted to those artists and works of art which in the eyes of scholars deserved closer consideration because they did not belong to the official sphere or, at least, deviated in some way from the Socialist Realist canon. This is understandable, no doubt, as far as aesthetic quality is concerned. We can see that the process of re-evaluation which is currently going on in the Soviet Union will lead to a hierarchy of artistic values in the Russian culture of the twentieth century which is totally different from the official one we know. But neither the political and ideological nor the aesthetic approach can elucidate the specific traits of Stalinist culture as a whole. On the one hand culture cannot be reduced to its political, ideological or organisational determinants, even though the attempt was made in the Stalin period to create a culture which was predominantly ideological. On the other hand the aesthetic approach is too narrow to do justice to the total phenomenon of Stalinist culture.

As far as I can see the development of the cultural approach to the Stalin period came from two sides, from political science and sociology and from literary and art criticism. From the first group I mention only studies like Robert Tucker's *Stalinism* (1977), Sheila Fitzpatrick's *Cultural Revolution in Russia 1928–31* (1978), Moshe Lewin's *The Making of the Soviet System* (1985) or Nina Tumarkin's *Lenin Lives!* (1983). As for the second group I confine myself to

Katerina Clark's book *The Soviet Novel* (1981), Vladimir Paperny's *Kul'tura dva* (1985) and my study *Die Verstaatlichung der Literatur* (1984). Paperny's book, which was written in the Soviet Union and later published in the United States, displays the influence of the cultural semiotics of Moscow and Tartu scholars who, wisely enough, have not ventured on this kind of subject. Yet, their theoretical approach may be of considerable interest for the study of Stalinist culture.

As there is no royal road to success in the study of the Stalin era, interdisciplinary research as it is presented in this volume seems to be still one of the best ways to cope with the problems. The first three contributions deal with the lower strata of Stalinist culture. John Barber is concerned with the impact of politicisation during the beginning of the 1930s on the patterns of workers' reading and their attitudes towards government. The cult of personality, as he points out, was limited to the *apparatchiki*, whereas the majority of the workers were more or less passive and fatalistically accepted the system. Exploring the elements of popular culture in Stalinism, Régine Robin describes the reutilisation of nationalist, authoritarian, folkloristic and other traditions. She comes to the conclusion that the 'quasi-popular culture' of the Stalin period creates hybrid forms which combine archaic and historically regressive values with new collective ones. Rosalinde Sartorti touches upon another aspect of the crucial issue of popular culture – the Soviet carnival. The carnival of the 1920s with its stress on *samodeyatel'nost'*, anti-religious propaganda and political education differs in many ways from the carnival festivals of the mid-1930s which have virtually been transformed into state shows of the new élite and public demonstrations of the new 'happy and joyous' life. The fate of utopian thought is Richard Stites' subject. He characterises the development from revolutionary millenarianism to the Stalinist disdain for utopian experiments, from egalitarianism to hierarchy, from the communal movement to the communal apartment. The eruption of utopian projects during the Five Year-Plan period is stopped abruptly by Stalin's anti-utopian interventions.

Reading the five contributions on art you get the impression that for many reasons the development of Soviet art is a highly instructive cultural paradigm. In his prehistory of Socialist Realism Aleksandar Flaker draws attention to the fact that the concepts of an emotional link with the masses or of socially harmful and unhealthy art existed long before the Stalinist *narodnost'*. During the 1930s they could be

utilised in order to bridge the gap between high and popular culture. Igor Golomstock puts forward some general ideas about the study of totalitarian cultures. Rather convincingly he suggests we should look at totalitarian culture through its own eyes. Each work of art should be taken as part of a structural whole and of a strict hierarchy of themes and genres. The provocative thesis of Boris Groys' contribution is that Socialist Realism in art can be derived from the spirit of the Russian avant-garde. According to this view Stalin, though he removed the avant-garde from official Soviet culture, developed to its logical conclusion the idea of fusing life and art. In this way Stalin became the highest, in fact the only creator and architect of reality. Jørn Guldberg is struck by the fact that it is almost impossible to give a definition of Socialist Realism in art. Having discussed in detail visual, non-visual and textual aspects of the question, he concludes that a historically specific institutional approach might be the most appropriate to solve this task. In opposition to Groys Vassily Rakitin, finally, argues that only the left pseudo-avant-garde could be utilised by Stalinism whereas the true avant-garde tradition always considered art as free, energetic creativity. Totalitarian culture could never make a compromise with true avant-gardism and persecuted it from the very beginning.

Turning to the field of literature, my comparison of a Socialist Realist and a National Socialist *Bildungsroman* is an attempt to show that texts of different ideological background contain similar structures which allow us to speak of 'totalitarian aesthetics'. In both cases the idea of development underlying the genre is extremely distorted. Jochen-Ulrich Peters describes the declining role of satire in the evolution of Soviet literature since the revolution. Two examples are selected to throw light on the fate of the genre: Zoshchenko's *Blue Book*, where the author managed to simulate the norms of Socialist Realism, and Bulgakov's *Master i Margarita*, which had no chance to find its way into the official culture of the time.

Architecture incorporates the spirit of a cultural epoch in a most conspicuous way. For Vladimir Paperny the emergence of the New City Moscow since the beginning of the 1930s in fact amounts to the restitution of an archaic city centred on a holy tomb. This type of city implies a system of concentric circles which symbolically separate areas of different value. Adolf Vogt's sketch of the creative biography of the architect Zholtovsky widens our picture of the evolution of Soviet architecture. Zholtovsky's persistent 'third' position of palladianism offers a counterpart to the two conflicting tendencies in

Soviet architecture, the constructivism of the 1920s and the neo-classicism of the Stalin period.

The cinema of the Stalin era is less explored than other cultural spheres. I am glad therefore to have two contributions dedicated to this 'most important of all arts' (Lenin) in this volume. Brenda Bollag compares Eisenstein's early film *Strike* with Donskoi's *Rainbow*. The difference between avant-garde aesthetics and Socialist Realism is demonstrated on several levels, for example, character construction, the relation between the hero and the masses and the use of montage and other devices. An analysis of Eisenstein's film *Ivan the Terrible* against the background of the cult of Ivan Grozny is given by Bernd Uhlenbruch. This cult emerged in 1941 as a historical legitimation of Stalin's policies. Though Eisenstein's picture outwardly seems to be well adapted to the official norms, it reveals on closer examination the tragedy of absolute power. The film is full of the subversive techniques of Aesopian language.

Without trying to give an account of the methodological and categorical framework used by the students of Stalinist culture in this volume I shall content myself with pointing out some central focusses of discussion. To begin with, there is the procedure of contrasting the Soviet culture of the 1920s and the Stalin era which is used quite frequently. Paperny's book *Kul'tura dva*, which is based on the alternation of two types of culture, shows that this procedure can lead to stimulating results. Indeed, Socialist Realism can be seen against the background of the avant-garde, Stalinist anti-utopianism and hierarchy against the background of utopian egalitarianism and so on. But like any binary opposition this approach entails the danger of schematicism. There is only one point I should like to mention: the avant-garde type of culture which was imposed by a revolutionary élite coexisted with the deep-rooted mentalities and cultural patterns of the Russian peasants and workers. There existed an enormous gap between the two cultures which remained unbridged during the 1920s. This problem was only 'solved' by Stalinism where the culture 'from above' and the culture 'from below' were united by force, where, in other words, a unified and homogeneous culture was created.

This brings us to the relationship between popular and high culture which turns out to be one of the crucial points of present-day discussions of Stalinist culture. In practice it is rather difficult to show how these spheres are linked. If we posit the existence of hybrid, syncretic forms, we should be able to show how this syncretism works

in detail. The problems concealed behind the ambiguous slogan of *narodnost'* – the trivialisation of literature or the adaptation of art to the taste of the masses – have not yet been studied thoroughly enough. The same applies to the categories of traditional popular culture as opposed to the new values propagated by the Party.

Another important aspect of the cultural approach to Stalinism is the exploration of cultural symbolism, of the rituals and myths of the time. Investigations into Soviet myth-making have shown most interesting results. On the level of myth we are confronted with the same problem which I have already mentioned: How can one determine the relative proportions of manipulation 'from above' and acceptance 'from below'? How 'organic' are Stalinist myths? There is another difficulty linked with the study of cultural symbolism and myths. It goes far beyond the customary division of labour among scholars. Being a specialist in the field of art or literature you always feel that in order to study the mechanisms of cultural symbolism you cannot do without frequent trespasses into other fields.

Last but not least, there is the controversial category of totalitarian culture. It is well known that the cultural approach to Stalinism has developed from a revision of the concept of totalitarianism, from the criticism of the ideas of monolithic structure and a perfectly function-ing machinery of repression. But if we go back to Hannah Arendt's *Origins of Totalitarianism* we find that she is quite aware of the fact that this sort of culture is not only imposed from above. Totalitarian regimes are accustomed to celebrate the alliance between the 'lea-ders' and the 'people', and I am afraid the existence of such an alliance cannot be denied. There is no regime of this type that does not appeal to the 'healthy taste' of the masses in its fight against degeneration. What makes the category of totalitarianism usable is not its mechanistic connotations but the aspect of comparability of phenomena of different ideological origins. To compare, of course, does not mean to identify, but to describe structural analogies. Many essential traits of art, literature and architecture cannot be explained by a certain ideology or national traditions, but only by a system which lays a total claim upon social reality without tolerating any neutral zones. Therefore the notion of totalitarianism can be looked upon as a heuristic instrument which can help us to establish the traits which are shared by cultures of a certain type.

It may sound utopian, but I can well imagine joint efforts of Western and Soviet scholars in studying the mechanisms of this type

of culture. A film like T. Abuladze's *Repentance* and V. Grossman's novel *Life and Fate* grew out of a deep experience, which sooner or later will reach the theoretical level.

Hans Günther

# Part I
# Popular Culture, Everyday Life, Ideology

Part I
Popular Culture,
Everyday Life,
Ideology

# 1 Working-Class Culture and Political Culture in the 1930s

## John Barber

While the 'cultural revolution' which accompanied Stalin's revolution from above most directly involved intellectuals, workers figured prominently among its intended beneficiaries. Bringing culture 'closer to the masses' and ending the 'isolation' of artistic work from 'real life' would, it was believed, strengthen the political consciousness of the working-class, on whom the success of the industrialisation drive most directly depended. In the longer run, it would facilitate the emergence, primarily from the proletariat, of the 'new Soviet man'– educated, culturally developed, ideologically aware, able to participate fully in the life of Socialist society. Accordingly the Party campaigned energetically both to promote the 'proletarian theme' in culture and to raise the cultural level of the working-class.

In this sphere as in many others, however, reality lagged some way behind intentions. It did so for two main reasons. First, the composition and condition of the working-class changed dramatically in the early years of rapid industrialisation, with important consequences for working-class culture. Second, cultural policy was invariably formulated with reference to the regime's economic and political objectives, and the latter were the chief priorities.

At the beginning of the first Five-Year Plan, the Soviet working-class was still the direct descendant of the revolutionary proletariat of 1917. Over half of industrial workers had begun work before the Revolution, over half were of proletarian social origin. Their average length of employment (*stazh*) was nearly 12 years. In the space of the next few years, the working-class changed almost beyond recognition. During 1930–31 alone, it doubled in size. Over the whole period 1928–40, it trebled. While new recruits were flooding into the

factories, many cadre workers were leaving the working-class, to take new opportunities of further education and promotion. Initially the majority of new workers were supplied by the towns; but by 1930 this source was quite inadequate to meet the demand. Thereafter a substantial majority of recruits, at least two-thirds, consisted of ex-peasants. Already by the end of the first *pyatiletka*, therefore, the majority of Soviet workers were of peasant origin. The average length of their work experience was six years, but nearly half had less than two years *stazh*. A larger number were young (40 per cent were 22 or under in 1932); and a higher proportion than ever before, around a third, were women.[1]

Simultaneously, workers' conditions changed drastically. Real wages in industry fell to around half of their 1928 level by 1932. The housing crisis deepened as the urban population swelled. Under the impact of collectivisation, nutritional levels worsened; and access to goods and services was sharply reduced. From 1934, living conditions improved; but the average worker's living standard was still lower in 1940 than it had been in 1928. Workers also experienced new pressures at the work place, with continual demands for increased output and productivity, and campaigns to improve labour discipline, backed by harsh, if not always effective, legislation.[2]

These changes had an immediate impact on the cultural level of the working-class. Already in 1929, one in seven industrial workers was illiterate, including 16 per cent of coal miners and 21 per cent of textile workers.[3] The influx of young rural migrants pushed these proportions up significantly. Among iron and steel workers in Western Siberia the illiteracy rate rose from 16 per cent in 1930 to 38 per cent in 1932–33.[4] A massive campaign was launched in 1929 to 'liquidate' illiteracy. By 1932, some 40 million people were said to be enrolled in *likbez* classes.[5] In 1936, however, it was acknowledged that the illiteracy rate among workers in some industries was still rising, since the newly (and barely) literate often quickly lost their ability to read and write, and lapsed into illiteracy.[6] By the late 1930s, the effect of universal primary education and increased adult education had substantially and permanently increased the literacy rate; and according to the 1939 census, 94 per cent of the urban population aged between 9 and 49 years were literate.[7] Nonetheless, trade-union statistics for October 1939 showed that around 5 per cent of members were illiterate and another 13 per cent semi-literate; around a million workers in all.[8]

Time budget studies provide further evidence of the decline in workers' cultural level in the early 1930s. The amount of time spent by workers on cultural and educational activities (ranging from reading newspapers, journals and books, visiting the cinema and theatre, to attending classes and lectures) had increased steadily from the early 1920s to 1930, in the case of women considerably. Thereafter it fell sharply; by 1936, the average male worker was spending a third less time on such activities, and the average female worker nearly a half less, than in 1923–24.[9] It is true that for both new and older workers these levels may have reflected an increase.[10] But the fact remains that the average worker in the 1930s devoted significantly less time to cultural activities than his or her predecessor had in the 1920s.

TABLE 1.1 *Hours per month spent on cultural and educational activities by working-class families, 1923–36*

| Year | male worker | female worker | housewife |
|------|-------------|---------------|-----------|
| 1923–24 | 51.3 | 16.9 | 4.9 |
| 1930 | 53.7 | 24.9 | 17.1 |
| 1932 | 45.0 | 9.0 | 9.0 |
| 1936 | 33.0 | 9.6 | 6.0 |

The forms of workers' cultural activity promoted by the authorities in the 1930s were many and varied. They included literacy classes, general education evening schools and correspondence courses, classes for raising qualifications, theatrical and musical circles, cinema clubs, sports societies. Behind official cultural policy, however, lay a common philosophy – pragmatic, production-oriented and unambiguously political. It found typical expression in the speech of a leading Moscow Bolshevik, K. Strievsky, to a plenum of the city's Party organisation in June 1929. Improved cultural provision, he declared, was necessary 'to satisfy the workers' growing cultural needs and simultaneously to help our construction, which cannot progress successfully with an illiterate or semi-literate population'. He attacked the 'excessive culturism' (*kul'turnichestvo*) of those who 'educate the worker and want to make him a person knowledgeable about everything, with all-rounded literacy. . . . we don't need this' (but) 'a literate metal worker, a literate textile worker etc'. And he

denounced 'apoliticism' in workers' education: 'all study must be imbued with political content'.[11]

Cultural policy involving the working class was thus clearly instrumental. Its prime purpose was to increase workers' skills and economic value, and to guarantee their political loyalty. This can be seen, for example, in respect of one of the most popular of workers' leisure activities, namely reading. In the 1930s radio and cinema, though attracting growing audiences, were not yet the universal forms of entertainment they would later become. (Even in 1940, with an urban population of 34 million families and another 9 million single people, there were only 4.4 million radios and reception points in Soviet towns. And the average urban resident in 1936 visited the cinema less than once a month.[12]) For many ordinary workers in the 1930s books were the main source of cultural experience. Analysis of official policy and trends here is illuminating.

Given the entry of millions of ex-peasants into the urban work force, it is not surprising that the early years of the industrialisation drive were accompanied by a decline in the amount of reading by workers. The number of books read annually by the average reader in trade-union libraries fell from 20.5 in 1927 to 16.1 in 1931. A much lower level, however, was recorded in a 1936 survey of workers in the Sverdlovsk region, where male workers were reading on average eight books a year, and female workers four. Only 16 per cent of male workers and 9 per cent of female workers were using libraries, although as many as 84 per cent and 42 per cent respectively read newspapers.[13]

These changes reflected not only the changed character of the working class, but also the access to and nature of the literature available to workers. A Soviet study of West Siberian libraries during the 1920s and the first half of the 1930s, for example, shows some of the real obstacles that stood in the way of raising workers' cultural level in this period. Funds allocated to libraries were often diverted to other purposes. As a result, nothing was spent on book purchasing for public libraries in 1930–31. The book stock grew much more slowly than the number of workers. In 1928 there were 3.7 books per reader in miners' libraries, in 1932 only 1.7.[14] Libraries were liable to be suddenly deprived not only of funds but even of premises. One library was evicted four times in the course of 1932. And in all Western Siberia, nothing was spent on library construction during the whole of the first *pyatiletka*. The situation gradually improved, although in 1936 libraries were still having often to return parcels of

ordered books because their funds had been cut, and were still being
'frequently flung from better premises to worse'.[15] It is not difficult to
sympathise with the view that 'perhaps nowhere more than in library
work was the underestimation of culture by certain personnel, the
illegitimate counterposing of its tasks to those of economic construc-
tion, expressed so strongly'.[16]

In libraries, the politicisation of culture was reflected in sweeping
purges of suspect literature from 1929 onwards. In October 1930 a
West Siberian territory purge commission ordered the removal from
libraries of all 'White Guard, opportunist, religious, ancien regime
and philistine literature'. In practice, librarians tended to employ
simpler criteria, such as year of publication, cover design and title.
The result was the removal from some libraries of works by Marx,
Engels, Plekhanov, and even those by Lenin and Krupskaya publ-
ished before 1930, together with books by Lev Tostoi, Saltykov-
Shchedrin, Poe, Maupassant, Shakespeare, and various dictionaries
and encyclopedias, including the celebrated *Brokgauz and Efron*
encyclopedia. In one railway workers' library, 'only brochures and
Lenin and Stalin were left'.[17]

Besides these excesses, libraries were subjected to discrimination
against fiction in favour of political and technical literature. Supply of
the latter was expanded rapidly while the former was subjected, in
the words of a Stalinsk official, to 'a strict quota'.[18] Given these
pressures, as well as the lower levels of literacy, it is not surprising
that the use of libraries by workers declined. Whereas at the
beginning of 1932 between a third and a half of workers in many
places visited libraries regularly,[19] in 1936 less than one in six in the
Sverdlovsk region did so.[20]

The influence of these trends was reflected in the pattern of
workers' reading. In the 1920s, their favourite authors were foreign
and classical Russian writers. A study of Moscow trade-union libra-
ries in 1926–27 found that nearly a third of all fiction borrowed by
workers was foreign. The most popular authors were Jack London
and Upton Sinclair, together with James Curwood (an American
writer of adventure stories) and Bernhard Kellerman (a German
romantic novelist). Tolstoi, Turgenev, Dostoevsky and Chekhov,
together with Gorky, also enjoyed considerable popularity.[21] A
survey of young workers' reading based on Moscow trade-union
libraries in 1928 similarly showed that the most popular authors were
London, Sinclair and Curwood, together with Victor Hugo, Guy de
Maupassant and Emile Zola. Nearly a third of the readers read only

fiction.[22] In the 1930s, the attempt to steer workers away from fiction towards more purposive technical or political literature appears to have had little impact on their tastes. The demand for fiction remained high even if the supply fell. But the purge of books by foreign authors clearly had an effect on reading habits. In Western Siberia, the most widely read works of fiction are said to have included, as elsewhere, Fadeev's *Razgrom*, Gladkov's *Tsement*, Serafimovich's *Zhelezny potok* and Sholokhov's *Tikhii Don;* although curiously the 'biggest queues' were for Defoe's *Robinson Crusoe.*[23]

Measuring the deeper psychological effect on workers of the policies described is beyond the scope of this chapter; but the conclusion reached by the authors of the West Siberian study is interesting.

> The sharp lack of artistic literature could not fail to be reflected in the aesthetic education of workers, on the formation of their feelings of beauty, of their tastes, and this was not so harmless as it seemed to certain cultural personnel at that time. The non-development of feelings of beauty amounts to damage which, as E. Ilenkov justly says 'does harm not so much to the particular individual himself, as to those people with whom he has to interact, and as a result to the very cause to which he is attached.'[24]

The socialisation of workers in the 1930s took many forms and involved numerous institutions, among them the Party and Komsomol, the trade-unions and the press, and voluntary organisations such as the League of the Godless and Osoaviakhim; and for this reason it is difficult to assess the specific impact of any single form. But it is worth asking how far the central political aim was achieved. To what extent did workers' *political* culture – their political attitudes, beliefs and behaviour – change in the 1930s? Difficult though it may be to generalise about the outlook of a large social group, certain hypotheses can be advanced.

Workers' attitudes towards the government and its policies perceptibly changed in response to events. There seems little doubt that the launching of the first Five-Year Plan evoked a positive response among many workers. While strong commitment was probably confined to the active minority which joined the Party, initiated Socialist competition, formed shock brigades, or set up production communes, its confidence no doubt affected others. The spirit of

optimism is reflected in the declaration of a turbine factory worker in 1930:

> It is said that there is no bread or meat. . . . But here are the machines that will get power stations going, and they will start up factories, and the factories will produce tractors and machines. Then you'll have bread and meat and cotton. This is a transitional time. If we can finish the *pyatiletka* in four years, things will be incomparably good.[25]

By 1931, however, as living standards fell and voluntaristic planning put increased strain on industry, such optimism was giving way to hostility. From Leningrad, it was reported that 'the common people are now surprisingly open in their speech; in any queue or gathering, the most vigorous invective against the present regime may be heard'.[26]

> An American engineer working in Stalinsk in 1931–33 reported that beginning around September 1931 there was a decided lowering, from month to month, of the efficiency of labour . . . due entirely to a lowering of morale in the ranks of the entire organisation . . . brought on by the increased hardships of the Russian people, and by their realisation of the apparent failure of the Plan in that none of the new plants would be ready to go into production on the dates set forth in the Plan.[27]

In the mid-1930s the atmosphere appears to have improved. Higher living standards, the end of rationing, the 'three good years' of 1934–36 in industry, a series of better harvests, together with a temporarily more relaxed political atmosphere, produced a more positive mood. It is hardly accidental that these years saw the biggest improvement in labour productivity in the whole decade. And the Stakhanov movement (initiated in 1935 to raise production norms), for all its centralised direction and contrived record-setting, attracted some genuine working-class participation and enthusiasm. The onset of the great purges sowed confusion and demoralisation among workers. Though the terror may have had less of a direct effect on workers than on any other group, they were undoubtedly affected by the industrial dislocation caused by the savage repression of many managers. This situation may have been briefly alleviated in 1939. But the advent of war in Western Europe and the increased Soviet

preparations for the approaching conflict brought new pressures on workers and a renewed mood of pessimism.

In terms of their attitudes and behaviour, three basic groups within the working-class can be identified. First, a minority of loyal workers, identifying with the regime's goals and values, and actively participating in the establishment and consolidation of the system. Working-class members of the Party are the most obvious examples of this group. While the leadership's enthusiasm for mass working-class recruitment declined sharply after the first Five-Year Plan (by the end of which workers by occupation in the Party numbered nearly one and a half million), there were probably still over a million working-class members on the eve of the War. As a proportion of all workers, Party members appear to have comprised around 13–15 per cent of all workers in 1928–33 and around 7–10 per cent thereafter.[28] In addition, a large number of workers were trade-union activists: members of factory committees, delegates to conferences and plenums, members of social insurance councils, of committees on labour supply, pay, housing and so on. This *aktiv* was said in March 1939 to comprise five million.[29] Altogether, therefore, as much as a fifth of the working-class in one way or another was actively participating in the system.

Resistance to the regime's policies is harder to identify. Reports of open criticism, comparing past with present, Bolshevik promise with Soviet reality, were not uncommon in the earlier part of the period. 'Although I am a Communist, I am still for the working class', a woman declared at a factory meeting in Moscow in April 1929.[30] 'What sort of workers' power is this which oppresses us' workers were said to be asking in 1930.[31] 'There's no difference in the worker's life between what it was like before the Revolution and what it's like now', a worker told a meeting in the Western region in April 1936.[32] Even at the height of the great purges, as Osip and Nadezhda Mandelshtam, living with a Kalinin steelworker, discovered, 'people talked much more freely in working-class homes than in intellectual ones . . . we were quite startled to hear the mercilessly outspoken way in which our hosts talked'.[33]

But not surprisingly there is little sign of organised political opposition on the part of workers. Evidence of poor labour discipline – high turnover, absenteeism, defective output, insubordination – while abundant provides little guide to workers' political attitudes. It is stretching the meaning of such phenomena to see them as protest or resistance.[34] On the other hand, two forms of 'deviant' behaviour

are significant. First, workers' hostility to Socialist competition and to the 'heroes of labour' who promoted it, ranging from ironic jibes to physical attacks, including even murder, is well documented.[35] Second, industrial sabotage was not always a figment of the NKVD's imagination. An American engineer working in the USSR in 1933 wrote that 'sabotage was a fact throughout Soviet industry'.[36] Another, working in the Soviet gold-mining industry from 1928 to 1937, spoke of 'unquestionable instances of deliberate and malicious wrecking' by workers, and concluded that 'such petty industrial sabotage was, and still is, so common that Russian engineers can do little about it'.[37]

The mass of the Soviet working-class, however, probably consisted neither of enthusiastic supporters nor of outright enemies of the system. Many, especially older, workers must have felt the kind of alienation which Nadezhda Mandelshtam observed in the Kalinin steelworker's family.

'They're just making fools of us with all that stuff about the working class', the wife declared. . . . While the people 'up top' fought and murdered each other, trading on the name of the proletariat, they as workers would have nothing to do with it and kept their hands clean.[38]

The cult of personality appears to have had relatively little impact on workers in the 1930s. Stalin's encouragement of workers' criticism of their bosses and his repeated attacks on bureaucrats may have helped legitimate the regime in workers' eyes as well as provide a safety valve for their resentment and discontent. But the Stalin cult was far more prevalent among *apparatchiki*, the official intelligentsia and the Party rank-and-file than in the working-class as a whole. Workers appear to have had a more down-to-earth attitude towards the leader. According to Nadezhda Mandelshtam, in the textile factory near Zagorsk where she worked in 1938, he was simply referred to as '*ryaboi*' (pock-face).[39] Political passiveness seems to have been widespread. Soviet prisoners of war interviewed in Finland in 1940 were said to display

a completely fatalistic acceptance of the fact that there must be some government, that some are worse than others, and that this one is worse than the last. To such questions as 'Why not get rid of the Commissars' government?', the answers are: 'That would only

lead to worse disorder', 'There would only be another govern-
ment', 'how are we to know that any new government will not be
even worse?'[40]

Such scepticism may nonetheless have coexisted with approval of
basic features of the system. The post-war Harvard survey of
Soviet émigrés found that while most workers questioned were
hostile to the regime as such, a large majority was in favour of
several of its fundamental social and economic policies, such as the
welfare programme, guaranteed work for all, nationalised heavy
industry and transport, state-provided education and health-care.[41]

This study of cultural and other factors influencing the attitudes of
Soviet workers in the 1930s helps to explain an important part of the
social basis of the Stalinist political system. Almost all systems of rule
rest on a combination of the backing of influential groups and the
acquiescence of the majority of the population. The Soviet working-
class contributed in both respects in the 1930s. A minority gave the
regime its active support in political and economic life, and also
provided the main source of recruits for the administrative apparatus.
The majority, though resentful of many features of their lives and far
from fully incorporated in the system, accepted it. And in so doing
they undoubtedly strengthened its legitimacy.

## NOTES

1.  See A.I. Vdovin and V.Z Drobizhev, *Rost rabochego klassa SSSR
    1917–1940 gg.* (Moscow, 1976); and John Barber, *The Composition of
    the Soviet Working Class* (CREES Discussion Paper SIPS no. 16),
    Birmingham: University of Birmingham, 1978.
2.  See Donald Filtzer, *Soviet Workers and Stalinist Industrialization*
    (London, 1986); and John Barber, 'The Standard of Living of Soviet
    Industrial Workers, 1928–40', in C. Bettelheim, *L'Industrialisation
    dans les années trente* (Paris, 1981).
3.  *Voprosy truda v tsifrakh* (Moscow, 1930), p. 30.
4.  A.S. Moskovsky, *Formirovanie i razvitie rabochego klassa Sibirii v
    period stroitel'stva sotsializma* (Novosibirsk, 1968), p. 133.
5.  *Nash leninskii Komsomol* (Moscow, 1932), p. 148.
6.  *Biulleten' VTsSPS*, 1936, no. 3–4, p. 9.

7. *Sovetskaya istoricheskaya entsiklopediya*, vol. 11 (Moscow, 1968), p. 803.
8. *Statisticheskii spravochnik VTsSPS* (Moscow, 1940), vypusk 1, p. 100.
9. Calculated from the findings of all-Union time budget studies of workers published in S.G. Strumilin, *Izbrannye proizvedeniya*, vol. 3 (Moscow, 1964), pp. 202–32; *Trud v SSSR* (Moscow, 1932), pp. 169–74; L.A. Gordon, E.V. Klopov, L.A. Onikov, *Cherty sotsialisticheskogo obraza zhizni: byt gorodskikh rabochikh vchera, segodnya, zavtra* (Moscow, 1977) p.51. See also John Barber, 'The Worker's Day: Time Distribution in Soviet Working-Class Families, 1923–1936'. (Unpublished paper presented to the CREES Social and Economic History Seminar), Birmingham, 1979.
10. As Gordon *et al.* argue, op. cit., p. 51.
11. K. Strievsky, *Material'noe i kul'turnoe polozhenie moskovskikh rabochikh* (Moscow, 1929) pp. 33–4.
12. Gordon *et al.*, op. cit., pp. 56–7.
13. A.v. Bakunin, *Bor'ba bol'shevikov za industrializatsiyu Urala vo vtoroi pyatiletke*, (Sverdlovsk, 1968) p. 218.
14. V.P. Butorin and P.F. Marchenko, 'Biblioteki zapadnoi Sibirii v period stroitel'stva sotsializma i prosveshchenie rabochikh (1920–1937 gg.', in *Rabochii klass Sibirii v period stroitel'stva sotsializma (Materialy k 'Istorii rabochego klassa Sibirii'*) (Novosibirsk, 1975) p. 158.
15. Ibid., p. 166.
16. Ibid., p. 159.
17. Ibid., pp. 154–6.
18. Ibid., p. 161.
19. Ibid., p. 144.
20. Bakunin, op. cit., p. 218.
21. *Kniga i profsoyuzy*, 1927, no. 1, pp. 8–12.
22. Ibid., 1928, no. 3, pp. 12–13, 52–5.
23. Butorin and Marchenko, op. cit., p. 162.
24. Ibid., p. 161.
25. A. Khain, V. Khandros, *Kto oni – novye liudi na proizvodstve* (Moscow, 1930) p. 7.
26. Report of the British Consul in Leningrad, February 1931: Public Record Office N5871/1215/38.
27. J.S. Ferguson, in 'American Engineers in Russia' Collection, Hoover Institution Archives, Stanford, USA.
28. Estimated from T.H. Rigby, *Communist Party Membership in the USSR, 1917–1967* (Princeton, 1968) pp. 52, 116, 167, 226; *Profsoyuznaya perepis'* (Moscow, 1934) pp. 59–60; *Bol'shaya sovetskaya entsiklopediya*, 3rd ed., vol. 21, p. 316.
29. *Profsoyuzy SSSR*, 1939, nos. 2–3, p. 45.
30. *Rabochaya gazeta*, 3 April 1929.
31. Khain and Khandros, op. cit., p. 7.
32. Smolensk Archive, T-88, roll 1, document 96.
33. Nadezhda Mandelshtam, *Hope Against Hope* (London, 1975) p. 403.
34. Filtzer, op. cit., pp. 254–6.

35. See Filtzer, op. cit., pp. 200–4; Solomon M. Schwarz, *Labor in the Soviet Union* (London, 1952) pp. 191–6.
36. PRO N5515/13/38.
37. John D. Littlepage and Demaree Bess, *In Search of Soviet Gold* (New York) p. 199.
38. Mandelshtam, op. cit., pp. 403, 405–6.
39. Nadezhda Mandelshtam, *Vospominaniya* (New York, 1970) p. 365.
40. The interviews were conducted by British intelligence officers. PRO N3288/132/38.
41. A. Inkeles and R.A. Bauer, *The Soviet Citizen* (1959) pp. 234–6, 238.

# 2 Stalinism and Popular Culture

## Régine Robin

The social history of the Soviet Union is increasingly concerned with the relevance of a cultural approach to the study of Soviet society in the 1930s. Scholars such as M. Lewin,[1] R.C. Tucker[2] and Sh. Fitzpatrick[3] have recently stressed the necessity of a cultural approach to the social sphere. In their eyes, we are victims of conceptual categories with which the Bolsheviks tried, without great success, to examine their economy, their social relationships, the dynamics of their society and its contradictions. Or, on the contrary, we are victims of *ad hoc* categories, such as the notion of *totalitarianism*, imposed on the entire field of Soviet studies in the West at the time of the Cold War. We must abandon this double trap and attempt to examine the enigma of Stalinism in its true complexity. In this chapter I want to deal with the question of Stalinism by focussing upon a thorny issue, its relation to popular culture.

In a recent statement setting the record straight on popular and traditional religion in Russia, M. Lewin, along with a number of historians of religion, has raised the question of how primitive Christian churches were received, recognised and accepted by the pagan masses. Quoting Max Weber, he writes: 'Neither the prophet nor the priest can afford to reject all compromise with the traditional beliefs of the masses'.[4] He recalls to what extent churches had to accept the traditional gods and saints, rebaptising them, according them another role or a double role. They had to accept the sacred places of pilgrimage, granting them a new kind of holiness within the new religion. And in the imposition of the new values, it was necessary for them to threaten, but also to work in harmony with the traditional mentalities. He concludes that this type of social compromise, sometimes conscious, sometimes unconscious, was never

reached by one side only but rather with a sharing of tasks, one would say.

The process of adaptation during the compromise certainly worked both ways. The church adapted herself and adopted popular customs in order to rule and to maintain its monopoly over the supernatural and the sacred as defined in its own terms. In turn, the rural world did its part from the other end. They accepted, selectively, the official new creed, but chewed up and transformed many of its elements. The peasants also preserved many components from their own old religion and carried them down through the centuries into our own time in a peculiar symbiosis with official Christendom.[5]

If all acculturation is necessarily syncretic, resulting from the grouping, the borrowing, the recombining of diverse cultural elements, the same must be true of Stalinism and the cultural approach to Stalinism.

But before getting to the heart of the matter, it is necessary to make a detour, because the extremely polysemic expression 'popular culture' has all kinds of traps in store for us. We are faced with both a definitional and an epistemological problem.

First the definitional problem. Popular culture generally means, quite simply, the traditional culture of rural people before the industrial revolution, all their social codes, beliefs, customs, ways of producing and exchanging, ways of speaking and entertaining themselves. This traditional culture is studied independently – its own structures are studied, its system, its logic, its dynamics – as well as in its relationship with the whole of the society in which it found itself, its relationship with the city through the intermediary of the market, the fair, the peddlar, through the government, through taxes, and in its relationship with the Church through the intermediary of the priests. The practices, customs and beliefs of the rural civilisations before the industrial revolution were already a syncretic mixture, a combination of ancestral elements from the depths of the popular culture and elements imposed by the government and governments that had fused into an amalgam. We can study the traditional rural Russian society; we can see its evolution since the end of serfdom, and Stolypin's reforms up until the end of the New Economic Policy (NEP). For example, we can look for what became fragmented without completely breaking up until collectivisation.

Sometimes popular culture means the culture of the urban masses born of the industrialisation process, telecommunications, the general mediatisation of everyday life and pastimes; the levelling out of values and tastes, the establishment of a consensus, which P. Bourdieu would call *middle art*. It is known that an initial mass culture had penetrated the cities, indeed even the large country villages in Russia at the turn of the century and the beginning of the twentieth century. As J. Brooks recently showed[6] so brilliantly, semi-literate readers avidly read illustrated opuscules that related stories of bandits and righters of wrongs. It was the first great acculturation and was tied to the first waves of industrialisation and the transformation of Russia; it was a culture oriented towards the market and profit, entering the commercial circuit, proof that the traditional society had moved.

Sometimes by popular culture we mean sector-based cultures or sub-cultures of the people, such as working-class culture which in pre-Revolution Russia had its own emotions, songs, workers' theatre, its forms of sociability and solidarity. When you think about it, they were not so far from those that R. Hoggart mentioned in his now classic book on England.[7]

At times, especially in the Soviet context, popular culture is confused with proletarian culture, that culture Proletkul't desired, which would have been a direct product of the proletarian milieu, and would have reconstructed an authentic people's culture from the *tabula rasa*. Shortly afterwards, proletarian writers, whether born of the proletariat, brought together in numerous cliques, or within the RAPP (Russian Association of Proletarian Writers – Rossiiskaya Assotsiatsiya Proletarskich Pisatelei), took up once again this question of a new cultural hegemony.

With regard to popular culture, it is also necessary to touch on the difficulty of understanding the evolution, the reversals and the divisions of the notion of *narodnost'*.

First used by Vyazemsky and Somov in 1820 to signify the way in which an author accurately depicted the main features of a national culture and local colour, the notion migrated shortly afterward and was found again among Westerners and Slavophiles, as well as in the symbolic of the czarist government, after 1843, when the Minister of Education of Nicholas I, Uvarov, appropriated it in his famous triad: *autocracy, orthodoxy and narodnost'*. Herzen and Belinsky tried to give it a progressive meaning. In a remark on the importance of the people in the development of Russian literature, Dobrolyubov[8] said

that a genuine party of the people did not yet exist in literature and that henceforth, it would be necessary to write from the popular point of view. In brief, the notion at stake was turned over and enriched; it created ambiguity between the Slavophiles and the *narodniki*, the *narodniki* and the Social-Democrats and the Bolsheviks. When it was taken up again in the 1930s, it was in still another sense. In his marvellous textbook, Victor Terras recently emphasised it very strongly:

> The aesthetic theory and critical practice of socialist realism give narodnost' a more important place than ever before, as it is made to refer to a content which represents the viewpoint and the interests of the people, in a form that is intelligible and congenial to the people. Hence narodnost' is seen as intimately linked, or in fact identical with partiinost'.[9]

Certain writers and political thinkers have attempted to define the notion of the 'popular' and 'popular culture' otherwise, and their reflections are useful for our purposes. In his desire to fight against fascism, B. Brecht, for example, was very anxious to extricate the popular from its archaic connotations. In *Volkstümlich* he says:

> The folk or people appears with its immutable characteristics, its time-honoured traditions, forms of art, customs and habits, its religiosity, its hereditary enemies, its unconquerable strength and all the rest of it. A peculiar unity is conjured up of tormentor and tormented.[10]

Brecht wanted to rethink the concept of the popular and he redefined it in the following manner:

> Popular means intelligible to the broad masses, taking over their own forms of expression and enriching them/adopting and consolidating their standpoint/representing the most progressive section of the people in such a way that it can take over the leadership: thus intelligible to other sections too/linking with tradition and carrying it further/handing on the achievements of the section now leading to the section of the people that is struggling for the lead.[11]

In Brecht we see a changing, historical notion of the popular; we also see (as in the reworking of the notion of *narodnost'*) it split up

between static and 'mentalitarian' (*mentalitaires*) elements, and progressive, developing elements. The same idea theorised otherwise is found in Gramsci, in his reflection on popular culture, which he calls folklore, and in his search for a symbiosis between the rational, explicative, structured discourse of the progressive intellectuals, and the progressive elements in popular culture. Combining what the people 'feel' without expressing it, what the intellectual knows without feeling it, and finding an alliance between these two progressive cultural forces, produces what became known as the *national popular*.

I have provided this rapid overview because it makes clear that when one tackles a subject such as 'Stalinism and Popular Culture', one is confronted with a multiplicity of problems arising from confusion concerning the notion. This is because popular culture can be, at one and the same time, the sector-based culture of the popular classes, the pre-industrial rural culture, a new culture that remains to be defined, and what is most archaic, regressive, most 'mentalitarian', or what is in itself the carrier of progressive values of humanity, solidarity, good sense and community. It can be both the anchorage of the worst *blut und boden*, and on the contrary, the jumping-off point for cultural innovation. Last, but no less important, the *epistemological problem*. The clear-cut dichotomies that often cut across sovietology from the moment we take on the Stalinist problem are to be avoided:

| | |
|---|---|
| *nachal'stvo* | *protiv naroda* |
| the State, that which commands | opposite the people |
| official culture | opposite popular culture |

It is as if there were no connection between what is designated as official culture and what is designated as popular culture; as if we found ourselves faced with two groups with waterproof partitions between them; and as if the history of the Soviet Union could be limited to a history of the regime's censorship policy and its purges; as if the all-powerful state imposed its orders, through a system of infallible driving belts, on a totally passive, atomised, numbed society.

That is exactly what M. Bakhtin proposed, in a sense, when he theorised on the notion of popular culture while writing his *Rabelais*.[12] He clearly wrote it in a polemic response to his forced exile and to the government's use of folklore at the end of the 1930s. We will

come back to this. Nevertheless, his insistence on separating true popular culture from official culture wrought havoc from the moment the theory was removed from the historical context in which it was formulated. This conception, centred on the popular carnivalesque, the corporal grotesque, the laughable, the phenomena of inversion (the low/the high) of all hierarchies, produced an authentically anti-dogmatic sound. K. Clark and M. Holquist are correct in seeing a dialogical but nonetheless polemic response to Stalinism in his work.[13] Nevertheless, I am in complete agreement with what they maintain when they define his position, in the context of the 1930s, as 'idealistic', with all the nuances that that implies.

They wrote, and I will ask you to excuse the length of the quote, but I feel it is very important:

The question raised by Bakhtin's carnival, with its emphasis on brotherhood, universalism and antidogmatism, is whether such a horizontally ordered world can be maintained for any length of time without introducing some kind of hierarchy, be it epistemological or political. There is in other words a strong element of idealization, even utopian visionariness, in Bakhtin's analysis of carnival. At this very time the official platform both literary and political was assigning the folk a major role in its scheme of things. For instance Gorky in 1934 urged writers to model their heroes on folklore. With official encouragement, folklore was collected and published in great quantity. Folk bards were set to writing epic songs and ditties glorifying the new age, its leaders, and their 'struggles.' The folk assumed a larger role in political rhetoric and ceremony. The leadership slotted folk proverbs into speeches, folk bands and dance groups became a standard feature at official ceremonies, and selected individuals from the folk such as Stakhanovites were singled out for public acclaim.

Bakhtin decries the narrow conception of the folk prevailing at his time, which excludes the culture of laughter and the marketplace with all its subversiveness, blasphemy, and blatant physicality. The result of this exclusion is a petrified, emasculated version of the folk with no bite. But while opposing one idealized conception of folk Bakhtin's own counterimage is no less idealized, dripping with urine and feces though it be.[14]

It seems to me that Bakhtin, the thinker of the heterogeneous, the hybrid, polyphony and novelistic plurilingualism, has too readily dichotomised persuasive and authoritarian speech. Better inspired, M. Lewin asks the correct questions about the 1930s:

> Studying peasant religion could also help with crucial problems of the Soviet period, as we ask ourselves how the peasants related to the kolkhoz, how they settled in the cities, to which they flocked in the millions during the thirties, how they responded to official ideology, and how they found their way in the complex social and institutional universe of the new Soviet state.[15]

In fact, in the acculturation processes, to which all traditional peasant cultures were subjected through the centuries, all the research on social history shows the importance of mixed processes and what, following P. Burke,[16] M. Vovelle[17] and C. Ginzburg,[18] we could call cultural intermediaries: all the frontier groups, straddling two social worlds, true cultural relays in both senses and participating in several cultural universes. Hence, the importance, not of untouchable, well-structured, cultural groups that oppose each other, but of syncretisms, heterogeneous groupings and, sometimes, symbioses and juxtapositions – more or less feeble articulations, vague, fragmentary, poorly-cemented sets, with some weak elements and other more resistant ones, historically-defined sets, and products of periodisation, whose elements, the combination they form, and its evolution, must be studied.

The formation of a new society after the Revolution of 1917, and the search for a new cultural base of a total *vospitanie* or better still, a *kul'turnichestvo* happened by way of a group of cultural elements that can be schematically set forth in the following manner:

(1) The cognitive level: access to knowledge, to learning, to the minimum elementary knowledge for integration into a society in the middle of evolution, access to technical knowledge. Hence the elimination of illiteracy among the masses and the provision of schooling. It is the first level, and that which Lenin stressed against the supporters of proletarian culture and the *tabula rasa,* accusing them of putting 'the cart before the horse'. His obsessive fear was the fantasy of an Asian and barbaric Russia hampered by its own ignorance.

(2) The axiological level: that of values or ideology, or, if one prefers, that of propaganda and agit-prop, in order to instill in the masses the new Bolshevik values, the new language developed by the press, even in the beginning, the press destined for the peasants, *Bednota* and *Krest'yanskaya gazeta*, the new discourse with its key words, its slogans, its lexical marks that became stereotypes very quickly.

(3) The symbolical level: with a new calendar, new holidays (May 1, the anniversary of the October Revolution), new street names, place names and city names, just as there were new names for people, new rituals at birth, upon marriage, and at death, new heroes and new songs. In brief, everything which throughout the everyday and the ceremonial, art and literature, strived to create a new social imaginary, in the strongest sense of the term.

(4) Finally, perhaps the most subtle level, that of the new social codes, new practices and new behaviour which characterised relations between classes and social groups, men and women, the old and the young, children and parents, individuals and families; in what characterised the attitudes toward sexuality, dietary codes, forms of sociability, the different ways of being together in society, of drinking *samogon* and rolling under the table, for example.

This four-level venture, and I am not referring here to the transformation of the economic infrastructure and social relationships, this four-level venture – knowledge, the symbolical, the axiological and the cultural, in the anthropological sense of the term – ran from the Revolution to the Civil War, from the Civil War to the NEP, from the NEP to the first Five-Year Plan, from the first Five-Year Plan to the 'Great Retreat',[19] to the purges and the war. It was a question of bringing a public culture to light. This venture went forward with breaks, changes in line, hazards, reversals, with certain elements that were transformed faster than others, with some successes and enormous failures. It was not only the necessity of finding a social base and responding to the pressures of the rank-and-file and a multitude of social groups that was felt, but also the necessity of cultural borrowings, of negotiating, consciously or unconsciously, with the former society, with the ancestral cultural customs, with a habitus that couldn't be transformed in 10, or indeed even 20 years. What, then, were these numerous borrowings?

What struck all the observers, the witnesses and the specialists, and what is doubtless the most familiar to us, is the re-utilisation in Stalinism of certain symbolical, axiological and cultural elements from the former czarist regime. I will mention the following elements while summarising here what many other specialists have studied in detail. Robert C. Tucker pertinently reminds us that a development model existed in Russia, a pattern that seemed to renew itself with Stalin. After the secular domination of the Mongols, the princes of Muscovy, surrounded by hostile nations, udertook the construction of a solid military state. The state was re-organised so that it became the whole social structure, in such a way that all classes of society found themselves indebted to the state and were at its mercy. It was a kind of 'Revolution from above'.

Ivan the Terrible (*Ivan Grozny*) formed his own police force, the *oprichnina*, of people from inferior circles to fight against the boyars, the aristocracy of that time. Peter the Great, whom Herzen called 'the crowned revolutionary', laid the bases of the modern state from start to finish during his reign, by intensifying serfdom and creating an aristocracy of ranks subordinate to the state.

According to Tucker, Stalin rediscovered a long tradition of construction of the state and re-organisation of the structure of the nation and social relationships, whose Russian roots were buried in the mists of time. This Revolution from above, followed by the Great Retreat, incorporated that which was most archaic in the plurisecular relations of the people to the state, and made use of the immemorial popular, the archaism of mentalities, and faith. It is necessary to make the connection between the extent of Stalin worship and the 'naive monarchism' of ancient Russia, so well depicted by D. Field[20] and M. Cherniavsky. [21] In the nineteenth century, Baron von Haxthausen[22] mentioned the peasants' profound respect for the authorities (although interspersed with bouts of anger and revolts). They addressed, he said, their father, *starost*, the emperor and God with the same word: *batyushka*. As soon as these words, which symbolised authority, were pronounced, they complied with prescribed, performative words: *prikazano* (it was ordered).

These myths about real and imaginary czars, the myth of 'if the czar knew', were easily revived under Stalin. Stalin was referred to by all sorts of names, the most important being *vozhd' i uchitel'*, *vozhd' rukovoditel'*, and *boets* or *otets*, or *krepkii khozyain*, but not *batyushka*,[23] even though the adjectives used with these terms accurately depict the same traditional beloved and, at the same time, feared

father. As the czars had done before him, Stalin ruined the powerful and promoted the poorest of the poor; he denounced the excesses of collectivisation[24] – he was just. This resurrection of the myth, of the cult, was already very strong at the time of Lenin's death. N. Tumarkin[25] recently brought to the fore the debates that surrounded the decision to embalm Lenin and the succession of popular devotions and legends that flourished at that time, uniting the event, the Revolution, and the most traditional forms of narrating. There was an obvious connection between the ideas of men such as Bronch Bruevich, Leonid Krasin, A. Lunacharsky and the popular belief that the corpses of holy men do not decompose after death. They were all connoisseurs of popular mentalities or had been part of the god-building movement. N. Tumarkin accurately showed the 'folklorisation' of Lenin worship even before that of Stalin.[26]

Stalinism again re-utilised strong archaic elements of traditional culture when, after 1934, it re-introduced values of authority, hierarchy, competence, discipline within the family, the school, the factory and society; when it re-established uniforms, epaulettes, exams and stripes. But here again these measures were not as unpopular as is believed. On the contrary, within the conservative masses, traumatised by the brutal changes brought about by the first Five-Year Plan, the cultural revolution and collectivisation, there was a great need for stability, and an even greater need for a stabilisation of values and experiences. We will only look at one example, but one that is illustrative enough for our purposes. Family law was revised in June 1936. Marriage became the basis of the family cell. Divorce was more difficult to obtain and more expensive, and abortion was forbidden except in cases where the pregnancy endangered the life of the mother or the child. In any case, it was up to the doctors to decide and not the woman. This legislation was regressive in comparison to that of 1926. But it must be noted that the 1926 law had been only grudgingly accepted by many women, particularly working-class women. They very accurately foresaw that in Russia's economic and cultural position in 1926, only men would benefit from such a law. They would profit from it by obtaining divorces that would have been difficult to obtain otherwise. It would also result in a generalised pauperisation of women who had been abandoned with their children, without work or qualifications, with the near certainty, despite the new legislation, of never procuring their alimony.[27] As a result there was pressure from women, who succeeded in having the legislation modified.

As Janet Evans appropriately stated in a recent study:

> The literature does suggest that women felt exploited by the change in sexual attitudes after the Revolution and that many were fairly enthusiastic about the package as a whole, which offered a hope of curbing male irresponsibility and of improving the status of women in personal relationships in the family.[28]

I quote this example in order to demonstrate that if Stalinism re-utilised the archaic, the traditional and the regressive, it also encountered on the way some pressure from popular circles, where the mentality was not always directed towards resistance or innovation.

And finally, it was a re-utilisation of tradition through nationalism, Great Russian chauvinism, russification, the promotion of *mat' rodina*, *velikaya Rus'*, and the heroes of traditional Russia after the defeat suffered by Pokrovsky and his school. But here again it is uncertain whether this nationalism, which claimed to be both Russian and Soviet, had touched the feelings of the masses, who were searching for new values of identification. In this respect, first consider the success of films such as *Pëtr Pervy* and *Aleksandr Nevsky*, which both showed the formation of the Russian nation, a formation in which a czar or a prince and the people found themselves associated. Admittedly, this nationalism, which once again approached the regressive and the archaic, had been noticed in its time (1938). Two fascist French critics, who greatly enjoyed Eisenstein's film, wrote in their *Histoire du cinéma*:

> And it is, in fact, a surprising, an admirable page in history that is going to be related to us. They are the Niebelungen of the Slavic past, just as moving and as rich, in the sense of the old German lieder . . . the past rises up, illuminated like a bas relief, strong as a legend . . . basically, with all those German echoes, with its hero worship, and its signs of the past, *Aleksandr Nevskii* is really the most beautiful, the most moving of the 'fascist' films. Nothing comes from Marxism in this war song of the Slavic people, and the film's blond hero takes his place in our memory, not beside Lenin, or even Peter the Great, but beside Roland, Siegfried and Perceval. It is the film that National-Socialist Germany would have invented, had it had a genius for cinema.[29]

But the most famous film of the Stalinist period is the Vasil'ev Brothers' *Chapaev*, produced in 1934. We should now consider other, less directly archaic and regressive connections between the popular and Stalinism: the emergence of new values; the mobilisation of the cultural intermediaries that we touched on earlier; new social classes, which during a difficult and sometimes dreadful period were able to create something brand new, profit from the great upward social movement and carve out a new popular culture at their level.

Soviet society in the 1930s was less monolithic, more complex and heterogeneous than the 'totalitarian' model leads us to believe and once again, cannot be reduced to a cruel encounter between the sprawling state and a pulverised civilian society. Working from primary sources, particularly the Smolensk archives, Sh. Fitzpatrick,[30] A.J. Getty,[31] Roberta Manning,[32] G. Rittersporn[33] and L. Viola[34] have demonstrated that here again we are dealing with a type of syncretism. If there was a Revolution from above, it was obliged, even at the worst moments during the collectivisation of the countryside and the purges, to take into account the various societal pressures.

First of all, there was the social fringe which, however small a minority in the beginning, was nonetheless very important and constituted the main link between the social intermediaries. I would like to speak about a heterogeneous group that consisted, just about everywhere, of not only members of the Party, the soviet, unions and committees, but more generally speaking, the *aktiv*. At the beginning, it was a composite group formed of enthusiastic young people, some united in the komsomol, some not. They were youths who pressed for radicalisation and a decrease in bureaucratisation just about everywhere; they were capable, within the 'light brigade', of raiding the local leaders, whom they accused of corrupt practices; they decided to take charge of the new campaign against illiteracy, the *kul'tpokhod*. These young people, organised or not, were not simply the driving belt of the Party. They had their own sub-culture, their jargon and their dreams. They formed a circle.[35] Here are two quick examples. Elena Tolstaya-Segal recently showed[36] to what extent the early editing of Ostrovsky's *Kak zakalyalas' stal'* was steeped in the komsomol milieu and the editorship of the *Molodaya gvardiya* and the *Komsomol'skaya pravda* in conjunction with the komsomol writers, Boris Levin and Viktor Kin. It was based on short stories in which the youths' disenchantment in face of the NEP and

their need to fight for a cause were reflected, and the 'heroisation' of the komsomol ensured the success of the book.

The second example, the production of the film *Garmon'* (The Accordeon) by I. Savchenko in 1934, is better known. This film was entirely the work of a komsomol team who enlisted the services of young Zharov, whose songs and poems were to become famous. A film produced by komsomols, its theme was very much culture – popular song and the fight between the old and the new. We know the story. Timofei Dudin, a jovial fellow, one of the boys, who spends his life playing the accordion, is chosen by the komsomols to become cell secretary. He takes his new role so seriously that he decides to abandon the accordion. Everyone in his village, where there are no longer either songs or dances, misses him. The kulaks take over and impose songs of the past and counter-revolutionary songs on everyone. Dudin then comes back and takes up the accordion again. It is a film that has plenty of spirit and ends with an accordion duel. It is far superior to Alexandrov's comedies, *Vesëlye rebyata* and *Volga-Volga*.

The komsomol and the group over which it exerted its influence, which was much larger than its membership, constituted one of those cultural intermediaries, one of those creative points of syncretism. True, their space and their scope were very limited, and all these initiatives were easily utilised, manipulated, and indeed even controlled; an overly critical attitude, too much in retreat or too far in advance of the general line ended in arrest, exile or even death. This is all known and true. But nevertheless, those young people constituted a pressure group that cannot be ignored. Other components of this heterogeneous group, which emerged in the 1920s and became important in the 1930s, were the *rabkors*; the *sel'kors*; the worker and peasant correspondents, who were intermediaries again, sometimes isolated and in great danger in the middle of a hostile population, but aware of the popular culture in which they were swimming, crossing swords with the new language and the new values; the village instructors who were at the head of the campaigns against illiteracy, who organised the Red gathering places and the reading contests; the widowed or divorced women, who were still badly received in the villages with traditional morals; the fringe, with their unscrupulous ambition, in search of change; all types of *bezbozhniki* and later, the shock-workers, chiefs of brigades and heads of kolkhozes, who were the first to break with the egalitarian ideology that prevailed among

the working class; and the stakhanovites, born of the people, promoted for a time to the rank of heroes.

It is necessary to add during the 1920s, on the one hand, the demobilised, former soldiers of the Red Army and the Civil War, who had returned to the villages with new ideas; and during the crucial period of collectivisation, on the other hand, the 25 000 workers sent to the countryside, who brought new values, and were not all simple agents of the NKVD. Finally there were, beyond this group of enthusiasts, beyond the *aktiv* in the strongest sense of the term, all those who, on several accounts, profited from these widespread changes. During the cultural revolution, hundreds of thousands of workers were promoted, including communists of working-class origins who were given technical jobs, posts in management or administration, or recruited to higher education. It was an outstanding phenomenon, the creation of a new élite, the *vydvizhentsy*. This whole mass was in contact with the millions of people who were on the road, having fled the countryside, flocking to building sites and to the cities. I would say that these people were also in contact with prisoners, the 'de-kulakised,' semi-prisoners, exiles, and so on. All this created the most extraordinary cultural mixing that had ever been seen, where official and underground propaganda, jokes, slang, word plays, dislocated elements of the traditional culture and new forms – a new folklore – were all mixed together.

At the first Soviet Writers' Congress, M. Gorky enjoined the writers to draw their inspiration from folklore. Praising the popular anonymous heroes and myth as cultural creation, he extolled the optimism of oral tradition:

> I again call your attention, comrades, to the fact that folklore, i.e. the unwritten compositions of toiling man, has created the most profound, vivid and artistically perfect types of heroes, the perfection of such figures as Hercules, Prometheus, Mikula Selyaninovitch, Svyatogor, of such types as Doctor Faustus, Vassilisa the Wise, the ironical Ivan the Simple and finally Petrushka, who defeats doctors, priests, policemen, the devil and death itself.[37]

This emphasis on folklore as a living source of creation allowed the setting up of expeditions on a national scale, best known of which is that of the Moscow region, but most of all it allowed the emergence, again semi-spontaneous, semi-controlled, of new forms of folklore occasionally borrowing from the older rhythmic, poetical and language

forms. Four groups were involved in the elaboration of this new folklore: the folklorists, specialists of the past and of the old forms; the singers, often very old, who remembered the olden *byliny* (ancient epic heroic folksongs) and were able to create new ones; the leaders, who defined the line, separating the wheat from the chaff, the good theme from the one addicted to the past; and the receivers, the local audience who celebrated some creations and rejected others. It was a complex process, not entirely spontaneous nor totally prescribed, one of those composite creations popular in itself. What then were these new forms imitated, sometimes inherited, from the old?

First there were the *chastushki*, short rhymed verses that inscribed the new themes. F.J. Oinas offers some, translated into English by Professor Willis Barnstone:

– on the first Five-Year Plan:

> The Five-Year Plan is not a twig
> It must not broken be
> For the Five-Year Plan both little and big
> Are ready to fight, you see.

– on women's liberation:

> A wife is not a slave
> Things are equal now
> With your arms don't wave
> Now a man must bow.

– and to the glory of Stalin:

> Now at last we do live well
> Comrade Stalin, we all agree
> That you have lifted us from hell
> And freed us from our poverty.[38]

There was also the resurgence of epic songs, a mixture of forms born of the *byliny*, of historical songs and laments instilled with newer themes. These productions were called *noviny*. One particular well-known singer, Marfa Kryukova, who lived in a village by the White Sea, had gained fame with her long epic poems glorifying

Lenin and Stalin. Here is a short translated excerpt of the 'Song of Lenin':

> In those days, in former ones,
> In those times, in olden ones,
> Under big Idol-Tsar of foul memory
> In Simbirsk, fine city of the Volga river
> (. . .)
> On a morning it was, on an early morning
> At the rise of the fair red sun,
> That Ilich stepped out of his little tent.
> He washed his fair face
> With spring water cold . . .
> As he played on his birchbark horn
> The whole people gathered and thronged
> They all thronged and gathered
> Up to that pillar the marvellous
> They gathered in a mighty force
> They took hold on the little ring, the magic one
> Hard it was to wrench the little ring
> With stout force they did wrench it
> Tuned about glorious Mother Russia land
> (. . .)[39]

The episodes surrounding Marfa Kryukova are well known. She travelled, was whisked away to the Caucasus so that she could see the village where Stalin was born. A professional writer, Viktorin Popov, was appointed to her: he supplied her with books and information on Lenin and Chapaev and eliminated the far too pronounced White Sea dialect from her writing. Finally, a medieval tower of sorts was built for her, a tower that seemed to come straight from the pages of a fairy tale. All this was no more nor less manipulatory than the association established nowadays within the framework of life stories so popular in the West, between a professional writer and one who does not write yet wishes to tell the story of his life.

There were also *skazy*, biographies of great men, or sung autobiographies that not only could pertain to politics or major events but also to the condition of women and everyday matters. There was also a folklore of factory workers, of anti-religious satires, of moral scenes against alcoholism inspired by the theatre of the *agitka* (an ideological, political propaganda sketch).

New heroes were being inscribed in these *noviny:* Stakhanovites, tractors, airplanes, the saga of the Chelyuskin with all its symbolics of conquest and grandeur, electricity (lampochka Il'icha), humble people devoted to their work and to their land. Such was this hybrid compound of genuine folk motifs, genuine popular creation and Communist propaganda. Even if controlled, this will to promote popular forms took hold of writers who left in droves for the kolkhozes, the factories and the non-Russian Republics, wishing to establish closer contact with the people. It looked very much like a populist crusade but with mutual exchange instead. V. Vishnevsky, who not long beforehand had defended James Joyce in a resounding article in *Literaturny kritik*, now declared:

We must find popular forms of art (. . .) These are as indispens-able as arms and marching songs are in the field (. . .) We must constantly ask ourselves: is what we create comprehensible, Comra-des? Should someone not understand, should it be complicated, subtle, etc. (. . .) All good and well, but it does not apply here today.[40]

Mention should be made here, though briefly, of how the writers, in their attempt to create a positive hero, a new man, in all to promote a new popular culture at the symbolic and axiological levels, stood ambivalently towards traditional popular culture, from Sholo-khov to Panfërov and from Leonov to A. Tolstoi.[41] This may have prompted K. Andreev to write idealistically:

The boundary between folklore and literature, which for centuries was supported by class distinctions in society, has now become more flexible; it is even disappearing: literature is penetrating the broadest masses of the working people who no longer need to restrict themselves to folklore; on the other hand, many talented representatives of these newly-awakened masses now have the opportunity to set down their creations in print, i.e. folklore is no longer their only outlet. Literature is becoming universally accessible, folkloric, while folklore is becoming literary.[42]

In addition to the latest popular songs, we must also add to these new emergences the important bard movement from Uzbekistan, Kazakhstan and Armenia. The best-known of these bards, Suleiman Stalsky from Daghestan, sent a poem to the first Soviet Writers'

Congress and made a great impression. Other bards were also well known, for example, Dzhambul Dzhabaev, the agyn Kazakh or the agyn Bek. Again, the thematics distributed itself between the exaltation of men, great and small, and the construction and transformation of the country, of the cities or of the customs. Here is a short excerpt on the construction of railroads:

> Those who used to be slaves and serfs
> Have now been made heroes by the Turkish
> The simple shepherd, tempered by work,
> Has now become dispatcher of the train,
> And has thus gained batyr-like power
> He used to herd the sheep and beat them with the whip
> But now with steady hand,
> He draws the diagrams of railroad traffic.[43]

We could cite countless others. To ask ourselves if they indeed were popular productions would make as much sense as asking ourselves today whether *Dallas* or *Miami Vice* are 'popular'. These productions reached a large audience, circulated throughout the land, and were sometimes recovered, reworked and deformed. They were the means of a new hybrid oral culture, both spontaneous and controlled. The same applied as well to other cultural productions, from awkward popular autobiographies to the works of fiction of shock-workers during the first Five-Year Plan. Many of these works from below lyrically told of the life of the factory and the poetry of the machines.

> Six o'clock sharp. The signal bell rang from the
> engine. The big handwheel started turning, shaking
> the dust from its steel shoulders. The rods stirred in
> unison and the axles began singing. The sheet mill
> moved forward to fight for the metal, for the first
> Five-Year Plan, for Socialism.[44]

Of course, one can smile before the lack of talent, yet this was but a first experience at writing, as were the clumsy autobiographies of Party candidates found in the Smolensk Archives, which moved N. Werth, who has studied them so well, to say:

How compelling these autobiographies can be, written as they are in such approximate syntax and spelling! They reveal to us what great upheavals these people have lived through seven years of war and revolution.[45]

A new genre also developed, that of the individual or collective letter to Stalin during holidays, commemorations, folk singing gatherings, and so on. In this connection, I would like to bring out the ambivalent character of the Stalin cult in the 1930s. He permeated both forms of the popular effect in culture, the archaic, the regressive that I mentioned earlier, and the new values inscribed in utopian, infantile forms. He symbolised both a regressive superego and all that embodied the fight against the old world and the old values. I studied the body of Yiddish schoolbooks in the 1930, distributed in Moscow as well as in Minsk, Kiev or the Birobidzhan. They abound in pictures of Stalin, poems about Stalin, and legendary forms mixing the real and the imaginary, deforming historical facts. They are infantile. Yet at the same time, new values come across these forms, new values that learn to re-read the past, tradition and nineteenth-century Yiddish literature. This in fact pertains to the secular all-Soviet imagery that exalted work and specifically the factory and the kolkhoz, the beauty of landscapes, the value of solidarity, the new holidays (1 May, the anniversary of the October Revolution), the new symbols, the Red Flag, the hammer and sickle, the Lenin Mausoleum, the construction of the Palace of Pioneers and of the Moscow metro, the new heroes, the aviators, Stakhanov, and so on, and science. I insist that this is a hybrid compound that, amidst the infantilism of form, makes new values emerge, values that will be able to develop beyond the Stalinist era.

The same phenomenon can be observed on the pages of *Pravda*, where we see Stalin pictured alongside workers, kolkhozniki, aviators, supermen heroes or humble ones at that. The campaign started in 1931 with the new slogan 'The Country Needs to Know Its Heroes', followed by photographs of 13 persons identified as shock-workers, and the like. Later there appeared a two-page feature on 32 persons, each identified by a photograph and a short autobiography: engineers, work-brigade leaders, heroes of socialist labour. They were examples of the 'new Soviet man'. This phenomenon also spread to the thousands of messages that flooded in on the anniversary of Stalin's birth or quite simply all year long. If many were of

questionable authenticity, the bulk of these messages reflected what Stalin did represent, a symbol of new values, expressed in outdated language.

One must finally take note of the attempts at collective writing spearheaded by M. Gorky, which resulted in a monumental *History of Factories and Plants*. In every factory, the editorial committee was in charge of writing the history of the plant and the 'literaturnyi kruzhok' organised the work. The workers participated in the gathering of material and the writing was entrusted to professional writers, though sometimes to workers also. One may remember a few successes: *Belomorsko-baltiskii kanal,* in which 40 writers, among them Shklovsky, Zoshchenko and V. Kataev, put into words the experiences of political prisoners and criminals; *Liudi stalingradskogo traktornogo,* in which can be found 32 autobiographies of workers and engineers; *Byli gory vysokie,* in which stories were often told by the workers themselves; and *Istoriya zavoda imeni Lenina,* written by a worker who was once a rabkor (workers' correspondent – rabochii korrespondent), N.P. Payalin.

I would also add to these the thousands of letters sent to newspapers in the 1930s. They were selected, of course, but not always rewritten by the editors. They were often authentic. The Smolensk Archives have revealed hundreds of these letters denouncing what was going wrong in genuine anti-bureaucratic statements that frankly expressed a true popular discontent and partook of a new radicalism that was to reveal itself in the mechanism of the purges. As J. Arch. Getty writes of the 1937 purges:

> It was not the result of a petrified bureaucracy's stamping out dissent and annihilating old radical revolutionaries. In fact, it may have been just the opposite. It is not inconsistent with the evidence to argue that the Ezhovshchina was rather a radical, even hysterical reaction to bureaucracy. The entrenched office holders were destroyed from above and below in a chaotic wave of voluntarism and revolutionary puritanism.[46]

This new popular culture emerged with great difficulty indeed and had to re-inscribe several characteristics of traditional culture. R. Manning indicates that

> In the Matrennikovskii rural soviet, admittedly an extreme case, the official hut librarian was a functional illiterate and spent his

time on the job drinking with the rural soviet chairman. The hut library here existed only 'on paper' possessing no book or even a room of its own in the rural soviet building. The periodicals to which the rural soviet was cajoled to subscribe by the Party, even *Pravda*, were stashed away in the chairman's office and utilized by members of the rural soviet for rolling cigarettes, to the dismay of the local schoolteachers.[47]

One must nevertheless take into account, in another respect than that of the archaic and the regressive, the great effort – even if oriented, even if supervised, even in its context of terror – of alphabetisation and participation on the part of workers and peasants in the elaboration of culture: autobiographies, histories of factories, histories of such-and-such locality during the Civil War, productions of scenes, *agitka* pertaining to everyday life, to dekulakisation, industrialisation and the fight against alcoholism, individual or collective attempts at writing fiction, sketches from life, numerous *ocherki* spread out in *Nashi dostizheniya*, portraits from rabkors, factory correspondents, new bards of the national minorities, and the resurgence of oral traditions. All this was in spite of the growing authoritarian nature of the regime. It was, and this is not the least of contradictions in the 1930s a genuine discourse from below. That this discourse was mystified, delinquent, supervised and channelled does not alter in the least the sociological phenomenon of illiterates and semi-illiterates being heard for the first time albeit in barbaric, ruralised, primitive forms.

Where does this lead us? Recognising that a complex popular culture is forging itself during the Stalinist era does not exonerate Stalin from the horrors of persecution and the disappearances that are his doing. Millions of innocent people perished. My study does not aim to justify or attenuate in the least this shadow in Soviet history. Let there be no misunderstanding on the subject. My study seeks to analyse the complexity of this society, the popular roots of the regime and the hybrid cultural forms that abound there.[48]

How can one conclude? Sh. Fitzpatrick recently outlined what I shall call a *congruence theory* in the framework of Revolution from above. She wrote that a

(. . .) process of negotiation might be discerned in the development of norms for the new kolkhozy for the regime's original

intentions were clearly modified in response to village realities and traditional patterns of peasant life.[49]

We have already mentioned these meeting points in reference to the family legislation and the mechanism which would lead to the great purges. I myself have even noticed these meeting points in the misunderstanding about the constitution of Socialist Realist aesthetics and the pressure from the reader.[50] V. Dunham,[51] in her study of postwar fiction, talks of a 'big deal', of a compromise between the new élite, former *vydvizhentsy* having become respectable, and the power, culminating in the appearance of petty-bourgeois values, a kind of new *meshchanstvo*. This new culture was already in the making in the 1930s. It inscribes within itself the two aspects of popular culture, the archaic, regressive, traditional, 'mentalitarian', nationalist and infantile, and also new collective values at the symbolic, axiological, cognitive and cultural levels. It combines obscurantism and also traces of the ideology of the Enlightenment, remnants of utopianism and mysticism. In it can be found the enthusiasm for new tractors as well as the fantasy of the archaic refuge Stalin represents, as shown in the *kolkhoznitsa's* dream in Ermler's *Krest'yane*.

How can we account for this strange combination, for the enigma of the combination? I believe M. Lewin provides us a clue when he proposes to speak in terms of acculturation/deculturation processes for the Stalinist period. Emphasising, as had M. Ferro,[52] the ruralisation of Party and management, and the semi-literate character of the new managers and the new élite, he writes:

> The cultural revolution of the 1920s-1930s was only beginning to bear its fruits. The educational effort undertaken before the war, remarkable as it was, had not yet transformed the population into an adequately educated one – a task impossible in a few years. Even the leaders (they in particular) were products of a revolution but not of a cultural one. The population and the cadres had reached some halfway point, as a result of the policies and the industrial effort pursued by the regime – and it was enough to wage and win a war but not enough to avoid its terrible, excessive cost. Instead of the term 'cultural revolution,' it is more appropriate to use something else – 'acculturation' perhaps – to express the reality of a still poorly educated population coming out from deep

illiteracy, producing a growing mass of trained people who formed nevertheless only a quasi-intelligentsia. These terms render better than others do the stage reached by 1941, not just in the sphere of culture, but broadly, in the realm of social and political relations. Further changes and advances which took place after World War II would make the term 'cultural revolution' more adequate.[53]

All the words here are important: halfway point, acculturation, quasi-intelligentsia. We could conclude our analysis by speaking in terms of *quasi-popular culture*, of a *transition period* from 1928 to 1941 with its different stages and changes of line, a period where the country (to quote Preobrazhensky out of context) was in the throes of the cultural primitive accumulation of Socialism. Hence its double feature at the level of popular culture, summed up in the notion of *quasi-popular culture*: its archaism and the new emerging forms which would release popular initiatives. Yet at the same time that these were being released, owing to a greater access to knowledge, they were in fact being blocked, caught up in the authoritarianism of the regime and of civil society. Hence the underground forms of this quasi-popular culture, for example, the jargon of prisoners, the unofficial collective memory or the jokes everyone still remembers today. The various forms of popular culture have marked Soviet society from below to above just as the forms of inculcation of official ideology have marked it from above to below.

But new problems arise. In conclusion, I would like to quote from an article in the 12 October 1986 edition of the *New York Times*:

> Mr. Klimov [newly-elected secretary of the Union of Soviet Cinematographers] must also face the reality that the innovative film makers he would like to promote are not necessarily those who will pack the theaters. Mr. Tarkovsky's highly refined films, for example, were largely ignored by the general public even when shown, while the most popular film of recent years, 'Moscow Does Not Believe in Tears,' was spurned by intellectuals while drawing some 80 million viewers. 'We feel we should support the tendency toward popular films, while raising their content and quality.'[54]

Such is the eternal problem of any political enterprise faced with popular culture, popular taste: a problem that revives the theories of Brecht and Gramsci and shows signs of maturity.

NOTES

1. M. Lewin, *The Making of the Soviet System* (New York, 1985).
2. R. Tucker, 'Stalinism as Revolution from Above', in *Stalinism*, R. Tucker (ed.) (New York, 1977) pp. 77–108.
3. Sh. Fitzpatrick, 'New perspectives on Stalinism: The View from Social History', paper presented at the panel on 'Stalinism' at the 3rd World Congress for Soviet and East European Studies, Washington, DC, 2 November 1985; 'NEP Society and Culture: Introductory Remarks', paper prepared for the Conference on NEP Society, Bloomington, In., 2–4 October 1986.
4. Quoted in M. Lewin, 'Popular Religion in Twentieth-Century Russia', in *The Making of the Soviet System*, op. cit., p. 60.
5. Ibid., p. 60.
6. J. Brooks, *When Russia Learned to Read* (Princeton University Press, 1985).
7. R. Hoggart, *The Uses of Literacy* (England, 1957).
8. N.A. Dobrolyubov, 'O stepeni uchastiya narodnosti v razvitii russkoi literatury', in *Sobr. soch.* (Moscow, 1961–64) II, pp.218–72.
9. V. Terras, *Handbook of Russian Literature* (Yale University Press, 1985) p. 293.
10. B. Brecht, *Brecht on Theatre*, trans. J. Willett (London, 1964), p. 108.
11. Ibid. p. 108.
12. M. Bakhtine, *L'Oeuvre de François Rabelais et la culture populaire au Moyen-Age et sous la Renaissance* (Paris, 1970).
13. K. Clark and M. Holquist, *Mikhail Bakhtin* (Harvard University Press, 1984).
14. Ibid, p. 310.
15. M. Lewin, *The Making of the Soviet System*, op. cit., p. 58.
16. P. Burke, *Popular Culture in Early Modern Europe* (New York, 1978).
17. M. Vovelle, *Idéologies et mentalités* (Paris, 1982).
18. C. Ginzburg, *Il fromaggio e i vermi* (Turin, 1976).
19. N.S. Timasheff, *The Great Retreat* (New York, 1946).
20. D. Field, *Rebels in the Name of the Tsar* (Boston, 1976).
21. M. Cherniavsky, *Tsar and People; Studies in Russian Myth* (New York,1961).
22. Quoted in G. Vernadsky, *A Source Book for Russian History from Early Times to 1917* (Yale University Press, 1972) 2 vols.
23. J.L. Heizer, *The Cult of Stalin, 1929–1939*, PhD thesis (University of Kentucky, Microfilms International, 1981).
24. J. Stalin, 'The Dizziness of Success', in *Pravda*, 2 March 1930.
25. N. Tumarkin, *Lenin Lives: The Lenin Cult in Soviet Russia* (Harvard University Press, 1983).
26. In fact, the Bolshevik leaders were opposed at first to promoting folklore and the traditional rituals. True men of the Enlightenment, heirs of the 1860 generation, they wanted to promote a new public culture, not prolong what they felt partook of 'oblomovshchina'. J. Brooks says it best in his book *When Russia Learned to Read* (op cit., p. 297):

The hostility of the revolutionaries toward frivolous reading, their suspicion of the common people's literary taste, and their certainty of the importance of literature in the transformation of man were shared by a wide circle of their contemporaries in the prerevolutionary era.

27. W.Z. Goldman, 'Working-Class Women and the "Withering Away" of the Family: Popular Responses to Family Policy', paper presented at the Conference on NEP Society, Bloomington, IN., 2–4 October 1986.
28. J. Evans, 'The Communist Party of the Soviet Union and the Women's Question: The Case of the 1936 Decree *In Defense of Mother and Child*', in *Journal of Contemporary History*, 16 (1981).
29. Quoted in J.L. Passek, *Le Cinéma russe et soviétique* (Paris, 1981) pp. 199–200.
30. Sh. Fitzpatrick (ed.), *Cultural Revolution in Russia, 1928–1931* (Indiana University Press, 1978); Sh. Fitzpatrick, *Education and Social Mobility in the Soviet Union, 1921–1934* (Cambridge, 1979); 'Stalin and the Making of a New Elite, 1928–1939', in *Slavic Review*, XXXVIII, 3 (1979). See also Note 3.
31. J. Arch. Getty, *Origins of the Great Purges: The Soviet Communist Party Reconsidered, 1933–1938* (Cambridge University Press, 1985).
32. R. Manning, 'Peasants after Collectivization', paper presented at the IInd Workshop on Social History of the Stalin Period, Columbia University, April 1985; 'The Collective Farm Peasantry and the Local Administration: Peasant Letters of Complaint in Belyi Raion in 1937', paper presented at the National Seminar for the Study of Russian Society in the XXth Century, 1983; 'Government in the Soviet Countryside in the Stalinist Thirties: The Case in Belyi Raion in 1937', in *The Carl Beck Papers in Soviet and East European Studies* (Pittsburgh, 1984).
33. G. Rittersporn, 'L'Etat en lutte contre lui-même: tensions sociales et conflits politiques en URSS, 1936–1938', in *Libre*, 4 (1978), pp. 9–38; 'Staline en 1938: apogée du verbe et défaite politique. Eléments pour une étude du stalinisme réel', in *Libre*, 6 (1979), pp. 99–164.
34. L. Viola, *The Campaign of the 25000ers: A Study of the Collectivization of Soviet Agriculture, 1929–1931*, PhD thesis (Princeton University, 1984).
35. Sh. Fitzpatrick recently proposed that we focus our attention on the culture of the youth as sub-group. I totally agree with her on the matter. It would bring out new, essential knowledge.
36. E. Tolstaya-Segal, 'K literaturnomu fonu knigi *Kak zakalyalas' stal'*', in *Cahiers du monde russe et soviétique*, XXII, 4 (1981) pp. 375–99.
37. M. Gorky in *Pervyi vsesoiuznyi s"ezd sovetskikh pisatelei* (Moscow, 1934) p. 10.
38. F.J. Oinas, 'The Political Uses and Themes of Folklore in the Soviet Union', in *Folklore, Nationalism and Politics*, F.J. Oinas (ed.) (Slavica Publishers, 1972) pp. 84–5.
39. Ibid., pp. 86–7.
40. Quoted in J.L. Passek, *Le Cinéma russe et soviétique*, op. cit., p. 68.
41. See R. Robin, *Le Réalisme socialiste: une esthétique impossible* (Paris, 1986); R. Robin (ed.), *Soviet Culture in the Thirties: A Reappraisal*,

*Sociocriticism*, 3 (Pittsburgh, 1986).
42. K. Andreev, 'Fol'klor i literatura', in *Literaturnaya uchëba*, 5 (1936).
43. T.G. Winner, *The Oral Art and Literature of the Kazakhs of Russian Central Asia* (Duke University Press, 1958), p. 165.
44. Quoted in J.P.A. Bernard, *Le Parti communiste francais et la question littéraire, 1921–1929* (Presses universitaires de Grenoble, 1972) p. 48.
45. N. Werth, *Etre communiste en URSS sous Staline* (Paris, 1981) p. 16.
46. J. Arch. Getty, *Origins of the Great Purges*, op. cit., p. 206.
47. R. Manning, 'Government in the Soviet Countryside in the Stalinist Thirties', op. cit., p.24.
48. See L. Marcou, *Une Enfance stalinienne* (Paris, 1982).
49. See Note 3.
50. See Note 41; 'Peasants as Readers', paper presented at the Conference on NEP Society, Bloomington (In.), 2–4 October 1986.
51. V. Dunham, *In Stalin's Time: Middle-Class Values in Soviet Fiction* (Cambridge University Press, 1976).
52. M. Ferro, *Des soviets au communisme bureaucratique* (Paris, 1980).
53. M. Lewin, 'Introduction: Social Crises and Political Structures in the USSR', in *The Making of the Soviet System*, op. cit., p. 41.
54. S. Schmemann, 'Winds of Change Stir Soviet Film', in the *New York Times*, 12 October 1986, p. 19.

# 3 Stalinism and Carnival: Organisation and Aesthetics of Political Holidays*
Rosalinde Sartorti

On first sight, 'Stalinism and Carnival' seems to be a contradiction in itself. It might rather suggest a description of the Great Purges 'that gathered force in 1935 and continued in a lunatic progression until the end of 1938'[1] as the 'saturnalia of arrest'.[2] Only in 1939, the wave of mass arrests began to recede.

Discussing Stalinism and carnival, however, is not meant in a metaphorical way but refers to the numerous carnival celebrations which took place in the Gorky Park of culture and leisure in Moscow in the mid- and late 1930s, of which the Carnival festival organised by the Moscow Trade Union Council on the occasion of the anniversary of the Soviet Constitution in July 1935 was only the first of its kind.[3] This very festival became the model for many similar carnivals in the following years until the outbreak of the Soviet-Finnish war. In the summer of 1937, for instance, at the time of the secret trial and execution of the Red Army high command, headed by Marshal Tukhachevsky, which preceded the unpublicised liquidation of approximately half the entire officers' corps, another carnival was organised in the Gorky Park. A description reads as follows:

'In the night of the 5th to the 6th August, a hundred thousand participants in costumes and masks were dancing waltz and tango, slow and fast fox-trot, they were enchanted by the torch processions of the carnival heroes, by the Ferris wheels, the fountains which resembled burning asters, by the nightly sky brightened by the play of the projectors, by the fireworks and the rockets, and they went down the river Moskva in boats decorated with pennants.

Forty orchestras played for them, and the visitors to the park enjoyed themselves in fair ground booths, in the circus, the theatre, at concerts . . . they were dreaming in the Garden of Reverie or on the Bridge of Sighs; on the Avenue of Fortune they tried to have a look into the future . . . The crowd was full of life, they felt free and unrestrained.'[4]

This kind of carnival was new in the Soviet history of holiday celebrations and it was new in several aspects not just as the organisers of the 1935 carnival put it, that it was 'the first attempt to organise a carnival festival on a massive scale based on the *samodeyatel'nost'* of the collectives'.[5] It was new in the sense that a political holiday served the purpose of staging a carnival with no explicit political connotation whatsoever. If we follow the numerous reports on the many carnival celebrations over the years – and these reports were basically interchangeable in content – we learn about the full range of Russian mythological figures, of all the legendary birds and animals of Russian fairy tales which served as a permanent decorum for these festivities. We hear about ancient Greek and Roman sites or historical Italian settings which were constructed in the Gorky Park on these occasions: for on one night history and fiction merged with reality. But even more striking was the eclecticism concerning the musical entertainment during those carnivals. Next to the, by then, almost traditional Soviet Russian folk dances, music and songs, we find orchestras playing tango, fox-trot, waltz and jazz, music which for many years had been considered alien to a proletarian society.[6] On the whole, the naive reader gets the impression of a Soviet society characterised by a holiday mood which knows nothing of scarcity, tension or necessity, but quite the contrary, a world of overabundance, amusement and forgetting. Or as *Komsomolskaya Pravda* put it:

There is happiness in the land of plenty. One lives happily and joyfully in our home country. Tomorrow to work. Work is just as beautiful and enjoyable as leisure, as play.[7]

As we can hardly pretend to be naive readers, this is the point to ask a few questions. We all very well know that the official military parades and militant demonstrations used to celebrate the 1st of May

and the anniversary of the October revolution did not disappear in the mid- and late 30s. Yet the mass carnivals staged during the very same period were a new feature of holiday culture in the time of Stalin. It would be too easy to conclude that in light of our knowledge of Soviet history of this period the carnivals were simply another form of bread and circuses for the people. Also, since there had been other forms of carnival and the carnivalesque in Soviet holiday design before, ranging from carnival processions staged by the Komsomol youth, in the early 1920s, to the so-called political and industrial carnival, characteristic of the NEP-period, trying to understand in which way the carnivals of the mid- and late 1930s were different and to what extent they were not only an adequate but a crucial expression of Stalinist culture requires some reflection of a more general nature. On the one hand, we have to consider what the function of a holiday, above all a public and political holiday, is and, on the other hand, we have to take into account the Soviet history of public political holidays in which the notion of carnival or the carnevalesque had been, for many years, the cornerstone of dissent and can as such be regarded as a recurrent *leitmotiv* in their history.[8]

Let me start with the central problem with which the new Soviet government was faced after the Revolution. They had to restructure and revolutionise not only the political and economic system but also the culture – the struggle for a *novyi kul'turnyi byt*[9] – in which the holidays were of crucial importance. The holidays were of importance not just in number – the orthodox calendar listed up to 150[10] – but, above all, in that holidays and the way in which they are celebrated do express the beliefs and convictions of the participants. Any official form of celebrating is but one aspect, though a very important one, for giving expression to the culture of the society as a whole. A public holiday is not merely a day of leisure, a day without work, a day to rest: 'The holiday is a condensed form of everyday life' (A. Piotrovsky). The ones who celebrate share common norms and values, they show a consensus. In principle, this is the basic prerequisite for celebrating a holiday. In other words, the people join to celebrate, to reassure each other and, at the same time, the public, of their common understanding of the specific occasion. In a public celebration the participants reconfirm specific ideas which make up the very fabric of society. And it is by traditional and familiar rituals that these common norms and values are expressed; it is these rituals – be it colours, sounds, words, gestures – which are of a highly symbolic nature and which serve as a means of identification.[11]

Just as any other revolutionary government, the new Soviet government was faced with the problem that the norms and values of the society that it was going to establish and construct were fundamentally opposed to those of the old regime they had just overthrown. Consequently, the new norms and values of a Socialist society in the making could not be expressed by the traditional rituals, nor by traditional holidays. In short, the czarist and the orthodox religious holidays were to be replaced by new Socialist, that is secular, political ones, of which the 1st of May and the anniversary of the October Revolution were only the most important.[12]

Yet, there is hardly anything as ingrained and deeply rooted in people's behaviour as traditional norms and values, expressed and backed up by rituals. This was especially true for the post-revolutionary Russian society which in its large majority – apart from the new political leaders, the artistic avant-garde and a small group of politically conscious – consisted of a backward and illiterate peasant population strongly attached to religious beliefs. Their 'tradition' was an ecclesiastical religious, to certain extents a heathen, but not a secular Socialist one. This is why in Soviet Russia the new public holidays were not merely and foremost an institution to reinforce common social norms and values but, first of all, an effective means to propagate these values. Above all, they were a means to teach or, at least, to show the illiterate masses who still lacked the necessary political consciousness through colours, images, slogans, sounds, in short, by acting on the senses, the visual and the auditive, what this new society was to be all about.

One cannot say that there had been a special 'theory of festivity' of the Bolsheviks. Still, opinions differed greatly among the political leadership on which forms of celebrating would most adequately express the new Soviet norms and values. One group favoured the ascetic and disciplined, the serious and solemn holiday rituals, represented by militant marches, demonstrations, meetings as a genuine proletarian tradition – among them Lenin, whose 'sobriety and dislike of pomp were almost proverbial'.[13] The other faction, which consisted mainly of avant-garde artists and theatre men, but also of politicians like Lunacharsky and Trotsky, advocated the celebration of Socialist holidays as a new sensuous and aesthetic adventure where the political side was just another opportunity to demonstrate the cultural and artistic emancipation of the Soviet people.[14]

Taking a stand for the ascetic and disciplined in the holiday design or favouring the more pompous, colourful and carefree instead, reflected the more general division of the Party leadership between 'industrialists' and 'agrarianists'. The former believed in the omnipotent organisational power of science and technology which ultimately would create a human being of technical rationality, whereas the latter gave much more consideration to the peasant tradition as a basis for social change.[15] In this way, the changes in the celebration of Soviet holidays were also an expression of the lasting conflict between urban and peasant culture and were, in fact, 'a reliable seismograph for political tendencies, for controversies inside the Party and for an assessment of the overall economic situation'.[16]

Furthermore, favouring either the urban, that is, the proletarian, or the popular, that is, the peasant element, was a problem of the extent to which the new leadership would allow the peasant masses to apply their own experience and ideas to organising and celebrating the new Socialist holidays. How much room would be given to the creative spontaneity of the masses and how much would the vanguard exercise its role as an educator and impose its own ideas on the people, channelling this spontaneity to transform it into consciousness (*soznatel'nost'*), or suppress spontaneity altogether? This precarious balance between orders 'from above' and decentralised self-initiative 'from below' is yet another aspect of the changes in the design of Soviet holidays over the years.

Despite their differing opinions on which form the new Soviet holidays should eventually assume, they all agreed on one point, that it was the masses themselves who should eventually organise and design their holidays. Yet, above all, in a period of transition, self-initiative could embody a great risk for the political leadership. The notion of festivity as well as the history of festivities shows how unstable a balance between order and disorder each festive celebration is. The question of the extent to which public celebrating should be left 'spontaneous' or be carried out in a centrally-planned and controlled manner is a problem inherent in any festivity. Celebrating is reconfirming common norms and values by certain rites with a more or less excessive kind of behaviour. It is, at the same time, a kind of leaving the restricted order of everyday life and entering into the realm of spontaneity. It is this anarchical side of any festivity which has to be kept under control in order not to endanger the system in which the festivity takes place. This control was even more

difficult to guarantee in a society where the values and norms which were to be reconfirmed by the very celebration had not yet become generally accepted, where religious beliefs clashed with political convictions and the traditional pagan and peasant customs and rites of the countryside with the new industrial world of the city.

These contradictions become even more obvious when we take into account the Russian peasant traditions of celebrating. Altrichter, in his study on the peasants of Tver',[17] gives a vivid picture of the drinking habits, of the long days spent on preparing alcoholic beverages (*samogon*), that were considered essential for each holiday. As a result, people did not only get drunk but in this total state of drunkenness engaged in fighting, in knifebattles and more often than not, at the end of the holiday, the village had to deplore several victims of a violent death.

It was this kind of 'popular culture' with its emphasis on drink, on emotional involvement, on physical contact, that the new government was up against. With its disinhibitory effect, alcohol could set free energies which could seriously endanger the system. But even more: not only were drunkenness and alcoholism opposed to efficiency in industrial production and to the concept of an ascetic and disciplined worker, to the rational model Socialist man, but the habit was, above all, considered a sad remnant of a former society characterised by exploitation and repression, where alcohol had been the only means for forgetting about the hardships of every day life.

> The life of the working family is too monotonous, and it is this monotony that wears out the nervous system . . . Hence comes the desire for alcohol – a small flask containing a whole world of images.[18]

In a Socialist society, free of exploitation, where labour would eventually be transformed from a disgraceful burden into an activity no longer governed by need, where labour would eventually assume a new form – that of play, there could be no need for forgetting.

On a similar stand, the new government campaigned against the many religious holidays which often overlapped with the new political ones. 'Red Sunday' coincided with the old Russian New Year and Twelve nights celebrations, and the anniversary of the February revolution and Commune came together with the pre-Lenten *maslyanitsa* ('butterweek'). And even ten years after the October Revolu-

tion the May Day celebrations had to gain the day over the orthodox tradition of the Easter week.

Religion was considered the 'opiate of the people' and as such was fundamentally opposed to the new atheist materialist *Welt-anschauung* of the Soviet state. Yet, as Trotsky rightly stated, religion could not be 'eradicated by criticism alone'.[19] The 'theatrical methods' used by the church had to be slowly transformed 'by distraction and play', by 'amusements' as a 'weapon of collective education'.[20]

With his dictum that 'the folk-festivals' (*narodnye prazdnestva*) were 'the most important result of the revolution',[21] Lunacharsky, in some way, referred to what Trotsky called 'man's desire for the theatrical, a desire to see and hear the unusual, the striking, a desire for a break in the ordinary monotony of life',[22] though less in respect to the people as simple on-lookers, than as active participants. By this, he gave expression to the more moderate and humanistic approach to cultural change, by an evolutionary rather than a revolutionary process, an approach based on what there was – the great majority of peasants – taking into account their deeply rooted likes and dislikes and slowly adapting and integrating them into the new and changing society. It was a question of which elements of Old Russia could be most fruitful applied to the creation of a Socialist society, and it is in this context that we have to see Lunacharsky's laudatio on the heathen Russia that, thanks to the Revolution, would, for the first time, be given the possibility to freely develop its unique potential:

> The Russian church paved the way for autocracy, and it hated the gudok-players and the cheerful jesters, since they represented a republican, a heathen Russia, free of asceticism. And it is this very Russia that has to come back now, only in a totally new form, a heathen Russia that has already experienced many ordeals, gone through many cultures, that possesses factories and railroads, but a Russia free, communal and heathen in the very same way'.[23]

Though even more important, the Russian people, liberated by the Revolution, free of repression and exploitation, would be free to laugh: ' . . . our air is still interwoven with the threads of the old culture . . . still, we already dispose of a tender weapon – our laughter'.[24]

In this idea of an unrestrained and joyful festive mood that should reign over the Soviet form of celebrating – 'we shall laugh' – he met with Kerzhentsev who also considered the 'revival of the folk festivals' a priority task of post-revolutionary cultural activity.[25] They were to be 'created anew and revised' on the basis of the 'collective creativity of the masses so long suppressed in the times of czarist autocracy'.[26] The folk festivals were to him the perfect occasion to apply their *samodeyatel'nost'*, 'to startle the creative instinct of the masses'.[27]

But even a man like Kerzhentsev who strongly favoured a colourful synthesis of different art forms as the more adequate expression of Socialist festivities[28] and who objected to the traditional marches and parades as 'by far too simple',[29] just as Lunacharsky expressed his regret over the lack of imagination and emotional involvement of the participants on the occasion of the new proletarian holidays[30]; even these protagonists of 'popular culture' stressed the necessity of education and of organisation in this matter. 'Everything which is supposed to leave a lasting impression must be organised'[31] said Lunacharsky and Kerzhentsev – though from the standpoint of a theatre man: 'Artistic education of the masses is indispensible for the success [of the new Socialist way of celebrating]'.[32]

## CARNIVAL AND SOCIALIST SOCIETY

Talking of the carnivalesque, and how it manifested itself in Soviet holiday design, is talking about the peasant or popular element opposed to urban culture. The conflicting ideas about the celebration of public holidays were not limited to the lasting conflict between 'town and countryside' or between the 'theatrical and the carnivalesque', as modern Soviet scholars see it.[33] Rather, there was a contradiction in the notion of carnival itself in relation to the structure of a Socialist society.

If carnival consisted of a temporary reversal of power relations, a 'world upside down', so to speak, how could power relations be reversed in a supposedly classless society, where 'the old masters' had been dethroned not in a staged, carnivalesque and playful rebellion but by the act of a political revolution, leaving a transitional society where the classless structure was to emerge and not be put at risk by rebellious, boisterous and uncontrolled behaviour that could shake

its fragile body more than the still existing tensions and conflicts of everyday life.

The traditional society was linked to an eternal, supra-historical, divine order and, as such, could easily deal with a carnival world upside down. This divine order legitimised the existing power relations on earth, and advocated the utopian formula 'Everybody is equal before God'. In this respect, carnival laughter was indeed part of the traditional society's ideological framework ('The last ones will become the first'). However, this possibility to ridicule oneself, this self-irony, inherent to societies based on religion, was not given in a Socialist, that is, an atheist society. Furthermore, there was a different notion of time. Any festivity leaves the ordinary time of everyday life behind. It either commemorates past events or anticipates the future as already somehow present. This also applied to the traditional Russian pre-Lenten carnival. Yet, the specific way in which the Russian peasant population celebrated was extreme in the sense that they indulged merely in forgetting. This ahistorical attitude was fundamentally opposed to the notion of history in a transitional society orientated towards the future, with all its necessary educational measures.

But even men of influence, such as Lunacharsky, who favoured the heathen peasant tradition and a carefree and gay holiday mood as expressing the freedom of the new Socialist society, agreed on the necessity to educate the people. It seems quite obvious that, in their eyes, the carnivalesque of the future Socialist festivities was to assume a somewhat more refined and 'civilised' form than the traditional Russian peasant way of celebrating, commonly considered a 'senseless drinking and brawling orgy'.[34]

Yet, whatever was called carnival or carnivalesque in the Soviet Union or organised and staged as such, in the years after the Revolution, it was clear from the very beginning that the Soviet type of carnival processions or festivals were supposed to be different from the pre-revolutionary ones. That Soviet carnival had very little to do with traditional carnival customs becomes quite evident when we look at the Russian word used for the Soviet carnival festivities.

In Russia, the equivalent to traditional Western European pre-Lenten carnival customs was called *maslyanitsa* (occasionally translated by 'butterweek' as of *maslo*, 'butter', reminding one of the French *Mardi gras*), whereas the Soviet forms of carnival were referred to as *karnaval*. This slavicised loan-word was not a Soviet innovation. It had already been used before the Revolution for

Western European carnival.[35] All the carnivalesque processions and allegorical parades staged by the czars, in particular by Peter the Great and Catherine II, were called masquarades (*maskarada*). The gigantic floats mounted during the pre-Lenten period with legendary figures and settings of familiar Russian as well as of foreign, ancient Greek and Roman origin, were an expression of wealth and luxury, they served for the Court's own entertainment and amusement, and captured the crowds as marvelling on-lookers.[36]

In which way then did the new Soviet government apply the carnivalesque in the celebration of their new public holidays, and to what extent were the (peasant) masses given an opportunity to bring elements of carnival into the new holiday design?

From the very beginning, the celebration of the new Soviet holidays was organised by the Central Holiday Commission, subject to the Department of Agitation and Propaganda. As the Bolshevik government could not expect that the new revolutionary holidays would immediately or automatically find a positive response in or be observed by large portions of the population, great efforts were made to get the masses to actively participate in the public demonstrations, marches and meetings. The solemn and serious tone of these first public rituals on the occasion of May Day or the anniversary of the October Revolution – 'they were demonstrations of strength. The atmosphere was filled with a spirit of struggle' (referring to the demonstrations in the years 1918 and 1919)[37] – might well have conveyed to the outside world, in particular to the observing foreign countries, Soviet Russia's potential enemies, the strength and deter-mination of the young Soviet state to pursue its goals. Whether these kinds of celebrations were equally successful in making the masses participate and identify with the ideas expressed must be doubted.

The militant and ascetic did not necessarily meet the peasants' expectations of a holiday mood; and a festive or a holiday mood could not be created by coercion, nor by persuasion or education. The 'revolutionary symbolism of the workers' state, . . . novel, distinct, and forcible – the red flag, red star, worker, peasant, comrade, International',[38] as Trotsky described it, was obviously not powerful enough to gain the active support of the majority of the population, especially when religious holidays overlapped with the new secular ones. If the new government wanted to stop the people from going to church and motivate them instead to participate in the celebration of political holidays, the attraction of the latter had either to be greater than the familiar church ceremony, or it had at least to

provide some familiar elements as points of reference, as a means of identification, for 'feeling at home' – to satisfy what Eric Hobsbawn calls the 'nostalgia for the old belief', referring to the incapacity to comprehend new ideologies that do not follow the old pattern. This implied a respect for the basic needs of the peasants, meeting their specific preferences and likings in festive forms. It is in this light that we have to see the steps taken by the Central Holiday Commission in the first years after the Revolution to enliven the official marches and demonstrations. Special appeals were issued in the daily papers, addressing clowns, jugglers, acrobats, musicians, to report to the Holiday Commission. Likewise in the Red Army 'all soldiers . . . who play the balalaika or the accordion, all folk dancers, jesters, jugglers and clowns' were assigned to participate in the May Day celebrations.[39] Public merry-making and fair ground attractions, traditionally part of Russian pre-Lenten customs, were used to raise the interest in a political holiday.

## KOMSOMOL CARNIVAL

Yet, there were other attempts made to distract the people from going to church that also applied carnivalesque elements, though of a much more aggressive nature. These were the carnival processions organised by members of the Communist Youth Organisation, Komsomol, and also by the voluntary association, The Godless (*Bezbozhniki*).

One of the most famous carnival-like processions of this kind, carried out in 184 cities of Soviet Russia during the Twelve Holy nights, between 25 December 1922, and 6 January 1923, served a clearly didactic purpose of anti-religious propaganda. According to the instructions and under the guidance of the stage director Vsevolod Meyerhold the Komsomol youth marched through the towns, carrying oversized puppets, representing the clergy and prophets of all major religions: popes, mullahs, rabbis, Buddah. At the end of the procession, these puppets were burnt in a great bonfire, an event which became known as 'Komsomol Christmas' (*Komsomol'skoe rozhdestvo*). Similar processions took place at Easter time.

As May Day almost always came close to the Easter week or the Jewish Passover holiday, organising the May Day celebration was combined with an Anti-Easter Campaign. Trotsky's statement that

distracting the masses from going to church was mainly a matter of providing something as unusual, colourful, bright and beautiful as the church service, some 'attraction not provided by the factory, the family, or the workaday street'[40] is reflected in the great efforts taken by the trade unions, the workers' clubs and the many voluntary associations during the annual Anti-Easter week (*antipaskhal'naya nedelya*). Next to the indispensable anti-religious lectures and group excursions to anti-religious museums, it was, above all, distraction, pleasure and amusement, offered by artistic variety shows, theatre and cinema, nightly costume balls (*karnavaly*), even fireworks, which tried to compete with the 'theatrical methods' of the church rites that worked 'on the sight, the sense of smell (through incense) and through them on the imagination'.[41]

Whereas fireworks, launched during the midnight Easter mass, obviously succeeded in being more attractive than the church ritual,[42] the carnivalistic processions staged by the Komsomol or the Godless did not quite achieve their intended enlightening effect, but were rather met with mistrust, suspicion if not with open hatred.[43] They did not take into account how deeply rooted religious beliefs were after all, and that such sledge-hammer performances of the politically conscious avant-garde, in the end, did more harm than good, that is they alienated the church-going masses from the Party's objectives rather than causing understanding, or generating an anti-religious consciousness.

How sensitive an issue the conflict between religious beliefs and counter propaganda was is also reflected in a Party decree of 1921, issued by the Secretary of the Central Committee, Yaroslavsky:

> As the First of May, this year, falls on the same day as Easter Sunday, the first day of the Christian Easter holiday, the Central Committee once again reminds every Party member not to behave, under any circumstances, in a way that can hurt the religious feelings of the majority of the population.[44]

And R. Katanyan, head of the Department for Agitation and Propaganda, affirmed on 9 April 1921: 'We have to avoid any action by which the religious feelings and prejudice of those could be hurt who have not yet developed the necessary consciousness and have not yet freed themselves of their religious beliefs'.[45] In this context, Yaroslavsky points out that only by respecting this order would the First of May 'turn into a holiday of the peasantry'.[46]

Large groups of the population had yet to be gained for the objectives of the future Socialist society, and greatest care was necessary to avoid the creation of an irreconcilable gap between the few who constituted the political vanguard and the many who had not yet reached the same level of consciousness. A Central Committee circular on 'Anti-religious propaganda at Easter', issued in 1923 and signed by Lenin, deals with the same problem.[47] It strongly objects to those carnival-processions staged by the Komsomol as they would hurt the religious feelings of the people.

Even in 1929, after more than ten years of educational efforts and continuous anti-religious propaganda, according to the trade union paper *Trud*, 'a bad tradition had evolved among the young people at Easter time', and this was to go to church: 'In groups and also individually they go to the Temple of Christ Our Saviour, simply to sight-see, to amuse, enjoy themselves'.[48]

This time, at Easter 1929, it was the students of the All-Union Artistic and Technical Institute (VKhutein) who planned to stage an anti-religious carnival in order to dissuade the Moscow youth from 'their senseless pastime': 'At 11 o'clock at night, some 2000 participants shall appear with brilliant masks, with torches, and various musical instruments in front of the Temple of Christ our Saviour'.[49]

And here again, just as in 1921, in a Central Committee circular, a serious warning is given to the organisers of the carnival, to restrain from inadequate invectives or aggression against the faithful and not to enter the church ground, since 'the carnival will only be successful when it does not embitter the believers'.[50]

## POLITICAL AND INDUSTRIAL CARNIVAL

Neither the fair ground type of amusement, employing jugglers, acrobats, jesters, gudok-players and the like, nor the carnival processions organised by the Komsomol or the Godless can be considered a form of celebrating designed and carried out by the masses themselves, on the basis of the *samodeyatel'nost'* and creativity of the masses regarded as essential for the new Socialist holidays by the Bolshevik government; as Kerzhentsev put it, 'without the activity of the masses, there is no festive mood *(prazdnestvo)*, there is no joy *(radost')*'.[51] Rather it was a small group of the politically conscious who, more or less successfully tried to either attract the crowds to

participate in public merry-making as part of political holidays or dissuade them from going to church by using certain elements of traditional carnival. Also, these forms of carnival or the carniva-lesque were just a complementary aspect, though an important one, of the actual holiday celebration.

While the instruction about the meaning and the purpose of the new Soviet holidays had been, as of 1921, entrusted to the institutions of political education, the aesthetic and artistic design of the celebra-tion was left to the 'Circles of artistic layman activity' (*Kruzhki khudozhestvennoi samodeyatel'nosti*) of the workers' clubs, attached to the trade unions and the many voluntary associations that emerged in the early 1920s. These voluntary associations, clubs and circles were not only conceived as providing 'a link with the masses' but as institutions to promote 'decentralised initiative', they would collect-ively constitute a 'transmission mechanism' through which the Party could influence, but also be influenced by, public opinion.[52] These clubs, the centres for *samodeyatel'nost'*, offered artistic circles of various kinds, drama and art circles being the most prominent. And statistics show that there was great interest on the part of the population in such activities. In 1927 the number of drama circles, for instance, had risen to 7000.[53] It was above all on the occasion of holidays that their members had ample opportunity for creative activity, to express their ideas with artistic means. It was through the activity of these clubs that a particular form of Soviet festivity emerged, characteristic of the years of the New Economic Policy, the so-called Political and Industrial Carnival.

The carnival element of these celebrations consisted mainly in floats prepared by the members of these circles for the May Day and Anniversary parades. Next to the grotesquely comic representations of imperialism, capitalism or foreign politicians and of the enemies at home – nepman, bureaucrat, alcoholic, pope, kulak – made out of wood, papier-maché, or straw, the factories demonstrated their products in these processions as part of 'production propaganda'. At first, the products were presented with great simplicity, but later they were blown up into oversized models which, like the personified foreign enemies, did not fail to have a comic effect.[54]

On the occasion of the May Day parade in 1925, for instance, the factory 'Bolshevik' displayed a large pair of scissors which cut through the symbol of foreign capital. The 'First Lenin-State Mill' portrayed a wind mill whose mill stones ground up Poincaré and McDonald.[55] In Leningrad the State Circus let a clown ride a carriage

drawn by pigs on whose backs were painted the names of famous representatives of imperialism, such as Lloyd George and Clémenceau.[56] They also displayed asses, and hyenas and foxes in cages, marked with labels as representatives of imperialism or capitalism. On 1 May, 1923, we see the construction of an oversized propane stove with a frying pan on top in which a man, easily recognisable as a Polish nobleman, made the oddest movements, every time a worker tried to light the stove, and the crowds burst out in peals of laughter.[57] Piotrovsky called it 'industrial metaphor': the nail factory representing a nail hammered into the coffin of capitalism, the cigarette factory showing an oversized burning *papirosa* labelled 'fascism'.[58]

The 'pope' or the 'kulak', for example, belonged to the social types ridiculed during traditional Russian pre-Lenten and Twelve Nights mummeries known to everybody as standard representations and masks.[59] These carnivalesque representations could count on finding a receptive audience (of peasant origin) that would recognise those figures as familiar ones and, in this way, be more apt to identify themselves with the new secular Socialist holidays. Unfamiliar representations of 'capitalism' or 'imperialism' were ridiculed by applying the same familiar elements of exaggeration, hyperbole and the grotesque. To this extent, the political and industrial carnivals were educational institutions that taught the masses about their economic achievements and their political enemies with a festive decorum. They were to learn by laughter.

The drama circles (*dramkruzhki*) of the workers' clubs with their sketch-like performances (*instsenirovki*) staged during May Day and Anniversary celebrations at street corners or on lorry platforms as part of the holiday parade fulfilled the same purpose. Both, designing, constructing and mounting of effigies, models and dummies of socio-political relevance for the floats and the playful staging of every day problems, political events, social or economic conflicts, often in an improvised form, gave the members of the workers' clubs ample opportunity to employ their creativity. But, more important, both forms of this 'collective creativity' gave room to shape and master reality, to gain insight into the social and political structure of one's everyday life by artistic means, by playing, by acting. As papier-mâché figures the foreign imperialist, the capitalist or other enemy powers were made ridiculous, and their actual power was at least symbolically dissolved. Instead of causing fear or anxiety one could only look at them and laugh. Be it 'the sick Englishman between the

legs of a Chinese coolie' (as in the May Day demonstration of 1927) or 'the imperialist puck who licks the feet of the bound kulak',[60] they were no more than 'paper tigers' who were already defeated.In this way, the future was anticipated. The utopian element, the hope for a victorious proletariat in the worldwide victory of Socialism, had at least in the visual display become reality.

It was the playful element in relating to reality, to the political enemies, to social problems and conflicts which helped create a distance from this very reality and thus a critical attitude. Changing roles – acting like the enemy or building his effigy – meant stepping outside, distancing everyday life and thus bringing it into perspective. An essential element of this kind of artistic activity creating a political awareness (the basic prerequisite for change) was the use of mockery and ridicule, humour and laughter in their liberating function.

It is difficult for us to judge what the 'carnival spirit' or 'carnival laughter' was like during what was called political or industrial carnival. We have to rely on secondary sources. According to these, however, the political and industrial carnival of the 1920s was considered a 'genuine Soviet type of festivity' (Tsekhnovitser), unique in its combining the serious with the gay, a genuinely new form of celebrating a revolutionary holiday:

> Even on the occasion of demonstrations concerning the most serious political issues, as for instance the note of the English government or the murder of comrade Voikov, elements of polit-carnival are used. The carnivalistic elements intensify and sharpen the political idea of the demonstration.[61]

If we follow contemporary Soviet holiday experts' views of the changes in Soviet festive forms, the official parades or manifestations were no longer a serious or solemn act but one of humour and laughter. This is perhaps best illustrated by the description of the difference between the atmosphere of the post-revolutionary militant demonstration and the political carnival of the 1920s, given by the theatre man Piotrovsky:

> [The demonstration] is different in character. Those of the years 1918 and 1919 were not only a festive anniversary, they were demonstrations of strength. The atmosphere was filled with a spirit of struggle. The pavement was burning. At that time, the demonstrator felt the hate-filled stares of the inhabitants of Nevskii, and,

at the same time, he was beating his enemy morally and poli-
tically . . . now they are all beaten. During the demonstrations we
no longer struggle but we only laugh at them and scorn them.
Therefore the posters 'Death to capital', 'Down with capitalism'
are replaced by a simple prison cell, placed on a truck . . . with a
sign: 'Sanatorium for the Bourgeoisie'. Then, the worker
struggled, today, he simply celebrates.[62]

Even if one cannot say that the political or industrial carnival
resembled traditional forms of carnival in their boisterous, excessive,
lavish aspects, even less so a 'world upside down', one could certainly
call the atmosphere of these celebrations relaxed. To a certain extent,
it was a unique combination of amusement and political education.
The representations on the floats were funny, if only by their use of
fantastic hyperbole, caricature and all sorts of deformation, by
artistic transformation as a means of expressing the essence of
something.They had a comic effect. They made the people laugh.

## CARNIVAL AND COLLECTIVE CREATIVITY

It is in the political and industrial carnival of the 1920s, designed and
staged by the workers' clubs, that we can detect elements of the
peasant tradition of Russian folk-festivals that had a bearing on the
celebration of the new Soviet holidays. In the effigies and dummies
one could easily see a revival of traditional Russian mummeries and
masquerades, in the *instsenirovki* a resemblance to the Russian
satirical folk theatre.[63] The very coarse rustic humour ascribed to
these peasant traditions re-occurred in the figurative representations
as well as in the sketches of the drama circles. But was the kind of
laughter that had come to reign over Soviet holidays true folk
humour in Bakhtin's sense?[64] The years of the NEP can be consi-
dered a period of a restricted but still wide freedom of expression
where party controversies were still a matter of public discussion. In
those years the clubs obviously constituted a forum where political
consciousness was not necessarily inculcated from above but, as N.
Krupskaya had envisaged it, was formed 'from below'.[65] However,
even in those relatively liberal years, mockery and ridicule 'from
below' were of an extremely precarious nature.

While in pre-revolutionary times the jesters (*skomorokhi*) – the standard figure of Russian carnival – 'made faces and told the Czar the truth and nevertheless remained slaves', the 'jesters of the proletariat' who Lunacharsky had praised as its future 'beloved . . ., fresh, lively, wise, witty and eloquent consultants',[66] were subject to censorship concerning the target of ridicule. Their mockery, or the one displayed in the floats, dummies and effigies, was strictly limited to the officially declared political or class enemies. Soviet political leaders or public personalities could only be represented in a form called 'friendly caricature' (*druzheskii sharzh*)[67] lacking any deriding element. And, as of 1929, even this form of caricature was no longer permissible.[68]

It is questionable to what extent the workers' club activities in the visual and the performing arts and their contribution to festive celebrations in the form of political carnival constituted 'an institution to regulate and ritualise social conflicts'[69] as it was characteristic of traditional carnival rituals. It is also questionable whether the potential of workers' and peasants' creativity found sufficient room for expression in constructing grotesque representations of the many internal and external enemies for May Day and October Anniversary parades. To combat alcoholism had been, all through these years, one of the main objectives of the new government in the process of cultural change. But how could soberness possibly be combined with a festive mood, above all for a Russian peasant? By the mid-1920s, revolutionary drive and vitality and originality in aesthetic design seemed to fade away, and the administration observed a 'general holiday fatigue' and a 'lost holiday spirit'.[70] Still, the reason why drastic changes took place in the celebration of holidays, ten years after the October Revolution, was not just caused by the upcoming tenth anniversary, but by the launching of the first Five-Year Plan.

In 1927, the debate over how to celebrate public holidays in a Socialist society was resumed on a much wider scale than ever before.[71] And, at that time, there were ten years of experience with Soviet festivities to refer to, to judge from. Ten years of Socialism in one country were supposed to find its adequate expression in the anniversary celebration. Ten years of Soviet power were to be celebrated with commensurate 'dignity', so that

Everyone, who goes out into the streets or into the squares during a public holiday, feels as master of Soviet construction, as master

of what he has accomplished, is filled with zeal for participating in the construction and with confidence in his own position.'[72]

Was amateur art (*samodeyatel'nost'*) then, in its modest artisanal, do-it-yourself aspect the adequate form of holiday design to convey the feeling of being 'master of Soviet construction'? Or was, as some Party administrators pronounced it, more professional guidance and instruction needed to make the amateurs see what they had to strive for, what could be done? Were the traditional popular forms of buffoon plays, Petrushka puppet shows or folk farce that had all entered into the famous *instsenirovki* really too elementary, too backward, too simple to come up to what Party officials considered characteristic of a society in the process of industrialisation?[73]

The public criticism of workers' club activities in general and of the art and drama circles in particular, which gained momentum in 1927 and sharpened with the launching of the First Five-Year Plan, denounced the apolitical character of their recreational activities and deplored the loss of political consciousness in the celebration of political holidays.[74] The obvious tendency towards public merry-making that, in the eyes of leading Party and government members, resembled any kind of petty-bourgeois leisure activity, gave rise to calls for more pronounced proletarian forms.[75] Yet, did this criticism not just show that, in the light of the plan of accelerated industrialisation, the potential of *samodeyatel'nost'* to become an authentic critical force was, more than ever before, seen by leading Party officials as a great danger, putting the established plan, its structure and its fulfillment, so closely linked to the Soviet political structure, that is, a highly centralised one, seriously at risk?

At no point in Soviet history was the administrative structure for organising the holidays of a kind that the Party or the government could have lost control. It was more of a question of to what extent this mechanism was used by the centre to actually exercise its power and control over the initiative from below. Concerning the amateur art activities of the workers' clubs displayed in industrial and political carnival of the official holiday celebrations, for the first ten years of Soviety history, not much more than a general topic was given, and – apart from the above mentioned limitations – in which form the topic would be presented, realised or performed was left to the initiative of their members. However, room given to self-initiative allowed for uninstitutionalised action, and the *laissez-faire* policy of the Party

concerning workers' clubs' activities and holiday celebrations during the years of NEP allowed, to a certain extent, for deviant ideas and thus implied the 'danger' of diverse opinions.[76]

In 1928, the artistic directors of amateur art circles were replaced by Party officials:

> The Party-cell . . . must appoint the most qualified and politically most disciplined comrades as directors of the club . . . The Party cell and the factory committee must assume the guidance in this matter . . . The work of the Party cell . . . must be carried into the club by making use of the *samodeyatel'nost'* of its members.[77]

The improvised drama productions were gradually replaced by more complex traditional forms of 'legitimate' state theatre – 'The era of primitive agitation is over'[78] or: 'Great times, great people demand great forms' (Maksim Gorky). In the late 1920s an increasing number of trade union courses were provided for the training of entertainment-directors (*massoviki-zateiniki*) who were 'to guide the masses, spur them in their festive mood with organised dances, singing and the like'.[79] It was not drama education that became an integral part of elementary education, next to teaching literacy – as Kerzhentsev had proposed in 1920, with regard to the emancipation of the Soviet people in a Socialist society,[80] but the teaching of basic skills to be readily applied in the production process.

The tightening of Party control over the clubs' activities in the course of the First Five-Year Plan reflected the old fear of leading Bolsheviks concerning the uncontrolled spontaneity of the masses.[81] The various measures taken to ensure a more rapid and more successful fulfillment of the Five-Year Plan also marked the end of cultural change seen as a gradual and evolutionary process, replaced by cultural revolution, cultural campaign (*kul'tpokhod*), and a 'victory' of urban over peasant culture, of town over countryside, imposed from above.

This 'Second Revolution', the 'Revolution from above'[82] deprived the people of the possibility to distance themselves from the social and economic process, in particular the production process. They were no longer allowed to step back to reflect on this process by playing and acting and by doing so to shape and change it. Production itself was no longer questioned. The whole society was sworn into production. The 16th Party Congress in 1928 declared: 'Work is a question of honour, of glory, of wisdom and heroism' (29 April

1928). And solemn public rituals of pledging the oath of allegiance to production goals[83] played an important role in underlining and emphasising the unity of the political vanguard and the working masses in their commitment to the industrialisation of the country. According to Comrade Podvoisky, chairman of the Preparatory Commission of VTsIK for the Tenth anniversary celebration, the October festivities were a great national school (*narodnaya shkola*) that was ' to explain clearly and in depth to the masses the essence of the Revolution'.[84] And what happened to the carnivalesque during the First Five-Year Plan?

## THE FIRST FIVE-YEAR PLAN AND THE CARNIVALESQUE

During the years of collectivisation (1928–33), carried out parallel to the industrialisation plan, it was no longer an issue to what extent elements of 'popular' culture equating with 'peasant' culture should enter into the design of holiday celebrations. The Five-Year Plan, plan figures, and the industrial worker – first represented by worker collectives and shock brigades (*udarnye brigady*), later by individual shock workers (*udarniki*) – became the central topic of May Day and Anniversary celebrations.

With the first year of the 'Socialist emulation' campaign (launched on 29 April 1929) the two major political holidays were transformed into a public 'review of the year's achievements' (*smotr itogov za god*). All production efforts were guided by these dates to publicly demonstrate and announce the success in fulfilling and exceeding the Five-Year Plan. Criteria of efficiency in production determined the marching order of the individual factories in the May Day parades. The ones that had fulfilled the financing plan (*promfinplan*) were to head the parade.[85]

The ascetic, disciplined worker, fatigueless and invincible in his commitment to industrial productivity who pervaded the literature and the visual arts of this period, was fundamentally opposed to a boisterous, gay and carefree peasant way of celebrating and left no room for the carnivalesque. The only remnant of former 'polit-carnivals' to be seen on May Day and Anniversary celebrations during the years of the First Five-Year Plan was a huge standard papier mâché figure representing capitalism, a man with black dress coat and top-hat. During the period of forced industrialisation 'Death

to capitalism' was no longer a topic of somewhat amusing *instsseniro-vki* or the workers' drama circles, but had become the daily task of each individual worker enacted by his commitment to fulfil the Plan. The carnivalesque had, by then, been reserved for the children for whom carnival merry-makings (*karnaval'nye gulyan'ya*) were organised on the occasion of political holidays.[86] The clowns, jugglers, accordionists, singers, who during the first years after the Revolution had been hired by the Central Holiday Commission to attract the crowds to join in the celebrations were, in 1929, still used to 'enliven the demonstration' in the long and tiresome waiting periods during the parades and marches.[87] However, by 1930, costume balls on the occasion of May Day were simply organised separate from the official marches and parades as an apolitical form of amusement.[88]

The official holiday rituals were to give expression to the power, the might, the grandeur of the industrialisation process. Here the art of counting and measuring, size and numbers, became symbols in themselves: 'Figures reigned over everything".[89] 'The Chamberlains and MacDonalds of the previous years have been replaced by numbers expressing the success of Socialist emulation during the first year of the Five-Year Plan'.[90] An American journalist described the festive design of the revolutionary holiday in 1931 with the words:

These boys are geniuses for advertising . . . There is 5-in-4. Just 5-in-4, without a word of explanation. The public knows that it is the Five-Year Plan in four years. It is as effective as our 4-out-of-5 for toothpaste. Or the figure 518, which I have been seeing everywhere, for the 518 new factories that must be put into operation this year. Or the Roman numeral XIV that I have been stumbling over mentally every half minute since I arrived in Moscow. They represent 14 years as tersely as anything can. They mock at those who doubted the Bolshevik regime could survive.[91]

Mockery after all? Only in a more refined, more ironical way? Was it the professional artists, assigned to design the festive decorum, who had the more striking ideas?.

The public announcement of figures though was not limited to the nominal indicators of the Plan and their fulfillment. It also included the participants themselves. The growing size of the May Day or Anniversary demonstrations were expressed in number of participants: 750 000 in 1929, 800 000 in 1930, 1 000 000 in 1931, to arrive at 1.5 million in 1933, symbolising the continuous growth of industry,

the rise in production – 'a giant show of giant achievements', impressive in their perfection and homogeneity. The militant demonstrations of those years reflected the spirit of military command which, at that time, prevailed in all spheres of society. The perfectly planned and organised parades were the model image for a perfectly functioning production process, for the victory of mechanisation. Yet, they were unique in still another aspect: there were no spectators, no audience:

> It is the world's most unique parade – the one parade in which . . . there are no spectators. Everybody marches. A parade for parades sake, without audience . . . .[92]

Was the elimination of spectators what avant-garde stage directors had once advocated as the future Socialist way of celebrating, where 'the boundaries which separate work from play, life from the arts, and the spectator from the artist will disappear',[93] or was it rather a centrally imposed unity that left no more room for deviant ideas or self-initiative? Soviet socio-political history proves the latter.

This is not to say that in those years, during the celebration of political holidays, the Soviet people and, in particular, the industrial workforce were given no occasion for mere amusement, or even that their commitment to fulfil the Plan let them forget altogether about days of leisure or about their innate desire to eat, drink and dance. All through those years ample room was given to public merry-making (*narodnoe gul'yan'e*). The difference though consisted in the degree to which the serious and solemn ritual of the official militant marches and parades were given more emphasis and attention in the media, the daily press, and were literally separated from the public merry-making. One can even say that the merry-making part of the holidays during the years of the First Five-Year Plan assumed the form of private amusements as, on the whole, the years of the industrialisation and collectivisation campaign were years of enormous hardship. Work for the fulfillment of the Five-Year Plan was anything but play. It was, in fact, labour under the most extreme and difficult conditions.[94] To combine the serious and the gay, considered so unique for the celebration of public holidays during the NEP-period, was by then forgotten. As from 1928, the food was rationed, and in 1931 the Soviet Union experienced the worst famine of its history. If we associate a festive mood with some kind of abundance the serious economic restraints, the scarcity and austerity that

characterised those years did not exactly favour conditions for a carefree and gay holiday mood. Rather the holiday was an occasion to publicly reassure each other of a willingness and determination to continue the struggle despite the hardships, striving for a better future. Or was proletarian holiday culture with its traditional notion of discipline and asceticism an 'essentially unfestive' one?[95]

The warlike atmosphere, the fighting spirit which prevailed during the first years of the Plan did definitely not favour or promote a holiday mood of the free and easy and forgetting. 'Exertion of every nerve, concentration of all social forces for the fulfillment of the Five-Year Plan' pervaded not just the field of production but all spheres of life. Neither was the First Five-Year Plan the sudden beginning of a Socialist utopia. Quite the contrary, it was the first, painful step to pave the way for the future Socialist society on the basis of heavy industry, which for long years was to be tantamount to greatest hardships and deprivation for the Soviet people.[96]

With the end of the First Five-Year Plan, in 1932/33, the ritual of praising Stalin lavishly and acknowledging him as the leader and architect of the country's achievements had been well established. Letters of thanks to Stalin by individuals and work collectives of all strata of society, enthusiastically addressing him as 'Our Leader' 'Our Teacher', 'Our Father' filled the daily press and, during May Day and Anniversary demonstrations, even the streets. On the occasion of political holidays this worship of Stalin was even visually omnipresent. Slogans, posters, portraits – all either referred to or depicted him. Georges Friedmann, in 1938, interpreted the Stalin cult as a concession to a still backward people, in need of a 'real person' – instead of an abstract idea – to relate to and identify with.[97] This official, strongly ritualised form of celebrating continued all through the coming years. The slogans differed, but the ritual itself, its procedure and outer appearance, remained basically the same.[98]

## STALINIST CARNIVAL

What then, in 1935, made the Party introduce a new kind of festival, next to or parallel to the official holiday rituals, the grand carnival festivals, organised by the trade-unions, that took place in the Moscow Gorky Park? Must this kind of festivity be considered just another kind of social control, extended to the sphere of entertain-

ment and amusement? Were the *karnavaly* as they were celebrated in
the high times of Stalinism mainly a dextrous move of the administra-
tion to fulfil man's basic need, man's longing for amusement,
distraction and laughter as opposed to the monotony of working life?
Were the staging of carnival festivals, with their obvious elements of
popular Russian culture, merely a concession to popular taste so long
officially repressed as 'low' or 'uncultured' (*nekul'turnyi*), at a time
when the Russian peasant was literally defeated? Were they simply a
means to make political use of these basic needs, to release tensions,
offer time and space for amusement and forgetting? Or were these
carnivals the adequate expression of the new élite's inclination, the
new élite's disposition for a festively colourful decorum, a new kind
of 'feeling at home', where, with a kind of Biedermeier attitude, even
formerly alien elements of popular and folk culture, now stripped of
their excesses, appearing in an orderly moderate version, became
respectable? Were these carnivals simply complementary to the
'orange lamp shades' and the 'classical ballet' by which Vera Dunham
characterised the cultural preferences of the 'new class'?[99]

In 1934, after two 'hunger years', food was, for the first time in five
years, no longer rationed. Material progress, indeed. Perhaps Stalin
was right when he declared one year later, 'Our life has become
happier and more joyous' (1935). In 1934 an overabundance of
flowers and light – the whole centre of Moscow was illuminated by
projectors – gave a new, so far unknown, touch to the celebration of
political holidays. And one year later, the May Day celebration, with
the same kind of decorum as in the previous year, was described by
*Komsomol'skaya Pravda* under the heading 'Joy, Beauty, Colorful-
ness, Flowers'.[100] Almost as a precedent to the first grand carnival
festival in the summer of 1935, a special carnival parade was
organised in Moscow, on the first of May, with 5000 professional
artists of the Moscow theatres as participants. The leading actors
were dressed up to represent the most popular heroes and heroines of
Russian and Soviet literature, opera and ballet.[101] The world of
fiction entered into the streets. Literary heroes, legendary figures,
mingled with the crowds. Stage and everyday life seemed to merge.
Was this the *rapprochement* or fusion between life and the world of
art as it had been conceived by the avant-garde artists of the 1920s?

A true fairy-tale world was to be constructed only two months
later, in the night of the Soviet Constitution day in Gorky park. The
scenario, issued by the Moscow Council of Trade-Unions, the
Moscow Economic Council and the Administration of the Gorky

Park of Culture and Leisure, describes in great detail the various
elements that were to serve as a festive decorum for the grandiose
*karnaval*.[102] Illuminations, projectors and fireworks were to turn
night into day. A colourful illuminated and oversized animal and
insect world of frogs, lady-birds, ants, bees, butterflies and grass-
hoppers, with glowing, rolling eyes and moving antennae or legs,
were to populate the greenery of the park. In the trees night birds
were put up, owls, eagle owls, but also the stork. The Pioneer lake
was transformed into a 'fairy-tale sea' with huge representations of
the legendary 'golden fish', the sturgeon, the pike, the whale.[103] The
antique statues bordering the roads of the park were disguised with
masks, beards, hats and the like.[104] (An officially sanctioned carnival
attack on model images? A world upside down?) This festive
decorum went along with fair ground attractions, like Ferris wheels
and swing boats, boat rides on the river Moskva, but also booths with
distorting mirrors, photo studios with funny background sceneries,
and even booths with fortune-tellers.[105]

All this took up elements of the traditional Russian fair ground
amusements, the *narodnye gulyan'ya* so popular all through the
centuries under the Czar, of which we have quite vivid reports by
foreign travellers to Russia.[106] Also there was a revival of traditional
masks and costumes, formerly used on occasion of the mummeries
and masquerades (*ryazhenie*) during the Twelve holy nights celebra-
tions (*svetki*) or the pre-Lenten *maslyanitsa*. But not only the old
admirers of traditional folk-culture were to derive some pleasure
from the visual decorum and the performances of ensembles of
folk-dancers from all the different republics of the Soviet Union, to
take delight in the folk-songs of choirs which were performed in the
park on this occasion. No, there was music and dancing provided in
all possible styles, from classical ballroom dancing to jazz. Judging by
the great variety of amusements offered in the Gorky park, no one
could feel left out concerning his taste, his likes or dislikes. There was
something for everyone.

If we follow the enthusiastic descriptions of these *karnavaly* over
the years, then it was not only music, dancing, fireworks, costumes
and masks that were to create this new festive mood, but, above all,
the overabundance of food and drink that according to the official
newspaper reports, characterised these kind of festivities. The
description of the May Day carnival in 1936 reads as follows:

It is hard to describe how Moscow enjoyed itself in these joyous days of the May Day celebrations . . . We have to talk about the garden of the plenty behind the Manezha building, this garden where sausages and Wurst were growing on the trees . . . where a mug of foaming beer was accompanied by delicious Poltava sausages, by pink ham, melting Swiss cheese, and marble white bacon . . . Walking across this square one could get a giant appetite.

And the report gives the conclusion we are to draw: 'There is happiness in the land of affluence'.[107]

In the Soviet Union public political holidays had become a *narodnaya shkola*, a 'school for the people', they were some kind of an institution to teach the masses about the new Soviet and Socialist norms and values. And, as from 1930, at the latest, the participants were instructed in great detail how to give adequate expression to these norms and values. The *samodeyatel'nost'* of the workers' clubs members had, by then, been reduced to skilfully fulfil the detailed orders and instructions given by the directing professionals. If *samodeyatel'nost'* was merely understood as some centrally guided and controlled leisure activity of an artistic nature (folk-dancing, painting, choir singing, and so on), then the carnivals of the mid and late 1930s were, indeed, as stated over and over again in newspaper reports on these events, the 'epitome of *samodeyatel'nost''*, of 'collective creativity'.[108] However, if we link this notion with the original concept of 'self-initiative' and 'self-realisation' then the peculiar transformation of *samodeyatel'nost'* had started in 1928 with the tightening of Party control over the workers clubs' activities. Isaac Deutscher states that in the course of the two decades after 1917 'all spontaneous impulses in the Soviet body politic had withered away'.[109] This is equally true for any kind of spontaneity in Soviet holiday celebrations. The official holiday rituals were staged, according to military command. So were the carnival festivals of the mid and late 1930s.

What then was the didactic purpose of these grand *karnavaly*? What were the people made to believe? That endless pleasure, joy and happiness reigned in the life of the Soviet people? In 1920 Kerzhentsev had still claimed that 'without the activity of the masses, there is no festive mood (*prazdnestvo*), there is no joy (*radost'*)'.[110] Did the people, only 15 years later, really enjoy themselves in the

'garden of plenty', in the fairy-tale world of the Gorky park? Or was participating in the *karnaval* just another form, a leisure form, of coercion – forced industrialisation, forced labour, leading to forced carnival, forced happiness and forced joy? And can a festive mood be created by coercion?

The carnival festivals of the mid-1930s were indeed carried out by the activity of the masses, though it was the amateur art circles as well as the sports organisations, selected on the basis of Socialist emulation, in striving for highest standards of perfection and quality, who were to perform on the many stages in the park guided by stage-directors.[111] According to the organisers, this was to 'transform the carnival into a bright holiday celebrating the cultural progress of the working masses, into a festive demonstration of their creative layman activity'.[112] The carnival was to be the 'expression of the common pride, joy and revelry'.[113] How far though could the participants feel unrestrained when every movement; to what extent were the time and place of their arrival in the park as members of a collective, the masks and costumes they were to wear, the route they had to follow on the many roads in the park, exactly determined by the plan? Where was there room for spontaneity when nothing was left to chance? How could they possibly relax and amuse themselves when they were to move about in the park 'in formation and orderly',[114] when they had to engage in singing songs under the guidance of entertainment directors who distributed the music and the words among the participants, songs that were especially written for the occasion, songs that had to be learned that very night?[115]

Despite the overabundance of mythological and legendary figures, the fair-ground type of amusements that prevailed during those carnivals, one corner of the park was still reserved for political caricature. However, it was not, as during the NEP period, left up to the workers' clubs to give expression to a particular topic. The figures to be mounted on the occasion of these carnivals were to follow the exact model given by famous caricaturists of the magazines *Krokodil*, *Pravda* and *Izvestiya*.[116] Needless to say, all work by the artistic circles was carried out under the supervision of well-known artists assigned for this special task.

The description of the carnival festival in the scenario, with its detailed instructions and timing of everything that was to take place, contrasted greatly with the reports of the same festivals in the daily newspapers. Here we are made to believe that the carnival celebrations were truly some kind of a utopia regained. Hopes expressed by

the avant-garde in the 1920s, that in Socialism the borders between art and life and work and play would eventually vanish, hopes that took up Socialist utopian ideas, seemed to have become reality. Chernyshevsky's dream:

> Every day there is play. Every night, in the aluminium palaces erected by science, orchestras, choirs, dancing and performances come together, the Fourier workers who do not know fatigue, exhaustion, nor satiety, work and love, compete to produce beautiful and vigorous bodies, . . . it is a humanity of joyous adolescents, of exquisite men and women.[117]

had become true under Stalinism. His vision compares easily with what we read about the Moscow May Day carnival in 1939:

> . . . there was no difference in the joyfulness of the festivities in the centre and the outskirts . . . And the carnival in the Palace of Culture of the Stalin-factory was the most joyous ball in Moscow . . . In the light of the projectors, colourful whirlwinds of confetti were spinning around. The orchestras and the radio in the streets did not fall into silence, and without fatigue couples were turning with the waltz forever.[118]

In November 1936 Stalin promulgated the new constitution in an address to the Eighth Congress of the Soviets. He declared that the first phase of Communism had been achieved; the working-class was no longer a proletariat; the peasantry had been integrated in the Socialist economy and the new intelligentsia was rooted in the working-classes.[119] Altogether, a harmonious society. Class-war had ceased ever since the liquidation of the kulaks as a class.[120] With this in mind, the carnival festivals in the mid and late 1930s could not be anything else than the expression of the new stage of harmony, characterised by the love and brotherhood of the many different peoples of the Soviet Union. In all its aspects, Stalinist carnival was not just deprived of its traditional pagan peasant significance and of its boisterous and carefree aspect – this can already be said about the other Soviet forms of *karnaval* of the 1920s – but it had been perverted into a state show of what the Party, the government, more particularly, the new élite,[121] considered the adequate artistic expression of joy and happiness in an allegedly classless society in the first phase of Communism: carnival reduced to a colourful variety show

with no excess whatsoever, moderate, regulated, under control, but pretty to look at.

Had the new élite not struggled for many years under enormous hardships and privation, in order to industrialise the country, to build Socialism? Had they no right to be rewarded for their sufferance by some festive decorum? Trained, retrained, finally in an administrative position – had they no right to see the fruits of their year long struggle to realise, at last, what the Revolution had promised, namely the end of repression, the creation of conditions for the realisation of happiness, where material abundance would replace scarcity and lead to the realm of freedom? In this context, these carnival festivals were not simply meant to give the Soviet people room for amusement and forgetting (this could have been achieved, as in previous years, by simple public merry-making), but in these carnivals the participating people had become supernumeraries in the self-staging of the new élite. The staging of an illusionary world of art served as an endorsement of their own position – eclecticism in the aesthetic design of the holiday as a means to satisfy everybody's needs, at least by sight and sound?

In 1934 living standards and consumer goods were given higher priority. Some historians even convey the impression of a 'Soviet spring' (Cohen, Fainsod). But even though the food was no longer rationed, there was a continued shortage of consumer goods, including shortage of clothes (how then, could they spare material for costumes?), and how did the everyday reality of the mid and late 1930s, compare to the 'garden of the plenty' that supposedly opened up in the world of Stalinist carnival? Was it a 'world upside down', after all?

We must not forget what took place while the carnival festivals were staged to demonstrate 'the joy and happiness of all the different peoples of the Soviet Union'. The assassination of Kirov in December 1934 touched off a new round of almost continuous purges. The call for vigilance, to beware of 'alien elements', that is of Zinov'evists, Kamenevists, Trotskyists, resulted in a mass outburst of denunciations,[122] in a mood of rising panic and disarray.[123]

By 1937, Soviet political prisons had become a scene of the cruellest methods of physical torture, continual debilitating interrogation (the 'conveyor' system) for weeks on end, and countless summary executions. Brutal atrocities were inflicted on men and

women, young and old alike. It was, concludes one Soviet historian, 'probably the most terrible page in Russian history'.[124]

Yet, according to *Pravda*'s daily editorials, by 'exterminating these spies, provocateurs, wreckers, and diversionists, . . . the Soviet land would move even more rapidly along the Stalinist route, Socialist culture would flourish even more richly, the life of the people would become even more joyous'.[125]

In 1927 the government still banned the wearing of masks on public holidays in order to prevent any possible excess or hooliganism.[126] Ten years later, society was under strict control, there was no more risk entailed for those in power to celebrate a public holiday with mummery and masquerades. Quite the contrary, even in disguise the new Soviet people were refined, orderly, temperate, well-behaved. Stalinist carnival had become a public demonstration of the high moral standards and conduct of Soviet man.

In this respect, Stalinist carnival was just another form of Socialist Realism: showing what there is of the future in the present.

And where had all the jesters gone? In a harmonious society there was nothing to ridicule, nothing to criticise, nothing to mock. So there was also no reason for any deriding carnival laughter. The people simply smiled, as they had nothing to laugh about – a smile, no longer even suggestive of gaiety – a mechanical response devoid of any feeling. Under Stalinism, carnival laughter had turned into a carnival smile.

Parades with 1.5 million participants; parades without spectators. Everybody participated; the utmost consensus, the highest level of consensus possible.

In the mid-1930s *karnavaly* were no longer staged by a minority of the politically conscious to attract the crowds and thereby prevent them from going to church, but were transformed into both a standard summer merry-making event to distract and amuse the urban population and, above all, into a national spectacle and manifestation of the harmonious, colourful and beautiful Soviet society.

Still, despite the lavish and bright decorum, the fair ground attractions, the music and dancing, provided at these festivals, they obviously had not achieved what the revolutionary government had once seen as its main objective in the public political holiday, namely

to create an emotional involvement, an identification with the new norms and values expressed on this occasion. The staging of the marches and parades, as well as of the carnival festivals, according to detailed instructions from above, had not been successful in turning the people away from traditional rituals. Despite long years of anti-religious propaganda and anti-religious education, still more than 20 years after the October Revolution, one of the major objectives of the Third Five-Year Plan was summarised in the slogan 'No room for religion and religious holidays!'[127] And in the newspapers we read about ecclesiastical holidays, lasting three to four days, celebrated on the kolkhoz-farms on occasion of the local saint's day – 'And the gathering of the crop must wait'.[128]

Alcoholism, drunkenness, fighting, homicide. The 'Peasants of Tver" (Altrichter) were still alive. The struggle for a *novyi kul'turnyi byt* had still a long way to go, even on a holiday.

## NOTES

*This article was made possible by a research grant from the Volkswagen Foundation and is part of an extensive monograph on *Festival Culture under Stalinism: A Study in Political Symbolism.*

1. Khrushchev Remembers, with an Introduction and Notes by E. Crankshaw. Transl. and ed. by Strobe Talbott (Little, Brown and Company) Boston/Toronto, 1970, p. 80.
2. A term also used by Stephen F. Cohen in his book *Bukharin and the Bolshevik Revolution. A Political Biography, 1888–1938* (Oxford University Press, 1980), to describe the mass arrests and deportations in the countryside during the years of collectivisation.
3. Karnaval v chest' Dnya Sovetskoi Konstitutsii', *Komsomol'skaya Pravda*, 9 July 1935.
4. *Narodnoe tvorchestvo*, no. 8, 1937, p. 46f.
5. *Plan stsenarii massovogo prazdnika-karnavala*, organizuemogo MOSPS, Moskopromsovetom i Tsentral'nym parkom kul'tury i otdykha im.Gor'kogo na territorii TsPKiO v noch' s 5 na 6 iyulya 1935 g. i posvyashchennogo Dnyu Konstitutsii SSSR.
6. See the most enchanting book on the history of Soviet 'proletarian music' and jazz by Frederick Starr, *Red and Hot. The Fate of Jazz in the Soviet Union* (New York/Oxford, 1983).
7. *Koms.Pr.*, 4 May 1936, p. 4.
8. Soviet scholars speak of the continuous struggle between the 'theatrical' and the 'carnivalesque' (*karnavalizatsiya* vs. *teatralizatsiya*). A.I. Ma-

zaev, *Prazdnik kak sotsial'no-khudozhestvennoe yavlenie* (Izd. Nauka) (Moscow, 1978) p. 356f.; and also Orest Tsekhnovitser, *Demonstratsiya i Karnaval. K desyatoi godovshchine oktyabr'skoi revoliutsii* (Leningrad, 1927).

9. For the different theories on culture as part of revolutionary transformation, see Krisztina Mänicke-Gyöngyösi, *'Proletarische Wissenschaft' und 'Sozialistische Menschheitsreligion'. Modelle proletarischer Kultur. Zur links-bolschewistischen Revolutionstheorie A.A. Bogdanovs und A.V. Lunačarskijs.* (Philosophische und soziologische Veröffentlichungen des Osteuropa-Instituts der Freien Univ. Berlin, vol. 19) (Berlin, 1982).

10. On the traditional religious holidays, see Helmut Altrichter, *Die Bauern von Tver'. Vom Leben auf dem russischen Dorf zwischen Revolution und Kollektivierung* (München: Oldenburg, 1984); in particular p. 100f.

11. On 'Ritual in industrial society – the Soviet case', see Christel Lane, *The Rites of Rulers* (Cambridge, 1981) and Christopher A.P. Binns, 'Sowjetische Feste und Rituale', *Osteuropa* 1 and 2 (1970), pp. 12–21 and 110–22.

12. For a detailed list of the new Soviet holidays see Christel Lane, op. cit., 'The Soviet ritual calendar', pp. 289–90.

13. Isaac Deutscher, *Stalin. A Political Biography* (New York: Oxford University Press, 1962) (2nd ed.) p. 269.

14. On the different festive forms in which the new Soviet holidays were celebrated after the Revolution, above all, the mass-spectacles (*massovye zrelishcha*), staged in Petrograd and other major cities, see the detailed account by René Fülöp-Miller, *Fantasie und Alltag in Sowjet-Russland. Ein Augenzeugenbericht* (Berlin/Hamburg: Elefanten, 1978).

15. See also the article by Susan Gross Solomon, 'Rural Scholars and the Cultural Revolution', in *Cultural Revolution in Russia, 1928–1931*, Sh. Fitzpatrick (ed.) (Bloomington/London, 1978) pp. 129–53.

16. Gottfried Korff, 'Volkskultur and Arbeiterkultur. Überlegungen am Beispiel der sozialistischen Maifesttradition', in *Geschichte und Gesellschaft*. 5.Jg./Heft 1 (Arbeiterkultur im 19. Jh.), p. 87.

17. Altrichter, op. cit., p. 102f.

18. Leon Trotsky, 'The Family and Ceremony' (from *Pravda*, 14 July 1923), in *Problems of Everyday Life. And Other Writings on Culture and Science* (New York: Monad Press, 1973)

19. Leon Trotsky, 'Vodka, the Church, and the Cinema' (from *Pravda*, 12 July 1923) in op. cit., p. 34f.

20. Ibid., p. 32.

21. A.V. Lunacharsky, 'O narodnykh prazdnestvakh', *Teatr i revolyutsiya* (Moscow: Gosizdat, 1924) p. 63.

22. 'Vodka, the Church, and the Cinema', op. cit., p. 34.

23. A.V. Lunacharsky, 'Budem smeyat'sya' (from *Petr. Pravda*, 14 March 1920), *Teatr i revolyutsiya*, op. cit., p. 62.

24. Ibid., p. 60.

25. P.M. Kerzhentsev, *Tvorcheskii teatr* (Petrograd, 1920) p. 99.

26. Ibid., p. 100.

27. Ibid., p. 104.
28. Ibid., p. 99.
29. Ibid., p. 103.
30. A.V. Lunacharsky, 'O narodnykh prazdnestvakh', op. cit., p. 64.
31. Ibid.
32. Kerzhentsev, op. cit. p. 104.
33. See footnote 8.
34. Altrichter, op. cit. p. 109.
35. Vs. Miller, *Russkaya maslyanitsa i zapadno-evropeiskii karnaval* (Moscow, 1884).
36. N.V. Solov'ev, *Pridvornaya zhizn'. 1613–1913* (St. Petersburg, 1913). Pylyaev, *Staroe zhit'ë* (St. Petersburg, 1892) p. 105f.
37. *Petrogradskaya Pravda*, 9 November 1923.
38. 'The Family and Ceremony', op. cit., p. 44f.
39. 'Prazdnovanie l-ogo maya', *Petr. Pr.*, 20 April 1920, p. 4.
40. Trotsky, 'Vodka, the Church . . .', op cit., p. 34.
41. Ibid.
42. A. Rishchev, 'Za proletarskuyu ideologiyu v kul'trabote klubov', *Revolyiutsiya i kul'tura*, no. 13, 1927, p. 47.
43. See also the description of anti-religious activities organised by the Komsomol or the Godless on the peasant population, in Merle Fainsod, *Smolensk Under Soviet Rule* (Cambridge, 1958) p. 432f.
44. Yaroslavsky, 'K prazdnovaniyu l-go maya. Vsem gubkomam', *Petr. Pr.*, 22 April 1921, p. 1.
45. R. Katanyan, 'O prazdnike l-go maya. Vsem gubkomam', *Petr.Pr.*, 9 April 1921, p. 2.
46. Yaroslavsky, op. cit.
47. Lenin, 'Ob antireligioznoi propagande vo vremya paskhi' (1923), *Sobr.soch.*, vol. 36.
48. 'Karnaval vmesto krestnogo khoda', *Trud*, 26 April 1929, p. 4.
49. Ibid.
50. Ibid.
51. Kerzhentsev, op. cit. p. 100.
52. St.F. Cohen, op. cit., p. 145.
53. 'Teatr i klub', *Pravda*, 15 April 1927, p. 8.
54. Illustrations of the various floats can be found *inter alia* in O. Tsekhnovitser, op. cit., and O. Nemiro, 'V gorod prishel prazdnik' (Leningrad, 1973).
55. Evg. Ryumin, *Massovye prazdnestva* (Moscow-Leningrad, 1927) pp. 27–8.
56. O. Tsekhnovitser, op. cit., p. 13.
57. Ibid., p. 126.
58. Piotrovsky, 'Godovshchiny', *Za sovetskii teatr! Sbornik statei* (Leningrad, 1925) p. 52.
59. Chicherov, *Zimnii period russkogo narodnogo zemledel'chelskogo kalendarya XVI-XIX vekov* (Moscow, 1957) p. 207f; A.A. Belkin, *Russkie skomorokhi* (Moscow, 1975); Yu. Sokolov, *Russkii fol'klor* (Moscow, 1938).
60. Tsekhnovitser, op. cit., p. 13.

61. Ibid., p. 6.
62. *Petr.Pr.*, 9 November 1923.
63. See Ochunkov, *Severnye narodnye dramy* (Moscow, 1909). The borders between mummeries (animal masks or specific social types) and sketchlike theatre performances were not clearly marked. This was the basis for the development of the Russian satirical folk-theatre.
64. See M. Bakhtin, *Rabelais and His World*, trans. Helene Iswolsky (Cambridge, Mass., 1968).
65. *Klub*, no. 1, June 1925, p. 76.
66. A.V. Lunacharsky, 'Budem smeyat'sya', op. cit., p. 61.
67. See the many 'friendly caricatures', published during those years in the weekly magazines, such as *Ogonek*, *Prozhektor*.
68. Cohen, op. cit., footnote, p. 444.
69. *Festivals and Carnivals. The Major Traditions* (UNESCO) Cultures III, no. 1, 1976, p. 9.
70. V. Zhemchuzhnyi, 'Demonstratsiya v oktyabre', *Novyi Lef*, no. 7/1927) p. 46; O. Tsekhnovister, op. cit., p. 14; L. Roschin, 'Iskusstvo massovogo prazdnika', *Revolyutsiya i kul'tura*, no. 12 (1929) p. 72; A. Kurella, 'Kakimi dolzhny byt' nashi proletarskie prazdniki', in *Revolyutsiya i kul'tura*, no. 17 (1928) p. 47.
71. In all the weekly and monthly magazines, even the daily newspapers, with the participation of artists, administrators, party officials and the public.
72. S. Tret'yakov, 'How should we celebrate the 10th anniversary of the Revolution'?, *Novyi Lef* 4 (1927).
73. As, for example, R. Pel'she: 'The course towards highest quality and highest qualification as the new principle of the government's policy, as a prerequisite to the construction of giant power stations and heavy industry must also be applied to theatre productions' ('Rabochie i teatr', *Pravda*, 16 April 1927, p. 6).
74. The most detailed contributions on this topic are found in *Revolyutsiya i kul'tura*, in 1928, but also in the daily trade-union paper *Trud*.
75. As, for example, by R. Pel'she in *Nasha teatral'naya politika* (Moscow-Leningrad, 1929) p. 49; see also Fr. Starr, *Red and Hot*, op. cit., p. 91f.
76. The tenth anniversary parade, in 1927, was the last one in Soviet history to see a demonstration of the political opposition, headed by Trotsky in Moscow, and by Zinov'ev in Leningrad. See Trotsky, *My Life*.
77. *Trud*, 24 October, 1928.
78. R. Pel'she, 'Rabochie i teatr', op. cit.
79. *Trud*, 1 April 1930.
80. Kerzhentsev, op. cit., p. 104.
81. On the traditional mistrust of the social democratic intelligentsia in relation to the spontaneity of the workers, see Kr. Mänicke-Gyöngyösi, op. cit., p. 29f.
82. 'As important in its consequences as the first one', *Kratkii kurs*, adopted by the CC of the CPSU in 1938.
83. What came to be known as 'industrial spectacle' (*industrial'noe zrelishche*) and as 'theatre of collective enthusiasm' (*teatr kollektivnogo entuziazma*), a light and sound show telling of industrial production and

Socialist construction.
84. Quoted by O. Tsekhnovitser, op. cit., p. 7.
85. *Trud*, 25 April 1931, p. 1.
86. *Trud*, 26 April 1929.
87. 'Garmonisty, pevtsy, klounada', *Trud*, 26 April 1929, p. 4.
88. 'Pervomaiskie prazdnestva', *Koms.Pr.*, 1 April 1930, p. 4.
89. E. Kogan, 'Chestnoe proletarskoe slovo', *Trud*, 9 April 1929, p. 3.
90. 'Da zdravstvuet chetyrekhletnyaya pyatiletka', *Trud*, 10 November 1929, p. 1.
91. Eugene Lyons, *Modern Moscow* (London: Hurst & Blackett, 1935) p. 209.
92. Ibid., p. 212.
93. P. Kogan, *V predverii gryadushchego teatra* (Moscow 1921) p. 39.
94. See A. Nove, *An Economic History of the U.S.S.R.*, p. 197.
95. 'The man who is limited to absolutely utilitarian activity . . . can rightly be called "unfestive", Kurt Eisner, *Feste der Festlosen*, Dresden 1906, from Pieper, *In Tune with the World. A Theory of Festivity*.
96. Michael Farbman, *Pyatiletka. Russia's Five-Year Plan* (German translation, Berlin, 1931) p. 12.
97. Georges Friedmann, *De la Sainte Russie à l'U.R.S.S.* (Paris: Gallimard, 1938) p. 217.
98. Only on 1 May 1987, under Gorbachev, was there no longer a military parade in Moscow.
99. Vera Dunham, *In Stalin's Time. Middleclass Values in Soviet Fiction* (London and New York, 1976).
100. *Koms.Pr.*, 24 April 1935, p. 4.
101. *Koms.Pr.*, 25 April 1935, p. 4.
102. *Plan stsenarii*, op. cit.
103. Ibid., p. 6.
104. Ibid., p. 5.
105. Ibid., p. 7.
106. Geissler, *Spiele und Belustigungen der niederen Stände in Russland* (Leipzig, 1801); Pylaev, *Staroe i novoe* (St. Petersburg, 1889); 'Das gemeinsame Lustwandeln in Russland', in: *Das Ausland*, 22 November 1835.
107. *Koms.Pr.*, 4 May 1936, p. 4.
108. See footnote 84.
109. I. Deutscher, op. cit.
110. Kerzhentsev, op. cit., p. 110.
111. *Plan stsenarii*, op. cit., p. 2.
112. Ibid.
113. Ibid., p. 1.
114. Ibid., p. 23.
115. Ibid., p. 14. And *Koms.Pr.* comments in 1936 that the 'chaperone attitude of the entertainment directors might, in the end, spoil the festive mood'. 'Veselo vstretim, l-oe maya', 26 April 1936, p. 1.
116. *Plan stsenarii*, op. cit., p. 19.
117. Quoted from Anda Bannour, 'Le fourierisme de Nicolas Tchernichevsky', in *Actualité de Fourier*. Colloque d'Arc-et-Senans sous la direction de Henri Lefebvre. (Paris: Éditions anthropos, 1975) p. 65.

118. *Pravda*, 4 May 1939.
119. Cohen, op. cit.
120. The Party Congress of 1934 was accordingly called the 'Congress of the Victorious'.
121. The 'new élite', the *vydvizhentsy*, product of the highest vertical mobility ever. On the significance of *vydvizhenie* for the Stalinist system, see: Walter Süss, *Die Arbeiterklasse als Maschine. Ein industriesoziologischer Beitrag zur Sozialgeschichte des aufkommenden Stalinismus*. (Philosophische und soziologische Veröffentlichungen des Osteuropa-Instituts der FUB, vol. 22) Berlin, 1985.
122. Fainsod, op. cit., p. 222f.
123. Ibid., p. 233.
124. Cohen, op. cit.
125. *Pravda*, 10 March 1938, p. 1 (from Cohen, op. cit., p. 380).
126. *Massovoe deïstvo. Rukovodstvo k organizatsii i provedenii prazdnovaniya 10-letiya Oktyabrya i drugikh revolyutsionnykh prazdnikov* (Moscow-Leningrad, 1927) p. 286.
127. N. Rumyantsev, *O prestol'nykh prazdnikakh* (Moskva, 1939) p. 43.
128. Ibid., p. 42.

# 4 Stalinism and the Restructuring of Revolutionary Utopianism

## Richard Stites

There was a huge difference between the utopian experimenters of the 1920s who attempted to build a Socialist counter-culture from the inside out and the hot-headed enthusiasts of the early 1930s who wanted to leap into modernisation and Socialism. Their goals and methods were antithetical to the utopian experiments of the previous age. They desired the subordination of all other 'socialist' currents and physical energies to the tasks defined by the regime: the rapid industrialisation of the country, the abolition of private economy and civil society, and the collectivisation of the peasantry. Their means were centralised organisation, a command economy, a militarisation of work, and a supremely authoritarian political culture. The first Five-Year Plan and its immediate aftermath witnessed constantly changing and extravagant goals, a headlong pace called 'Bolshevik tempo', *shturmovshchina* or assault methods of production, and the rapid fulfillment of the varied, autonomous revolutionary utopian strivings in favour of the single utopia of Stalinism.

The 'great break' that resulted from this frenetic national campaign was not only unprecedented in history but also unanticipated. Prudent economists like V.G Groman used the word fantasy to describe the bacchanalia of planning the speed of its tempo. The great plan, with its arbitrary goals, unpredictable results, and jerky and continuous pace, transformed the economy and the social landscape and affected the entire national psychology. Haste and shock were the key features of this traumatic experience.[1]

The political sinew of forced industrialisation under a central plan was – and had to be – administrative coercion and command, rule by whim, and a harsh authoritarian style adapted to the tensions of the industrialisation drive. New terms emerged to signify the culture of

bossism: *glavokratiya* or rule by heavy bureaucratic methods, *appa-ratnym putem* or administrative command, *nakachka* or pumping out orders to underlings, and *davai!*, the harsh and crude word for 'do it now!', couched in the arrogantly familiar *ty* form of address – a form of linguistical expression that many in the Revolution had fought to abolish forever. The authoritarian traditions of Bolshevism were augmented by an expanded military lexicon, reminiscent of the Civil War:

> War Communism had militarized the revolutionary political cul-ture of the Bolshevik movements [writes Robert Tucker]. The heritage of that formative time in the Soviet culture's history was a martial zeal, revolutionary voluntarism and elan, readiness to resort to coercion, rule by administrative fiat (*administrirovanie*), centralized administration, summary justice, and no small dose of that Communist arrogance (*komchvanstvo*) that Lenin later in-veighed against.

Communist urban elements sent into the countryside often acted like occupying troops, seeing the peasant as an enemy and themselves as the sole agents of 'Soviet power'. Storming, shockwork, takeovers, sieges, cavalry attacks and a dozen other terms from the frontline idiom entered ordinary discourse about factory operation, labour, political organisation and even cultural work.[2]

War or its psychological surrogate, a war atmosphere, generates a need for iron discipline and social control. In 1917, both the pro-war elements (such as Milyukov) and the soldiers had known this; during the Civil War the merging of total social organisation and the waging of war was actually and openly symbolised in the very name given to the period: War Communism. Stalin recreated the warlike atmos-phere and invoked the martial virtues of revolution and civil war. In doing so, he not only copied and far surpassed Trotsky's 'militarisa-tion of labour', but also unconsciously adopted the psychology and vision of traditional Russian administrative style: the combination of military dragooning and regimentation with defensive needs, econo-mic activity, and putative welfare. As in the case of all such utopias, its organisers described it in rational, symmetrical terms, in the mathematical language of planning, control figures, statistics, projec-tions and precise commands.

This mode of human behaviour conflicted with the anti-authoritarian and egalitarian community building utopias of the

Revolution. 'The new world being built was not the better and freer world of the dreamers', to quote Lewin again 'but a Caliban state. That a progressive ideology, initially intended to enhance human freedom and to create higher forms of community, came to serve a police state is one of the peculiarities of the period.'[3] The ideology of the Russian Revolution was not simply Marxism, as expressed in spoken and written texts, but an amalgam of Marxism (as applied to Russian conditions) and native Russian revolutionary values and visions that often went beyond the schemata of Marx and were expressed by human 'texts' – myths, behaviour patterns, symbols, visions, gestures and dreams. Stalinism – a wholly appropriate name for the new political culture born in the 1930s – was also an amalgam: of the ever present authoritarian elements in Bolshevism; of the military zeal generated to control and orchestrate the transformation; of Stalin's personal despotism and greed for power; of the persistent Russian state bureaucratic heritage; and of the social authoritarianism of the Russian people themselves. It was an extremely potent and violent revolution pitted against many of the values of the Revolution of a decade earlier.

Stalin's ruthless despotism and his colossal thirst for total power led him to create one of the vastest and most sophisticated political machines in history, founded on principles of information collection and retrieval, secrecy and paranoia, the cynical use of people, moral corruption, gratuitous violence, and a fantasmagoric belief in the potential treachery of everyone outside the inner circle of power. Stalin despised idealists and genuine prophets of moral revolution. If one must apply the word 'utopian' to the system that he built, it must be distinguished clearly from the utopianism of the revolutionary period. His was a single utopia, a unified and tightly controlled political economy run by authoritarian methods, by live men – not machines or computers – and backed by force. 'Socialism', he remarked in September 1938, 'is converted from a dream of a better future for humanity into a science'. In referring to the 'utopian' Populists in Russian history, Stalin explained their failure: 'sinking to idealism, [they] did not base their practical activities on the needs of the development of the material life of society, but, independently of and in spite of these needs, on "ideal plans" and "all-embracing projects" divorced from the real life of society'. Leaving aside Stalin's own isolation from 'the real life of society', it is clear that he neither understood nor respected the efforts of culture-building utopians and speculative minds to create or generate new ways of life. His style of

rule, to use the language of administrative theory, emphasised structure and institutional machinery over the transformation of values and coercion over re-education.[4]

But Stalin was not alone at the centre of this formidable organisational machine. He was assisted by more or less like-minded power-oriented people. At the time of the great transformation, the early 1930s, his principal agent and spokesman for the new order was Lazar Kaganovich, an unyielding purger and a despotic administrator who once said to a group of factory managers that 'the earth should tremble when the director walks around the plant'. The Party needed 'efficient, powerful, harsh, impetuous' leaders. Kaganovich was the main voice in the war against the utopian experiments of the 1920s: the *Zhenotdel* (women's section in the Communist Party), the visionary town planners, Communist moral teaching, communes, equality, and virtually everything else that smacked of autonomous culture building, independent social experimentation, and 'useless' speculation about the future. There can be no doubt that he spoke for Stalin, and Kaganovich's disdain for revolutionary utopia was palpable in his speeches and writings. He wanted 'small Stalins' in the factories and throughout Soviet society. As boss of Moscow, Kaganovich had ancient churches near the Kremlin torn down over the protest of Lunacharsky and several architects to whom he contemptuously replied: 'And *my* aesthetics demands that the demonstration processions from the six districts of Moscow should all pour into Red Square at the same time' – a vivid illustration of the new Stalinist iconoclasm and the exaltation of mechanised precision in ritual over the beauty of décor. In 1932 Kaganovich became furious when egalitarian-minded officials boycotted their own 'special stores' in Ivanovo-Voznesensk. His rude, harsh, ill-mannered style was widely emulated in the Moscow Party apparatus which he led, among Metro construction managers, and along the railways.[5]

Accompanying Stalin's economic revolution and the political reorganisation of the Soviet Union was a massive social upheaval. Between 1926 and 1939 Soviet cities grew by some 30 million people; during the First Five-Year Plan the urban population swelled by 44 per cent. The Moscow and Leningrad regions grew by three and a half million each. This produced a giant urban trauma, raging social tensions, and the misery of overcrowding, crime and anomie. At the same time, the working-class swelled rapidly between 1930 and 1933. The machinery of affirmative action, rapid promotion, and geographic and social mobility brought the reshaping of peasants, freshly arrived

from the villages, into unskilled workers; of unskilled into skilled workers; and of high-performing workers into technical or managerial courses and then into positions of power in the economy and in politics. This brought about the 'proletarianisation' of the Party and the corps of managers, a prime goal of the Bolshevik Revolution and of Lenin. But the suddenness of the change and the speedy technicisation of millions without the balance of a humanistic education created a generation of ambitious, career-oriented, former workers-turned-bosses – practical people who were opposed to 'disruptive' experiments. The upwardly mobile segments of the population wanted, in the words of Sheila Fitzpatrick, structure, permanence, traditional ladders of advancement, easily apprehended symbols of success and performance, security, and rewards in the coin of familiar goods that were both consumable and showable. They became correspondingly apolitical, deferential to authority, and conservative.[6]

The 'ruralisation' or 'rustification' of Soviet cities in the 1930s affected the economy and culture of Soviet civilisation. The primitive work habits of the newly arrived peasantry, their laxness and drift, their urge to wander in search of better jobs – all led the regime to full-scale compulsion and the imposition of discipline. The general influx of poorly educated masses led to an overall narrowing of culture, and to a spread of 'irrational and obscurantist tendencies' in the workplace and in all walks of life. Peasants were unable to leave their values behind in the villages. To the extent that the Russian peasants were still culturally isolated, suspicious, dogmatic, superstitious, or even 'primitive' in cultural outlook – even though graced with humour, colour, and generosity – to that extent the cities become more deeply imbued with peasant values – at home, on the streets and at work. Urban civilisation did not efface rural mentalities; rather the opposite occurred. In Pilnyak's image, the wolf (a metaphor for the peasant instinct), when captured by civilised man and caged, runs around the cage 'like a machine' but remains, nevertheless, a wolf. The Socialist Revolutionary leader Victor Chernov once said that 'the peasant is the true autocrat of Russia'. This only became true, in a figurative way, in the 1930s, when for the first time a Russian political culture became peasantised.[7]

Much of the old political and cultural intelligentsia was annihilated in the 1930s or reduced to impotence. This loss, together with the mass exodus of educated elements in the Civil War, meant that Russia was culturally decapitated. The flooding of the cities by peasants and the simultaneous rise of the proletariat into the ranks of

power changed drastically the whole cultural face of that huge country. The peasantry, outside of mainstream history for ages, now stamped its personality upon the Soviet state. Old Russian traditions, mostly rural, helped to shape Soviet practices: the hagiographic tradition was·linked to Communist self-pride; *pravda* to the 'single truth' of *Pravda*; Orthodox intolerance and bigotry to Communist dogmatism; the work rhythm and lyrical disorder of farm labour was translated into uneven 'work-storms' in the factory; and the provincialism of 'our own village' into refusals to take responsibility for anything except one's own immediate job.

The cultural revolution of 1928–31, long neglected as a subject of historical analysis or simplified by Soviet historians, is now clearly a part of Soviet history thanks to the work of Western scholars. The contributors to Sheila Fitzpatrick's *Cultural Revolution in Russia* have shown that behind the whirlwind of events and the bewildering complexities and contradictions of the period, three major elements stand out: a rapid and frenetic ascendance of utopian speculation, millenarian enthusiasm and amplified experimentation all aimed at building a new world in the near future as an accompaniment to the economic and social changes launched by the Five-Year Plan; a strong social and generational revolt of young Communists and workers to displace the old established professionals and specialists entrenched in academia and the administration; and a shifting and confused policy of the victorious Stalinists to channel this revolt into an assault against class and ideological enemies and intraparty opponents and then – when it threatened to get out of hand or set off unexpected and uncontrolled forces – to curb it and to retreat into the more familiar ruts of economic realism and ambition.[8]

But a widely accepted view that utopianism in Soviet history was a product of the Civil War, passed into a state of somnolence during the NEP, and revived again during the Five-Year Plan and the cultural revolution does not hold. In fact utopian speculation and experimentation with new forms of life and human relations continued unabated – and in some forms even increased – in the 1920s. What set the 1920s apart from the Civil War period and the period of cultural revolution was the element of millenarianism, apocalypse and euphoric expectation. In the first years of the Revolution, idealists looked across hundreds of mental and spiritual fronts and thought they saw their dreams about to be fulfilled – by a leap into Communism, by a worldwide revolution, by a universal human renewal, and by technological miracles. When this euphoric vapour

was dispelled by hard reality in 1921–22, utopianism took the form of deep but leisurely fantasy, preparatory designs for a new life, and social experimentation. In 1928 the forces of apocalypse were once again released and all the previous revolutionary fantasies bubbled into great and throbbing visions and dreams. The strong currents of egalitarianism, militant atheism, iconoclasm, anti-intellectualism, cultural nihilism, and other feelings, held in check by the strong embankments of Party policy in the 1920s, burst over these banks and inundated the social and cultural scene. Future visions, city plans and communal experiments rose to extravagant heights, seen by their creators as something about to be realised.

The apparent explosion of utopianism in the years 1928–32 was really a historical volcanic eruption of the sort that occurred in 1917; that is, it threw to the surface ideas and plans from a variety of periods, including pre-revolutionary years. All of the reductionist and nihilistic currents were new editions of Civil War visions – though more loudly and vigorously articulated in the late 1920s, especially the idea of the imminent withering away of various out-of-date human institutions – the state, the school, the family, and the law. Those with the most immediate applicability and enjoying at least partial state support – city planning, house commune schemes, and communalism in the workplace – were distinctly products of the 1920s. The utopianism and experimentalism of the Five-Year Plan – visibly flourishing for a time right under the noses of Stalin, Kaganovich and their associates – included both novelties unleashed by cultural revolution and well-established visions originating in the Revolution or even before it.

How did the social revolution and the cultural revolution of early Stalinism link up? The meticulous researches and penetrating interpretations of recent scholars of social history in the Stalinist period reveal the great historical significance of this nexus. On the one hand, some of the less attractive features of the Russian working class – social resentment of oldtime experts, suspicion of intellectuals and (often) of ideas in the abstract, xenophobia, class pride, and lingering anti-Semitism (related to the above traits by a complex of circumstances) – were unleashed by the generalised anti-intellectualism of the cultural revolution. On the other hand, the millions of workers – Communist or not – promoted into the white-collar class directly or via preferential admissions policies in schools of higher education, prompted in many workers the urges of ambition, technical mindedness, and 'seriousness' in the sense of material practicality. Their

ideals were hard work and rapid advancement – of themselves and of their society. Both elements of this growing mood and deepening mentality of the urban masses made them indifferent or hostile to the experimentation, the utopia, the creative fantasies and the daring schemes that emerged at the very time when they were entering a path of social mobility. It was not simply the anger of Stalin and his cohorts at utopianising – though that was perfectly clear – but also the emergence of a new kind of population in power and in production that helped bring about the end of the age of revolutionary dreams.[9]

The Stalinist regime, for its part, began to put the brakes upon the cultural revolution as a whole and on utopianism and experiment in particular, announcing along the way that only the single national Great Experiment, the economic leap into modernity, deserved the energetic work and creative forces of the Soviet people.

But the death of the utopian currents of the Revolution cannot be explained solely by the Stalinist political and social system that emerged in the mid-1930s. Stalin's Five-Year Plan actually released utopian energies and visions, feeding the hope that utopian solutions to human problems were imminent. It is also true that the NEP system which allowed the pluralism under which many utopian experiments and speculations flourished was deeply hated by some of the utopians themselves. It was hard for anyone to predict that the massive economic transformation would be accompanied by a political culture that would not only turn against the utopias of the plan era but also on most of the earlier dreams as well – indeed on the entire libertarian and visionary culture of the nineteenth-century radical intelligentsia.

Furthermore, in the course of the cultural revolution of 1928–31, some utopians turned against one another and fought down each other's fondest dreams in favour of their own. A multi-coloured world of utopia opened up for a few years until it became apparent that not all visions could be realised; when the powers determined priorities, most of the schemes advanced at the time appeared not only unrealistic but hatefully wasteful and extravagantly fantastic. We may even assume that for some leaders, the anger they felt toward 'dreamers', 'utopians', 'crackpots' and 'leftish' levellers in 1931–32 was a deflection of the frustrated anger and panic they felt when faced with the unrealisability of leaping into the perfect world. Finally it must be remembered that peasants, workers and the urban masses in general held widely divergent views and feelings about the various schemes for reshaping the world. As I shall indicate in the

coming pages, lower class mentalities were extremely complex and shifting and thus reacted to both intelligentsia schemes and workers' experiments with attitudes ranging from euphoric endorsement, through indifference and suspicion, to genuine hostility.

One of the basic innovative strains in the Russian Revolution was iconoclasm – a massive and often spontaneous urge to tear down the old and build a new culture. It broke out in cruder forms of vandalism in the countryside when peasants looted and gutted country estates of the gentry. In the towns, hated signs of the past were torn down and streets and squares renamed. Cultural nihilists of the avant-garde tried to discredit old culture and promote their own brands. Anti-intellectualism joined this torrent of anti-cultural activity with campaigns of abuse against intellectuals, people who wore glasses, and specialists of all sorts. The Bolsheviks opposed the generalised sweep of iconoclasm and used its energies on selected targets, but attempted to preserve order and to conserve what they saw as the best of the past. In the Stalin period, active vandalism broke out again against old buildings and churches, partly a conscious policy of atheist agitation and partly provincial spontaneity. A telling example was the demolition during the Five-Year Plan of St. Petersburg's oldest structure, the Trinity Cathedral near the Fortress, in order to erect a Constructivist edifice for the Society of Old Populists; in 1937 this in turn was destroyed. An orgy of 'anti-national' destruction was unleashed. Anti-intellectualism was now revived and it soon degenerated into purging and terrorising, while at the same time the anti-specialist movement was curbed by the regime, which built protective walls around its selected privileged élite – economic, administrative and cultural. Vestiges of avant-garde culture and the great blossoming of experiment in the arts disappeared in the early 1930s, giving way to a new cultural norm of 'Socialist Realism' – a genre that was neither Socialist nor realistic.[10]

Holiday celebration in the early years possessed utopian and culture building elements of carnival, public jollity, explosive artistic decor, outrageous designs, monumental statues, grand mythic outdoor theatre performances, and a great deal of variety and improvisation. From the outset, of course, the Bolsheviks attempted to control and use festival for politically symbolic purposes. Carnival and control meshed fairly well in the Civil War period and during the 1920s a constant tension between them endowed the festival as a public art form with a certain amount of interest.[11]

In the 1930s under Stalin, it became unequivocally a panegyric ritual of power and solidarity. The November 7th holiday in particular grew into a cultic service to a semi-divine leader. Parade, decor and spectacle were carefully orchestrated as never before, and the whole phenomenon became very rigid, standardised, politicised and militarised. The merry-making or carnival side of festival was banished to other quarters: large-scale popular entertainments such as that of August 1938 when thousands of people danced under paper lanterns to Gypsy music (earlier outlawed) and the popular 'Rio Rita'. The Red Square parade was increasingly embellished with a show of metallic force: new hardware rolling across the cobbled plaza before Lenin's tomb and the skies blackened with hundreds of warplanes. Loudspeakers poured out canned propaganda to the masses while menacing floats of 'Ezhov's glove' (a spiny fist from *ezh* or hedgehog) showed how Soviet power dealt with the sneaky vermin of Trotskyism. Lazy workers were shamed in effigy and live workers' parades offered a votive demonstration of loyalty and productivity by holding on high portraits of Stalin, mockups of his book, and promises to produce more goods. Celebration – once a joyful concept – now descended to the ritualised war on sloth. The standardised scenarios of Stalinist ritual were replicated in other Soviet cities. Even sport – once a mass movement for healthy bodies – now joined the ritual system with vast stadiums, flags, medals, 'stars', spectacles linking sport with war, and full-fledged professionalism.[12]

God-building was another experimental current of the 1920s that died under Stalinism. It took the form of a movement for public, community and life-cycle rituals, an effort to replace church forms with secular ones and to offer the masses a suitably warm-hearted culture of common reverence through symbols and gestures to replace their church. Workers' clubs experimented with new kinds of solemn gatherings. Parents 'Octobered' their babies with new revolutionary names such as Guillotine, Barricade, Struggle, Spark, Vladlen, Robespierre, Electrification. A parallel effort was mounted in the Komsomol and among youth groups in general in the towns to carve out a new Bolshevik code of behaviour based on revolutionary virtues. Endless arguments resounded over questions of drinking, smoking, the proper dress, dancing, swearing, and attitudes to women and to ethnic minorities. During the Five-Year Plan, this movement declined. Militant atheists turned all energies to the destruction of churches and not to building a counterfaith out of Bolshevism. Kaganovich publicly scorned the time-wasting activities

of the morality builders. Indeed the whole atmosphere of harshness in the villages, in production, and in everyday political life allowed no scope for anything resembling God-building or Socialist religion.[13]

Revolutionary egalitarianism was the keystone of the utopian urge, and the campaign against it set the entire tone of the 1930s under Stalinism. During the Revolution, the masses surged forward to divide and dispossess, to level, to abolish outward signs of privilege and deference. Bolsheviks from the very start used this urge for their own designs (against the old regime and its friends), but insisted on a modicum of privilege for themselves. Egalitarianism and anti-egalitarianism co-existed in the 1920s, pulling and pushing, conceding and demanding, but without a final resolution. Symbolic of egalitarian experiments of the time was the 'Orchestra without a Conductor' (1922–32) which shared labour equally and abolished the 'dictator' of the podium. In 1928 the surge repeated itself on a grand scale and some people interpreted the end of NEP as a sign of the victory of the egalitarian principle. But in 1931 Stalin – after a few preliminary warnings – emphatically repudiated the very notion of equalising as un-Communist, archaic and petty bourgeois. Stalin's anti-egalitarianism was in fact the element that informed the entire system of subcultures in the Stalin years. It was not only a rejection of wage equalising tendencies – still strong before 1931. It was an exaltation of hierarchy, unequal power, privilege, stratification, whole new subcultures of *kulturnost'* and respectability, visible signs of success for the millions of upwardly mobile groups in society – especially workers. It built a culture of signs, uniforms, gestures of authority and deference, rhetorical styles, audience applause, reverence for leaders, subservience to bosses, and a re-symbolising of the gender role of women, who had once been seen as mythic equals in the revolutionary movement.[14]

The main medium for expressing utopian fantasy in the 1920s was science fiction, a genre that flourished for about a decade (1920–31). Communist heavens of the future were wondrous worlds of high technology, stateless machine-run societies of equals, unified planets without nations, urbanised globes of glass and steel, socially just relations among all people who lived serenely and harmoniously without fear of war, unemployment, hunger, violence or crime. A similar genre focussed on the capitalist hells: plutocratic, fascoid and militarist slave states that exploited labour through the Taylor system and employed 'mad scientists' to conjure up doomsday weapons, death rays and 'horror machines' designed to destroy the Socialist

commonwealth. The whole genre was attacked by the proletarian writers movement during the plan and outlawed after 1931, the date of the last SF utopia – Yan Larri's *The Land of the Happy*. Some writers were purged; Socialist Realist canons disallowed excessive fantasy; and private presses and journals of the 1920s that had supported this kind of literature were suppressed. Radiant visions of the future that could be held alongside the harshness of Soviet realities of the 1930s could not be permitted: in fact, no Soviet SF utopia appeared in Russia for the next quarter of a century (until 1957, with Ivan Efremov's *Andromeda's Mists*). The villains of Zamyatin's novel *We* (1920) had declared dreaming to be a 'mental disease'. Stalin in effect, performed a fantasectomy upon the utopian dreamers of SF and forced writers into the mould of his own fantasising. Stalinist SF was characterised by near projection, technological tinkering, weaponry, patriotism, militarism and espionage. Russian science fiction underwent something like what the genre underwent in Hitler's Germany in the same period.[15]

The quintessential utopian experiment of the 1920s was the communal movement. In the years 1917 to the early 1930s, thousands of peasants and other social groups lived in rural communes, pooling their resources and sharing lives and work, sometimes dining together in an atmosphere of mutualism, the big family and community. The genuinely religious sectarian communes among these were the most extreme in their communalism and often the most successful. In the towns, workers and students set up hundreds of communal life dormitories or flats, self-consciously promising to share everything: time, space, leisure, friendship, and of course all material goods. All of this ended in the Plan era. Collectivisation launched a war against the countryside, abolishing communes as freely as it abolished private farms and old peasant mir holdings; sectarians were rooted out and sometimes arrested; urban communards abandoned their experiment willingly in the heat of the drive to production or were forced out by various means. Even collectives of work – production communes and collectives and artels that flourished for a time during the Plan – were broken up as harmful institutions of solidarity and wage-sharing. The house-commune, a widely praised residential pattern in the 1920s, was abandoned for the overcrowded parody of it known as the *kommunal'naya kvartira*, or communal apartment.[16]

For most utopians of the 1920s, the word 'we' embraced not the mindless and chilly despotism of stone and glass described so

eloquently in Zamyatin's novel, but rather spontaneous and self-designed experiments in liberation of the personality and in reshaping society. The identification of Zamyatin's Single State and the utopianism of the Russian Revolution is a false one. Most of the experiments in utopia were launched after he wrote his novel. Some of them were as 'green' in their cultural outlook as his wilderness 'beyond the green wall'. And even the urban and modernising fantasies and experiments were expressed in liberational and not repressive terms. The utopians were often naive, delusionary, fanatical, and even arrogant in their visions of the present, the near future, and the far future. Some conformed very well to the conventional use of the word 'utopian' as hopelessly unrealistic. But most of them, the levellers, the fantasists of the future, the communalists and the city planners were in quest of a leap into perfection from the nightmarish backwardness that engulfed them. Most of the utopians deserve an outburst of laughter and tears – and perhaps some applause – rather than contempt. But contempt, hostility and – in some cases – liquidation is what they got from the regime that superseded them.

Stalin's anti-utopianism was rooted in the Bolshevik tradition but went well beyond it. During the Revolution and all through the 1920s, Lenin and his successors looked upon utopian experiments with ambivalence. But the impulses that drove the utopians – idealism, communitarianism, the remoulding of the psyche, and even egalitarianism – were accepted as legitimate. They could not be allowed immediate realisation, but their validity for the future under Communism was tacitly and sometimes openly recognised by many leaders of the 1920s. After all, utopian experimentalism, though dramatic in social form and colourful in style, did not menace the foundations of NEP society – a one-party authoritarian political culture reposing on a relatively plural society and a mixed economy. It was a flurry of minds, a forest of symbols, and a network of mini-laboratories working out in life the deeper meanings of the Revolution. Stalinism swept away the ambivalence and turned a harsh and hostile face upon all such experiments as fundamentally harmful to the now unified and carefully calibrated goal of industrialisation, the liquidation of pluralism, and the creation of a mammoth police state.

In the 1930s Stalin and his associates waged war upon the dreamers. Cultural innovation and spontaneous carnivalism were crushed. Imaginative attempts to forge a civic ritual were abandoned

in favour of elaborate displays of military might on public holidays. Campaigns for a new morality were crudely brushed aside as petty debates and children's games. Levelling – now contemptuously called *uravnilovka* by Stalin – gave way to massive stratification, hierarchies of power and privilege, and the resurfacing of titles and ceremonies of deference – often masked behind thin façades of plain military tunics and unobtrusive automobiles. Utopian urbanisers were denounced as Mensheviks; deurbanisers as Fascists – and the new leaders declared that Soviet cities, since they were located in a Socialist state, were already Socialist. Communes of every sort were disbanded and dismissed as 'utopias' – petty-bourgeois and Trotskyist ones at that.

Moscow in the 1930s was a living monument to the twisted parody of revolutionary utopianism that Stalin had created. It was the capital and the sacred centre of revolutionary myth but also of xenophobic nationalism. By standing atop the tomb of Lenin on high Communist holy days, Stalin and his entourage – it is no longer appropriate to speak of them as his comrades – could claim to have incorporated the heritage of the dead prophet on display below while the deferential masses on Red Square cheered him and held aloft icons of his face. Beyond Red Square Muscovite citizens were stuffed into over-crowded apartments, ludicrously called 'communal' though the only sharing was of doorway, hall, toilet, bath and kitchen – the kitchen being sectored off among the separate occupants. At the same time, the leaders and the privileged – including foreigners – enjoyed the emoluments of large flats, private cars and imported goods, the enjoyment of which was, however, lessened by the looming sword of mass terror. Beneath the ground rumbled the newly built Subway of the Revolution– the Moscow Metro – at the cost of hundreds of lives, a monument to power in its conception, its execution and its overpowering ornament. Above ground, the skies of Moscow were pierced with the edifices of an architectural counter-revolution – huge stone confections whose towers shouted out the might of Muscovy while in back streets and workers' quarters, buildings crumbled and people waited in queues for basic commodities. An Orwellian reality behind a Zamyatinesque façade.

The original utopian dreamers of the Revolution had no place for dictators. Dictators in science fiction had been fascist or militarist products of capitalism; and the utopian vision of a future politics was one of Communist democracy, vaguely (and often quite unreal-istically) consensual in some cases, self-regulating and cybernetic in

others. Stalin's 'Socialism' was not the culmination of revolutionary utopia, or of the reveries of three generations of the intelligentsia; it was a nightmare regime of power, force, personal aggrandisement, and driving militarism and industrialisation. As a leader who cultivated the image of prince, father, hero and god, Stalin could not abide the egalitarian and self-directional experimenters of the Revolution any more than he could political opposition. Stalinism was a dystopia realised, and not a utopia. It was a fantasy state in which the myth of a Godlike leader enshrouded all the other myths of the Revolution and in which the dreams of the early years were rudely dispelled. Unlike Orwell's Big Brother who was a non-functioning (and perhaps even non-existent) symbol of power, Stalin was the directing hand and the active force behind the system that came to be known as 'totalitarianism'. Unlike Zamyatin's Well-doer, Stalin succeeded neither in creating a smooth functioning, rational, symmetrical world nor in destroying the fantasy of the peoples over whom he ruled for 25 years.[17]

## NOTES

1. Naum Jasny, *Soviet Economists of the Twenties* (Cambridge: Cambridge University Press, 1972) p. 135.
2. Moshe Lewin, *Political Undercurrents in Soviet Economic Debates* (Princeton: Princeton University Press, 1974) pp. 97–124, 356–65; Robert Tucker, 'Stalinism as Revolution from Above', in Tucker (ed.), *Stalinism* (New York: Norton, 1977) pp. 91–2; Sheila Fitzpatrick, *Education and Social Mobility in the Soviet Union, 1921–1934* (Cambridge: Cambridge University Press, 1979) pp. 161–2.
3. Lewin, 'Society, State, and Ideology During the First Five-Year Plan', in Fitzpatrick, *Cultural Revolution*, p. 42.
4. I.V. Stalin, *Problems of Leninism* (Peking: Foreign Languages Press, 1976) pp. 849–51; Stephen Sternheimer, 'Administration for Development: the Emerging Bureaucratic Elite, 1920–1930', in W.M. Pintner and D.K. Rowney (eds) *Russian Officialdom* (Chapel Hill: University of North Carolina Press, 1980) p. 322.
5. Lewin 'Society, State, and Ideology', pp. 62, 64, 74; Roy Medvedev, *All Stalin's Men*, trans. H. Shukman (New York: Anchor, 1985) pp. 113, 118, 120, 124 (quote).
6. Lewin, 'Society, State, and Ideology', pp. 44–54; Fitzpatrick, *Education*, pp. 8, 59, 158, 249–52, *passim*; *idem*, 'Cultural Revolution as Class War', in *Cultural Revolution*, pp. 3–4, 33, 35, 39. The relatively conservative apoliticism of many workers was noted by Mensheviks in the 1920s: Vladimir Brovkin, 'The Mensheviks and NEP Society in Russia', *Russian History* 9/2–3 (1982) pp. 344–77.

7. Lewin, 'Society, State, and Ideology', pp. 54–9, 72; A.R. Tulloch, 'The "Man vs. Machine" Theme in Pilnyak's *Machines and Wolves*', *Russian Literature Triquarterly*, 8 (1974) pp. 329–39.
8. Fitzpatrick, *Cultural Revolution, passim.*
9. See the works of Fitzpatrick cited above, her articles on related matters, and her *Russian Revolution, 1917–1932* (New York: Oxford University Press, 1982).
10. Richard Stites, 'Iconoclastic Currents in the Russian Revolution', in Abbott Gleason *et al.* (eds), *Bolshevik Culture: Experiment and Order in the Russian Revolution* (Bloomington: Indiana University Press, 1985) pp. 1–24; Kathleen Berton, *Moscow: an Architectural History* (London: Vista, 1944) p. 202; P. Savitsky, *Razrushayushchie svoyu rodinu* (Berlin, 1937); Lev Kopelev, *Education of a True Believer* (New York: Harper, 1980) p. 114; L. Syrkin, *Makhaevshchina* (Moscow: Gos. stos.-ekon. izd., 1931) pp. 69–76.
11. Christel Lane, *Rites of Rulers* (Cambridge: Cambridge University Press, 1981); Nina Tumarkin, *Lenin Lives!* (Cambridge, Mass.: Harvard University Press, 1983); Stites, 'Adorning the Revolution: the Primary Symbols of Bolshevism, 1917–1918', *Sbornik* (Oxford, 1984) pp. 39–42 (illustr.); *idem*, 'Origins of Soviet Ritual Style: Symbol and Festival in the Russian Revolution', in L.E. Blomquist and D. Tarschys (eds), *Symbols of Power* (Uppsala, 1987).
12. Lane, *Rites*, pp. 173–80; *Pravda* (9 November 1938) pp. 1–6; A.I. Mazaev, *Prazdnik kak sotsial'no-khudozhestvennoe yavlenie* (Moscow: Nauka, 1978) p. 365; James Riordan, *Sport and Soviet Society* (Cambridge: Cambridge University Press, 1977).
13. C. Binns 'The Changing Face of Soviet Power: Revolution and Accommodation in the Development of the Soviet Ceremonial System', *Man*, 14 (December 1979) 585–606; Stites, 'Family and Community Rituals in the 1920s', to appear in Fitzpatrick, *et al.* (eds) *Soviet Society and Culture in the 1920s.*
14. Stites, 'Utopias in the Air and on the Ground', in *Russian History*, 11/2–3 (Summer-Fall, 1984) pp. 236–57; David Dallin, 'The Return to Inequality' in Robert Daniels (ed.), *The Stalin Revolution*, 2nd edn (Lexington: Heath, 1972) p. 109; Mervyn Mathews, *Privilege in the Soviet Union* (London: Allen & Unwin, 1978); Nicholas Timasheff, *The Great Retreat* (New York: Dutton, 1946); Vera Dunham, *In Stalin's Time* (Cambridge: Cambridge University Press, 1976).
15. Darko Suvin, 'The Utopian Tradition in Soviet Science Fiction', *Modern Language Review*, 66 (1971) pp. 139—59; Stites, 'Heaven and Hell in Revolutionary Science Fiction', to appear in *Sbornik* (1987); Alexander Bogdanov, *Red Star: the First Bolshevik Utopia*, (ed.) L. Graham and Stites (Bloomington: Indiana University Press, 1984); Yan Larri, *Strana schastlivykh* (Leningrad: Leningradskoe oblastnoe izdatel'stvo, 1931).
16. Robert Wesson, *Soviet Communes* (New Brunswick: Rutgers University Press, 1963); Basil Kerblay, 'Les utopies communautaires', *Revue des études slaves*, LVI/1 (1984), pp 97–103; Klaus Mehnert, *Youth in Soviet Russia* (New York: Harcourt, 1933); A. Naishtat *et al.*, *Kom-*

*muny molodëzhi* (Moscow: Molodaya gvardiya, 1931); Lewis Siegalbaum, 'Production Collectives and Communes and the "Imperative" of Soviet Industrialisation, 1929–1931', *Slavic Review*, 43/1 (Spring, 1986) pp. 65–84; Anatole Kopp, *L'architecture de la période stalinienne* (Grenoble: Presses universitaires, 1978); S. Frederick Starr, 'Visionary Town Planning During the Cultural Revolution', in Fitzpatrick, *Cultural Revolution*, pp. 207–40.

17. For further understanding of cult and culture of the Stalin period, see: Katerina Clark, *The Soviet Novel: History as Ritual* (Chicago: University of Chicago Press, 1980); Tucker, *Stalin as Revolutionary, 1879–1929* (New York: Norton, 1973); *idem*, 'The Rise of Stalin's Personality Cult', *American Historical Review*, LXXXIV/2 (April 1979); *idem*, 'Does Big Brother Really Exist' in Irving Howe (ed.), *1984 Revisited: Totalitarianism in Our Century* (New York: Harper & Rowe, 1983); George Urban, *Stalinism* (Cambridge, Mass.: Harvard University Press, 1986); Régine Robin, *Le réalisme socialiste: une esthétique impossible* (Paris: Payot, 1986); *idem*, (ed.), *Soviet Literature of the Thirties: a Reappraisal* (Montpelier: Sociocriticism, 1986); Hans Günther, *Die Verstaatlichung der Literatur* (Stuttgart: Metzler, 1984); and Rosalinde Sartorti, *Pressefotografie and Industrialisierung in der Sowjetunion: die Pravda 1925–1933* (Berlin-Wiesbaden: Harrassowitz, 1981).

# Part II
# Art

# Part II
## Art

# 5 Presuppositions of Socialist Realism

## Aleksandar Flaker

### ART AND THE RUSSIAN WORKER

Among the delegates to the Fourth Comintern Congress in Moscow in 1922 was the Croatian writer August Cesarec, who, after returning to his homeland, published a series of reports, among which we have already called attention to the ones concerning the receptive possibilities of the Russian working-class public, and which thus enter into the questions of the aesthetic process of the 1920s as presuppositions of the coming normativism.[1] He founded his anxiety over the fate of art, especially painting, in post-revolutionary society on his own observations of the working-class's attitude toward various types of fine art. At an exhibition which was dominated by the Russian avant-garde with Larionov, Malevich and Tatlin, he did not notice a single Russian worker; the misunderstanding of Derain's figurative Samedi from Shchukin's collection left an uneasy impression on him, but, in contrast to the isolated worker before whom 'the whole of modern art' stood as a 'trial',[2] he emphasised the common public's pronounced interest in Repin in the Tretyakov Gallery, but also the receptive habits of 'the primitive man in whose life art has been some bad icon in church or an enlarged copy of a photograph'.[3]

If Cesarec expressed scepticism about the Russian painting avant-garde, calling on the oppression of the working-class audience and its Russian 'religioznost",[4] then this scepticism was considerably less when he gave his accounts of the theatre. He considered Meyerhold's productions the fundamental model of revolutionary theatre, with their shortcoming, to be sure, of reduced 'spectator activity' and intellectualism, comparable to cubist painting,[5] but his partially-stated doubts had other causes: state intervention was already on the horizon. Lunacharsky had spoken out against the production of *Le cocu magnifique* from the position of Communist 'morality'. Cesarec still believed that it was a matter of a personal quarrel and hence that one could not speak about the 'obituary' of the avant-garde theatre

because such an 'obituary' would at the same time mean the 'obituary' of Lunacharsky as a Communist.[6]

Another Croatian witness of Moscow theatre life, Miroslav Krleža, spent time in Moscow on the occasion of the meeting of the Fifth Plenum of the Executive Committee of the Comintern in 1925. In Meyerhold's theatre was already playing Erdman's *Mandate*, which Krleža compared with Wedekind's 'Uberbrettel' and Grosz's pictures, but he had to observe that Meyerhold's actors 'along with all their enthusiasm for style are detailed realists to the smallest detail'.[7] Here, however, it is worth emphasising Krleža's observations concerning the reception of the performances. He divided the theatregoing public into two groups: one, loyal to theatre tradition (MKhaT) in theatres where 'the aristocratic ambiance of the Third Empire reigns and everything has the appearance of a grotesque "status quo ante",' and the other from peripheral theatres – not at all decorative:

> But when the executioner on stage hangs some revolutionary and the orchestra strikes up 'Zhertvoyu pali,' the wooden chairs rumble spontaneously in the whole auditorium and everyone sings that funeral march with bowed head and devoutly. In those souls the relation to the beauties of the stage is virginal-religious, and when the rifles fire on the barricades or dynamite explodes and heroes fall, there people stamp their feet on the floor, there people shout and applaud in a higher, rapturous exaltation.[8]

Krleža experienced that sort of reaction in the 'Komediya', at a performance of A. Tolstoi and P. Shchegolev's *The Empress's Conspiracy (Zagovor imperatritsy)* – a propangandistic piece, but 'shallow and weak',[9] or again at a performance of *The Year 1881*, which truly filled up the theatre coffers.[10] It is significant that both external witnesses notice a specifically Russian 'devout' attitude in the common people's reception of art, while Krleža remarks on a heightened interest in the dramatic trivialisation of history, as Cesarec noticed it in the attitude to Repin's canvas (*Ivan the Terrible*). After all, one of the authors of *The Empress's Conspiracy*, Count Aleksei Tolstoi, would become in the 1930s the canonical author of texts in which history was trivialised (*The Road to Calvary– Khozhdenie po mukam*, 1922–41) or falsified (*Bread – Khleb*, 1937).

# FROM JOINER TO ENGINEER

Predispositions for the movement of the arts towards ever more demanding reception 'from below' and 'from above' already existed early on, not only among the 'proletarian' artists, primarily dilettantes, but also in the circle we today call the avant-garde. The avant-garde was in fact creating a new type of artist who, in contrast to the social analyst or bearer of exalted ethical principles from the era of realism and the mythical subject of Russian symbolism, elevated above the commonplace (who, with Vjacheslav Ivanov, dreamed of art as an act of collective ritual), appeared early on as the anonymous constructor of a work of art and taught:

. . . krasota ne prikhot' poluboga,
A khishchnjy glazomer prostogo stolyara.

(O. Mandelshtam, *The Admiralty* – *Admiralteistvo*, 1913[11] – . . . beauty is not the caprice of a demigod,/ But rather the rapacious measure of an ordinary joiner.) The name 'Poets' Workshop' (*Cekh poetov*) itself bore witness to the Acmeists' tendency to equate poet with craftsman, while today Mandelshtam's remarks about the offer which artists present to the state as a 'powerful instrument', 'as tools of social education', expressed in 1920 in connection with the appearance of the Dalcroze method of rhythmic gymnastics, even sounds sarcastic. This 'offer' referred to rhythm – which is needed everywhere 'where victors are needed'.[12] We know that it was not, however, Mandelshtam who offered the state his own rhythms – it was Mayakovsky in *Left March* (*Levyi marsh*, 1918), who proclaimed one of the fundamental contradictions of the post-October avant-garde: contradictions between the revolutionary rhetor and the specialist (Russ. abbreviation *spets*) of poetry who offers his services to the Party and the state. In the poetic feuilleton *Homeward* (*Domoi*, 1925), Mayakovsky summarised a whole programme for the functionalisation of the poetic act which, in hyperbolic statements, sounded truly grotesque, especially in the readiness it evinced to submit to the 'tasks' of the state planning organ (*Gosplan*), the commands of the 'commissar of time', to the point of closing the 'lips with a lock' after work, and to the verses cited so often in the time of the poet's canonisation:

Ja khoču,
      chtob k shtyku
            priravnyali pero.
S chugunom chtob
          i s vydelkoi stali
o rabote stikhov,
          ot Politbyuro,
chtoby delal
          doklady Stalin.[13]

(I want/ the pen to be like/ the bayonet./ That with iron/ and the manufacture of steel/ about the work of verses,/from the Politburo,/ for Stalin/ to make reports.)

There ensued comparisons of poetry with mathematics, with chess, and then an entire programme for the fulfillment of 'the social command' (*social'nyi zakaz*) in the text *How to Make Poetry? (Kak delat' stikhi?*, 1926):

> In my opinion, the best poetic work will be the one that is written according to the social command of the Comintern, that is committed to the goal of the victory of the proletariat, conveyed in new words, expressive and comprehensible to everyone, worked out on a table that is ordered according to NOT (*Nauchnaya organizaciya truda* – the Scientific Organization of Labour), and delivered to the editors' office by aeroplane.[14]

1925 is not only the year of the Central Committee's intervention in literary affairs, but also the year of offers of etatisation of literature and the arts, so not only is state planning mentioned in Mayakovsky's text, but the title of the constructivist collection *State Plan for Literature* (*Gosplan literatury*)[15] should also be understood in that way, as well as the synchronous aspirations for central state management of art, selective with respect to 'all that is politically and ideologically harmful', and realisable in the 'State Plan in the Province of Art' – which were pronounced among fine artists and critics.[16]

In these offers the etatisation of the arts was preceded as well by a semantics which, at the time of the dehierarchising pathos of the avant-garde, reduced the former 'creator to the level of a shoemaker, a joiner, a tailor',[17] but the very reduction of the arts into connection with (industrial) production implied the equalisation of the artist with

the 'engineer', and so in about 1923 the concept of the 'artist-engineer' appears in Tarabukin,[18] and in Mayakovsky even earlier, in connection with the comprehension of 'the formal work of the artist as only engineering, needed for the sake of shaping our whole practical life'.[19]

The demand for *state* regulations laid down by a part of the avant-garde opposed in fact to the collusion of the 'proletarian' writers and the *Party* is not adopted in the 1920s, but in 1932 Stalin took up the comparison of writers with engineers as a ready-made formula.[20]

## 'AN EMOTIONAL LINK'

The most striking examples of the constitution of Socialist Realist models are offered to us by easel painting, which, despite the resolute opposition of the avant-garde, had to orient itself to the new ordering party whose aesthetic habits were noticed by Cesarec. This commissioner, again, according to Malevich, sought from painting that it make the beauty of a 'rose' from his own 'mug' (word-play in the Russian: *roza* – rose, *rozha* – mug, snout).[21] Already in 1922 the AKhRR (Assotsiyatsiya khudozhnikov revolyutsionnoi Rossii) was formed, which with its thematic exhibitions and reliance on the Russian genre-painting of the *peredvizhniki* attracted a new audience and, despite criticism from the most authoritative direction (Lunacharsky), received the support of individuals at the top of the Party (Yaroslavsky) and gained the sponsorship (*metsenatstvo*) of the army,[22] and this circle, along with painters from the group OST (*Obshchestvo stankovoy zhivopisi* – The Society of Easel Painting),[23] gave the most names to Socialist Realism.

Here, however, we should point out the programmatic text of the painter who, precisely in 1925 joined the AKhRR and in the same year, in a journal that operated under the direct influence of Lunacharsky, published a contribution from which the editorial board distanced itself but at the same time saw in it 'an indicator of the ideological tendencies that are now noticeable in the circle of participants in the arts who are far from the revolution'.[24]

Namely, the author of the cosmic vision of revolution in *New Planet* (tempera, 1921, Tretyakov Gallery), Konstantin Yuon, in the text *What Art Must Be for the Popular Masses*, in contrast to the productionist aesthetics of the avant-garde, spoke in favour of an

aesthetics of reception in which the receiver is not identified by class but rather by the general concept of *narod* (people, nation), and replaced the concept 'proletarian' with the concept of 'socialist art'. Consistent with that, he proceeded from the categories of 'accessible, comprehensible', 'interesting', but in the social-pedagogical sense 'necessary' and 'goal-directed art' (*tselevoe iskusstvo*) which 'must influence and affect' the masses. In order to realise that imperative,

> Between the author who embodies his ideology in artistic forms and the ideology of the receiver (*vosprinimayushchego*) there must exist an *emotional link* (*simpaticheskaya svyaz'*) – a kinship without which understanding, evaluation and artistic impulse are unthinkable.[25]

Beginning from what we would call today the horizon of expectation, though not completely consistently, Yuon postulates a series of norms among which we shall stress 'clarity', 'simplicity' (*prostota*), 'strikingness' (*naglyadnost'*), figurative 'expressiveness', 'simplification of technique' (*uproshchennost' tekhniki*), 'decorativeness', 'completeness' and 'monumentality'. Aside from the aesthetic categories we note the concepts of 'reasonableness', 'health', 'strength' and 'sound morals'. It is particularly worth pointing out the emphasis on the need for 'ordinariness' and 'prevalence' (*ustoychivost'*) of forms – in order to satisfy 'the people's' aspirations toward 'prevalent forms of life' (*ustoychivye formy zhizni*), but along with that the abandonment of 'poorly understandable and uninteresting' experiments. At the same time Yuon sets up a whole series of aesthetic prohibitions which concern all that is 'hazy, indefinite, understated', 'of uncertain approximation' or 'ambiguity' (*dvoistvennost'*) as traits which 'must be driven out', to be sure, in the name of 'great style'. Unlike the followers of 'heroic realism' in the AKhRR, Yuon does not orient himself toward the tradition of the *peredvizhniki* but rather toward the Italian Renaissance, Old Russian art, and also acknowledges the virtues of Millet, Hodler, Meunier and Puvis de Chevannes.[26]

## 'THE BOILEAU OF THE SOCIALIST ERA'

Approaching the 'people' in its traditional Russian significance, Yuon nevertheless underlined 'the difference between the people and

its leading groups, between the proletariat as a whole and its own leading avant-garde, which it has set apart (*vydvinutym im*)'.[27] He drew his normative requirements from the horizon of expectation ascribed to the 'people' at a time when the Party's 'leading groups', proclaiming on principle 'the free competition of various groupings and currents', in essence opened the way for protectionism of the 'proletarian' alliances and heralded 'the penetration of dialectic materialism' into extra-scientific fields:

> *The conquest of positions in the field of belles-lettres just the same must sooner or later become a fact.*[28]

From there the path led towards the monopoly of RAPP, accomplished with the support of Party leadership in the years of the 'great rupture' in social structures, and also toward the slogan of the 'dialectic-materialistic method' in literary creation which assumed not only a class but also an ideological priority in the evaluation of texts. A normativism, for now under the name 'proletarian', was emerging. The ideologues of RAPP themselves acknowledged it. Thus we read in Averbakh:

> In an article entitled 'In Defence of Reality' Comrade Bespalov (*Krasnaya nov'*, vol. 9–10, 1930) speaks out against normative aesthetics, ironising 'the Boileau of the era of socialist revolution'. . . . However, our theory of the artistic method too must not only *interpret*, but also *change* the practice of proletarian writers! To be sure, our sort of 'normativism' does not constitute anything that would stand outside of literary reality – it feeds on its juices and is rooted in it – showing its goals, setting its tasks, directing its searches.[29]

In the name of a platform which wished to collect writers around a programme no longer of 'proletarian' but rather of 'Socialist' Realism,[30] Averbakh was pushed into non-existence, while RAPP was dissolved. The concept of 'method' remained, however, the central concept of the new doctrine, and with it a normative aesthetics too, developed into a deliberate system which, particularly in Lukács's work, acquired a scholarly, philosophical justification.[31]

## 'SOCIALLY HARMFUL ART'

> Before us lies enormous labour on internal reorganization not only in the socio-political, but also in the psychological sense. We must carefully reexamine everything we have inherited from the chaotic past, and then, having selected what is valuable and useful, discard what is worthless, relinquish it to the archive of history. More than anyone else, we need psychic health, alertness, faith in the creative power of reason and will-power.

This is not an excerpt from a text such as Gorky wrote after his return from (Fascist) Italy, called upon to expound the doctrine of historical optimism with his authority, but rather a citation from an article he published in 1913. We quote further:

> We live in a country with a variegated population of 170 million people who speak half a hundred languages and dialects; our wretched people drink enough vodka yearly for almost a billion and – drink more and more.[32]

The articles in which the creator of the myth of 'barefoot romanticism', in the name of the current social situation, placed ethical demands before art are written as a protest against the adaptation in MKhaT of Dostoevsky's novels *The Brothers Karamazov* and *The Demons*:

> Why do people try to draw society's attention precisely to those unhealthy phenomena of our national psyche, to its deformities? We must struggle with them, heal ourselves of them, a healthy atmosphere must be created in which those diseases would find no place.
>
> But people here point to the festering wounds, the deadened bodies, compelling us to think that we are living amid dead souls and living corpses.[33]

Regardless of the allusions to texts of the 'classics' of Russian realism, this is already the language of Socialist Realist criticism. The axiology is definite: on one side art, 'ethically dubious and unconditionally harmful socially'[34], 'socially harmful'[35] artistic action, and on the other side, again, the postulate of social hygiene – 'health, alertness', 'spiritual convalescence', which, in Gorky, are directly linked to the

'socio-educative significance' of the ideas shown in artistic 'pictures',[36] and then from that position the question of utilitarianism is posed: is a certain work of art 'necessary and useful in the interests of social pedagogy?'[37] At which Gorky distinguishes media in their impact on the receiver: what is permitted in a novel is not permitted in the theatre:

> The stage transports the observer from the realm of thoughts, that freely allow argument, to a realm of suggestion, of hypnosis, to the murky realm of emotions and feelings. . . ,[38]

and so Gorky promises his opponent that, should he become minister, he shall not burn Dostoevsky:

> Gorky is not against Dostoevsky, but rather against Dostoevsky's novels being presented on stage.[39]

Gorky does not give the reaction of viewers to the adaptations of Dostoevsky on stage: there is no 'Russian worker', in whose name a Croatian Communist expressed scepticism about avant-garde painting, nor is there 'the people' in whose name Yuon set his own normative requirements; at that time there already exists an arbitrary judgement about what is 'diseased' in art, and what is 'healthy'. For Gorky in 1896 art is already, in an article on 'decadent' poetry, in itself a possible cause of social infection:

> But something morbid and nervous, the psychosis of decadent creation, gradually, unnoticeably, drop by drop, penetrates into the blood of society and it falters. . . . . There is born in it that sickness that its children, the Verlaines and Maeterlincks, cradled and cultivated – they cultivated it and now have injected its refined, destructive poison into society.[40]

We know: the struggle against 'decadence' was continued by all available means in the 1930s. We cannot call Gorky, to be sure, the Boileau of that time, but we can already find the assumptions in a canon of Socialist Realism of arrested motion in his early texts.

NOTES

1. Cf. A. Flaker, 'Cesarec, témoin des transformations de l'art soviétique pendant les années vingt', *Cahiers du Monde Russe et Soviétique*, 1967, no. 2, pp. 434–46; *Književne poredbe* (Zagreb, 1984) pp. 333–55; *Poetika osporavanja* (Zagreb, 1984) pp. 102–22; *Ruska avangarda* (Zagreb, 1984) pp. 459–70.

2. A. Cesarec, 'Umetnost i ruski radnik', *Književna republika*, 1924, no. 2, p. 321.

3. Ibid., p. 318.

4. Describing the worker in whom were 'personified all the masses of the Russian revolution' (ibid., p. 321) and who pronounced his 'judgement' of Derain's picture, Cesarec emphasises a precisely religious approach to art. It was, for a Communist who saw in the Russian Revolution the annulment of the opposition Russia-Europe, 'one of those Russians, of whom when you see them you have to come to the erroneous Voltairean thought that if god did not exist a god would have to be created for them . . . But some god appeared to one such man in the form of a revolution which awoke in him better propensities and needs, namely that he enjoys or at least tries to be interested in art . . .' (ibid., p. 318). At the same time Malevich devoted attention to the correlation of art-religion-industry, beginning with the treatise *God is not Cast Down. Art, Church, Factory (Bog ne skinut. Iskusstvo, tserkov', fabrika*, Vitebsk, 1922), up to the manuscript written à propos of the religious-iconic attitude toward Lenin's death in 1924, preserved in the Amsterdam archive.

5. A. Cesarec, 'Teatar i ruska revolucija', *Savremenik*, 1923, p. 443.

6. Ibid., p. 446.

7. M. Krleža, *Izlet u Rusiju* (Zagreb, 1926) p. 106.

8. Ibid., p. 102.

9. Ibid., p. 105. That success, among the public, along with the remark that the piece 'has no serious artistic value', is also noted by criticism of the time: R. Pel'she, *Problemy sovremennogo iskusstva* (Moscow, 1927) pp. 91–2.

10. This refers to the historical spectacle by T. Shapovalenko, directed by Lyubimov-Lanskoi, about the terrorists of 'The People's Will', which was 'watched with extraordinary interest by thousands of proletarian viewers', although the direction was considered 'mediocre, colourless'. A theatre critic nonetheless singled this piece out from the category he called *kassovye p'esy* (plays for the cashbox) as opposed to the notion of *klassovye p'esy* (class plays). R. Pel'she, as above, pp. 85, 88. The acceptance of that sort of trivial play, along with all the qualifications having to do with their aesthetic value, along with simultaneous criticism of Meyerhold, is characteristic of the Latvian Communist and close co-worker of Lunacharsky.

11. O. Mandelshtam, *Sobr.soch.* vol. 1 (New York, 1967) p. 29.

12. Ibid., vol. 3, 1969, pp. 69–70.

13. V. Mayakovsky, *Poln.sobr. soch.*, vol. 7, Moscow, 1958, p. 94.

14. Ibid., vol. 12, 1959, p. 89.
15. For greater detail about the anthology and Zelinsky's article of the same name, cf. R. Grübel, *Russischer Konstruktivismus* (Wiesbaden, 1981) pp. 147–52.
16. A. Fedorov-Davydov, 'Gosplan po delam iskusstva', *Pechat' i revolyucija* 1925, no. 2, p. 141.
17. O.M. Brik, 'Khudozhnik i Kommuna', *Izobrazitel'noe iskusstvo*, 1919, no. 1, p. 26.
18. Tarabukin projects the abandonment of institutionalised aesthetic spaces and the transition of art into production, beginning from the 'crisis' of art as a social fact – the disappearance of the class foundations of 'aesthetic gourmandise':

    > Confirmation of this thought may be found already in facts whose existence cannot be denied: the exhibitions of the present winter season (1921–1922), even after their lull in the last four or five years, have not met, as they say, with 'success'. They have gone past ordinarily unnoticed. (N. Tarabukin, *Ot mol'berta k mashine*, Moscow, 1923, p. 15)

    Tarabukin sees a 'democratisation' of art in 'production', but no longer on the 'workshop' level of applied art:'

    > The artists in his work does not begin from techniques of craft, but from the creative coordination of two fundamental elements of the contents of a thing (*veshch'*), its apportionments and forms. By the particular scope of contents which is characteristic mainly of the artist and his creative work, the work of the artist-engineer, the thing as a production masterpiece is distinguished from the simply industrial thing (p. 19).

    It is also worth mentioning how, in relation to easel painting, Tarabukin supports the rising Soviet 'puritanism':

    > Old-fashioned, 'sacred' art prostitutes itself in innumerable 'studies' and sniffs cocaine. It is 90 per cent sexual. L. Tolstoi is right when he accuses it of debauchery (p. 42).

    The concept of 'professional engineering' is utilised by Arvatov too in his review of Tarabukin's book. *LEF*, 1924, 4, p. 210. Cf. A.N. Mazaev, *Koncepciya 'proizvodstvennogo iskusstva' 20-kh godov* (Moscow, 1979) p. 176.

19. Parizh (Zapiski lyudogusya) 1922; V. Mayakovsky, op. cit., vol. 4, 1957, p. 212.
20. The full text of Stalin's statement in which writers are called engineers who lead the *construction* of human souls (italics A.F.) from Kirshon's notes from the assembly of the First Plenum of the organising commit-

tee of the Union of Soviet Writers in 1932; cf. H. Günther, *Die Verstaatlichung der Literatur* (Stuttgart, 1984) p. 12.

21.  'The artist now, as before as well, awaits the proletarian chief of the main administration (*zaglava*) in order to be worthy of immortalising his picture on handmade canvas . . . The old pictures are pulled out of the same frames and others are inserted into the same nests . . . Art which wants to make a rose from a mug . . . If the bourgeois class confirmed itself in art, then we too must smear ourselves likewise onto the canvas and confirm ourselves on it as the very image of the bourgeoisie.' K. Malevich, *Notebook IV*, 1924, manuscript in Stedelijk Museum, Amsterdam.

22.  Cf. H. Gassner, E. Gillen, *Zwischen Revolutionskunst und Sozialistischem Realismus* (Köln, 1979) pp. 266–8. The support of Yaroslavsky and Voroshilov, and along with that the attractiveness of the association because of its 'material base', is mentioned in memoirs and V. Kibrik, 'Vsegda otkrytie', *Novyi mir*, 1980, no. 1, p. 206. Malicious remarks at the expense of AKhRR were also made by the Lef member N. Chuzhak: 'Here a Portrait of the President of the *Financial Commission*', an institution which supports AKhRR, there a portrait of 'The Horse of a Friend' . . . innumerable names of patrons, that is the proper path towards a classless society'. Cf. H. Gassner, E. Gillen, op. cit., p. 285.

23.  The members of the group OST, named thus precisely out of opposition to the avant-garde negation of the easel painters, did not proceed from the traditions of the *peredvihniki*, acknowledged the achievements of the European avant-garde, Russian and European (German) expressionism, but calling now and then on the example of Mayakovsky, declared its readiness to functionalise figurative painting, especially with regard to industrial and workers' themes (Deineka, Pimenov and others): Cf. V. Kostin, *OST (Obshchestvo stankovistov)* (Leningrad, 1976; H. Gassner, E Gillen, op. cit., pp. 324–34.

24.  K. Yuon, 'Kakim dolzhno byt' iskusstvo dlya narodnykh mass', '*Pechat' i revolyucia*', 1925, no. 4, p. 130. We mention this text here also because Yuon's name is not found in Gassner and Gillen's otherwise carefully composed documents.

25.  K. Yuon, as above, p. 135.

26.  In that inventory it is worth singling out Hodler's name. Only two years later appeared the canvas of a member of the group OST, A. Deineka, *The Defense of Petrograd* (Central Museum of the Soviet Army, Moscow), which is strikingly similar to Hodler's *Departure of the Jena Students (Aufbruch der Jenenser Studenten*, 1908. Fresco, University of Jena). Cf. E. Gillen 'Künstlerische Publizisten gegen Romantiker der roten Farbe', in: *Kunst in die Produktion! Sowjetische Kunst während der Phase der Kollektivierung und Industrialisierung 1927–1933*, Neue Gesellschaft für Bildende Kunst Berlin (West), 1977, pp. 118–19.

27.  K. Yuon, as above, p. 137.

28.  Emphasised in the original text. *O partiinoi i sovetskoi pechati. Sbornik dokumentov* (Moscow, 1964) p. 344.

29. L. Averbakh, 'Predislovie', in: *Bor'ba za metod. Sbornik diskussionykh statei o tvorchestve* (Moscow-Leningrad, 1931) p. 5. It is worth mentioning that Averbakh does not speak here about the 'inveteracy' of norms in the social, but rather in the 'literary' reality of his time.
30. A scheme of the chronological sequence of statements with regard to their relationship toward the Realist tradition is provided by L. Robel, *Littérature Soviétique: Questions* (Paris, 1976) pp. 81–6.
31. The dissimilarity of language and paths of Zhdanov, Gorky and Lukács, but also their 'co-sounding' (*sintonia*) are convincingly noted by Vittorio Strada, stressing the conjunction of philosophers who gave to Socialist Realism an 'intellectual carcass' with 'literary bureaucrats' who had one advantage: 'they knew better whom and what that organism had to serve'. 'Introduzione', in Gy. Lukács, M. Bachtin e altri, *Problemi di teoria del romanzo* (Torino, 1976) p. XLI.
32. 'O karamazovshchine', in M. Gorky, *O literature* (Moscow, 1955), p. 152.
33. Ibid., p. 152.
34. Ibid., p. 155.
35. 'Eshcho o karamazovshchine', ibid., p. 158.
36. 'O karamazovshchine', p. 153.
37. Ibid., p. 151.
38. 'Eshche o karamazovshchine', p. 158.
39. Ibid., p. 156.
40. 'Pol' Verlen i dekadenty', ibid., p. 12.

# 6 Problems in the Study of Stalinist Culture

## Igor Golomstock

'The Stalinist epoch has receded into the past, already judged, ridiculed, despised, caricatured, but not yet understood',[1] wrote Alexander Zinoviev in his book *The Flight of Our Youth*. The culture of the Stalinist epoch has receded as well, itself caricatured rather than understood. The visual arts, as part of material culture, have proved to be the most fragile creation of the Stalinist spirit. History shows that as the spirit wanders at will, its material embodiment is easily susceptible to destruction. Now that the most grandiose monuments of that epoch have been blown up, the chief masterpieces of the major Stalinist laureates are hidden in inaccessible museum stores, and are preserved only in muddy reproductions on the pages of artistic periodicals of the time, which are themselves becoming bibliographic rarities. Yet (and this is not unimportant for students) silence characterised Stalinist culture from the start. It would be pointless to expect the publication, even in some distant future, of, let us say, Andrei Zhdanov's memoires, Lazar Kaganovich's diaries, or the notes of Stalin's table-talk – not because they have been concealed or destroyed, but because the nature of that culture precluded their very existence. The most important ideological components to power its mechanisms were not fixed in texts, but rather worked out behind closed doors, and their esoteric meaning was intended for the initiated alone. Moreover, the initiated were not so few in number: one could not speak of the secret openly, so those who were somehow concerned with the sphere of culture had to absorb it from the atmosphere through the 'class-awareness' (as one had it) that came naturally to all, or through 'the sole correct Marxist-Leninist-Stalinist worldview' (from the German 'Weltanschauung'). As the Stalinist generation dies out, taking with it the essence of its culture, that grandeur so attractive to the masses, the outside observer is left with no more than the empty shell of its demagogic phraseology.

A great variety of problems face the historian of Stalinist culture. I should like to deal with a few of these which seem to be of primary

110

importance. The first problem is that of the context of Stalinist culture. Was it, as its own aesthetics maintained, a logical continuation of the Russian culture in a 'new type' of state which stood out against the rest of the world as a 'bastion of progress', or was it a result of the complex political, social, spiritual and other processes common to the twentieth century? In studying this culture must one look straight into the historical past or around at its geographical parallels with contemporary phenomena? Meanwhile historians both in the USSR and abroad generally cling firmly to the first tradition and usually reject the second flatly, sometimes aggressively. They continue to regard the 'Stalinist style' as an 'alien element in contemporary culture, unworthy of investigation',[2] in the phrase of Frank Roh, who, it must be said, had the art of the Third Reich in mind. Indeed the conservatism, archaism and eclecticism of Stalinist culture, its adherence to the past, its lack of any spirit of free inquiry or innovation – all of this makes it alien to what we call the 'spirit of the twentieth century'. But if one considers it not merely in terms of spirit but of the whole experience of contemporary culture, then Stalinist culture will not seem so alien and certainly not unique. A similar type of culture has arisen throughout our century whenever a totalitarian state has conscripted the whole range of creative activity into its service. Such a culture began to emerge in Germany immediately on Hitler's rise to power; beginning in the mid-1930s the art of Mussolini's Italy followed it closely; it arose in China straight after the Communist Revolution with the certainty of a physical law; after the war this type of art acquired official status in the countries of the Soviet Bloc, depending directly on the degree to which totalitarian ideology had penetrated them (more so in the German Democratic Republic and Bulgaria, less so in Hungary and Poland). These characteristic peculiarities of Stalinist culture, which do not seem so vital in a local or national context, now come to the fore in this context. I have in mind three factors which define the nature not only of totalitarian culture but of totalitarianism as a whole:

(1) the primary role of ideology (always understood in its various nuances as the sole correct, scientific teaching);

(2) the organisation of the whole of artistic life (through creative unions, similar to each other in aims and structure, established to control and guide other components in the megamachine of totalitarian culture);

(3) a struggle to the death with all tendencies that differ from the official (that is, in essence, cultural terror).[3] The final product

of this culture, an artistic style that proudly calls itself 'the new type of art', in all totalitarian states is formed from the interaction basically of these three factors. If one considers the scale, prevalence and proportions of this culture in the general artistic experience of our century, then it would not appear too bold to call it the 'second international style in contemporary culture (alongside Modernism)'.

The second problem is the question of the experience of Stalinist culture itself. It is clear that not all creative works of that epoch were uniform in style and theme. Even in the grimmest years of Stalinism in Russia many masters who subscribed neither to the ideological nor the aesthetic dogma of the regime continued to work: Filonov, Rodchenko, Tatlin, Petrov-Vodkin, Tyshler, Saryan . . . and even Alexander Gerasimov himself – then the omnipotent dictator of Soviet art – on occasion tore himself away from portraying the politica! leadership to paint sodden terraces and the succulent skin of fruit refracted in the angles of cut-glass vases (at the same time as Barlach, Kollwitz, Otto Dix, Emil Nolde and Pechstein were working in Nazi Germany). Were one to gather all of these creative products in one pile, it would be possible to draw from it proof of any position one might choose to defend. For example, the well-known Soviet philosopher and critic Mikhail Livshits used this method ten years ago to prove that Fascist and National Socialist art were derived from Modernist and the artistic avant-garde; in his work *Art and the Contemporary World* he illustrates the chapter 'Fascist Art in Germany' with the works of Kanoldt, Hüther, Doll and others, supplying them with such commentaries as 'an imitation of Cézanne', an imitation of Expressionism, Neue Sachlichkeit and so on; room was found here even for Franz Marc, who died in 1916, but none for any representative work of official Nazi art (for obvious reasons of its uncomfortable similarity to Stalinist art).[4] This method grants the widest opportunity for all kinds of falsification and distortion, even of the Stalinist epoch itself. Thus the Stalinist Realism section of the 'Paris-Moscow' exhibition in the Beaubourg (Paris, 1979), opened with some of Malevich's figurative work. At the huge Soviet exhibition in Düsseldorf in 1983 the section on the art of the 1930s and 1940s was dominated by the works of Saryan, Tyshler, Filonov, with the glaring omission of any official Stalinist art. The same principle was at work in the presentation of the gigantic exhibition. 'The Thirties: the Art and Culture of Italy', which took place in Milan in 1982.

To understand the nature of Stalinist (and of totalitarian) culture, one must regard its creations, as it were, through its own eyes. Only then can we examine the foundation, the fundamental law, on which this type of culture is based. I shall call it the principle of the identity of beauty in art and life. In Stalinist aesthetics this principle was formulated with the utmost precison: 'For the first time in many centuries reality and the artistic ideal no longer contradict each other . . ., for never before has there been an epoch in which the very basis of historical reality has been beautiful'.[5] From this was derived the basic method of Stalinist art or Socialism Realism: the reflection of life in the forms of life itself. But this reality, beautiful in its 'very basis', was not regarded uniformly as being so – in its different strata lay variously valued deposits of artistic material. Ideology made of this reality a subtle system of values, structured according to themes and genres. Thus masters of worthy subjects became members of creative unions and obtained the right to practice professionally, the worthier won Stalin Prizes, while the most worthy of all were elected to the USSR Academy of Arts (after 1947), occupied high administrative posts, and the like. So, what sort of structure was it? What sort of artistic work was central to it, and what peripheral? The answer to these questions can be found in an analysis of the winners of Stalin Prizes, in which this structure is reflected as in a drop of water.

The Stalin Prizes were set up in 1939 and served as the main tool in the creation of the Sovietic cultural establishment (Hitler and Mussolini had introduced analogous prizes with the same aims two years earlier). The first Stalin Prizes were won by 13 artists for the following works: A. Gerasimov, 'Stalin and Voroshilov in the Kremlin'; B. Efanov, 'Unforgettable Meeting' (Stalin and members of the government meet women workers in heavy industry); S. Merkurov, monument to Stalin at the All-Union Agricultural Exhibition; S. Kakabadze, monument to Stalin in Tbilisi; M. Manizer, monument to Lenin in Ulyanovsk; N. Tomsky, monument to Kirov; V. Ingal and V. Bogolyubov, monument to Ordzhonikidze; V. Mukhina, the group sculpture 'Worker and Collective-Farm Girl'; B. Ioganson, 'In an Old Urals Works' (grim labour conditions in czarist Russia and the awakening of class consciousness); N. Samokish, 'The Crossing of Sivash' (from the Civil War); F. Fedorovsky and M. Saryan, theatrical decorations; I. Toidze, illustrations to the works of Shota Rustaveli.

So, 10 of the 13 prizes were awarded to examples of what Soviet aesthetics called 'thematic art', that is, the depiction of the leadership and their colleagues, revolutionary events, heroics in work and war. Moreover, four were based on Stalin's image. Of these first Stalin laureates, A. Gerasimov, B. Ioganson and N. Tomsky alternated as President of the USSR Academy of Arts (Tomsky died in this office as late as the 1930s).[6]

The reality thus structured ceased to be a uniform experience. It was created by the wise and unyielding will of the leadership, and this was the most beautiful aspect of it. Ceremonial portraits of the leaders and monumental sculpture formed the kernel of Stalinist art. This reality had been born in the revolutionary struggle of the whole people under the guidance of the Party – the memory of revolutionary events was considered secondary only to the cult of the leader. Therefore the historico-revolutionary genre was, as it were, a continuation of the ceremonial portrait, and occupied the second rung in the hierarchy of values. Eventually, this reality was reproduced and consolidated thanks to the labour of the broad popular masses – in totalitarian hagiography the great names of the leaders, heroes and martyrs of the Revolution are always followed by nameless toilers in the form of generalised images of 'The Worker'. 'The Collective-Farm Girl', 'The Miner' and 'The Soldier', and so on.

Ceremonial portraits of the leaders, monumental sculpture, works on the themes of the Revolution and labour formed the centre of this structure. After these, and already on the periphery, came landscape art, understood either as the image of the Motherland, or as a symbol of the new state. And on the very fringes vegetated the still-life. As the structure evolved, its centre, ever expanding, encroached on the periphery, as the latter was forced beyond the pale of the permitted. Thus in 1947 10 out of 17 Stalin Prizes were awarded to depictions of the leadership, and in 1949 no fewer than 13 winners reproduced the image of the Great Leader and Teacher himself – Stalin. In the meantime attacks grew in strength on such master-realists as Konchalovsky, who painted pointless apples and lilacs, thus distracting the masses from pressing tasks (an analogous process took place in National Socialist art). Reality, as seen through these eyes, is not a dynamic experience, but a subtle system of values, gravitating towards eternal stasis in a hierarchical pyramid. Only by understanding it this way can we see in this declining culture what was obvious to its adherents.

It might seem that this pyramid reproduced the hierarchy of values on which the culture of the last century was based. The Stalinist epoch resurrected the hierarchy of genres that had been established at the rise of the European academies of art, it restored the artistic language of the nineteenth century, a mixture of realism and academic classicism. On the other hand, it was a sharp break with the artistic traditions of preceding decades, a violent volte-face, effected from above with the ideological aim of creating a culture of the 'new type'. This raises the major problem in the historical evaluation of Stalinist (or any totalitarian) culture: was it a product of revolution of restoration?

'In a certain sense National Socialism did produce its own art, but on closer inspection nothing emerges except a repetition of the principles of the nineteenth century, stereotypical imitation of nature, mixed in with declamatory pathos. It is strange how similar National Socialism and Bolshevism are in this respect, when one considers how much they hated each other'.[7] This is the opinion of Frank Roh, as stated 20 years ago, and it can still be taken as typical (at least in its first part) of the writings of most Western researchers on the question of the culture of totalitarian regimes. Indeed the similarity noted by Frank Roh is striking, but only at first glance; 'on closer inspection' something rather different emerges.

For all the visual resemblance between Stalinist total realism and its historical prototype, the internal structure of this art reflected ideological and social realities quite different from those of the nineteenth century. Having re-animated the division of art into genres, this monolithic culture at the same time sensed (as it were intuitively) the inferiority of its own visual aspect, broken down as it was into various thematic units. So in totalitarian aesthetics, at least in its Soviet variant, the centre is occupied by the concept of 'thematic art', that is, above all 'ideological' art. This meant that whatever an artist drew – a portrait of the Leader or a cucumber – he must be guided by this general worldview or 'Weltanschauung', accepting that what he depicted could only be viewed in an ideological setting. The concept of so-called 'art for art's sake' was regarded with profound hostility by every totalitarian ideology.

Any object d'art imagined or created in accordance with such requirements then became part of a whole, and acquired meaning, sense and beauty only through the higher values of the philosophy of life or some social doctrine. In this way, for example, a picture of a

merry band of boys on a Moscow street received the highly progress-
ive title 'They saw Stalin', a portrait of a concrete figure was
transformed into the image of 'The Konsomol Member', 'The
Delegate' or 'The Tractor-Driver', a simple country corner became
'The Expanse of Our Motherland', 'Collectivised Land', or the place
where 'Soviet Transport Forges Ahead', while a still-life of fruit and
vegetables depicted the 'Fruits of Collectivised Abundance' (I use the
names of pictures, well-known in their time, by Stalinist laureates).
'A child or a cow ceased to be so when depicted . . . A nude was no
longer a nude, nor a factory a factory . . . They had become masks
for the content being proclaimed'.[8] 'Each individual picture at an
exhibition proclaimed either spiritual grandeur or some act of
inspiring heroism. The works on display together created the impres-
sion of a single integral life, free from the problems and tensions of
contemporary existence'.[9] These evaluations of National Socialist art
can be applied in their entirety to Stalinist Socialist Realism. High
ideological content seeped into all layers of Stalinist society from
above, cementing it simply into a single monolith. The nineteenth
century has gone down in history as the epoch of eclecticism, stylistic
freedom and the hypertrophy of creative idividualism, and it knew
nothing of ideological integration and the blending of aesthetics with
a collectivist worldview.

But did Stalinist (or totalitarian) culture create its own style to
counterbalance Modernism and the nineteenth century? This must be
the last questions that I shall dwell upon briefly. Totalitarian culture
distrusted the very word 'style'. Officially Socialist Realism was not a
style but a creative method.Its array of formal attributes was not
clearly defined, and its inter-relation altered along with its artistic
application. Despite its distrust for the term, Socialist Realist aesthe-
tics (like that of any totalitarianism) still demanded from art the soil,
fermentation and foundation from which every great style had arisen
in the past, namely a single, integral worldview, embracing all aspects
of life. Georg Mosse, and not he alone, called this type of worldview
a 'secular religion', and its accompanying rites a 'political liturgy'.[10]
Stalinist culture was not merely part of such a liturgy, but in many
ways created it, and in this respect bore the signs of a cultural
mass-ritual.

Art by its own definition belonged to the 'people' in Stalinist
culture, although it was in their possession, that is, was not
designated for individual use. Originals of Stalinist masterpieces
could not be bought, only contemplated in 'temples of art', as

museums were so loftily called, or in various palaces – of Labour, Culture, of the Revolution – in official institutions and public places. This applied especially to the centrepiece of Stalinist official art – the portraits of the leaders.

The iconography of Lenin's and Stalin's images is rivalled in intricacy only by the iconography of Christ and the major Christian saints, and it is based on roughly the same scheme. Their iconographic existence began in childhood and ended in immortality beyond the grave. The image of the Leader emerged in all its universal essence in ceremonial portraits and monumental sculpture, and in its lower genres was divided into a multiplicity of aspects, each directed at a certain class, profession, nation or age-group of the population. In children's parks, kindergärten and pioneer camps all over the Soviet Union there usually stood a plaster figure of a little boy with curly locks in a costume of the last century, similar to the plastic, thoughtful figures in old daguerrotypes (V. Tsigal's 'Lenin in Childhood'); V. Oreshnikov's picture 'Lenin Sitting an Exam' or similar works by other artists hung in the assembly halls of schools and universities; a picture like V. Serov's 'Peasant Messengers with Lenin' were essential items in collective farm clubs, while workers' clubs were decorated with various exhortations from Lenin and Stalin to the revolutionary proletariat; I. Toidze's picture 'Stalin at Rioges' (the construction-site for a hydroelectric station) was especially popular in Georgia, and so on. In all Soviet institutions – schools, hospitals, People's Commissariats, plants, factories, barracks and scientific institutes – there were special meeting-rooms and 'red corners' (krasnye ugolki) for the enactment of the political liturgy. Their essential attributes were pictures or sculptures (originals in more important cases, otherwise copies and reproductions) on some of the above-mentioned themes, depending on the nature of the respective institution. (In Hitler's Germany areas with a similar purpose were called 'Rooms of Honour').

This art did not merely serve the cult; its own creations became fetishes, and the most revered of them acquired a sacred character. The revolutionary novelty of this sort of art (in comparison with similar forms in modern societies) lay not so much in its orientation towards a collective public, as in its embodiment (albeit in a perverted form) of the retrospective dream of the avant-garde – namely, collective creativity. The clearest expression of this new type of creativity in the USSR was claimed to be the so-called 'brigade method', by which one work, even a small one, was created by a

number of artists under the direction of one master. This method was widespread at the end of the Stalinist period. Thus, for example, the painting 'Lenin's Speech at the Third Congress of the Komsomol', attributed to B. Ioganson, was executed by a brigade of 15 people, N. Tomsky's relief 'Lenin and Stalin – Leaders of the Soviet State' by seven sculptors, E. Vuchetich's high-relief 'We Pledge to Thee, Comrade Lenin' by three, and so on. The Stalin Prizes awarded to these works were divided equally amongst the contributors. Anonymous iconographers and the builders of medieval cathedrals once worked in this way. But totalitarian culture was far from anonymous. It needed to personify its achievements and so promoted leaders in all its spheres. The name of the author was no more than a symbol of collective creativity, irrespective of whether its bearer led a brigade or worked alone, for his name represented not an individual talent, but a gigantic cultural megamachine, in which he fulfilled the role of 'cog or screw' (to use Lenin's phrase).

An ideal model of this style and its execution can be found in the projected Palace of the Soviets; a cyclopic figure of the Leader soaring into the Heavens, lower storeys decorated with pictures of historical events associated with his name, of the heroic struggle, achievements and happy life of the people, embodied in all aspects and artistic techniques. Hundreds of artists, sculptors and architects prepared thousands of square metres of painting, frenzied kilometres of fresco, dozens of gigantic sculptures, and all of this found its place in an ideal structure planned not by the mind of one man, but by some higher will: the authorship of B. Iofan was no more than the sign of the work of thousands of nameless masters, embodying the divine design of the whole project, which was attributed to Stalin himself. This all united to form a stern monolith in a grandiose architectural framework, blended into one picture, created, according to one version, 'to show how Lenin and Stalin led the people of the (Soviet) Union to freedom and happiness',[11] according to another, 'to create the image of the New Man in socialist society.'[12]

Totalitarian art, with its monolithicism, subjugation of individual parts to the whole, and its hierarchy of values, does not incline towards the nineteenth century, rather to more remote times, when the religious image stood at the centre of art, and what remained had significance only as the earthly representation of the heavenly, and surrendered all intrinsic meaning to something higher. It spanned the bourgeois individualism of the nineteenth century, with its eclecticism and stylistic freedom, on bridges to the 'golden age of cathe-

drals' of which the 'pioneers of contemporary designs from Morris to Gropius' had dreamt. Having destroyed the avant-garde, it usurped and tried to realise the avant-garde idea of the 'new community' and 'new totality' of future culture, when society would be organised on a rational basis and strictly subservient to ideological ends. In this sense totalitarian art is, with all its retrospective tendencies, a legitimate child of our time. True, it realised the dream of the avant-garde in a perverted form and sought to build its monolith not from contemporary materials, but from the conceptions left to it by the nineteenth century.

A few words remain to be said in conclusion about contemporary tendencies in relation to totalitarian art and, in particular, to its Stalinist variant. It is difficult not to associate recent interest in this phenomenon with the general switch from extremely radical creative currents to more traditional figurativism in Western art in the 1970s. As is always the case in periods of transition, art sought support in the traditions of the recent past, and beyond the turbulent sea of aimless abstractions in the 1960s and 1950s there loomed the solid edifices of life-affirming social realism from the 1940s and 1930s. Nostalgia for art's spurned social role, for its purposeful organisation, for its forgotten links with social and political life, inclined certain critics to start to toy (largely unawares) with totalitarian aesthetic doctrine: 'While Modernism is dying in Western art . . ., it is impossible to dismiss the Soviet attempt to join Art and Life as an empty political plot'.[13] Totalitarian art has recently arisen from its limbo, showing the world its already bedimmed visage, which it is not possible simply to regard as the former façade of the 'new type' of regimes: at such exhibitions as 'Art of the Third Reich', which toured the cities of West Germany in 1974, 'Paris-Moscow' and 'Realism' (1981) at the Beaubourg, Paris, 'The Thirties; Art and Culture in Italy' in Milan, and some others, totalitarian realism, torn out of context and relieved of the peaks of its official expression, seemed quite inoffensive. To some impartial observers, including many critics and art historians, these random fragments recalled associations not so much with the well-defined aesthetic system of which they had once been a part, as with more familiar images: memorials in the squares of London, New York and Paris, with the monumental frescoes on the walls of governmental buildings in Oslo and Stockholm, not to mention the innumerable quite realistic portraits and still-lives that adorn the salons and commercial galleries of all the European capitals. One vital detail eluded these observers: for all their occasional res-

emblance to the analogous effusions of totalitarian regimes, such artifacts fulfil quite a different function and occupy a different position in the cultural life of democratic countries, in no way claiming immortality through a hiearchical pyramid of artistic values for their time and for all mankind.

To me such aberrations of aesthetic judgement appear to be the result of enduring confusion about the historical context that I have considered in this chapter. The elucidation of this context is perhaps the most serious problem facing the historian of Stalinist culture. Only then can the monuments of that epoch acquire their own semantics and aesthetic meaning.

## NOTES

1. A. Zinoviev, *Nashei yunosti polet* (Lausanne: L'Age d'Homme, 1983) p. 8.
2. F. Roh. *Geschichte der Deutschen Kunst von 1900 bis zur Gegenwart* (Munich, 1958) p. 151.
3. Although examination of these given factors seem exceptionally important to me for the understanding of Stalinist culture, such problems lie beyond the scope of this chapter. See further: I. Golomstock, 'Die Sprache der Bildenden Kunst im Totalitarismus', in *Kontinent,* Berlin, Ullstein, pp. 224–72 (Russian variant in *Kontinent,* no. 7, 1986, pp. 331—92). Their detailed analysis can be found in my book *Totalitarian Art,* being prepared for publication by Collins (London) and Sintaksis (Paris) at time of writing.
4. M. Livshits, *Iskusstvo i sovremennyi mir* (Moscow, 1978).
5. *Voprosy teorii sovetskogo izobrazitel'nogo iskusstva* (Moscow, 1950) pp.14 and 93. The essence of this proposition can be found in one or another formulation in any theoretical tract on art from the Stalinist period.
6. Alongside the State Prizes in Nazi Germany Goebbels established the so-called 'List A', or 'List of Immortals', consisting of the names of 12 artists. The place of honour was occupied by the authors of the major Nazi monuments and portraits of the Führer, A. Breker and J. Thorak, followed by the authors of the best-known pictures on the historico-revolutionary theme (A. Kampf, V. Peiner, L. Gall), then Professor W. Kreis, who was responsible for bringing Hitler's 'plan of monumental propaganda' to life.
7. F. Roh, *German Art in the Twentieth Century* (London, 1968) p. 152.
8. B. Hinz, *Art in the Third Reich* (Oxford, 1979) pp. 80–1.
9. R. Grunberger, *A Social History of the Third Reich* (Penguin Books, 1974) p. 537.

10. G. Mosse, *The Nationalization of the Masses* (New York, 1972), *The Crisis of Germany Ideology* (New York, 1964) and so on.
11. *Iskusstvo*, 1938, no. 4, p. 181.
12. *Iskusstvo*, 1939, no. 4, p. 119.
13. P. Ackroyd in *The Sunday Times*, 21 June 1981.

# 7 The Birth of Socialist Realism from the Spirit of the Russian Avant-Garde

## Boris Groys

### I

Increasing attention has recently been devoted by students of Soviet culture to the period of transition from the avant-garde of the 1920s to the Socialist Realism of the 1930s and 1940s.[1] This transition had not previously seemed problematic: it was usually regarded as the result of the crushing by Stalin's conservative and despotic regime of the 'true, contemporary and revolutionary art of the Russian avant-garde' and the propagation of 'backward art', reflecting the low cultural level both of the broad masses of the Soviet population and of the Party leadership, in the spirit of nineteenth-century naturalism. As the materials of that period have come to be more closely studied, such a purely sociological explanation of this transition has ceased to be satisfactory.

Firstly, an essential difference, which is justly stressed by Soviet art criticism, cannot but be observed between nineteenth-century realism, which Soviet art history customarily calls 'critical realism', and the art of Socialist Realism in their approach to the subject represented: Socialist Realism has a positive relationship to its subject, its aim, often affirmed, being 'to hymn Socialist reality', not to keep it at arm's length and treat it objectively and 'realistically'. This difference is also noted by Sjeklocha and Mead:

> To us [Westerners] this realism implies a dispassionate analytical stance which is assumed by the artist without sentiment. If emotion enters into realism, it is generally of a critical nature intended to instruct by way of bad example rather than a good . . . In short, although such realism is essentially didactic, it is also essentially negative. Visionary artists have not been found among the realists.

122

However, the Soviet State requires that its artists combine realism and visionary art.[2]

Socialist Realism shows the exemplary and the normative, which are worthy of emulation. Nevertheless, it cannot be considered a new version of classicism, although classical elements may indeed be found in Socialist Realist artistic compositions. Although antiquity and the Renaissance were highly praised by Soviet critics, the art of Socialist Realism is without the direct antique stylisation so characteristic, for example, of the art of Nazi Germany, which is in many other respects quite similar. Socialist Realism judges the reality created in the Soviet Union to be the highest achievement of the entire course of human history and does not, therefore, oppose the antique ideal to the present as a 'positive alternative' or 'a utopia already once realised',[3] as has so often been done in West European modern art. Socialist Realism is just one of the ways in which world art in the 1930s and 1940s reverted to the figurative style after the period of relative dominance of avant-garde trends – this process embraces such countries as France (neo-classicism), the Netherlands and Belgium (different forms of magical realism) and the USA (regional painting) as well as those countries where various forms of totalitarianism became established. At the same time, the stylistic differences between Socialist Realism and other, parallel artistic movements are obvious on even the most superficial examination.

All this indicates that the Socialist Realism of the Stalin period is an original artistic trend with its own specific stylistic features, which cannot simply be translated into other artistic principles and forms familiar from the history of art. However, in that case it is also impossible to speak of the simple 'propagation' of Socialist Realism: before something can be propagated, it must already exist. Although, like any other artistic trend, Socialist Realism belongs to its time and place, it cannot be regarded in a purely sociological and reductionist light, but should, first and foremost, be subjected to normal critical analysis with the object of describing its distinctive features.

This task is not, of course, possible within the framework of the present article. Its aim, rather, is to distinguish in the most general terms between Socialist Realism and a number of other artistic phenomena with which it may be confused. The specific quality of Socialist Realism is that it seeks by artistic means that are sufficiently close to conventional nineteenth-century realistic painting – above all the Russian Peredvizhnik school – to express a completely different

ideological content in completely different social and historical conditions, which naturally leads to a fundamental disruption of the form of traditional realistic painting itself. Thus, difference of form proves to be bound up with a definite purpose in regard to content, to ignore which may result in a quite inadequate interpretation of the formal difference, as has often happened in the past.

A similar situation occurs in relation to the art of the Russian avant-garde. This is often regarded in an aestheticised, purely formal, stylistic light,[4] although such a view is opposed to the objectives of the Russian avant-garde itself, which sought to overcome the traditional contemplative attitude towards art. That, today, the works of the Russian avant-garde hang in museums and are sold in galleries as 'works of art' like any other works of art should not make us forget that the artists of the Russian avant-garde strove to destroy the museum, to wipe it out as a social institution, ensuring the future currency of the modern idea of art as the 'individual' or 'hand-made' production by an artist of objects of aesthetic contemplation which are then consumed by the spectator. As they understood it, the artists of the Russian avant-garde were producing, not objects of aesthetic consumption, but projects or models for a total restructuring of the world on new principles, to be implemented by collective actions and a social practice in which the difference between consumer and producer, artist and spectator, work of art and object of utility, and so on, disappeared. The fact that these avant-garde projects are hung in present-day museums as traditional works of art, where they are viewed in the traditional light, is a symptom of the ultimate defeat of the Russian avant-garde, not of its success, a symptom of the ultimate loss by the Russian avant-garde of its historical position: the true spirit of the Russian avant-garde was more truly reflected by its place in the locked store-rooms of Soviet museums, to which it was consigned as a consequence of its historical defeat, but from which it continued to exercise an influence on the victorious rulers as a hidden menace.

The modern museum is undergoing a period of general expansion and increasingly includes the utilitarian: museums of technology, aeronautics, contemporary utensils, and the like are constantly opening. In the past icons, which to a great extent constituted a reference point for adherents of the Russian avant-garde, became part of museum collections; they, too, were regarded in no way, either by their creators or by their 'consumers', as 'works of art'. However, neither in the Soviet Union nor in the West is Socialist Realist art now represented faithfully in museums. In the Soviet

Union it vanished from the eyes of the public during the period of the 'thaw', while in the West it was never seriously regarded as art at all. The position of Socialist Realism 'outside art' is, in itself, sufficiently convincing testimony to its identity with the avant-garde era, during which the desire to go beyond the bounds of the museum became the motivating force of artistic experiment. Like the art of the Russian avant-garde, the art of Socialist Realism wanted to go beyond the bounds of the traditional 'artist-spectator-aesthetic object' relationship and become the direct motivating force of social development. The collectivist project of Socialist Realism was expressed in rejection of the artist's individual manner, of direct perception of nature, the quest for 'expressiveness' and 'picturesqueness' and, in general, all that is characteristic of traditional realistic art and, in particular, of the art of the Russian Peredvizhniki. As a result, Socialist Realism is often judged to be traditional realism of 'low quality' and it is forgotten that Socialist Realism, far from seeking such artistic quality, strove, on the contrary, to overcome it wherever it reared its head. Socialist Realist pictures were regarded by Socialist Realism itself as at once works of art and utilitarian objects – instruments of Socialist education of the working people – and as a result could not but be standardised in a certain way in accordance with their utilitarian function.

In this elimination of boundaries between 'high' and 'utilitarian' art Socialist Realism is the heir not so much of traditional art as specifically of the Russian avant-garde: Socialist Realism may be said to be the continuation of the Russian avant-garde's strategy by other means. This change of means is not, of course, fortuitous and will be singled out for special examination later. But it cannot be regarded merely as something imposed from outside, artificially breaking off the development of the avant-garde, which otherwise would have continued in the spirit of Malevich or Rodchenko. It has already been noted that, in any case, by the end of the 1920s the artists of the Russian avant-garde had begun to return to representational principles. While Malevich had adopted a new interpretation of traditional painting, Rodchenko, El Lissitsky, Klutsis and others were increasingly devoting themselves to photo-montage, which in the framework of the avant-garde aesthetic, signified in fact a turn towards figurativeness while preserving the original avant-garde design.

This design, which consisted in moving from portraying life towards artistic shaping of life, is also the motivating force of Socialist Realism. The Russian avant-garde adopted from the West a new

relationship, developed within the framework of cubism, to the subject of art as a construct and made it the basis of a project for the complete reconstruction of reality on new principles. In this the subject of art itself underwent fundamental changes – the Russian avant-garde displayed its constructive nature with unprecedented radicalism – which subsequently enabled the secondary aestheticisation of the achievements of the Russian avant-garde and their interpretation exclusively in terms of the search for a new artistic form. In the 1970s a number of Soviet artists engaged in aestheticising the achievements of Socialist Realism within the framework of the Sots Art[5] movement, which made it possible to approach Socialist Realism in a new way as a purely aesthetic phenomenon, just as the approach of pop art to commercial art stimulated its study as an artistic phenomenon.

These mechanisms of secondary aestheticisation cannot be examined in this article, but they point indirectly to the mechanisms of primary utilitarianisation implemented both by the Russian avant-garde and Socialist Realism and, in part, by the commercial art of advertising. Behind the external, purely formal distinction between Socialist Realism and the Russian avant-garde (a distinction made quite relative by the photo-montage period and by the art of such groupings as OST), the unity of their fundamental artistic aim – to build a new world by the organisational and technical methods of 'Socialist construction', in which the artistic, 'creative' and utilitarian coincide, in place of 'God's world', which the artist was able only to portray – should, therefore, be revealed. While seeming initially to be realistic, the art of 'Socialist Realism' is, in fact, not realistic, since it is not mimetic: its object is to project the new, the future, that which should be, and it is for this reason that it is not simply a regression to the mimesis of the nineteenth century, but belongs wholly to the twentieth century. The central issue of Socialist Realism remains, incidentally, why and how the transition took place from planning in the spirit of the avant-garde to planning in the spirit of realism. This transition was connected both with the immanent problems of avant-garde art and with the overall process of Soviet ideological evolution in the 1920s and 1930s, which can be described here only in the most general terms.

## II

Art as 'life building' is a tradition that, in Russia, can be traced back at least to the philosophy of Vladimir Solov'ev, which conceived of

the practice of art as theurgy,[6] a conception later borrowed by the Russian symbolists. However, the decisive step towards interpreting art as transformation rather than representation was taken by Malevich in his works and writings. For Solov'ev and the symbolists, the precondition of theurgy was the revelation by the artist of the concealed ideal order of the cosmos (*sofiinost'*) and of society (*sobornost'*); however, Malevich's *Black Square* marked the recognition of nothingness or absolute chaos lying at the basis of all things. For Malevich the black square meant the beginning of a new age in the history of man and the cosmos, in which all given forms of cosmic, social, psychological or other reality had revealed their illusoriness.

Malevich possessed a contemplative and mystical nature and rejected technical progress and social organisation on more than one occasion as attempts artificially to impose definite goals on life after the traditional aims of Christianity had been discredited. At the same time Malevich concluded from his discovery that a new restructuring of the world with the object of restoring lost harmony and a kind of 'aesthetic justification of the world' was necessary.[7] Malevich's 'arkhitektony' or 'planity' were conceived as projects for this restructuring and his suprematist compositions were at one and the same time direct contemplations of cosmic internal energies and projects for a new organisation of the cosmos. It was no coincidence that, during the controversy with AKhRR, Malevich took as his standpoint the 'creation of life',[8] demonstrating the fundamental unity of the Russian avant-garde's intentions despite the wide variety of its views and its internal quarrels and conflicts, from which one must detach oneself when giving an overall exposition of avant-garde attitudes. Despite the fact that such detachment inevitably leads to simplification, it does not result in fundamental distortion of the aims of the avant-garde: the artists and theoreticians of the avant-garde themselves reveal the high degree of similarity of their attitudes in polemics with opponents in other camps.

The logical conclusion from the concept of Malevich's suprematism as the 'last art' was drawn by, among others, the constructivists Tatlin and Rodchenko, who called for the total rejection of easel painting in favour of direct design of the new reality. This rejection undoubtedly arose from the immanent logic of avant-garde artistic development and may be observed to a greater or lesser extent in the West: for example, in the activities of the Bauhaus which, it may be noted, did not come into being without Russian influence, the Dutch group De Stijl and others. However, the radicalism of the constructivist posi-

tion can be explained only by the specific hopes aroused in artists by the October Revolution and its slogan of the total reconstruction of the country according to a single plan. If, for Marx, philosophy had to move from explaining the world to changing it, this Marxist slogan only confirmed for the artists of the Russian avant-garde their goal of relinquishing portrayal of the world in favour of its creative transformation.

However, these parallels between Marxist and avant-garde attitudes show in themselves that the artist with his 'life-building' project was competing with a power that also had as its goal the total reconstruction of reality, but on economic and political, rather than aesthetic, principles. The project to transform the entire country – and ultimately the entire world – into a single work of art according to a single artistic design through the efforts of a collective united by common artistic conceptions, which inspired the Russian avant-garde during the first post-revolutionary years, meant the subordination of art, politics, the economy and technology to the single will of the artist: that is, in the final analysis to the will of one Artist, since a total project of this kind cannot result from the sum of many individual efforts. Marx himself, in an observation constantly quoted in Soviet philosophy and art history, wrote that the worst architect was better than the best builder bee, since the former had in his head a unified plan of construction.

In a certain sense the avant-garde standpoint marks a return to the antique unity of art and technique (tekhnē), in which Socrates also included the activity of the legislator. The rejection by the avant-garde of the artistic autonomy traditional of the modern age and the 'bourgeois' relationship between 'artist and spectator', understood as 'producer and consumer', led in effect to the demanding of total political power for the artist in order to realise his project. The concept of the new authority as an ideal instrument for implementing their artistic aims was especially characteristic of the early pronouncements of Russian avant-garde artists and theoreticians.

Thus, Alexei Gan, one of the theorists of Russian constructivism, wrote:

> We should not reflect, depict and interpret reality but should build practically and express the planned objectives of the newly active working class, the proletariat, . . . the master of color and line, the combiner of spatial and volumetric solids and the organiser of mass action – must all become Constructivists in the general

business of the building and movement of the many millioned human mass.[9]

Statements of this kind, which occur constantly in the polemical writings of the Russian constructivists, could be multiplied. At the same time, the constructivists themselves were by no means blind to the contradictions and illusions of their own programme. Ivan Puni, for example, noted that, in essence, the artist has nothing to do with manufacture, since engineers and workers have their own criteria for this.[10] However, the logic of the avant-garde's development began to overstep these sober reflections. While Rodchenko, Tatlin and others were at first in the forefront of those struggling for the new reality, they themselves gradually came to be accused of giving priority to purely artistic design over the demands of production and the direct formation of reality. The evolution of the avant-garde from Malevich to constructivism and, later, to Lef proceeds by way of increasingly radical demands for the rejection of traditional artistic individualism and the adoption of new social tasks.[11] In itself this evolution refutes the idea that artists were only at first the victims of illusion, which they were obliged gradually to abandon. Quite the contrary: if it is supposed that the artist's move towards forming reality is the result of illusion, it must be acknowledged that this illusion has by no means weakened, but has burgeoned with time.

Thus, it may be observed, both in the internal polemics of members of the avant-garde and in their confrontations with other artistic groupings, that the proportion of directly political accusations constantly grew. As artistic decisions were recognised more and more to be political decisions since, to an increasing degree, they were perceived to define the future of the entire country, the fierceness of the controversy and the realisation that positions which had formerly seemed close to each other were incompatible also strengthened: striving for collective creation led inevitably to a struggle for absolute leadership. The productionist position of Lef and its subsequent aspiration to equate art, technology and politics, uniting these three contemporary modes of forming reality in a single total project, represent the extreme point of development of the avant-garde and its internal intentions. In the course of this development the avant-garde itself rejected its earlier manifestations as individualistic, aestheticist and bourgeois. Thus, it should not be thought that later criticism in this spirit by the theoreticians of Socialist Realism represented anything fundamentally new: in essence, it only repeated

the accusations formulated in the process of development of the avant-garde itself, which had become common ground by the time of its liquidation at the end of the 1920s – coincidentally, the time at which the avant-garde achieved the peak of its theoretical, if not of its purely artistic, development.

The artists of the avant-garde are commonly accused of neglecting the human factor in their plans for reconstructing the world: that is, the fact that the generality of the Russian population then held utterly different aesthetic ideas. In essence, the avant-garde intended to make use of the political and administrative power offered it by the Revolution to impose on the overwhelming majority of the population aesthetic and organisational norms developed by an insignificant minority of artists. This objective certainly cannot be termed democratic. However, it should not be ignored that the members of the avant-garde themselves were hardly aware of its totalitarian character.

The artists of the avant-garde paralleled Marxism in believing that public taste is formed by environment. They were historical 'materialists' in the sense that they thought it possible, by reconstructing the world in which man lives, wholly to rebuild his inner mechanisms of perception and judgement as well. Malevich considered that, at the sight of his black square, 'the sword will fall from the hero's hands and the prayer die on the lips of the saint'.[12] It was not fortuitous, therefore, that an alliance formed within the framework of Lef between the avant-garde and 'vulgar sociologists' of the Arvatov type: both were inspired by a belief in the direct magical effect on human consciousness of changes in the conditions of man's 'material existence'. The artistic engineers of the avant-garde disregarded man because they considered him to be a part of element of social or technical systems of, at best, of a single cosmic life, so that, for a member of the avant-garde, to be an 'engineer of the world' also automatically meant being an 'engineer of human souls'. The avant-garde artist was above all a materialist in the sense that he strove to work directly with the material basis in the belief that the 'superstructure' would react automatically. This avant-garde 'historical materialism' was also connected with its purely 'aesthetic materialism'. The latter consisted in maximum revelation of 'the materiality of material', 'the materiality of the world itself', concealed from the spectator in traditional painting, which used material in a purely utilitarian way to convey a definite content.[13] Such 'aesthetic materialism', which gave an important fillip to the future formal development of art and is

an important achievement of the Russian avant-garde, presupposes, however, a contemplative, anti-utilitarian understanding of materialism which was repudiated by the avant-garde itself in the context of Lef's productivism. Moreover, as already noted, a shift took place within the avant-garde itself towards the complete, extra-aesthetic 'utilitarianism' of the project; that is, the purely aesthetic, non-utilitarian contemplative dimension of the avant-garde, which enabled its secondary aestheticisation, was recognised by the avant-garde itself as a relic of traditional artistic attitudes that was ripe for rebuttal. In practice, the art of the avant-garde during its Lef period assumed an increasingly propagandist character that was not creative in the sense of productivism: avant-garde artists, lacking direct access to the 'basis, turned increasingly to propagandising 'Socialist construction' implemented by the political leadership on a 'scientific foundation'. The principal occupation of the Russian avant-garde became the creation of posters, stage and exhibition design, and so on – in other words, work exclusively in the sphere of the 'superstructure'. In this respect the observation by the theorists of AKhRR, that the activities of Lef, for all its revolutionary phraseology and emphasis on its specifically proletarian attitude towards art, differed little in essence from capitalist commercial advertising and borrowed many of its devices,[14] is justified. For AKhRR the utilitarian orientation of Lef had no specific Socialist content, but amounted to a shift by the artist from cottage to mass production dictated by the general change in the technical level of manufacture characteristic of both West and East rather than by the goals of 'Communist upbringing of the workers'.

### III

There is a widespread opinion among scholars that the transition to Socialist Realism marked in fact the victory of AKhRR in the struggle against avant-garde tends. It is usual to see the genealogy of Socialist Realism exclusively in the turn towards representationalism taken by AKhRR as early as the 1920s (just as, in literature, it is usual to interpret the establishment of Socialist Realism as, in effect, the victory of RAPP). This point of view is based in the first instance on the external similarity between the realistic style of AKhRR and Socialist Realist style and on the fact that many artists moved from AKhRR to key positions in the new unified artistic associations of the era of Socialist Realism. The forthright criticism of both AKhRR and

RAPP during the period preceding the proclamation of Socialist Realism is usually overlooked. As a rule it is judged to be merely a tactical move on the part of the authorities with the object of pacifying artists from other groupings and integrating them in unified creative unions.

However, criticism of this kind has been persistently repeated in Soviet historical writing over several decades, which alone renders the view that it represented no more than a temporary tactical move untenable. Comparison with avant-garde criticism, that is, criticism by Lef of AKhRR, reveals both a similarity and a difference which make it necessary to revise some established ideas.

The turn towards realism in Russian post-revolutionary art is placed at different times. It is dated by some as early as the formation of AKhRR in 1922, while others place it in 1924–25. At the same time a noticeable coincidence may be shown in assessments of the reasons for and significance of this turn by critics belonging to the avant-garde camp and by those who were already laying the foundations of the theory of Socialist Realism. The common view of critics was that the rebirth of representational easel painting was connected with the NEP period and the emergence of a new stratum of art consumers having definite artistic tastes. Critics holding avant-garde views referred directly to an artistic reaction corresponding to economic and political reaction. The landscapes, portraits, genre scenes and so on with which both AKhRR and many other groups of the time, such as OST and 'Genesis', supplied the market aroused a fairly similar response and were regarded as symptoms of the same process, although AKhRR, of course, was welcomed for its mass approach and its progressive character, while OST was praised for a higher level of professionalism. A. Fëdorov-Davydov, for example, who became a leading critic and art historian during the Stalin period, noted as early as 1925 the general turn by both Soviet and West European art towards realism, singling out neo-classicism in France and Italy and expressionism in Germany in particular. He observed that neo-classicism, although 'close to the proletariat in its striving for organisation, order and discipline', could not serve as a basis for proletarian art because of its quality of stylisation while expressionism saw things in too gloomy a light, and concluded that the attention to detail of neo-classicism should be combined with the passion of expressionism – advice which, in a slightly amended form, would often be repeated later in the Stalin period. Turning to Soviet experience, Fëdorov-Davydov wrote:

In order to understand and evaluate AKhRR, we must understand what kind of realists they are. We shall scarcely be mistaken if we say that they understand realism in the sense of naturalistic, figurative – in essence, genre – realism. It is in this, disregarding the question of talent, that, perhaps, the reason lies for their inability genuinely to reflect the revolution. Enthusiasm and the heroic cannot be conveyed by the passive methods of naturalism.[15]

The same judgement was passed by Ya. A. Tugendkhol'd, who was fully in sympathy with AKhRR's turn towards realism. Writing of the current AKhRR's exhibition, he referred to the 'naturalism of AKhRR painting' and concluded: 'They were large illustrations in colour, but not what AKhRR expected, not the painting genuinely needed by us in the sense of 'heroic realism' – which was found in Surikov and, in part, in Repin and S. Ivanov'.[16] The arguments heard later during the era of Socialist Realism may easily be recognised here. And one further quotation from Alfred Kurella, who also played an important role in preparing the ground for Socialist Realism, is to the point. In an article characteristically entitled 'Khudozhestvennaya reaktsiya pod maskoi geroicheskogo realizma' (Artistic reaction behind the mask of heroic realism), Kurella wrote of the necessity for 'organising the ideology of the masses by the specific means of representational art'[17]; failing to find what he wanted in AKhRR, he accused it of naturalism.

These accusations of naturalism, which constituted the initial reaction not only of avant-garde critics but also of the future theoreticians of Socialist Realism and opponents of avant-garde art, were later repeated officially during the campaign against AKhRR in the late 1920s and early 1930s which preceded the formation of Socialist Realism. It was at this time that accusations, now traditional, of AKhRR's fellow-travelling ideology, its lack of involvement in the achievements of the Revolution and Socialist construction and its refusal to participate directly in Socialist construction as its 'vanguard', as well as of 'disparaging criticism' and 'Communist arrogance', were heard. These accusations are also rehearsed in contemporary Soviet historical writings. The assessment of the artistic situation in the 1930s given in a special article devoted to this problem by E.I. Sevost'yanov, long-time head of the Iskusstvo publishing house, is characteristic. The author quotes sympathetically the observations of critics of the 1930s concerning the 'imitative Peredvizhnik approach of AKhRR' and the necessity for criticism to

struggle simultaneously against 'formalist tricks' and 'passive naturalism'.[18] Similar quotations could be taken from many other Soviet publications reminding us that a struggle against groupings of the RAPP and RAPKh type (which had emerged from AKhRR) – by that time the avant-garde had been effectively eliminated – preceded the appearance of Socialist Realism.

In recalling the actual context of the period, we should note that it coincided with the liquidation of NEP – that is, of the milieu in which, according to the general view, the art of groupings like AKhRR had developed. The transition to the 1930s and the Five-Year Plans meant the implementation of measures that had been proposed in their time by the left ('plundering the peasantry', accelerated industrialisation, and so forth), although by other methods and in a different historical context. Amid conditions of intensifying centralisation, the programme of 'building Socialism in one country' and the 'growing enthusiasm of the masses', Mayakovsky was proclaimed the greatest poet of the age and the Leninist slogan 'it is necessary to dream' was quoted with increasing frequency in the press. In these new circumstances Socialist Realism put into effect practically all the fundamental watchwords of the avant-garde: it united the artists and gave them a single purpose, erased the dividing line between high and utilitarian art and between political content and purely artistic decisions, created a single universal and easily recognisable style, liberated the artist from the service of the consumer and his individual tastes and from the requirement to be original, became part of the common cause of the people and set itself not to reflect reality but to project a new and better reality.

In this respect Socialist Realism was undoubtedly a revival of the ideals of the avant-garde after a definite period in which individualised artistic production with its purely reflective, mimetic character had dominated. Most importantly, a break with tradition was made in the very role and function of the artist in society. Socialist Realist painting, like the work of the avant-garde, is above all a political decision concerning how the future should look, which may be approached with purely political yardsticks. The Socialist Realist artist renounces his role as an observer detached from real life and becomes a part of the working collective on equal terms with all its other parts. However, all the obvious similarity in the way the avant-garde and Socialist Realism understand the role of art does not, of course, provide an answer to the key question in this context:

why is there so little external, purely visual similarity between the avant-garde and Socialist Realism?

## IV

Apart from the immanent laws of artistic development whereby, following a period of intensive development in a particular direction, art usually changes course when the impression forms that this development has entered a cul-de-sac and begins to move in a completely different direction, the reason for the changed character of the visual material with which the avant-garde had worked lay primarily in the changed position of the artist in Soviet society as it continued to evolve. Avant-garde art was a reductionist art that adhered to a new principle – it was advancing from Malevich's black square as the sign of absolute zero and absolute rejection of the world as it is. The art of the 1930s was confronted by a 'new reality', the authors of which were political leaders, not the artistic avant-garde. If avant-garde artists had at first striven to work directly with the 'basis', utilising political power in a purely instrumental way, by the 1930s it had become clear that work with the basis could be implemented only by the political authority, which did not brook competition.

A similar situation developed in philosophy. While Marxist philosophy had proclaimed the primacy of practice over theoretical cognition, this primacy was understood initially to denote the gaining by the philosopher of political power with the aim of changing the world instead of knowing it. But as early as the late 1920s and the beginning of the 1930s the primacy of social practice could only be understood as the primacy of decisions by the political leadership over their theoretical interpretation, which led to the ultimate liquidation of the philosophical schools that had earlier emerged.[19] Similarly, artists, nurtured on the principle of the primacy of transformation over representation, could not but recognise, following their own logic, the dominance of the political leadership in the strictly aesthetic sphere as well. The artists left this sphere in order to subordinate political reality to themselves, but in so doing they destroyed the autonomy of the artist and the work of art, thus subordinating the artist himself to political reality 'at the second move'. Having made social practice the sole criterion of truth and beauty, Soviet philosophers and artists inevitably found themselves obliged to recognise political leaders as better philosophers and

artists than they themselves, thus renouncing the traditional right of primacy.

In these circumstances the question of the artist's role in society and the objective significance of his activity at a point where both the representation and transformation of reality had gone beyond his control was naturally raised again. We may note that this new role had already been marked out by Lef and consisted in agitation and propaganda for the decisions of the political leadership. The emergence of this role marked in itself a significant shift in the consciousness both of artists and of Soviet ideologists as a whole.

The theoreticians of the avant-garde proceeded from the conviction that modification of the 'basis' would lead semi-automatically to change in the 'superstructure' and that, in consequence, purely 'material' work with the basis was sufficient to achieve a changed view of the world, a changed aesthetic perception, and so on. In the late 1920s and early 1930s this widespread opinion was judged to be 'vulgar sociologism' and sharply criticised. The superstructure, that is, the sum of ideological, aesthetic and other conceptions, was proclaimed to be relatively independent and situated in a 'dialectical', rather than a one-sidedly causal, relationship with the basis: the basis, as well as defining the superstructure, is 'strengthened' or, conversely, 'weakened' by the superstructure. This new emphasis on the superstructure, brought about in the first instance by disillusion with the prospects for world revolution in the developed Western countries as a result of the 'unreadiness' of the proletariat, made available to art a definite, partially autonomous area of activity. Art, together with philosophy, literature, history and other 'superstructural' forms of activity, was given the task, if not of defining the overall face of the new reality, then, at any rate, of promoting its formation in a particular sphere: specifically, by forming the consciousness of Soviet citizens, who in their turn stood in a dual, dialectical relationship to this reality as both its creators and its 'products'.

Of the many examples that illustrate this development in the thinking of Soviet theoreticians of art, we may cite a few of their later pronouncements, not in essence differing from the principles worked out in the 1930s, but more elaborated. In an article by N. Dmitrieva entitled 'Esteticheskaya kategoriya prekrasnogo' (The aesthetic category of the beautiful), the author, describing such Stalinist construction projects as canals, hydroelectric stations and irrigation programmes as well as the construction of industrial installations, states: 'This is the formation of being according to the laws of beauty'.[20] For

Dmitrieva, the beautiful is the 'harmonically organised structure of life, where everything is mutually co-ordinated and every element forms a necessary link in the system of the whole'.[21] In essence, therefore, the beautiful coincides for the author with 'systematic practical activity' and does not consist in art alone as a specific form of activity. The beautiful is, in the first instance, reality itself, life itself, if it is beautifully organised, but 'the beautiful in art neverthe-less does not fully coincide with the beautiful in life',[22] since art fixes the attention on 'the typical features of beauty' of each given period; by typical is meant here not the 'statistical mean', but the common aesthetic ideal of the age, that is, the artistic norm for the formation of reality itself. The beautiful in art reflects the 'typically beautiful in life', not art itself as such, and thus may in itself play a formative role in relation to reality.

A similar position is taken by G. Nedoshivin in his article 'Ob otnoshenii iskusstva k deistvitel'nosti'[23] ('On the relationship of art to reality'), which emphasises the educative role of art 'inseparable from its cognitive role'. Art, like science, simultaneously cognises and forms life, doing this, however, not theoretically, but in typical images. The typical is again oriented towards practical social goals, towards the future and the 'dream'. Many similar observations could be cited. All, in essence, are interpretations of Stalin's renowned directive to writers to 'write the truth'.

To write or 'depict' the truth meant for the Soviet criticism of that time – and, indeed, still does – to show the objectives towards which social practice was in reality striving, not to impose objectives upon society from outside, as formalism tried to do, or to observe the movement of society towards these objectives as this really hap-pened, which 'uninspired naturalism' did. However, such a purpose presupposes that social practice develops not spontaneously, but with the object of realising certain definite ideals in the mind of the 'architect' of this process, who is distinguished from 'the very best bee'. Naturally, the political leadership and, specifically, Stalin were seen in the role of architect.

It was, indeed, to Stalin that the avant-garde role of creator of 'the beautiful in life itself', that is, the task of 'transforming' rather than 'representing' life, passed during the 1930s. The political leadership responded to the demand by philosophy and art for political power in order to realise in practice their plans for reconstructing the world by appropriating philosophical, aesthetic and other significance to itself. As the artist of reality, transforming it in accordance with a unified

plan, Stalin could, by the logic of the avant-garde itself, demand that others standardise their style and direct their individual efforts towards bringing it into harmony with the style of the life given shape by Stalin. The demand to 'paint life' has meaning only when that life itself becomes a work of art. The avant-garde had previously rejected this demand, since, according to the formula 'God is dead', it no longer perceived the world as the work of God's art. The avant-garde artist laid claim to the vacant place of the total creator, but in fact this place had been filled by the political authority. Stalin became the only artist, the Malevich, so to speak, of the Stalin period, liquidating the avant-garde as a competitor in accordance with the logic of the struggle – a logic which was not foreign to avant-garde artists, either, who willingly resorted to administrative intrigues.

Socialist Realism, with its collectivist ideas, strove for a single, unified style, as did suprematism, for example, of the analytical art of Filonov. It should not be forgotten that the stylistic variety of the avant-garde was associated with constant splits and struggles among leading artists, which are reminiscent in this respect of the struggle during the early stages of evolution of the Communist Party. Within each faction, however, discipline and the striving for standardisation prevailed, making, for example, the faithful disciples of Malevich almost indistinguishable. Such standardisation inevitably resulted from the ideology of the avant-garde, which scorned individualism and the objective for an artist of a 'unique manner' to good effect and stressed adherence to the 'objective laws of composition': the new world could not be built on a polystylistic basis and the cult of personality of the single, unique artist-creator was, therefore, deeply rooted in avant-garde theory and practice. Of course, individual variations were always possible within the framework of a school, but these were as a rule explained by the necessity for broadening the sphere of reality that was embraced, that is, in terms of the individual nature of the specific task and not that of the artist.

A similar situation confronts the student of the art of the Stalin period. Contemporary artists were in essence 'followers of Stalin' (by analogy with 'followers of Malevich'), who all worked in the 'Stalinist style', but with variations depending on whether their task was to portray the great future, hymn the workers of factory or field, struggle against the imperialist inciters of war or depict the building of Socialism in this or that particular national republic. In all these situations style underwent definite changes, while at the same time

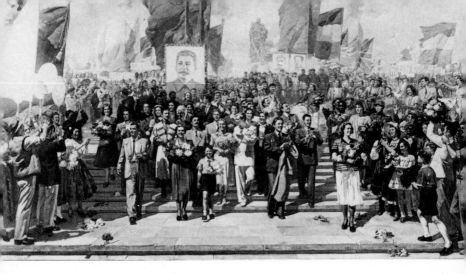

(*above*) A.I. Vepkhvadze, D.D. Gabitashvili, K.M. Makharadze, G.K. Totivadze: Youth of the World for Peace, 1950–51.

(*below*) A. Gerasimov: The Oath, 1949.

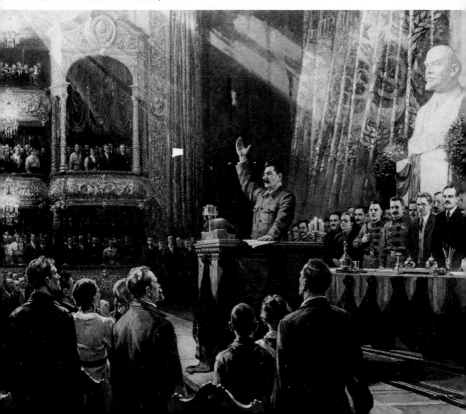

3. A. Deineka: Mosaic to the ceiling of Novokuznetskaya Metro Station, 1940–43.

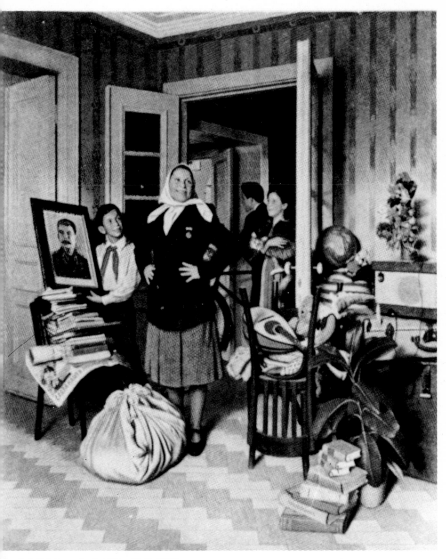

4. A. Laktionov: In the New Flat, 1951.

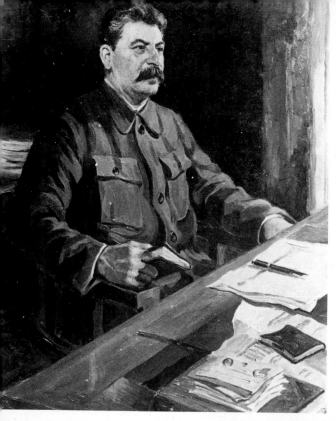

5. (*left*) A. Gerasimov: Port
of I.V. Stalin, ca. 1942.

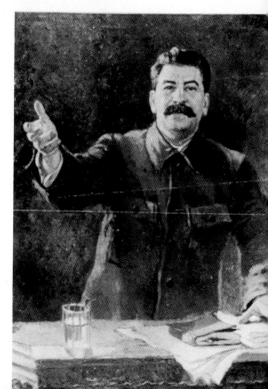

6. (*right*) A. Gerasimov:
I.V. Stalin, 1939.

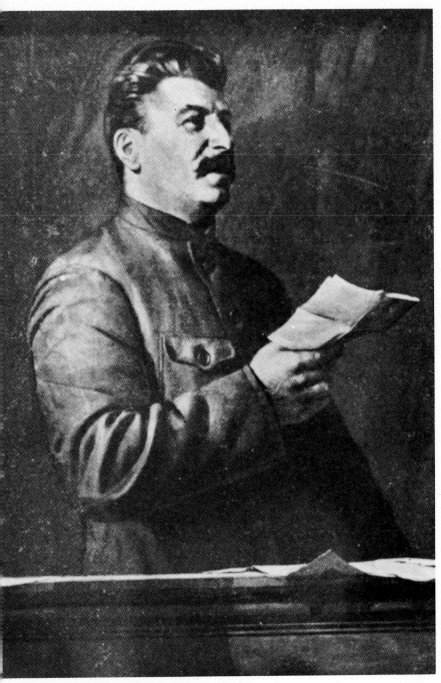

7. I. Brodsky: Portrait of I.V. Stalin, 1932.

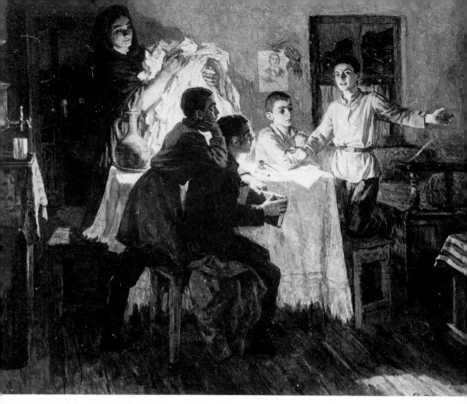

8. (*above*) Z. Volkovinskaya: Stalin's Childhood, 1949.

9. (*below*) P. Kotov: At Lenin's Death-Bed, ca. 1944.

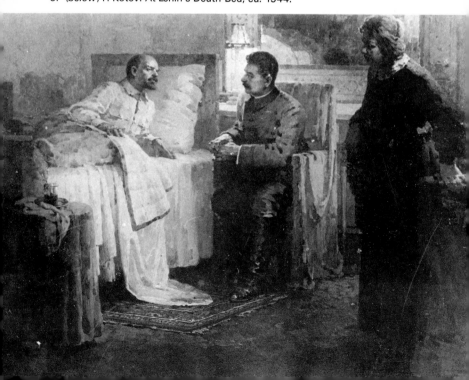

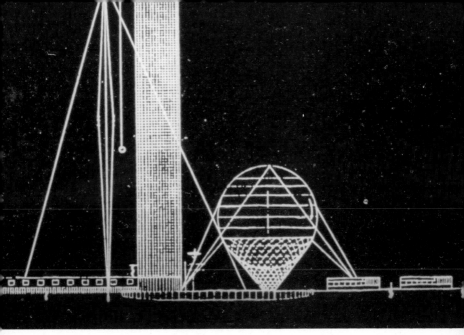

10. (*above*) Ivan Leonidov: Lenin Institute (National Library), 1927.

11. (*below*) Rudnev and others: Lomonosov University, Moscow, 1952.

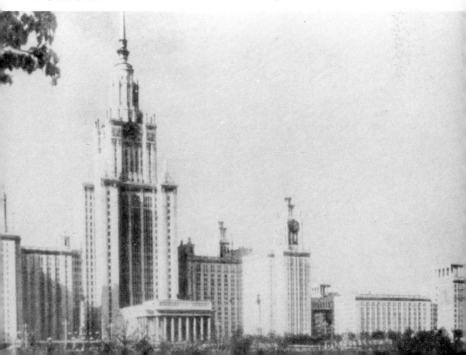

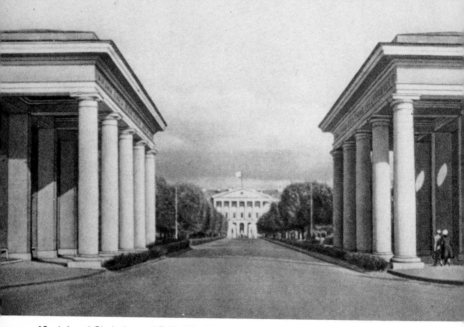

12. (*above*) Shchuko and Gelfreich: Doric Arcade, Smolny Palace, Leningrad, 1922.

13. (*below*) K. Malevich: The Knife Polisher, Oil painting.

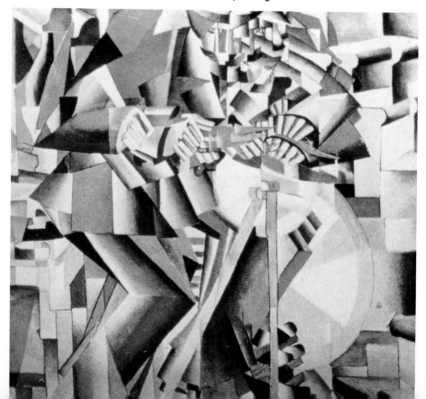

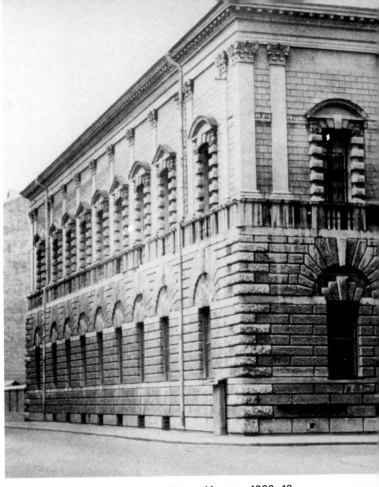

14. (*above*) I.I. Zholtovsky: Tarasov House, Moscow, 1909–10.

15. (*below*) I.A. Fomin: Villa Polovtsev, Petersburg, 1911–13.

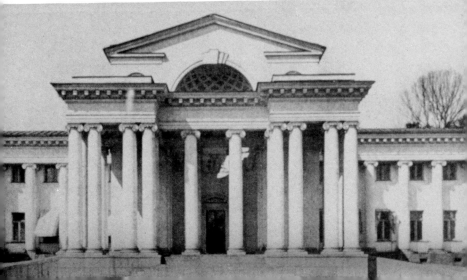

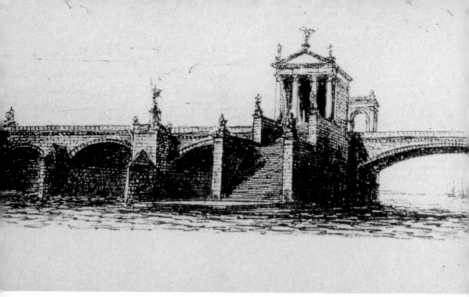

16. (*above*) I.I. Zholtovsky: Bridge over the Moskva, 1921.

17. (*below*) a. Tatlin: Tower of the ''Third International'', 1919.
   b. Vesnim Borthers: Editorial Building for the *Leningrad Pravda*, 1924.

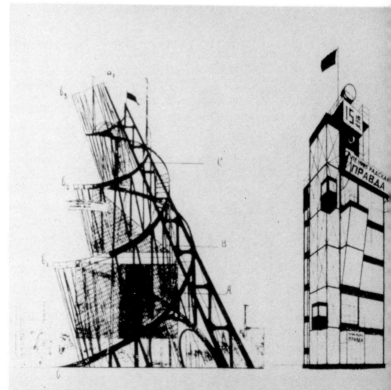

VLADIMIR TATLIN, ENTWURF FÜR DENKMAL
ler 3. Internationale. 1920
GEBRÜDER WJESNIN, ENTWURF FÜR LENIN-

GRADER PRAWDA-GEBÄUDE. 1924
90 HANNES MEYER und HANS WITTWER, Pr
FÜR PETERSSCHULE, 1925, Basel

18. I.I. Zholtovsky: State Bank, Moscow, 1927.

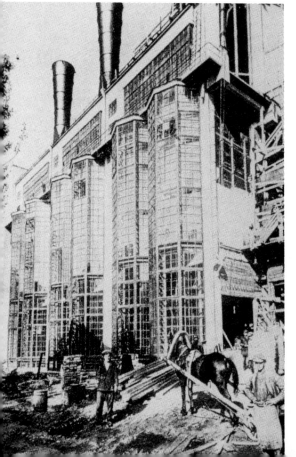

19. (*above*) I.I. Leonidov: Lenin Institute (National Library), Moscow, 1927.

20. (*left*) I.I. Zholtovsky: Boiler House, Electric Power Plant MOGES near Moscow, 1927.

21. (*above*) Barshch and Vladimirov: Commune-Building with Maternity Ward (left) and School (right), 1929.

22. (*below*) I.I. Zholtovsky: Palace of Soviets competition, first design, one of three First Prizes, 1931–32.

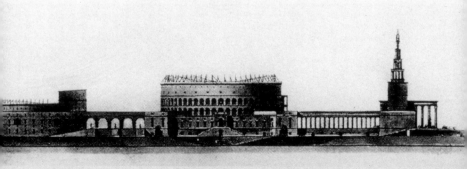

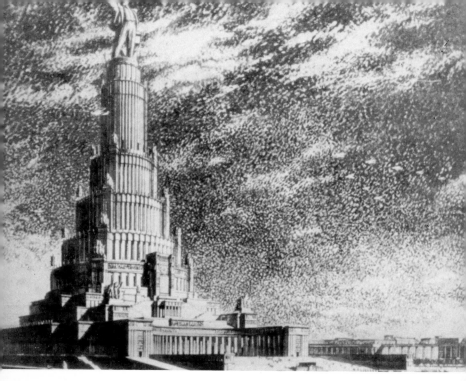

23. (*above*) B.M. Yofan, with Shchuko and Gelfreich: Palace of Soviets, competition Phase, 1933–35.

24. (*below*) I.I. Zholtovsky: Palace of Soviets competition, second design, 1933.

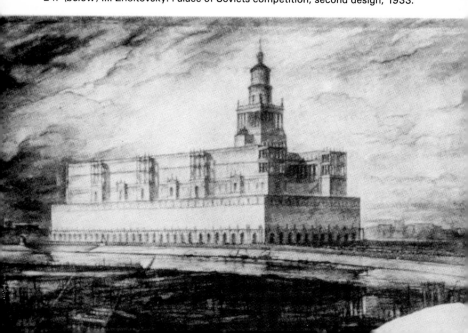

25. (*right*) B.M. Yofan: Palace of Soviets competition, model, 1935.

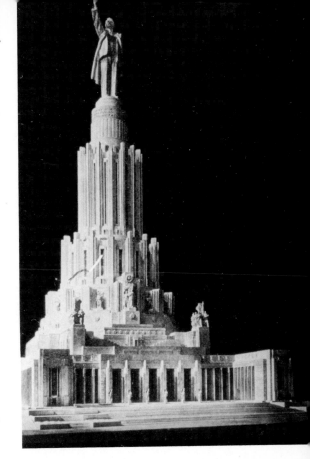

26. (*below*) I.I. Zholtovsky: Apartment house near the Old University ('Intourist' Building), Moscow, 1933.

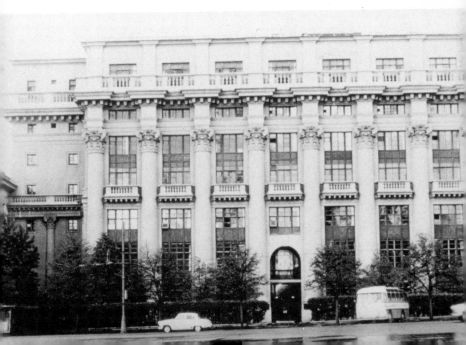

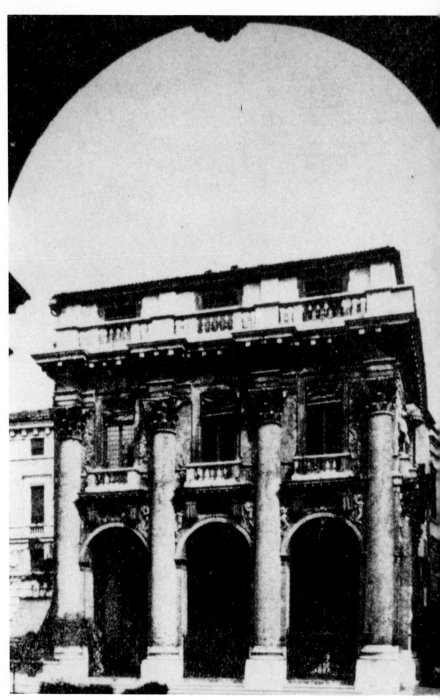

27.  Palladio: Loggia del Capitaniato, Vicenza, Italy, 1571.

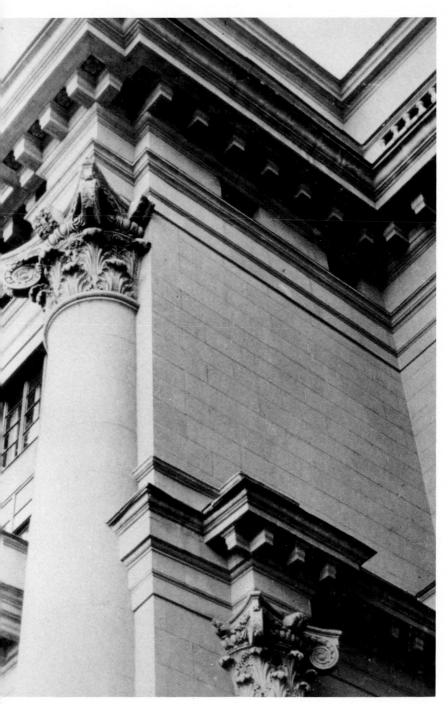

28. I.I. Zholtovsky: Intourist Building, Detail, Moscow, 1933.

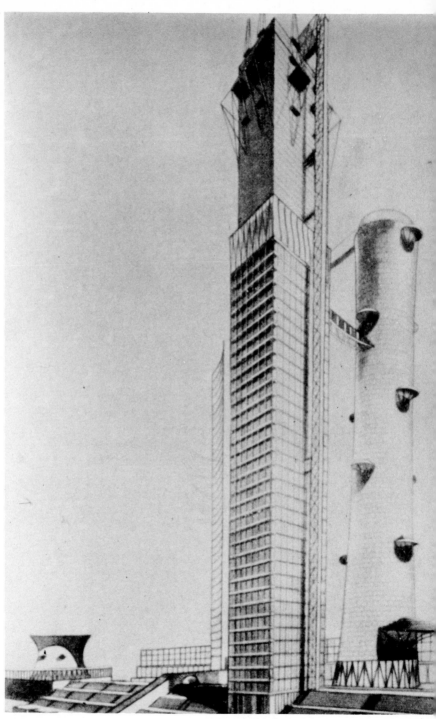

29. I.I. Leonidov: Ministry of Industry, Kremlin, Moscow, 1934.

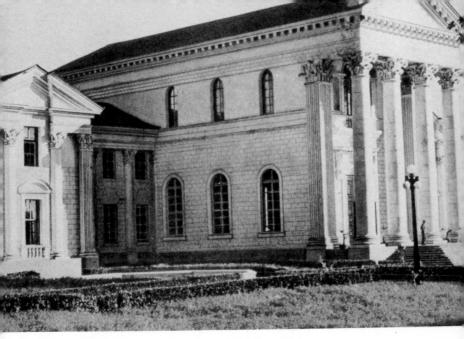

30. (*above*) I.I. Zholtovsky: City Hall in Sochi, Black Sea, 1936.

31. (*below*) Adytum Baalbek (Lebanon) Reconstruction, 150 A.D.

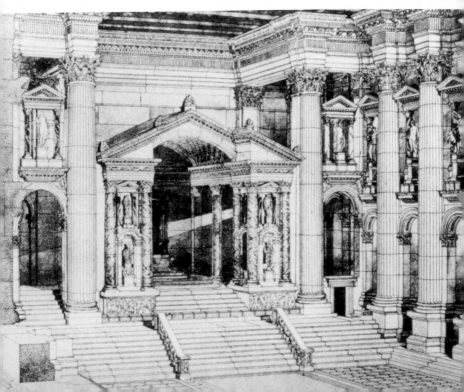

32. Map, Eastern Mediterranean and Black Sea (Sochi: above right, Baalbek near Beirut).

the general trend was nevertheless towards elimination of these subject-related differences. Thus, artists, particularly during Stalin's last period, described in detail and with pride how they had succeeded in freeing themselves of all tokens of individual style and even of the characteristic 'non-typical' principle of the subject represented.[24]

The criticism of the Stalin period constantly demanded that artists bring their vision closer to the 'normal' vision of 'normal' Soviet people, the creators of the new life. In the last years of Stalin's rule the 'team method' of manufacturing pictures, directed at completely overcoming the individuality of a particular painter, was widely practised. Thus, the Soviet artist of the Stalin period did not occupy the position of a realistic reflector of the new reality – this was precisely the position that had been condemned in the case of AKhRR. The artist of Socialist Realism reflected not reality itself, but the ultimate goal of its reconstruction: he was at once passive and active in that he varied and developed Stalin's thinking on this.

The difference between Socialist Realism and the avant-garde consists in the first instance not in their relationship to art and its goals, but in the area of application of this new relationship: while the avant-garde – at any rate in its pre-Lef period – directed itself towards forming actual material reality, Socialist Realism set itself above all the goal of forming the psychology of the new Soviet person. The writer, following Stalin's well-known definition, is 'an engineer of human souls'. This formulation points both to continuity with the avant-garde (the writer as engineer) and to a departure from it, since a new area of application is provided for the avant-garde principle of engineering design after responsibility for projecting reality itself has been assumed by others. At the same time this role proved to be still more an honorary one, since the initial slogan of the Five-Year Plan, 'technology decides everything', was soon replaced by another – 'the cadres decide everything'.

However, the problem of projecting the New Man presents the artist with tasks other than those of projecting material reality. In the absence of what might now be called 'genetic engineering', the artist is inevitably tied to unchanged human appearance – from which, in essence, also emerges the necessity of turning again to traditional painting. This represents not only the statement of achieved successes, but also an acknowledgement of certain limits. It is in this sense that Socialist Realism is 'realistic': realism here stands opposed

as realpolitik to the utopianism of the avant-garde. The task of educating the New Man proved significantly more difficult than had been initially supposed.

The transition from the avant-garde to Socialist Realism was thus principally dictated by the logic of development of the avant-garde idea of projecting a new reality itself and not by concessions to the tastes of the mass consumer, as it has often been represented. There is no doubt that the avant-garde was foreign to the ordinary spectator. It is equally beyond doubt that the return to picture painting during the NEP period was influenced by the new mass demand for art. However, the centralisation of Soviet art from the beginning of the 1930s made it totally independent of consumer tastes, an independence upon which, we may note, the theoreticians of Lef had insisted from the very outset. The art of Socialist Realism does not give the ordinary spectator the opportunity to identify with it, since it is opposed to them as an educative institution. With the passing of time the Union of Soviet Artists has gained great economic power and relative economic independence, even of official institutions and their tastes, since purchasing policy is determined in the first instance by the union itself. No link exists at any level between the ordinary consumer and the union and the art of Socialist Realism interests the ordinary Soviet person as little as does the art of the avant-garde. In the absence of economic criteria or sociological surveys, an indirect indication of the spectator's real tastes may be obtained from the completely unprecedented success during the post-Stalin era of an artist like Il'ya Glazunov. Other examples may also be cited which indicate that the mass spectator in the Soviet Union, while inclined towards realistic painting, is by no means oriented towards Socialist Realist painting.

At all events, in fulfilling its basic mission of projecting the New Man Socialist Realism was limited from the outset, as has already been stated, by the unchanging quality of the human countenance and the necessity to take this into account. Lef, too, was obliged to reckon with this constant factor when, at the end of the 1920s, the artists of the Russian avant-garde began to use the human face and figure in their propaganda montages. However, for the art of Socialist Realism representation of the human being occupied a central place and, in fact, all other purposes were subsumed to it. As the theoreticians of Socialist Realism recognised from the beginning, this circumstance restricted the compositonal opportunities and expressive means of painting. In essence, the subject of representa-

tion became the expression of the human face and the pose of the human body, testifying to the person's inner spiritual state.

Practically all art criticism of the Stalin period was devoted to endless analysis of the poses and facial expressions portrayed in Soviet pictures in relation to the psychological content they conveyed. The methods and criteria of such analysis, together with the number of examples necessary, cannot be examined here in greater detail and it is sufficient to state that in time artists and critics jointly elaborated a distinctive and quite complex code for external appearance, behaviour and emotional reaction characteristic of the 'true Soviet man' which embraced the most varied spheres of life. This highly ritualised and semanticised code enables any Soviet person brought up inside Stalinist culture to judge from a single glance at a picture the hierarchical relationships between the figures, the ideological intentions of the artist, the moral characteristics of the figures and so on. This canon was elaborated over many years before gradually disintegrating. In many paintings and in articles on them, wherein were defined the poses and facial expressions that should be considered 'flabby', 'decadent' and bourgeois or, conversely, energetic, but energetic in the Soviet rather than in the American or the Western style, that is, with a genuine understanding of the prospects for historical progress, which pose could be considered inspired, but not exalted, which calmly brave, but not static, and so on, a new canon was painfully worked out in light of the recognition that direct reliance on the classical models of the past was impossible. Now Socialist Realism as a whole is, nevertheless, perceived as somewhat colourless by comparison with the classics. But in making such a comparison it should not be forgotten that Socialist Realism lacked the opportunity for prolonged, consistent and unbroken development that was enjoyed by the classics. If we recall that its entire evolution occupied no more than a quarter of a century, we must acknowledge that, by the end of Stalin's rule, Socialist Realism had achieved a very high degree of internal unity and codification in its basic ideological positions and spiritual states.

The reasons for the turn by Soviet art from the basis to the superstructure were set out quite clearly at the very inception of this process by Ya. A. Tugendkhol'd. In his essay 'Zhivopis' revolyutsionnogo desyatiletiya' (The painting of a revolutionary decade), which is still insufficiently 'dialectical' from the standpoint of later Soviet art history, but is sufficiently clearly written in consequence, Tugendkhol'd argues against the notion of the left that its practice was based

on a materialist view of the world. Tugendkhol'd quotes Punin in this connection, who wrote:

> Being defines consciousness, consciousness does not define being. Form=being. Form-being defines consciousness, that is, content . . . Our art is the art of form, because we are proletarian artists, artists of a Communist culture.[25]

Tugendkhol'd expresses the following objection:

> For Punin [form] is the command given by the age, at once Russian and Western, proletarian and bourgeois. In other words, this form is set by the objective conditions of the age, which are identical for all. Punin did not understand that, since the form of the age is obligatory to all, the difference between proletarian and non-proletarian art consists not in form, but in the idea of utilising it . . . it is in the fact, too, that the master of the locomotives and machines is the proletariat itself that the difference between our industrialism and Western industrialism lies; this is our content.[26]

Thus, the appearance of man in art is directly linked by Tugendkhol'd to the discovery of the relative independence of the superstructure from the level of production. Man and his organising attitude towards technology are at the very heart of the definition of the new social system, which is thus in part given a psychological foundation. The extreme expression of this new 'cult of personality' in art is, of course, the concentration on the figure of Stalin as the creator of the new life *par excellence*.

It is also Tugendkhol'd who notes that the decisive move towards the portrayal of man was connected with the death of Lenin, when 'everyone felt that something had been let pass'.[27] In future it was to be the image of Lenin and, later, Stalin that stood at the centre of Soviet art as the image of the ideal, the exemplar. The numerous portraits of Lenin and Stalin, which may seem monotonous to the contemporary observer, were not monotonous to the artists and critics of that period: each was intended to 'reveal a side of their multi-faceted personality' (recalling somewhat Christ's iconography, in which different, dogmatically inculcated means of presenting the personality of Christ in its various aspects are contained). These portraits were associated with a definite risk to the artist, since they represented not only an attempt at an external likeness, but also a

meaningful interpretation of the personality of the leaders that had no less ideological and political significance than a verbal or literary interpretation. Characteristically, a portrait was invariably condemned as a failure both when the critics failed to find this type of clear-cut interpretation in it and when the interpretation was seen as 'unoriginal'.

By the end of Stalin's rule Socialist Realist art had begun to move increasingly evidently towards the creation of an integral, monumental appearance for Soviet cities and, ultimately, a unified appearance for the entire country. Plans were drawn up for the complete reconstruction of Moscow in accordance with a single artistic concept and painting was being increasingly integrated with architecture while conversely, buildings of a functional character – factories, underground stations, hydroelectric stations, and so forth – were taking on the character of works of art more and more. Portraits of Lenin and Stalin as well as of other leaders, not to mention the 'typical workers and peasants', gradually became increasingly depersonalised and depsychologised. The basic canon was already so formalised and ritualised that it was now possible to construct a unified reality from elements created in preceding years.

Of course, this new monumental style bore little external resemblance to the avant-garde, yet in many respects it realised the latter's aims: total aestheticisation of reality and the rejection of individualised easel painting and sculpture that lacked monumental purposes. The importance of museums began, correspondingly, to decline: an exhibition of gifts to Stalin was mounted in the Pushkin Museum of West European Art in Moscow.

Neither may this style be considered a simple restoration of the classical. It is true, of course, that the Academy of Arts was reorganised at this time and the struggle against 'undervaluation of the old Russian Academy of Arts' began at its very first sessions. At the same time the 'Chistyakov system', named after the teacher of many of the Peredvizhnik artists,[28] began to be published. The purpose of the campaign was to demonstrate that the Peredvizhnik artists were in a direct line of descent from the Russian classical school, whereas earlier it had been their break with the academic tradition that had been stressed.

A new approach to justifying the necessity of 'a solicitous attitude towards the cultural heritage' also dates from this time. While, previously, this necessity had been based on the theory that each class creates progressive art during the period of its rise and reactionary art

during the period of its decline and that Soviet art should, therefore, imitate the art of periods of progressive development, such as, for example, the art of antiquity, of the Renaissance and of nineteenth-century Russian realism (the avant-garde was regarded here as the art of decline and decadence), now this theory, too, deriving from the very first declarations of the Party leadership in the area of cultural policy,[29] was accused of representing 'vulgar sociologism'. The new, far more radical justification advanced was that, in essence, all 'the genuinely good art of the past' expressed the interests, not of a definite class – even if progressive – but of the entire people and thus, given the total victory and the 'flourishing'[30] of the people, could be fearlessly imitated.

Despite all these obvious references to the past, the art of the Stalin period is not classical in the sense that, for example, the art of the Renaissance or the art of the French Revolution were. Antiquity was still ultimately rated an age of slave-owning and the hero of Soviet books on the period was, above all, Spartacus. The same is true of all other historical epochs: all were regarded as no more than preparatory stages on the road towards the contemporary Soviet age and never as independent models or exemplars. In the profoundest sense Socialist Realism remained the heir of the avant-garde to the end. Like the avant-garde, it regarded the present age as the highest point of history and the future as the embodiment of the aspirations of the present. Any stylisation was, therefore, foreign to it and, for all the monumentality of their poses, Lenin was represented without any feeling of clumsiness in jacket and cap and Stalin in tunic and boots.

This teleological perception of history led inevitably to an instrumentalisation of the artistic devices of the past and to what, seen from the outside, was taken as eclecticism, but was in fact not eclecticism. The art of previous ages was not regarded by Soviet ideology as a totality, which should not be arbitrarily dismembered. In accordance with the Leninist theory of two cultures in one culture, each historical period was regarded as a battleground between progressive and reactionary forces, in which the progressive forces were ultimately aimed at the victory of Socialism in the USSR (even if the clash took place in the remote past), while the reactionary forces were striving to block this. Such an understanding of history naturally led to quotation from the past of everything progressive and rejection of everything reactionary, which, viewed externally, seems to be extreme eclecticism, since it violates the unity of style of each era, but which, in the consciousness of Soviet ideology, possessed the true

unity of everything progressive, truly popular and eternal and rejected everything ephemeral and transitory associated with the class structure of society.

Ideas of the progressive or reactionary quality of a given phenomenon have naturally changed with time and what is or is not subject to quotation has changed correspondingly. Thus, in the art of Socialist Realism quotation and 'eclecticism' have a semantic and ideological, rather than an aesthetic, character. The experienced Soviet specator can always readily decipher an 'eclectic composition' which, in fact, possesses a unified ideological significance. However, this also means that Socialist Realism should not be conceived of as a purely aesthetic return to the past, contrasting with the 'contemporary style' of the avant-garde, too.

The real difference between the avant-garde and Socialist Realism consists, as has already been stated, in moving the centre of gravity from work on the basis to work on the superstructure (avant-garde work on the superstructure being assumed by Stalin), which was expressed in the first instance in projecting the New Man as an element of the new reality rather than in merely projecting its purely technical, material aspects.

If, thereby, Socialist Realism finally crushed the avant-garde – to regard the avant-garde totally superficially as a purely aesthetic phenomenon, which contradicts the spirit of the avant-garde itself – at the same time it continued, developed and, in a certain sense, even implemented its programme. Socialist Realism overcame the reductionism of the avant-garde and the traditional contemplative standpoint associated with this reductionism (which led to the success of the Russian avant-garde in the 'bourgeois' West) and instrumentalised both man and the entire mass of culture of the past with the object of building a new, total reality as a unified work of art. The practice of Socialist Realism is based not on a kind of primordial artistic contemplation, like Malevich's 'Black Square', but on the sum total of ideological demands, which in principle make it possible freely to manipulate any visual material (this circumstance, it may be noted, enabled preservation of the principles of Socialist Realism even after Stalin's death, although, visually, Soviet art has also undergone definite changes).[31]

By the same token Socialist Realism took the principle, proclaimed by the avant-garde, of rejecting aesthetics to its extreme. Socialist Realism, free of any concrete aesthetic programme – despite the external strictness of the Socialist Realist canon, it could be instantly

changed in response to political or ideological necessity – is indeed that 'nothing art' the avant-garde wanted to become. Socialist Realism is usually defined as art 'Socialist in content and national in form', but this also signifies 'avant-garde in content and eclectic in form', since by national is meant everything 'popular' and 'progressive' throughout the entire history of the nation. Avant-garde purity of style is, in fact, the result of the still unconquered attitude of the artist towards what he produces as an 'original work' corresponding to the 'unique individuality' of the artist. In this sense the eclectic may be regarded as the faithful expression in art of a truly collectivist principle.

The collectivism of Socialist Realism does not, of course, mean anything like democracy. At the centre of Socialist Realism is the figure of the leader, who is simultaneously its principal creator (since he is the creator of Socialist reality itself, which serves as the model for art) and its main subject. In his turn Stalin as leader, has no definite style – he appears in different ways in his various persons as general, philosopher and theoretician, seer, loving father of his father and so on. The different aspects of Stalin's 'multi-faceted personality', usually incompatible in an ordinary person, seem eclectic in turn, violating standard notions of the original, self-contained human personality: thus, Stalin – as a figure in the Stalin myth, of course – unites in himself the individual and the collective, taking on superhuman features which the artist of the avant-garde, although he, too strives to replace the divine project with his own, nevertheless lacks.

If, at first glance, the transition from the original style of the avant-garde to the eclecticism of Socialist Realism appears to be a step backwards, this is only because the judgement is made from a purely aesthetic standpoint based on the unity of what may be called the 'world museum'. But Socialist Realism sought to become the world museum itself, absorbing everything progressive and worthy of preservation and rejecting everything reactionary. The eclecticism and historicism of Socialist Realism should, therefore, be seen not as a rejection of the spirit of the avant-garde, but as its radicalisation: that is, as an attempt ultimately to identify pure and utilitarian art, the individual and the collective, the portrayal of life and its transformation, and so on, at the centre of which stands the artist-demiurge as the ideal of the New Man in the new reality. To repeat: overcoming the concrete, historically determined aesthetic of the avant-garde meant not the defeat of the avant-garde project, but its continuation and completion insofar as this project itself consisted in

rejecting an aestheticised, contemplative attitude towards art and the quest for an individual style.

NOTES

1. H. Günther, 'Verordneter oder gewachsener Kanon?, in *Wiener slawistischer Almanach*, vol. 17 (Wien, 1986) pp. 305–28.
2. Paul Sjeklocha and Igor Mead, *Unofficial Art in the Soviet Union* (Berkley and Los Angeles, 1967) p. 35.
3. Annemarie Gethmann-Siefert, 'Das klassische als das Utopische. Überlegungen zu einer Kulturphilosophie der Kunst', in *Über das Klassische* (Frankfurt a.M., 1987) pp. 47–76.
4. Lodder links this aestheticisation of the Russian avant-garde in the West with the Berlin exhibition of 1922. Christina Lodder, *Russian Constructivism* (Yale University Press, 1985) pp. 227–30.
5. *Sots-Art*, The New Museum of Contemporary Art (New York, 1986).
6. Vladimir Solov'ëv, *Sobr. soch.* (Brussels, 1966) vol. 6, p. 90.
7. K. Malevich, 'God is not cast down', in K. Malevich, *Essays on Art* (Copenhagen, 1968) vol. 1, pp. 188–223.
8. K. Malevich on AKhRR in H. Gassner and E. Gillen, *Zwischen Revolutionskunst und Sozialistischem Realismus* (Cologne, 1979).
9. Cf. Chr. Lodder, op. cit., pp. 98–9.
10. Chr. Lodder, op. cit., p. 77.
11. B. Arvatov, 'Über die Reorganisation der Kunstfakultäten an den VChUTEMAS', 1926, in H. Gassner and E. Gillen, *Zwischen Revolutionskunst und Sozialistischem Realismus* (Cologne, 1979) pp. 154–5.
12. K. Malevich, *Suprematismus – die gegenstandslose Welt* (Cologne, 1962) p. 57
13. H. Gassner, *Alexander Rodschenko. Konstruktion 1920* (Frankfurt a.M., 1984) pp. 50–1.
14. H. Gassner and E. Gillen, op. cit., pp. 286–7.
15. A. Fëdorov-Davydov, 'Vopros o novom realizme v svyazi s zapadnoevropeiskimi techeniyami v iskusstve' (1925), in *Russkoe i sovetskoe iskusstvo* (Moscow, 1975) p. 24.
16. Ya. A. Tugendkhol'd 'Zhivopis' revolyutsionnogo desyatiletiya' (1927), in *Iskusstvo oktyabr'skoi epokhi* (Leningrad, 1930) p.34.
17. H. Gassner and E. Gillen, op. cit., p. 288.
18. E. I. Sevost'yanov, *Esteticheskaya priroda sovetskogo izobrazitel'nogo iskusstva*, p. 206.
19. Ijegosua Jachot, *Podavlenie filosofii v SSSR (20–30 gody)* (New York: Chalidze Publications, 1981).
20. N. Dmitrieva, 'Esteticheskaya kategoriya prekrasnogo' (Moscow: *Iskusstvo*, January-February 1952) p. 78.
21. N. Dmitrieva, op. cit., p. 78.
22. N. Dmitrieva, op. cit., p. 79.
23. G. Nedoshivin, 'Otnoshenie iskusstva k deistvitel'nosti' (Moscow: *Iskusstvo*, July-August 1950) pp. 80–90.

24.  Yu. Neprinchev, 'Kak ya rabotal nad kartinoi *Otdykh posle boya* (Moscow: *Iskusstvo*, July-August 1952) pp. 17–20.
25.  Cf., for example, Ya. A. Tugendkhol'd, op. cit., p. 24
26.  Ya. A. Tugendkhol'd, op. cit., pp. 24–5.
27.  Ya. A. Tugendkhol'd, op. cit., p. 31.
28.  A.M. Gerasimov, 'Zadachi khudozhestvennogo obrazovaniya', in *Akademiya khudozhestv SSSR. Pervaya i vtoraya sessii* (Moscow, 1949) p. 62.
29.  Alexander Bogdanov, 'The Proletarian and the Art' (1918), in *Russian Art of the Avant-Garde. Theory and Criticism*, ed. J. Bowlt, p. 177.
30.  A. Stambok, 'O nekotorykh metodologicheskikh voprosakh iskusstvoznaniya' *(Iskusstvo,* no. 5, September-October 1952, pp. 42–6.
31.  For example, *Aspekte sowjetischer Kunst der Gegenwart*, exhibition at the Museum Ludwig (Cologne, 1981).

# 8 Socialist Realism as Institutional Practice: Observations on the Interpretation of the Works of Art of the Stalin Period

Jørn Guldberg

I

In the catalogue accompanying the Moscow version of the retrospective exhibition 'Artists of the RSFSR through XV years' in the summer of 1933, the chairman of the exhibition committee, M.P. Arkad'ev, could state laconically that 'the style of our epoch is Socialist Realism. The artist not only depicts our Socialist construction truthfully, but also takes an active part in it himself'.[1] However, in the official address to the participants of the First Congress of Soviet Artists, which took place at the beginning of 1957, the CPSU Central Committee was not particularly generous in its appraisal of the achievements of Soviet art up till then. Summarising the development of Soviet art, the Central Committee stated: 'The character of Soviet man, who is emancipated from exploitation and its spiritual world, has not yet been wholly represented in works of art'.[2] The address did not, however, specify the reason why Soviet artists had not so far been able to recognise and represent the new and emancipated Soviet man. The Party furthermore offered only one piece of advice for the relief of the inadequacy of Soviet art. This was 'to enrich the forms and styles, the types and genres, of Socialist Realism, which requires a true, historically concrete depiction of reality in its revolutionary development'.[3]

In the intervening 25 years, dozens of artists had received the honorary titles of 'People's Artist', 'Honoured Art Worker' or 'Hero

149

of Socialist Work', and hundreds of Stalin Prizes had been awarded as an expression of official recognition of the ideological and aesthetic qualities of works of art. Thousands of pages had been published with panegyrics to Soviet art from the 1930s and 1940s as genuine examples of Socialist Realism and as the culmination of world art history. Thousands of paintings, graphic works and sculptures idealising the Socialist way of life in the Soviet Union had been exhibited.

A preliminary conclusion, which is neither surprising nor controversial, is naturally that the majority of the works which, from the mid 1930s up to the early 1950s, were exhibited, discussed and prized as unsurpassed masterpieces were products of Stalinist political culture.

The reaction against the administrative routines and the ideological-stylistic standards of the Stalin era, which can be read about directly and between the lines in the documents from the first Artists' Congress, was levelled at both historical-thematic pictures and the politically more 'neutral' landscape painting, genre painting and portraiture. The works were generally criticised for *illyustrativnost'* or *fotografiinost'*, or for putting a glossy appearance on reality, *lakirovat' deistvitel'nost'*. The essence of this criticism was that the portrayal of Soviet society and social life exaggerated the harmony and lack of conflict, thus making it difficult for art to live up to its educational mission, as it offered no possibilities of identification which could raise the observer's experience of reality up into the world of ideal values, and thus enable the citizen to measure his spontaneous experiences of Soviet society with the help of a yardstick relating to a more perfect, utopian world. The fictitious world represented by art was so far removed from what was experienced in reality that art was robbed of its cathartic function.[4]

In the period following the 20th Party Congress both political and artistic authorities tried to save Socialist Realism via the reaction to the Stalin era's organisational ideological capriciousness, which at that time was legitimised by reference to this theory. But what in fact remained of Socialist Realism, apart from such apodictic formulations like those quoted above from the statutes of the Artists' Union, and some key concepts (*partiinost'*, *narodnost'*, *tipichnost'*) whose meaning no-one dared to interpret, apart from the classic references to Lenin's 'Party Organisation and Party Literature', the conversations between Lenin and Clara Zetkin and the correspondence between Engels and Miss Harkness, and so forth? Was it at all possible to argue for Socialist Realism as a credible, practicable

theory? Evidently not. After references to Socialist Realism at the first two Artists' Congresses (1957 and 1963) had had to keep alive the illusion of a continuity in Soviet art from 1932 onwards, from the Artists' Union's third congress in 1968, and in particular after the major retrospective exhibitions and publication of historical surveys in connection with the anniversary of the Revolution in 1967, Socialist Realism did not survive the modifications and adjustments in defining term, primarily referring to the period from the mid-1930s to the mid-1950s. As a conceptual term of reference the theory of Socialist Realism did not survive the modifications and adjustments in art criticism and technical vocabulary which were the inevitable consequences of the change undergone by Soviet Realism in the 1960s – both in terms of form and style and of theme and content[5].

If one wishes to be specific as to the concrete functions Socialist Realism has or had, it is therefore necessary to examine the ways in which this formula functioned in practice as life-size standards for the Soviet art scene. Or, to put it another way, in order to get an idea of how and with what result the theory of Socialist Realism influenced the style of Soviet art, and notions of art criticism and historiographical paradigms, it is necessary to focus on the institutional structures through which this norm was implemented. Socialist Realism is much more than a style, that is, a specific visual entity, and the most characteristic features of Socialist Realism as a phenomenon are in fact non-visual.

It would, of course, be too naive to conclude that it is just the difficulty of defining Socialist Realism as a style that is the reason why various Western encyclopaedic accounts of modern art either contain no reference to Socialist Realism, refer to it only as an inferior aspect of realism[6] or place the emphasis on the 1920s when dealing with the Soviet version of Socialist Realism.[7] The lack of enthusiasm from Western art historians for a reasonably broad and research-based knowledge of Soviet art history after 1930 is almost certainly due to all the non-visual aspects of Socialist Realism, for instance, the explicit socio-political references of the formula, and more generally to the fact that it is an art form whose practioners seem to have accepted (and continue to accept) that what is often perceived by Westerners as non-aesthetic and extra-artistic is a part of the *raison d'être* of this art form. The type of parade pictures which dominated the All-Union exhibitions in the 1940s are displeasing to Western observers not because of the 'core content' or 'message' of the pictures, but because of the lack of ironic tone in the structure of the

pictures, something which characterises their Western counterpart, the advertisement image. And when paintings such as the huge canvas 'Youth of the World for Peace' by a Georgian artists' collective and exhibited at the All-Union exhibition in 1951 (ill. 1) or the painting 'The Oath' (1949) by Aleksandr Gerasimov (ill. 2) were criticised in the mid-1950s in the Soviet Union, the main objection was the photographic and illustrative character of the pictures, that is, the absence of any distance to the subject matter – for example a historical perspective or a vehicle for subjective empathy (humour, sentiment or the like). It was not the themes as such – in this instance 'young people gather together for peace in the world in the name of Communism' or 'the duty of Soviet political leadership towards the legacy from Lenin' – but the conception of the picture, which was rejected and associated with the cult of personality.

In the following I will be concerned partly with a brief discussion of some possible approaches to Socialist Realism as a *stylistic entity* and as a *specific artistic practice*; and partly with arguing for employing an institutional approach in an attempt to clarify which factors produced the idiom of Socialist Realism. The starting point is that Socialist Realism is not a single entity – not *one* doctrine or *one* artistic practice – but a doctrine which has shown that it can legitimise or disqualify a number of different artistic, critical and scholarly practices.

Socialist Realism was and is of an extremely unstable nature and has shown that it can be adapted to various historical, political and social needs. During the 1930s one of the most important needs was to legitimise Stalin's position of power, and as summed up by Katerina Clark in her analysis of the Soviet novel, this legitimisation took place via the ritualisation of all public activity in Soviet society. In this ritualisation a view of history is produced which associates Stalinist leadership directly with Lenin and Leninism.[8] In this connection, pictorial art functioned as an accommodating instrument when it came to *showing* and making tangible – rather than just postulating – Stalin's role as Lenin's comrade-in-arms in the central leadership of the October Revolution; Stalin as executor of Lenin's, and Leninist, policies; Stalin as Leninist theoretician and theoretician in general. More than any other medium, pictorial imagination – in paintings, sculptures, graphics and so on – was suitable for compensating for the inadequacy of actual history in producing documentation for what 'neutral' mechanical media such as photography and films had been unable to report – a close comradely co-operation

between Lenin and Stalin. At the end of this study I shall discuss some examples of the 'Staliniana' of Soviet art.

## II

The most obvious way of gaining an understanding of Socialist Realism is to examine the *visual material* usually perceived as a product of an artistic practice which has the doctrine as its theoretical, ideological and moral reference point. With a traditional formal analysis such as this it is possible to observe, record and possibly systematise a number of features characteristic of smaller or larger groups of works. On the basis of a number of examinations of individual works, it will further be possible to say something very general about Socialist Realism. Using very general terms one can say something about Socialist Realism as a *style*, and if this style needs closer specification a relevant characterisation would be *eclectic*. A number of typical works from the 1930s and 1940s are easily identified as formal paraphrases of compositions from Renaissance and Baroque Classicism. The strict classical composition format is frequently softened and blended with something which lies between Impressionist clichés and the mood of 'Biedermeier' art from the first half of the nineteenth century. Although an analysis focussing on the visual and formal qualities of Socialist Realist works would produce a fair amount of concrete information, the approach raises several problems. Firstly, the common denominator which it would be necessary to operate with in order to define Socialist Realism as a style would be the lowest imaginable. It would thus be difficult to pinpoint the stylistic features common to the two previously mentioned works and, for example, Aleksandr Deineka's mosaic ornamentation of the 'Novokuznetskaya' Metro station from 1940–43 (ill. 3), or Aleksandr Laktionov's genre picture 'In the new flat' from 1951 (ill. 4). In practice therefore one would be forced in principle to characterise all the individual pieces of work analysed as exceptions to this common denominator. Secondly, it would therefore be difficult to consider these works as concrete materialisations of the theory of Socialist Realism.

This leads to two possible conclusions. One is that the doctrine has been been able to generate the type of visual consistency which is the prerequisite for being able to discuss style in the sense that art historians traditionally do. Of the three types or levels of style which classical style analysis employs – individual, regional and epoch style[9]–

at most only individual style will thus be of importance. The second conclusion is that we are forced to accept modern art historiography's claim that style is something which only manifests itself in the individual work.[10] But as this modern notion of style reflects the twentieth century's stylistic pluralism and the turbulent succession of -isms which is among other things a product of the Western art scene's commercial organisation, the methodological necessity of using this concept of style is in direct conflict with Socialist Realism's ideological self-knowledge as 'Soviet art's creative method', that is, as the core of a uniting and collectively committed cultural programme.

Even a not particularly penetrating analytical approach to the visual material reveals some discrepancies in the relationship between theory and practice. If Arkad'ev's optimistic claim from 1933 that 'the style of our epoch is Socialist Realism' does not, without a number of reservations, allow itself to be confirmed and documented on the basis of an analysis of the artistic products, one can ask whether it is possible to reach a consensus about Socialist Realism based on the *textual material* through which the doctrine's norms and standards have been effected. The aim of this approach should be to form a qualified idea about Socialist Realism as a specific theory of pictorial art by examining what has been presented as authoritative theorising about the aesthetic and ideological components of Socialist Realism that is, hundreds of articles and exhibition reviews in *Iskusstvo*, *Tvorchestvo* and so on, conference and seminar reports and aesthetic, critical and historical papers written or compiled by such authorities as G. Nedoshivin, O. Beskin, V. Zimenko, all the Lebedevs, and so on.

It quickly becomes obvious, however, that what we are confronted with here is a textual terrain which, seen as a contribution to the formation of a theory, is characterised by an almost exhausting degree of redundancy, and one is likely to come to the probably not completely irrelevant conclusion that the redundancy is in fact a basic feature of the theory of Socialist Realism. The huge number of texts which from the mid-1930s to the mid-1950s were to function as a precision of the doctrine's historical, aesthetic and cultural-theoretical references demonstrate a surprising lack of consensus, apart from some standard points of view and some forms of argumentation which are repeated over and over again.

From the published text material one has to conclude that Socialist Realism is first and foremost defined negatively. It is far easier to get

an idea of what Socialist Realism is *not* than to make a positive statement on the basis of what the texts produce in the way of operative concepts. There is no mediation or reversibility between the endless assurances in the texts that 'art is bound to the people', that 'the artists create the works which the Stalin epoch deserves', that 'the artists cannot do without the inspired and comradely guidance of Stalin and the Party' and so forth, and what we are actually presented with.

To perceive the *textual material* about Socialist Realism as theory of art in the proper sense of the term will only give rise to frustration. In order to understand both the 'literary' character of this material and its actual function along with its long-term consequences for Soviet art critics' and art historians' conceptual references, attention must be moved away from the content of the texts to the *rhetoric* through which the few theoretical positions, in a traditional sense, are expressed. By focussing on the literary qualities of the textual material, so to speak, it becomes clear that the texts do *not* present a theory about what was drawn, painted or sculpted during the period, but rather represent a particularly panegyric and hagiographical literary genre suited to one definite task: to praise Soviet society *as* a work of art – or, more precisely, to present Soviet society as the 'artistic' medium for the only true artist, Stalin. Art in the traditional sense is in fact superfluous – therefore there is no need for the postulation of special theoretical concepts or aesthetic categories.

A particularly illustrative example of this kind of text is a short unsigned article published in *Iskusstvo* in 1951: 'Towards a Soviet Classic'.[11] The occasion for the article was the fifth anniversary of the Central Committee resolutions on the periodicals *Zvezda* and *Leningrad*, on the repertoire of the dramatic theatres and on the film 'The Magnificent Life'. As well as going over these resolutions the article contains a number of reports of Soviet artists doing this and that, but typically the article's only references are to Russian nineteenth-century artists (Repin, Surikov, and so forth) along with a few Renaissance and Baroque masters. The idea behind the text is clearly that whatever concrete works Soviet artists may be carrying out is of secondary importance, as their task in reality is to imitate what already *has* been created by the Party and Stalin. At one point the text has a long and linguistically ambiguous sentence where 'granite, marble, bronze and colours' are directly connected with 'the Bolshevik Party and its leader, comrade Stalin'.[12] The Party and Stalin are not named as one among many subject matters of high

priority for artists using the materials mentioned, but as the suppliers of subject matter. Nowhere in the text does it appear that the efforts of Soviet artists are to do with creating art, but rather that in their work they try to realise the goals formulated by Stalin, and that they do this by concentrating on a content and using a form already supplied by Stalin.

A third approach, which seems particularly suited to relativising the characteristic features of Socialist Realism will also be briefly discussed.

In an article on 'Realism in Pictorial Art' the Swiss art historian Konrad Farner sums up around 50 concepts of realism, all of which refer to art from this century.[13] This number can quite easily be doubled, so there ought to be plenty of possibilities for carrying out comparative studies on several levels: functional, formal-stylistic, theoretical-ideological. But since the relationship between theory and practice, and the functions of both in Soviet society, are specific to Socialist Realism, I think it is difficult to define standards of comparison where one is not forced to ignore one or more important aspects. For example, the discussion of the possibilities of comparing Soviet Socialist Realism and German Nazi art appears to be distracted by the fact that the comparisons reveal both similarities and disparities on all levels. Two political ideologies, antagonistic in principle, were able to produce art which as far as *formal* characteristics are concerned are entirely commutable, while with regard to *content* or *subject matter* there is only one, but an important, difference, which manifests itself particularly in paintings and monuments which represent work, work processes and the cultivation of nature: what these works tell us is that the ideal Nazi society is an Arcadian idyll populated by Arian craftsmen and farmers, whilst the ideal Socialist society is a highly industrialised and thoroughly organised multinational society.

The controversial question connected with a comparison between Socialist Realism and Nazi art is whether the formal and structural similarities which the works reveal, and which are difficult to overlook, are so to speak neutralised and become in fact real differences in scholarly and critical perception, since the two types of art can only be evaluated adequately from a respectively Marxist or Fascist conceptual framework.[14] Or whether the characterisation of both artistic practices must be the same because their common social task is the same from a historical point of view, despite possible differences; that is, to idealise a social order and to compensate for

the citizens' actual experiences of a totalitarian, brutal and repressive political system.[15]

Other comparisons would also be interesting – for instance, between Socialist Realism and 'The American Wave' or 'American Scene Painting', the current which dominated (and shook) American artistic life from the mid-1920s till around 1940 and which during that period forced modern, abstract art onto the defensive. The principal idea of 'The American Wave' was to promote a national, American cultural renaissance by demanding of art that it depict American themes in a style which should also be American. In other words, it was a cultural programme which was to contribute to the formation of a specifically American historical and cultural identity, and in this way break the influence of foreign and 'imported', that is, European, cultural norms. Contrary to both Soviet Socialist Realism and the archaic realism of the Third Reich, 'The American Wave' was not essentially state-supported and promoted art, even though the idea of cultural democracy behind the comprehensive public art projects of the 1930s was a perfect political framework for the nationalistic populism of the wave.

Neither the politically radical Social Realism, which some historians include in 'The American Wave',[16] or typical works by some of the movement's central figures – for example, the three 'Regionalists' Thomas Hart Benson, John Steuart Curry and Grant Wood – have anything more than superficial similarities to Socialist Realism, both as far as formal, visual qualities and choice of theme are concerned. On the other hand there is a noticeable symmetry between the points of view expressed by Thomas Craven, the leading 'theoretician' and fellow critic in 'The American Wave', and theoretical-ideological positions which both anticipated Socialist Realism and characterised it in its High Stalinist version.

At the end of 1925 Craven wrote in an article with the title 'Men of Art: American Style' that 'Americans were not able to create a viable native art by copying Frenchmen, for the American soil . . . could not nourish a metaphysical imported style'.[17] In 1924, in celebration of the second anniversary of its formation, and having gained considerable popularity, the leadership of AKhRR (the Association of Artists of Revolutionary Russia) produced a circular for its branches. AKhRR was the largest and most populistic artist group of the 1920s, and was from the mid-30s officially perceived as a forerunner to Socialist Realism and as a link between the *Peredvizhniki* movement and Soviet art. In the circular the AKhRR leadership

summarised the fundamental tenets of the group, including its attitude to the avant-garde:

> The creation of the elements of a social art in the Russian school acted . . . as a logical balance to the development of . . . so-called leftist trends in art; it displayed their petit-bourgeois, pre-Revolutionary decadent substance, which was expressed in their attempt to transfer the fractured forms of Western art – mainly French (Cézanne, Derain, Picasso) – to a soil alien both economically and psychologically.[18]

Similarly, the basic anti-art or anti-aesthetic attitude, which, as previously suggested, characterises the ideas behind the theoretical and critical texts produced in the Soviet Union during the culmination of the Stalinist cult of personality, where Socialist Realism was given an extremely nationalistic emphasis, can be found in Craven's writings. For example, in 1929 Craven wrote:

> The truth is that the Yankee believes the homely virtues and Anglo-American moralities indispensible to the conduct of life, and deep down in his heart he considers beauty corruptive and libidinous, something unholy and intoxicating, a little beyond his pragmatic grasp.[19]

Lenin's oft-quoted remarks about art that it should be understood by millions, which have always been an obligatory standard reference when the *narodnost'* of Soviet art has had to be closely defined are echoed in Thomas Hart Benson's artistic credo: 'I believe I have wanted more than anything else to make pictures, the imagery of which would carry unmistakably *American meaning* for Americans and for as many of them as possible'.[20] With only a few changes to the wording, every loyal Soviet artist would be delighted at being able to express so precisely their ambitions as artists.

For most of the ideas expressed in Socialist Realism's textual material, identical or corresponding formulations were expressed by American artists and critics in the interwar period; even the paradigm of *partiinost'*, with certain modifications. Many interesting compilations of quotations could be made. Soviet art authorities were, for example, not unique regarding the frequently stated demand about creative mastery (*masterstvo*), or about kinship between art and the people:

Art must not only be good but it must be popularly grounded. Only that art which draws its inspiration from the body of people can be good art in the last analysis and mean something to the people for whom it has been created.

This quotation is not from Comrade Stalin, Aleksandr Gerasimov or an *Iskusstvo* editorial; nor does it come from the writings of Craven or Benton, but is in fact from Adolf Hitler, as quoted in the American magazine *The Nation*. It is also interesting to note in this context that the only notable articulate opposition to the militant nationalism which Craven and the 'Regionalists' subscribed to was formulated by the American Social Realists, many of whom were organised Communists. And in 1934 Alexander Trachtenberg, the American Communist Party's spokesman for cultural affairs, declared that the Party officially supported the holding of national writers and artists conferences in order to stem the tide of Fascism in the USA and Europe and to fight the 'Roosevelt-fostered national chauvinist art'.[21]

## III

An analysis of visual and textual material will not give any reliable and precise understanding of Socialist Realism as a style and as a specific theory of pictorial art. And comparisons with other contemporary artistic practices, and the ideologies behind them, show that the most important constants in the ideas about Soviet artistic culture during the Stalin period are not specific to Socialist Realism. Liberal, Fascist and Socialist ideologies seem capable of developing cultural strategies which from a *formal* point of view are analogous in their populistic and nationalist tones. Artists and authorities who regard themselves as loyal to these various political ideologies appear to be unanimous in expecting art to glorify and idealise the appropriate social and political order. They also agree in demanding that art which is specifically either American, German or Soviet should be uncomplicated, straighforward, realistic and figurative in order to be able to present a true picture of reality. There also seems to be agreement that the moral task of art does not lie in relating to the basic conditions of human existence as such, but in creating visual metaphors of the mental, moral and emotional superiority which characterises individuals who live in the humane and socially con-

scious conditions promised by the respective political ideologies. In this sense the demand for *partiinost'*, that is, the artist's undivided loyalty to, and ritual profession of, a set of narrow political ideas and their strategic presentation through a single person, is not peculiar to Socialist Realism.[22]

If nothing else, then precisely the *partiinost'* of Soviet art has been *the* trademark, and in Western opinion, the disqualifying factor for Socialist Realism. Whilst we in the West – where Nazi art and phenomena such as 'Regionalism' are merely unpleasant historical facts – have become used to the idea that political explicitness and lack of ideological ambiguity are ideas which are incompatible with artistic truth – ideas which are in conflict with the nature of art – Party-mindedness in this sense has been perceived as a force ever since the October Revolution by articulate artists in the Soviet Union. The problem is rather that the meaning of *partiinost'* on a concrete level, where this paradigm ought to function as a norm for artistic practice, has been revised several times – sometimes from one day to the next.

I have argued above – directly and indirectly – that generalist approaches, whether they be style analysis, textual criticism or comparative approaches, are unable to specify the features which characterise Socialist Realism as artistic culture. In order to obtain a precise and accurate idea as to how the standards of Socialist Realism functioned, it is necessary to employ a historical, concretising approach.

In the first instance it will be of great value to analyse closely both typical representative works from different historical phases in the establishment of the Socialist Realism idiom and the different political and ideological components in Socialist Realism as a theory of pictorial art, corresponding to the detailed studies of the literature of Socialist Realism recently published by Clark and Günther.[23] There is little doubt that a number of the general points about Socialist Realism as literary practice will also apply to pictorial art. This is true of both Günther's considered observations on the establishment of Socialist Realism as a State system of norms and Clark's interesting points in connection with the analysis of the 'master plot' of the Socialist Realist novel employing an anthropologically and ethnographically inspired approach.

There are also, however, some important and major differences between the two types of material which it is important to keep in

mind, as they affect the possibilities for transferring points from one area to another.

In the first place there are some media-specific differences. For the traditional visual art forms (painting, drawing and sculpture) the 'message' cannot be realised by the epic structure of a narrative. The painter cannot present his positive figure of identification by showing how the figure's desirable human qualities are a result of perfect conduct in the conflict situations and intrigues around which a story is built up. The characters in a novel exist in a world of actions, and the things which motivate the reactions of a hero or an anti-hero in a given situation can be communicated to the reader – either by the author or through the character's inner monologue. Even though a representation of a milieu may appear just as much constructed, and a figure appear as psychologically unconvincing, qualitatively the novelist has other possibilities for activating and influencing the reader's moral and ideological ideas, and thus also for accomplishing the very important didactic task which artists have in the Soviet Union. Thus, the attention of the authorities was (and is) in the first instance directed towards literature, and most of the *concretising* decrees and resolutions concerning Socialist Realism from the period under discussion concern literature.

In the second place Socialist Realism was consequently far more developed and varied as a literary practice and literary political strategy than it was for other art forms. This also means, however, that the conventionalising and canonising of certain creative practices is most pronounced, and homogenisation most noticeable, in literature. The relationship between literature and pictorial art is in many respects a derivative or transfer relationship as far as political ideological components are concerned. A number of theoretical and ideological notions we come across in art literature thus have a literary theoretical and literary political origin. This, of course, does not render superfluous a close examination of the adaptation and concrete function of the notions in relation to pictorial art, but it is the complex processes themselves, under which the application of the standards took place, which are of primary interest.

What literature and pictorial art historically have in common is the political and ideological background and, of course, importantly, the fact that Socialist Realism in all art forms is an *institutionalised* practice. The mediation between political decision-making and the specific artistic practice of for instance *having* to apply paint to a

canvas is, as far as Soviet art is concerned, at once both more direct and far more complicated and indirect than the type of mediation which socio-historical investigations can usually elaborate. One reason for this is that an artistic practice referring to Socialist Realism affects and is itself affected by related and similarly institutionalised social practices in a unique way from a Western point of view. The general practice in art criticism and art historiography in the Soviet Union had (and has) not solely the character of *posteriora*. The formation of critical norms and the development of scholarly categories was not duty bound to observe and spread the standards of Socialist Realism to a less degree than art itself. Socialist Realism's meta-level is unusual in that critical and scholarly discourses are both descriptive and prescriptive in referring to the primary level. Further, it was seldom knowledge elaborated by research, gained via, for example, the inclusion of new material, or by discovering and illuminating hitherto unseen connections or the like, which resulted in new scholarly positions or entailed the use of new research paradigms. On the contrary, the development in what we usually understand by scholarly discourse from the mid-1930s to the mid-1950s is characterised by a steadily more consistent exclusion of material and a radical reduction of research paradigms used, such that only one actually had operative validity around 1950; the life-work paradigm. This did not mean that the artist's mental constitution, or biographical material in a general sense was focussed on, nor that an artist's output was seen in the light of, his or her 'personal' private life. When dealing with Soviet artists, this involved – as the most important aspect in this connection – both life and work being described as a public matter, in which the only and decisive motive for success was whether the artist had managed to take advantage of the comradely and generous help of the Party and Stalin. When dealing with Western art history and cultural inheritance it meant that a specific 'humanistic' tradition was constructed, of which Socialist Realism was the culmination.[24]

Instead of being characterised by the inertia which normally distinguishes scholarly discourse, Soviet art historiography has shown itself to be extremely flexible – or inconsistent, if you will – in that it has demonstrated an unusual responsiveness to political ideological signals, just as it has quickly and effectively accomplished the tasks assigned to it.

The Soviet art scene during the Stalin era is characterised by the existence of a number of types of practice or practice levels. In the

ideal situation there would be a balance between the different types of practice, but investigations of given situations will show that one type has had priority, or that one level has apparently given optimal operativeness in connection with the implementation and definition of Socialist Realist norms. This priority does not, however, appear to have been determined by the potential contained in the individual practice and already demonstrated by it. The priority was rather conferred upon the artistic, critical and scholarly practices by an authority which lay beyond and above, and which did not have the functioning of the art scene as its primary concern.

In order to make possible a characterisation of Socialist Realist visual culture, that is, the artistic culture during the Stalin period, I would suggest employing an institutional approach.[25] Focussing on Socialist Realism as institutional practice – to summarise both the main theme and the digressions of the above in a schematic way – will allow a definition of Socialist Realism as a complex of interrelated practices in which different aspects determine the degree of co-ordination between the different types of practice. This institutional approach should not be seen as a 'new' method – and not at all as *the* method in this connection. Nor does an institutional approach render superfluous the use of, for example, semiotic, hermeneutic or anthropological methods; nor does it make irrelevant, for example, a socio-historical or mental-historical study of the history of Soviet art during this period. The objective in defining Socialist Realism as institutional practice is rather to establish a kind of meta-scientific frame of reference for a combination of different approaches, which can all contribute to answering the superordinate question of how Soviet artists were confronted with Socialist Realism as a set of life-size standards – why they met the demands attached to these standards in just the way we can establish that they did.

By establishing such a frame of reference, it should be easier to co-ordinate systematic and historical approaches, in that it then becomes possible to define, for example, which type of *semiosis* Soviet pictorial art represented at a given time, and then decide which *contexts* it would be relevant to operate with.

A simple diagrammatic model of the area of investigation could look like the following:

Figure 8.1   The Semiosis of Soviet Pictorial Art

The model operates with a functional frame referring to organisational-administrative aspects and political-ideological aspects and three practice levels – artistic, critical and scholarly.[26] In the following I will give a brief outline of some concrete possibilities for the application of the model and in doing so hopefully supplement the preceding argument.

The disbanding of all existing literary and artistic groups by the decree of 23 April 1932 had two aims, in that it was intended to solve both organisational and political-ideological problems. The new Union, which, according to the decree, was to be established, had the task of both *organising* the artists and *mobilising* them for a programme the most important element of which was to support Soviet power. Shortly after this the *formula* of Socialist Realism was launched, at first as a slogan which was to function as a conceptual reference for both organisational and ideological endeavours.

However, a Soviet artists union at All-Union level first became a reality in 1957, and although an organisation committee was set up in 1939, organisational problems as such were not discussed until the committee's 12th plenum in 1952.[27] This meant that the creative problems raised by the development of Socialist Realism could be solved in two ways – either through ideological upbringing or by administrative interference in everything that affected the artist's professional existence as an artist (admission to art schools, the housing situation, studio allocation, granting of decoration commis-

sions and the like, along with the individual artist's share of the scant rations of paint, canvas, brushes and so forth).

The official authorisation of one single body whose task it was to deal with both organisational and ideological tasks as part of the same routine was not forthcoming until 1957. In some situations until then the relationship between the organisational and ideological aspects can be specified as a supplementary relationship in which the organisational routines were followed by ideological ones, and vice versa. In other situations, organisational innovations which in some cases were initiated due to a desire to solve a purely administrative and organisational problems resulted in short- and long-term adjustments to the ideological function aspect, so that a new fundamental constellation arose in the relationship between organisational and ideological problems. (This is indicated in the diagram by the formation of a new circle.) This was the case for example when the Art Committee, *Komitet po delam iskusstv*, was formed in January 1936 with central and regional administrations for those branches of art which still had no All-Union organisation. The committee's job as watchdog had immediate effect on all practice levels and came to function as an institutional legitimisation of the intensification of ideological demands on artists. On a concrete basis, the Art Committee came to function as the prime mover in the first campaign against 'formalism' and in a preliminary definition of the historical references of Socialist Realism. This took place partly by a new and positive evaluation of nineteenth-century Russian realism, and partly by determining the date of the collapse of Western art history. Around 1940 the authorised view of this was that it coincided with Post-Impressionism and Cézanne.

Conversely there were other situations where the balance was shifted the other way, that is, where ideological revisions gave rise to organisational and administrative expansion which at first sight seems to have been the result of panic. This was the case, for instance, during the second intensive campaign against 'formalism' at the end of the 1940s, when museum directors organised new hangings, artists were excluded from various local organisations and art college students were expelled (including some of the artists who from the end of the 1950s became key figures in the 'second', 'unofficial' Soviet art scene). At this time reprisals were taken against art critics and historians who, until then, complying with prevailing norms and practices, had written positively about Impressionism. Because the collapse of Western art now suddenly becomes localised to

Impressionism itself in connection with the campaign against 'formalism', these critics and historians entered into intense and parodic self-criticism and a flood of anti-Impressionist articles, the intensity of which is otherwise inexplicable, was published in the years 1949-52.

Anti-Impressionism around 1950 is a good example of Socialist Realism as institutional practice. The second campaign against 'formalism' had its origin in the previously mentioned Central Committee resolutions. In order to follow the resolutions in practice, the artists, critics, historians and aesthetes had to define exactly what both 'formalism' and 'non-formalism' might be. As there was no possibility of making use of positive guidelines – for example in the resolutions, which gave no positive instructions, or in the practices employed up till then, which, one had just learned from the resolutions, had not sufficiently respected the demands concerning *partii-nost" narodnost'* and so on – those who felt obliged to follow the resolution were forced to construct some operative criteria. One solution was, so to speak, to 'push' the date for the beginning of Western decadence further back toward the Renaissance and the Baroque. After a number of attempts to establish a usable distinction between different Impressionists, the result was that Impressionism in general was removed from that part of art history which Socialist Realism could use as a model. From 1949 until 1956, when a major exhibition of modern French art was held in Moscow, it was therefore sufficient to use terms such as 'abstractionism', 'formalism', 'bourgeois-capitalist' and the like when Impresssionism was discussed.

In 1941 K. Sitnik had published an article on Auguste Renoir in which he presented a largely positive evaluation of the artist, and, more generally, of the significance of Impressionism on the development of modern art.[28] In 1949 the 90th anniversary of the birth of Nikolai Kasatkin was celebrated. Kasatkin (1859-1930) occupies a position in Soviet art as the 'father' of Socialist Realism, corresponding to that of Maxim Gorky on the literary scene. From about 1910 Kasatkin had quite clearly been influenced by Impressionism, and previously this had been taken as an uncontroversial fact. Sitnik, who wrote the obituary for *Iskusstvo*, is silent about this, however. Not only that – Sitnik rebukes those critics and historians who had up till then seen traces of Impressionism in Kasatkin's work, and at the same time he uses the opportunity to dissociate himself from his Renoir article of 1941. He distances himself from the relatively positive

references to Impressionism in this convincing and impressive manner: 'With that I sank down into an objectivist position and thus concealed the utterly reactionary, subjective-idealistic, formalist and anti-popular (*antinarodnyi*) aspects of this bourgeois decadent art form'.[29]

The new situation also received a different and direct expression in pictorial art, in that the All-Union exhibitions in 1951 and 1952 were the culmination of the phenomenon of *fotografiinost'* in Soviet art. There is no doubt that the effectiveness of the campaign against 'formalism' was dependent on how far the arguments could be supported by quotations from Lenin or Stalin. Whether Stalin can be made personally responsible for Soviet art's *fotografiinost'* is of course open to discussion. There is, however, little doubt that an anti-Impressionist argument where a sacrosanct Stalin quotation was built in had a major and direct effect. So perhaps the All-Union's exhibitions *were* Stalin's work nevertheless: a short series of articles by A. Zotov came to an end in the January 1950 edition of *Iskusstvo* with the laconic statement that Stalin, with his brilliant theory of artists as 'the engineers of the human soul' had shown 'the way to vanquishing the remnants of Impressionism in Soviet painting'.[30] Zotov makes no attempt to define more closely what implications Stalin's frequently quoted works had in this context where in concrete terms it was a question of avoiding Impressionist ideology and imagery. On the practical level on which Zotov develops his criticism of Impressionism it is not necessary for him to do so anyway. The mere suggestion of a connection was sufficient, unless it was immediately opposed. But when all was said and done, who would have dared claim that Stalin's remarks were in fact *not* anti-Impressionist, and which artists at that time would have dared risk prosecution for being in direct opposition to Stalin?

That the anti-Impressionist campaign had some effect even on the very élite of the cultural bureaucracy is quite evident when one compares the works of Stalin's 'court painter', Aleksander Gerasimov, from before 1945 with those from around 1950. Under the Zhdanovshchina Gerasimov was the most powerful and influential individual artist and it should have been him more than anyone who had reason to feel superior to the kind of diffuse criticism of which anti-Impressionism was an expression.[31] Yet it is remarkable how the more laconic and spontaneous painting technique, typical of his works up to the mid-1940s, for example, the portrait of Stalin from c. 1942 (Ill. 5), was replaced by a more elaborate, detailed realism in

his works from around 1950, as can be seen in 'The Oath' (Ill. 2), which was exhibited at the All-Union exhibition in 1950.

## IV

In relation to the cult of personality, the activities on the critical and scholarly practice level aimed at constructing functional evaluation criteria from theoretical and historiographical positions which directly or indirectly could be credited to Stalin. On the creative practice level the cult of personality manifests itself in the vast number of works which present Stalin as the very centre of the political, social and cultural life of that time and as a key figure in the history of the Soviet Union.

The 'Staliniana' in Soviet pictorial art can typologically be divided into three main groups. The majority are dedicated to the celebration of Stalin as state and Party leader and as the person who presented the visions of Communist society. Works which depict Stalin addressing party conventions and/or receiving delegations along with pictures of Stalin being cheered by the people – in person or as an icon – are legion. Almost as many contribute to the (re)construction of a Stalin-biography in agreement with official history-writing, that is, representations of Stalin, alone or with Lenin, as the chief person in the history of the Bolshevik Party and the October Revolution. Also belonging to this group are the many pictures which describe Stalin's childhood. A third group appear quite clearly to have functioned as disavowals of matters not discussed officially but of which it was obviously important to thematise in a positive manner. Such a subject could for example be Stalin's possible connection with the murder of Kirov or with the death of Gorky. Portrayals of the amicable, friendly co-operation between Stalin and Kirov appear in many variations, just as shortly after Gorky's death many paintings appeared showing Stalin alone or, more frequently, along with other representatives of the Party and state leadership at Gorky's bed-side. Finally a large number of works exist which quite clearly had the 'task' of rejecting the perception of Stalin as a not very productive theoretician and as an unoriginal political thinker. In many instances individual works belong to two of the groups or to all three.

In the following I shall briefly discuss some examples of Soviet art's 'Staliniana'. Rather than focusing on works which are well known in the West, I will draw attention to some paintings which have rarely or never previously been introduced to the Western public – paintings

which are, however, no less representative and typical, but in which the meaning or message is conveyed in a more subtle way.[32]

The celebration of Stalin can be 'discreet' as in Laktionov's 'In the New Flat' (Ill. 4), where a family take possession of their new home. Laktionov has chosen to show a view of the flat with a system of doors, in order to stress the comfortable size of the residence. Through only showing half of the double door to the left and in not allowing streaming sunlight or shadows from the window bars to draw patterns on the relatively wide area on the parquet floor in front of the bundle of clothes and the furniture, the artist creates an impression of the size of the sitting-room. The parquet floor, the gold-decorated wallpaper and the stuccoed ceiling suggest a stateliness which corresponds to the Socialist elegance of the woman. A perfect setting for the family-life of model Soviet citizens. The family's belongings, some of which are placed inside the door to the sitting-room, suggest their intellectual and artistic interests, and the globe and the wireless emphasise contact with the outside world.

The female head of the family is depicted in a situation where, still impressed and overwhelmed by the splendid new surroundings, she has to make the first important decision in connection with the moving in, that is where the portrait of the beloved Stalin should be placed. The mother looks round the room in order to select a suitable place on the wall and decides on a position high up. Her Pioneer son lifts up the framed portrait of Stalin while contemplating the mother with an expectant look. Via his picture Stalin is present and integrated into the family. With the mother as the symmetrical axis, the others distribute themselves in pairs on each side of her, so that the family with Stalin as the fifth member can describe a triangle. In this way Stalin completes the family and by replacing the absent 'real' father, he re-establishes the family's harmony and order. Stalin acts simultaneously as another kind of father-figure: his portrait forms the pinnacle in a pyramidal arrangement with a chair on which are placed a poster and a pile of books. We can see enough of the poster to decide that it is a popular 1st of May poster from 1949, showing Stalin behind Pioneers carrying flowers, and which has at the bottom the inscription, 'Glory to our beloved fatherland'. Stalin is not present as 'art' – strangely enough the artist Laktionov does not suggest that this cultivated family owns paintings. It is not an intimate portrait of Stalin, nor a reproduction of such which the family has as private property, but rather a portrait of Stalin in the role of 'father of the country', that is to say, the official photograph of the state leader in

field-marshal uniform, millions of copies of which were issued at the end of the war and in the years following. The intimate relationship between Stalin and the family is ceremonially created in the ritual of moving in, which begins with the placing of the portrait of the beloved leader, like an icon, in a prominent and central place.

In this way Stalin becomes absent and present at the same time. The aura of solemnity and authority of the official black and white portrait photo indicates that Stalin belongs to an order extending beyond that of the family. This is further emphasised by Stalin's gaze away from the portrait, away from the family and out of the window which, as the main source of light, causes short shadows which form diagonal lines from people and objects into the room. At the same time Stalin is omnipresent as a symbol of this higher order, the essence of which at this time is the fatherland. As such Stalin subsumes the usual family feelings: the son's love of the father (it is really a portrait of a stepfather the son is lifting up and his Pioneer status tells us that he is in the process of acquiring the father's ideas), and the woman's love for the spouse (we can assume that the biological and legal father is absent because he is dead, that is, having fallen in The Great Patriotic War, the deeper historical and existentialist sense of which is symbolised by Stalin in field-marshal's uniform). In this way Stalin becomes the element which unites the family and links its fate with that of the fatherland, its order with that of the fatherland and its defence.

Stalin gives and Stalin receives – Stalin in our hearts and in our homes!

Whilst Laktionov's painting is representative of the thematisation of Stalin's symbolic presence in the daily life of the Soviet citizen found in many genre-pictures, the more bombastic visual expressions of the cult of personality are found in the works of Gerasimov who, at the same time as being Stalin's 'court' painter, produced a series of 'intimate' representations of the 'private' person Stalin. In his 'Portrait of I.V.Stalin' from the beginning of the 1940s (Ill. 5), Gerasimov shows us Stalin at his desk. Stalin is sitting back pensively in his chair, whilst in his right hand he holds the book he is reading and which perhaps has given rise to his pensiveness. His index finger holds the book open at the place he has reached. The format of the book and the colour of the cover give us reason to believe that it is *The 1936 Constitution* ('The Stalin Constitution') on which he is reflecting. On the table in front of him there are papers and a fountain pen ready for use. To the right of this there are newspapers,

a notebook (or a diary) and some letters on top of a thick book. A sheet of paper is inserted roughly in the middle of the book. On a table behind him there are more piles of papers. Gerasimov has perhaps wished to present Stalin as the statesman who combines and creates a connection between private contact with the citizens (the letters), engagement in current affairs (newspapers and a diary) and reflections concerning more long-term and comprehensive political-ideological problems.

The function of books and papers in the Stalin pictures can be more closely defined as they are obviously a constant, essential and at times dominating iconographic element. The solemn and ceremonial calm and order which characterises the ritual taking of the oath in Gerasimov's 'The Oath' (Ill. 2) is broken by one conspicuous detail – the two dazzlingly white sheets of paper underneath Stalin's left hand on the rostrum. The sheets of paper are hanging over the edge and would slip if Stalin raised his hand. They presumably contain the declaration which he is now swearing by on behalf of the political and military leadership and the representatives of the various peoples of the Soviet Union, age groups and social classes who are present. In this way the papers enter into several meaningful relationships. The 'heavenly' light which from an invisible source high up falls dia-gonally in over the scene, otherwise dominated by horizontal and vertical lines, divides into two rays. The higher ray falls on and emphasises the white marble bust of Lenin, while the lower ray surrounds the rostrum and Stalin with a glow. This ray further divides into two in such a way that the one falls on Stalin's right hand whilst the other is reflected in the sheets of paper. With their glaring whiteness the sheets of paper contain a reference on a chromatic level to the white Lenin bust. The connection between Lenin and what Stalin is engaged in is underlined in another way in that Stalin is the only figure (with the possible exception of Krupskaya), in which the angle of the body and the gaze of the Lenin bust are repeated. The other political authorities between the rostrum and the bust are staring at various points in the space beyond the limits of the picture to the left. In order to emphasise this Gerasimov has even had to interfere with the perspective of the picture. He has manipulated the perspective line formed by the front edge of the draped table behind which Molotov, Kalinin and others are standing. This means that in a somewhat unnatural way we see these political notabilities rather more *en face* and can therefore read their gaze more precisely.

Nobody could possibly doubt that Gerasimov's painting is a staging

of Stalin as Lenin's heir. It is extremely unlikely that Gerasimov wished to say via the papers on the rostrum that Stalin was incapable of remembering the wording of an oath in which allegiance to Lenin is sworn. It is more natural to assume that the papers should, so to speak, make the relation between Stalin and Lenin more dynamic, so that Stalin does not merely appear as someone who repeats Lenin's political ideas in a mechanical and passive way, but appears rather as the person who realises these ideas through his active and con- templative dedication. The gaze of the delegates from the floor and from the balconies emphasises this fact, in that it is concentrated on both the bust of Lenin and the figure of Stalin. The ceremonial statics which characterise the participation of those present in the taking of the oath are raised to a monumental and universal expression in the white marble of the Lenin bust. The only dynamic element in the picture is supplied by the figure of Stalin, with his raised right hand, and especially by the papers, which are so 'alive' that they seem to be making their way over the edge of the rostrum.

What is the idea behind these papers which in a great number of other pictures too are shown as being on their way over the edge of a table or suchlike? Stalin's limited intellectual ability and unoriginality as a political thinker was already a controversial open secret while he was alive and has since been well documented.[33] One can therefore reasonably assume that these pictures were intended to make visible what thousands of books and articles in newspapers and journals had claimed, that is that Stalin was a brilliant, original and productive theoretician.

In another of Gerasimov's portraits of Stalin from 1939 (Ill. 6) Stalin for once addresses the observer directly and face to face. His right hand is raised in an energetic gesture that begins in his left hand which is spread over a pile of papers. In the middle of the table in front of him, lying on top of the obligatory, rather untidy pile of papers, there is a book kept open by a pencil. This indicates that Stalin is in the process of carrying out a productive adaptation or a supplementary interpretation of the text which, judging by the cover, is perhaps his own 'Problems of Leninism'.[34]

In Isak Brodsky's portrait from 1932 of Stalin delivering a speech (Ill. 7), the postulate concerning the personal and original aspect of Stalin's political message receives subtle emphasis. The piece of paper which Stalin is holding in his right hand, covering the area of the heart, quite clearly displays signs of having been folded and of

having been in a pocket. On the rostrum in front of him papers are
lying spread out, this being rather difficult to overlook as a corner of
one of the sheets is turned upwards and forms a triangle with the edge
of the rostrum as its base.

If we believe what the pictures from this period tell us, we must
conclude that Stalin had demonstrated his theoretical and rhetorical
powers long before he met Lenin and became involved in the
activities of the Russian Social Democratic Party. Stalin had not
merely inherited his message from Lenin. The Ukranian artist,
Zinaida Volkovinskaya painted the picture 'Stalin's Childhood' (Ill.
8) for the exhibition 'Stalin in pictorial art' which, as previously
mentioned, was opened on Stalin's 70th birthday in 1949. In the
family's modestly-furnished sitting-room the young Stalin, gesticulat-
ing excitedly, captures the attention of three comrades gathered
round a table. In the background the mother has stopped her work
with the washing in order to listen to the son as well. A hidden source
of light creates a dramatic effect on the table, and the pile of papers
which Stalin is ostensibly using in his argument and which hang over
the edge of the table, receive an intensely shining, almost magical
glow. The papers are also accentuated in another way. A line can be
drawn from Stalin's mother's head sloping down through the heads of
the two boys at the front which are seen in sharp silhouette against the
background of the illuminated washing, and further down to the
papers where the line on the perpendicular edge of the paper changes
direction towards Stalin. Dare we guess that Stalin here is about 12
years old and that Volkovinskaya, in order to give her description of
Stalin's extraordinary gifts, trustworthiness and visual authority has
leaned heavily on the iconographic schema of the representation of
the 12-year-old Jesus among the scribes?

The 'Staliniana', especially from the 1940s teems with allusions to
the Christian iconography of the Renaissance and Baroque period. In
particular it seems that representations of the relationship between
Lenin and Stalin could be given a mythical dimension through being
interpreted by means of testamental accounts and through being
visualised by means of the iconographic schemata of Christian art.[35]
In this way the well-known problematical and controversial aspects of
the co-operation between Lenin and Stalin are referred to the
tactical-political sphere with its unimportant details. Mythologising
and allegorising representations on the other hand place the Lenin-
Stalin partnership in a sphere beyond the discursive logic of rational

sense, that is, the sphere in which miracles are possible. These representations become unintentionally comical and parodying at times and almost always ambiguous.

Petr Kotov's painting from the beginning of the 1940s 'At Lenin's death-bed' (Ill. 9) is thus not merely a disavowal of the existence of Lenin's so-called will which he wrote on his death-bed in Gorki outside Moscow and which, had it been heeded, would in reality have rendered impossible Stalin's further political career. Kotov's painting is to all intents and purposes a paraphrase of the story of Jesus wakening up the dead son of the widow from Nain. It is, however, difficult to decide what is 'happening' in the picture, which is in itself unusual when one considers the didactic clarity and unambiguousness which otherwise characterise this type of picture. The ambiguousness is undoubtedly intentional. In her posture Krupskaya expresses surprise, as if she were amazed at something she had just witnessed, by getting up from (or sitting down on) a sofa. She leans heavily against the draped arm of the sofa, still overwhelmed, while she turns her head in the direction of 'the events'. Neither gesture nor facial expression reveal which of the two people in the background have said something or are about to say something. Perhaps Stalin's somewhat strained sitting position is meant to suggest that he is listening attentively to Lenin? Perhaps Lenin's correspondingly tensed, half-lying down, half sitting-up position is meant to indicate the opposite situation. Perhaps silent consent between the two is depicted. Perhaps the shining halo-like circular area around Stalin's head, formed by the lamp and its reflection in the mirror, suggests that a miracle is about to take place, that is, that Stalin is about to revive Lenin – not to life in the physical sense, but to a monumental existence in white marble, which in the 1930s and 1940s could legitimise and authorise Stalin's political leadership.

NOTES

1. Cf. M.P. Arkad'ev, 'Smotr sovetskogo izo-iskusstva', *Chudozhniki RSFSR za XV let (1917–1932). Katalog vystavki* (Moscow, 1933) p. XV.
2. 'Privetstvie tsentral'nogo komiteta KPSS vsesoyuznomu s''ezdu sovetskikh khudozhnikov', *Materialy pervogo vsesoyuznogo s''ezda sovetskikh khudozhnikov* (Moscow, 1958) p. 5.
3. Ibid., p. 6.

4. See, for example, the account by the chairman of the organisational committee, B.V. Yoganson, 'Sostoyanie i zadachi sovetskogo izobrazitel'nogo iskusstva', ibid., pp. 11–55.

5. I have discussed the characteristics of the Soviet art scene in the 1960s in other articles. A selection of my articles, essays, addresses and papers on Soviet art 1917–87, originally mainly published in Danish, and including three articles dealing with the new trends in the art of the 1960s, that is, the so-called 'austere style' and regionalism, is scheduled for publication by Odense University Press in 1990: *The Socialist Monumental Style – and other Studies in Soviet Art, Mostly Institutional*.

6. *The Phaidon Dictionary of Twentieth Century Art* (first edn., Oxford, 1973) does not mention Socialist Realism at all.

7. See, for example, *Dictionnaire de la Peinture Moderne* (Paris, 1980) German/Swiss edn, *Knaurs Lexikon der modernen Malerei* (Munich and Luzern, 1982). Of the 3.1/2 columns devoted to Socialist Realism only half a column deals with Soviet Socialist Realism from 1934 to Stalin's death, cf. the German edn., pp. 452–3.

8. Cf. Katerina Clark, *The Soviet Novel. History as Ritual* (Chicago and London, 1981) pp. 10ff.

9. Cf. the introduction to the Swiss art historian Heinrich Wölfflin's 'classic' and influential *Kunstgeschichtliche Grundbegriffe* (Basel, 1915) (Engl. trans., *The Principles of Art History* (New York, 1973).

10. Cf., for instance, the contributions to Berel Lang (ed.), *The Concept of Style* (University of Pennsylvania Press, 1979), especially that by Richard Wollheim.

11. 'Na puti k sovetskoi klassike', *Iskusstvo*, 1951, 5, pp. 3–6.

12. Ibid., p. 6.

13. Konrad Farner, 'Realismus in der bildenden Kunst', *Kunst als Engagement* (Darmstadt and Neuwied, 1973) pp. 193–220.

14. Cf. the contributions to the discussion in *Ästhetik und Kommunikation*: Berthold Hinz, 'Produktion, Rüstung, Krieg. Beispiele nationalsozialistischer und sozialistischer Ästhetik', and Eckhart Gillen, 'Ist sozialistischer Realismus mit national-sozialistischer Kunst vergleichbar?', *Ästhetik und Kommunikation* 26, 1976, pp. 80–95.

15. Cf. Martin Damus, *Sozialistischer Realismus und Kunst im Nationalsozialismus* (Frankfurt am Main, 1981) especially pp. 7ff.

16. Cf. Matthew Baigell, *The American Scene: American Painting in the 30's* (New York, 1974), see especially pp. 55ff.

17. Matthew Baigell, 'The Beginning of "The American Wave" and the Depression', *Art Forum*, Vol. XXXVII, 4, Summer 1968, p. 338.

18. The circular is translated in John E. Bowlt, *Russian Art of the Avant-Garde. Theory and Criticism 1902–1934* (New York, 1976) pp. 268–71, at p. 268.

19. Quoted from Baigell, op. cit., note 24.

20. Thomas Hart Benton, 'Statement' in John Baur (ed.), *New Art in America. Fifty Painters of the 20th Century* (New York, 1957) p. 131.

21. The Quotations from Hitler and Trachtenberg are taken from Baigell, op. cit., note 23. The Writers' Congress was held in 1935, the Artists' Congress in 1936.

22.  T.V. Smith has touched upon aspects of what one might somewhat cautiously call 'the cult of personality' around Roosevelt in connection with a discussion of the ideological mobilisation to do with the 'New Deal', cf. the article 'The New Deal as a Cultural Phenomenon' in F.S.C. Northrop (ed.) *Ideological Differences and World Order* (New Haven, 1949) pp. 208–28.

23.  Katerina Clark op. cit., and Hans Günther, *Die Verstaatlichung der Literatur. Entstehung und Funktionsweise des sozialistisch-realistischen Kanons in der sowjetischen Literatur der 30er Jahre* (Stuttgart, 1984).

24.  It is presumably unnecessary to say that there are also many exceptions to this. Nobody would seriously contest the professional integrity of the 'great' Soviet art historian, Mikhail Alpatov. Many of his analyses of Western European art have in fact formed or contributed to the formation of schools of thought among non-Socialist art historians in Western Europe.

25.  With the terms 'institutional theory of art' and 'Socialist Realism as institutional practice' I am not primarily alluding to the so-called 'institutional theory of art' as outlined and developed by George Dickie in *Art and the Aesthetic. An Institutional Analysis* (Ithaca and London, 1974) and Arthur C. Danto in 'The Artworld', *Journal of Philosophy*, 1964, pp. 571–84. Although many contributions to the still intense discussion about the relevance of a specific 'institutional theory of art' come close to points which are of relevance to the Soviet art scene (cf., for instance, Jeffrey Wieland's 'Can there be an Institutional Theory of Art?, *Journal of Aesthetics and Art Criticism*, XXXIX, 4, Summer 1981, pp. 409–17) it is not primarily the philosophical aspects of an institutional theory which interest me, but the possibilities for a historical concretisation of – in this instance – the actual institutionalisation of Soviet art.

26.  In the case of Soviet literature, Hans Günther has suggested a partly similar and partly different distinction between levels and discourse types. Cf. Günther, op. cit., pp. 170ff.

27.  For details, see my article 'Artists well Organised', *Slavica Othiniensia* 8, Slavonic Department, University of Odense, 1986, pp. 3–23.

28.  K. Sitnik, 'Ogyust Renuar', *Iskusstvo*, 1941, 1, pp. 58–66.

29.  K. Sitnik, 'Narodnyi chudozhnik', *Iskusstvo*, 1949, 5, pp. 57–70, at p.68.

30.  A. Zotov, 'Za preodolenie perezhitkov impressionizma', *Iskusstvo*, 1950, 1, pp. 75–80, at p. 80.

31.  During the *Zhdanovshchina* Gerasimov was chairman of the *Orgkomitet Soyuza Sovetskikh Khudozhnikov*, president of the Soviet Academy of Arts, member of a consultative body of the Art Committee and co-editor of *Iskusstvo*. For further information about the role of Gerasimov in the artistic bureaucracy see my article 'Artists Well Organized, op. cit., pp. 17–19.

32.  Two exhibitions are of special interest in connection with the 'Staliniana': 'Stalin i lyudi sovetskoi strany v izobrazitel'nom iskusstve', which opened on 23 December 1939 as a contribution to the celebration of Stalin's 60th birthday, and 'I.V. Stalin v izobrazitel'nom iskusstve',

which opened on Stalin's 70th birthday, 21 December 1949. The latter received considerable attention in the art press, including two major articles in *Iskusstvo:* 'Stalin i socialisticheskaya kul'tura' (1949, 6, pp. 3–28) and the review, 'Neissyakaemyi istochnik tvorcheskogo vdochnoveniya' (1950, 1, pp. 3–20). Both the catalogues and the articles contain large number of illustrations.

33.  See, for example, the 'classic' account by Roy Medvedev, *Let History Judge* (New York, 1973) especially pp. 71ff. and 498ff.

34.  Ibid., p. 509f. for a discussion of the origin of *The Foundations of Leninism*.

35.  For a discussion of the religious symbolism in Socialist Realism see, for instance, Lars Kleeberg and Sixten Ringbom, 'V.I. Lenin in Smolnyj' and' The Second Coming', *Russian History/Histoire Russe*, 1984. I have tried to survey the problem in a paper 'Christian Iconography as a Source of Socialist Realist Imagery' (forthcoming).

# 9 The Avant-Garde and Art of the Stalinist Era

## Vassily Rakitin

In the 1930s, this subject was called 'Formalism and Socialist Realist Art'. The term 'Formalism' referred to a wide range of artistic phenomena from Post-Impressionism to Abstraction.[1]

Some artists were accepted into Socialist Realism and others were not. It was necessary to earn a place in this new Noah's Ark, to go through an examination of ideological faithfulness to the Stalinist regime. Any contacts with avant-garde art were completely rejected. Only artists of the former left who could show that they had completely broken with their disgraceful past made their way into the ranks of Socialist Realism.[2] Numerous articles of the 1930s – among their authors are the ideologues of the current Academy of Arts of the USSR, V. Kemenov, P. Sysoev, and A. Lebedev – maintained that the legacy and experience of 'left' art was a manifestation of hostile ideology.[3] Let us note that this condemnation occurred before the famous directives in *Pravda* in 1936. The decisive turning point in the attitude towards the avant-garde had already occurred in 1933. The anniversary art exhibition 'Artists of the RSFSR: 15 Years', first opened not in Moscow, but in Leningrad on 17 November 1932. Its layout – the curator was N. Punin – was organised by groupings and directions. That is, it tried to give a realistic picture of artistic life. In 1933, the exhibition travelled to Moscow, the capital of the Soviet Union, where it opened on 27 June, and here the entire exhibit was markedly and fundamentally changed.[4] It was no longer an attempt at an objective showing of what had been done during 15 years. Its subject became the battle for the establishment of the new thematic realism. The space allotted to 'left' art was sharply reduced, and it was displayed as a negative example in a separate hall. According to one of the curators, G. Kaganskaya, this hall was immediately dubbed the 'black room'.[5] I remember that already at that time, 'left' works were usually hung in museums with negative explanatory plaques of the type: An example of art in the Age of Imperialism.[6]

The then-popular booklet, *On Formalism in Painting*, by Osip Beskin, was published in 1934. However, it was based on a 1933

article and a lecture given at the Moscow Union of Artists.[7] The
author of this booklet was not just any critic of these years; one might
say that he was the General of all the critics. During the 1930s,
Beskin was the chief editor of the journals *Iskusstvo* and *Tvorchestvo*.
I will not discuss here the philosophical level of Beskin's publications.
He did not write theoretical works; rather, he carried out a difficult
task for anyone who likes art: the task of dividing artists into 'pure'
Soviet and 'impure', that is, potentially not Soviet formalists. The
incompatibility of the new Socialist Realism with the old 'left' art was
thus demonstrated and seemed to have become an axiom forever. It
determined the selection of works for exhibitions, the system of
government orders and prizes, and the character of museum exposi-
tions: in 1936 all 'left' art was taken from the halls of the Tretyakov
Gallery and the Russian Museum and put into the reserves. In 1947
there was a plan to take it out of the Russian Museum to the
Solovetsky Monastery on the White Sea, that is, to send it into exile.
Fortunately, this project was never realised. In the 1950s and 1960s,
Western historians of the avant-garde did not question the incompati-
bility of the avant-garde and Socialist Realism. I mean such authors
as Waldemar George, Herbert Read, Michel Seuphor and, of course,
Camilla Gray in her book, *The Russian Experiment in Art*.[8]

Such an attitude towards the problem of the interrelation of the
avant-garde and Socialist Realism inevitably had to be broken down.
The rehabilitation of the avant-garde in the Soviet Union during the
1960s and 1970s could proceed only by way of adaptation and
accommodation of the avant-garde to the general ideological schemes
of Soviet art history. It was necessary to co-ordinate the history of the
avant-garde with the so-called mainstream line of growth, that is,
with the assertion of Soviet themes and the principles of Party spirit.

The artistic route of Mayakovsky into the Soviet era interpreted
superficially and romantically, was taken as a model. Mayakovsky
underwent a tragic evolution from rebel, avant-garde poet and
revolutionary to orthodox agitator and propagandist of the spirit of
Stalinism. Stalin expressed his gratitude to the poet posthumously, as
it were, by declaring him the greatest poet of the Soviet era. It had
been necessary to demonstrate that blind submission to the dogma of
the period was naturally the correct route. Of course, Malevich,
Tatlin and Filonov are turned into orthodox Soviet artists with great
difficulty, but in each instance – where there's a will – it is possible to
find something acceptable. The avant-garde, in its ambitions, lay
claim to the lofty problems of the spirit, as well as to a reworking of

the entire spacial environment: street, home, cup and clothing. Thus, it was easy to view part of their comprehensive universal concept as the whole. A paradoxical situation resulted: Kandinsky was propagandised as a painter of cups and Malevich as an illustrator of shoes. The main concerns were spoken of only in passing: 'There is nothing there that is puzzling or strange: no more than training in order to beautifully decorate a cup'. Of course, I am exaggerating; however, this caricature has a bearing on Soviet artistic clichés. What inspires the new Soviet adherents of the avant-garde? That the avant-garde was no worse than the Socialist Realist models already acknowledged as classics. That is, Tatlin is no worse than Brodsky with his numerous standardised images of Lenin.

Naturally this recognition of the avant-garde was given out in limited doses. But in exhibitions and books oriented towards Western viewers and readers, more and more often it is precisely the avant-garde that appears as the true Soviet art. It is remarkable, for instance, that a one-person show of Malevich could travel to Düsseldorf in 1980 or that paintings by Kandinsky from Soviet museums were shown in Paris at the Pompidou Centre and in Italy. But there was a significant progandistic element in these shows. They created the illusion of wide recognition of this art in the Soviet Union at a time when similar exhibitions were not being organised there, and books publicising these artists were not being published.[9]

I repeat that all of this often happened and happens out of the best intentions. At first, for convenience, the avant-garde was put on equal footing only with the agitational art of the revolution, after that it was equated with the concept of a genuine Soviet art. In the same way, from asserting its equality with realistic tendencies it changed into a virtual assertion of the ideological unity of artistic culture in the Soviet era. And once all was equal in the light of a general ideology, could the avant-garde and classical Socialist Realism be but two sides of one coin? Yet the direct propaganda of the avant-garde led to its rejection anew in various intellectual circles.

A new logic of evaluating the avant-garde began to form on the reverse principle. The argument goes like this: they gave us much documentary material on the avant-garde and attempted to prove that it was one course among the main tasks of Soviet art. Official art criticism today cannot speak directly of Stalin or Stalinism; in essence, even using such abstract terms as the 'cult of personality' of Stalin is forbidden. But it is impossible for us not to see a reflection of Stalin's totalitarianism in classical Socialist Realism. And so does not

the avant-garde, too, share in the responsibility for this ideology, since it shared the general ideological principles of Soviet art? From the uninspired, mechanical and rationalistic squares and red wedges there was a direct route to a soulless and unthinking man-screw whose creation Stalin and his comrades-in-arms worked on not without success.

This poorly concealed disappointment in an avant-garde that was apparently alien to humanism can be sensed now in the Soviet press and in the Russian press abroad. I mention as examples articles, similar in their arguments, by two very interesting authors: Vadim Kozhinov in Moscow, the author of one of the very few works on the character of avant-garde aesthetics,[10] and Naum Korzhavin, a wise and cultured poet whose work appeared in the Parisian journal *Kontinent*.[11] Soviet researchers and historians of the avant-garde in the 1970s diligently strove to align the history of the avant-garde with the prepared schemes of the history of Soviet art. But the intellectual backlash to these straightforward schemes also entered into the standards of Soviet art history. In a certain sense, it is possible to consider the predecessor of these new critics of the avant-garde as such a strongly intellectual and persuasive orthodox thinker as Mikhail Lifshits. In the 1930s, Lifshits was the intellectual centre of the journal *Literaturnyi kritik* and an expert on European Marxism. But in the 1970s, he was the sharp opponent of modernism in the Academy of Arts of the USSR. The works of Lifshits, for example, the book *Crisis of Ugliness*,[12] which uses European modernism as its example, express his view that distortions of humanism brought about the triumph of National Socialist ideology. Roughly speaking, according to Lifshits, Picasso, the Bauhaus and the Expressionists were all to blame for Hitler. They are guilty, says Lifshits, to the extent that they destroyed classical Renaissance vision and, conse-quently, classical Humanist consciousness. In the Russian-Soviet variant it was only necessary to replace these names by Malevich, Vkhutemas, Rodchenko and Tatlin. Of course, this is not to pass off Soviet culture of the 1930s as a kind of salvation of world humanism, as Lifshits does, but to put Stalinism honestly in the same position as National Socialism. For a Western writer the expression of these ideas is easier. In the Soviet vocabulary, the term Stalinism is remarkably absent, but it can be replaced by less offensive termino-logy at times, for example, the years of the first Five-Year Plan. Be that as it may, here we are aiming for poster-like clarity. Thus, yesterday we had an avant-garde agitational art of the Revolution, a

utopia, and an intellectual fashion. The Stalinist political regime
profited by a certain concept of the Revolution. Today the avant-
garde, too, is considered a route to totalitarianism. But we are not
taking into account the fact that we are talking about a phenomenon
which arose in a battle for the self-sufficiency of art, of the artistic
idea and personality, just as no attention is being paid to the
ideological profiteering associated with the concept of revolution.

The time of greatest activity of the avant-garde was 1914-21.
Stalinism officially began in 1924. In the 1930s, the country had
already become an empire Socialist in form and slave-holding in
content. Many of the avant-garde artists were still alive at the time
and continued to work. But only one-sided conclusions can be drawn
from the fact of their physical presence in the Stalinist era. We are
always reassured that nothing terrible happened; despite individual
mistakes and temporary difficulties, the avant-garde kept pace within
Soviet art. Alexander Drevin and Gustav Klutsis did become victims
of the Stalinist terror,[13] or more precisely the genocide against the
Latvian emigration, but Klutsis succeeded up until that point in
drawing a fair number of enthusiastic posters showing the leaders on
the platform of the mausoleum.[14] Another student of Malevich,
Nikolai Suetin, not only continued work in the Leningrad porcelain
factory, but directed the decoration of Soviet pavilions at the World's
Fair in Paris in 1937 and in New York in 1939, very official pavilions,
we may add.[15] The names Alexander Rodchenko, Varvara Stepa-
nova and El Lissitsky were listed as designer-decorators in an
illustrated propaganda pamphlet entitled *The USSR Under Construc-
tion,* which was meant for the progressive Western community. Of
course, the very same Rodchenko, along with Filonov, were unjustly
criticised for formalism. But no one arrested them. Neither
Matyushin nor Malevich died in Siberia in a camp, but in their own
homes. And Tatlin was even honoured with a Stalin prize for stage
designs for the 1943 production of *Glubokaya razvedka* (Deep
Mission) at the Art Theatre.

The almost idyll, near harmony in the relations of the former
avant-garde with the period really are the true facts. But their
interpretation and the conclusions drawn from them contradict the
spirit of Soviet culture and the logic of its history. The genesis of
Socialist Realism can be explained in various ways – as the growth of
realistic tendencies, for instance, and as their profanation. A ques-
tion can be raised as to the relation between sincerity and deception
in its romantic zeal. And so on. But primarily, Socialist Realism goes

back to the policy of the Party in the sphere of culture. This policy also determined its attitude to the avant-garde.

It is naive to explain the considerable emigration of avant-garde artists from Soviet Russia as the result only of personal circumstances and coincidence; that is, people were not just leaving the homeland, they were leaving the government, which was preparing to set up its unprecedented social experiment. Many left who had been very active in cultural life during the Civil War, such as Ivan Punin, Marc Chagall, Vassily Kandinsky, Naum Gabo, Anton Pevzner, Alexandra Exter and Pavel Mansurov. Why? Chagall formulated the reason succinctly in his autobiography, *My Life*: 'They don't need me'. Artists, out of experience and intuitively, already knew that they were not simply unneeded, but that they were not possible in the culture that the new ideology wanted to organise. Already in February 1919,[16] the Party led a constant and consistent battle against the avant-garde. Monuments in the Cubist style were forbidden. The now-famous *Realistic Manifesto* by Gabo and Pevzner (1920) was banned by the authorities the day after its release.[17] Lenin ordered Lunarcharsky to search out 'reliable anti-futurists'.[18] The Party wanted an official illustrative art.

Of course, for those who left, it was easier; they could say they didn't understand the new conditions. But what about those who didn't leave and who well understood the new reality? What was their pattern of behaviour and their understanding of the interrelationship of art and the government during the early Stalinist period in the 1920s? In one of the debates Malevich said that the situation for innovative art was worse than before the Revolution. Tatlin agreed with him, although he softened Malevich's sharpness by adding that it had not always been easy before the Revolution. The weekly publication *Zhizn' iskusstva* (The Life of Art) gave a short account of this without any kind of commentary.[19] Pre-revolutionary society vacillated between curiosity and indifference towards the new art. The new society's aggressive attention to the avant-garde artist who was not doing what was expected of him was dangerous.

Art was regarded as a form of ideology. And, in order to avoid severe ideological control, Malevich tried to secure the status of a scientific institution for the Institute of Artistic Culture. Of course, even this status did not free him from the necessity of defending his search for an absolute plastic form with pseudo-sociological phraseology. Occasionally, this profanation of social loyalty reached the point of anecdote. Only the regular committee came to the institute

to check its work. An assistant to Malevich, R. Pavlov, recalls that a common plaster figure of Lenin, that had been bought in an ordinary stationery store was placed on the arkhitekton. When the committee left, the statuette was laughingly taken down and put away until the next unpleasant official visit.[20]

For three years the adherents of absolute art – Malevich and his students, Matyushin and his students, Pavel Mansurov, and at one time Tatlin and Filonov – found refuge at the Leningrad Institute of Artistic Culture. But naturally such an artistic preserve could not exist for long. Because of a scandal, at the end of 1926, the institute, considered un-Soviet and unneeded by the Soviet government, was closed. Was it because of the intrigue and the envy of colleagues, was it a mistake by one of the cultural functionaries? Over 50 years after the demise of the Institute I spoke with one of the active participants in the event, the art critic, Sery. He had been a member of the committee to investigate the work of the Institute. While they were working, Sery took a number of monographs from Malevich, who possibly was hoping that this time everything would go more or less successfully. Now a bibliophile, Sery gladly showed me these rare brochures. However, he said with conviction that everything had been done correctly, he wasn't retracting a word of his provocative article about the Institute, 'A Monastery Under Government Subsidy', which was published in *Leningradskaya Pravda*, the newspaper of the city Party Committee.[21] All that had been done was proper, he said, 'We wanted to build a Soviet art, the institute broke down the youth, diverted them from the tasks of classical art'. Under the conditions of a totalitarianism that was growing stronger year by year, even a quiet disengagement was reprehensible. The norm became an absolute submission to the dogmas of the new ideology.

I also remember several other episodes in the history of the interrelationship of the Party leaders and the avant-garde. Already in 1927, the first Party-sanctioned destruction of the new art occurred in Leningrad: several works from Pavel Filonov's School made for the Dom Pechati (House of the Press) were destroyed. The Russian Museum's attempts in 1929–30 to obtain official permission to open an exhibition of Filonov's works were unsuccessful. At the same time in Kiev, the censor banned an exhibition of Malevich and the Tretyakov Gallery had to reject a plan to organise an exhibition of Rodchenko. In 1932 the Moscow Museum of Fine Arts organised a showing of a model of Vladimir Tatlin's flying apparatus; it elicited a heated discussion. But the discourse was about the problems of

aviation; the project was not recognised as a remarkable work of organic artistic culture. Moreover, it was displayed as an example of the mistaken route of the artist, the alienation of his work from the tasks of art.[22]

Thus we are continually running into historical oddities: The avant-garde participated in the artistic life of the 1920s and the early 1930s somewhere on the periphery, and they are reflected in this life as negative figures who did not comprehend the historical objectivity of the artistic process taking place. But even worse than that, some contributed to contemporary Western formalist art. A further oddity is that it was precisely these peripheral phenomena which determined the first-rate level of art in the 1920s in the Soviet Union.

Let us recall again that art critics of the 1960s and 1970s attempted to overcome these contradictions, reducing the complex of the avant-garde to the practice and psychology of agitational art, the theories of Lef and the phenomenon of production art. Through this prism, they began to examine whether the other component parts of the avant-garde movement were necessary or not. The one-sidedness of this is apparent. Their simplified considerations of the very models of a social 'left' art became similarly evident. Already in the 1920s Boris Arvatov had carried out the similar operation of dividing the avant-garde into a necessary and an absolutely unnecessary (Malevich, Kandinsky, Filonov) art.[23] Arvatov, Aleksei Gan and Sergei Tretyakov are interesting even today in their glaring extremism and no less glaring inconsistency. Sometimes, and not altogether rarely, their slogans were more than anything an aesthetic provocation of the artistic milieu and an 'artistic deception of the Party patrons of the art'. Even more often, today's authors call upon the clear social cynicism of Osip Brik.[24] In December 1917 Brik spoke out as the organiser of protests against the Bolsheviks, but in a year he was already a collaborator of the Chekists. For him, to observe the destruction of the intelligentsia was an intellectual experiment as, for instance, Fascism was for the prominent French writer, Louis-Ferdinand Céline.

In practice, the artists who were practitioners of the 1920s left agit-art, a Rodchenko or Lissitsky, have much less in common with leftist sociological hypotheses than has been supposed. For them, ideology was one of the functional given qualities of a work, but not the end in itself. They were fascinated by a new visual culture, but their works are obviously closer in spirit to Mies van der Rohe, Le Corbusier, De Stijl, Art and the Bauhaus than to leftist theories.

Their art is a sign of a civilisation that did not originate in the USSR and that is thoroughly alien to the Soviet model of life. This art is an energetic, free force, intended for the participation of free, active persons. In the 1930s the Soviets assigned the viewer the role of an extra in its deceitful idyll, the Party and governmental ideal. One of art's ideologically important tasks was to cover the complicated reality with showy and pretty decoration, just as the Stalinist Constitution, which was in many of its points democratic according to the words, concealed the lack of a real, living democracy in the country. Insofar as this art was working with a certain abstract ideal, it is logical to define Socialist Realism as Social Classicism,[25] but since it is only a simulation of classicism, it might better be called kitsch. The enormous statues of leaders on the locks of canals, built with the slave labour of prisoners, and the paintings of splendid collective farm holidays, painted at a time of famine in the countryside, and the deceitful and poster-like primitive historical canvases – many, very many bear the organic stamp of kitsch. The new Party patron of the arts, and the consumer of culture are reminiscent of Monsieur Jourdain from Molière's *Le Bourgeois Gentilhomme*. Jourdain was surprised that he spoke not in ordinary words but in prose. The new Soviet man wanted to hear only odes . . . Malevich, in a letter to Lenin as early as 1920, protested against the narrow-minded, philistine position of the Bolsheviks in art; he called it a 'philosophy of shoemakers'.[26]

In one of the discussions of the *Pravda* articles in 1936, the first commissar of art under Lunacharsky, a former Parisian émigré artist, David Shterenberg, spoke to the point: 'It's good that Malevich died. Otherwise you would harangue him about the "black square" '.[27] As a whole, the avant-garde under the totalitarian political system in many ways voluntarily left the proscenium of artistic life, but they didn't yield, and didn't reject their free art for the sake of a philistine Socialist Realism.

Tatlin's speech at the discussion of the *Pravda* articles was expressed almost as a challenge: 'I will not disavow my old works'.[28] He publicly named as his teacher Mikhail Larionov, who had already been living in Paris for some time, which, in the usual Soviet terminology meant almost 'non-returnable' (Larionov went to work with Diaghilev during the First World War and decided never to return to post-revolutionary Russia.) In his own small studio, Tatlin drew trees and flowers, but not leaders or parades.

Students of the Academy of Arts in Leningrad were expelled if it was found out that they had visited Filonov's studio.[29] In the years of terror, Filonov turned to the fantasies of the nineteenth century thinker Nikolai Fedorov, which concerned the resurrection in the cosmos of all the dead of past generations. During the blockades the future president of the Academy of Arts, Vladimir Serov, deprived a sick artist, the formalist Filonov, of a supplementary ration.[30] Alexander Rodchenko unexpectedly even for himself, returned to abstraction in the years of rejection of not only non-objective work, but even of the most inoffensive Cézannism.

In Leningrad, individual students of Malevich, Matyushin and Filonov comprised practically a secret artistic circle. They worked together and discussed each other's works, following the lessons of their teachers. The work of these artists, such as Tatyana Glebova, Alisa Poret, Lev Yudin and Pavel Kondrat'ev, differed sharply from Socialist Realism. In the 1930s the very rejection of official thematic painting and the turning to a world of small intimate art was seen as the right of the individual to his own inner life and as a quiet protest against conformism.[31] Thus, the question about the fate of the avant-garde and about contemporary trends in art generally, logically brings us to a new, interesting historical and cultural problem, that is, the theme and tradition of the outsider in the art of the Soviet period.

## NOTES

1. Let us note the constant tendency in the Soviet era to a widening of the understanding of 'formalism'. In 1936–37, it included V. Favorsky and his school of graphics which combined Realism with elements of Cubism. At the end of the 1940s, Impressionism was also included.
2. Of the best artists of 'left' art, not one was awarded the honour of being included in the so-called 'Gold fund' of Socialist Realist art.
3. As a characteristic example of the new demagogy in art criticism, we might point to V. Kemenov's article 'On Pseudo-nationalness in Art' (*Literaturnaya gazeta*, 16 May 1936), in which he disclaimed whatever link might have existed between the striving of the avant-garde and national art.
4. Much material on both exhibitions is contained in the journal *Iskusstvo* for 1933 (numbers 1–6).
5. Discussion in February 1978. The husband of G.E. Kaganskaya – N.M. Shchekotov – was the Secretary of the governmental commission to organise the exhibition.

6. This was done in the Tretyakov Gallery in Moscow and in the Russian Museum in Leningrad, where the exhibits in the show 'Art of the Age of Imperialism' were without exception accompanied by a text that characterised them negatively.

7. O. Beskin's article 'On Formalism in Painting' was published in the journal *Iskusstvo* (1933, no. 3).

8. Camilla Gray, *The Russian Experiment in Art 1863–1922* (London, 1986).

9. For instance, Kandinsky's centennial was not recognised in the Soviet Union; Malevisch's in 1978 unaccompanied by even a small exhibition.

10. 'Estetika avangarda' is in a collection dedicated to the 75th year of Prof. Pospelov: *Stil'. Napravlenie. Metod* (Moscow, 1976).

11. N. Korzhavin, 'The Psychology of Enthusiasm', in *Kontinent*, nos. 8–9.

12. M. Livshits, *Kriziz bezobraziya* (Moscow, 1970).

13. Drevin was executed in 1938 and G. Klutsis died in a camp in Kazakhstan in 1944.

14. On the work of G. Klutsis in the Stalinist era, see L. Oginskaya, *Gustav Klutsis* (Moscow, 1975) and also V. Rakitin, 'Gustav Klutsis: Between the Non-objective World and World Revolution', in *The Avant-garde in Russia, 1910–1930: New Perspectives* (Los Angeles: County Museum of Art, 1980).

15. In the account of the mounting of the Soviet pavilion at the Paris exposition in 1937, it was pointed out: 'visitors will receive an idea of the system' [that is, of the Soviet political system – V.R.]. Except for the Soviet pavilion, such an openly ideological approach, in the opinion of the authors of the account, was observed only at Italy's pavilion – 'Tributes to the IDEL – the principles of Fascism'. The critique of the German pavilion is also notable: ' At the exhibit Fascist Germany . . . avoids showing the world the "achievements" of its system'. Quotation from I. Ryazantsev, *Art of the Soviet Exhibition Ensemble, 1917–70* (Moscow, 1976) p. 109.

16. The conflict between the new government and the avant-garde arose first of all out of the rejection by Party functionaries in Moscow and Leningrad of the devices of 'left' art in the decoration of city streets and squares for various revolutionary holidays and manifestations.

17. The exhibition of Gabo, Pevzner and G. Klutsis was also closed right away. The 'manifesto' had been published as a broadside for the opening of the exhibition.

18. V.I. Lenin. Note to M.N. Pokrovsky from 6 May 1921. Published in the *Complete Works*, vol. 52, p. 180 and cited from *V.I. Lenin and Fine Arts – Documents, Letters, Memoirs*, V. Shleev (ed.) (Moscow, 1977)p. 445.

19. *Zhizn' iskusstva* (Petrograd, 1923) no. 8.

20. Discussion with V. Pavlov, 1970.

21. Discussion with G.M. Sery, Leningrad, November 1970. The article 'Monastery Under Government Subsidy', published in the newspaper *Leningradskaya Pravda*, 10 June 1926.

22. The title of the article by E. Kronman on the exhibit is symptomatic: 'An Exit into Technology: Tatlin and Letatlin', *Brigade of Artists*

(Moscow, 1932) no. 6, pp. 19–23.

23. See, for example, his article 'Two Groupings', *Zrelishcha* (Moscow, 1922) p. 8.
24. V. Shklovsky said in *Tret'ya Fabrika* (Leningrad, 1927) that if Brik had had both legs cut off, he would prove that it was comfortable without legs.
25. V. Weidlé, *Art Under the Soviet Regime – Studies on the Soviet Union*, Munich, vol. 7, no. 2, November 1981, pp. 135–51.
26. There is a reference to this circulating letter (today we would call it samizdat) in B. Arvatov's review of Malevich's book *Bog ne skinut* in *Pechat' i revolyutsiya* (Moscow, 1922) no. 7, pp. 343–4.
27. There is a stenogram of the discussion of the *Pravda* article on formalism, which took place in the Moscow department of the Union of Soviet Artists, 29 February and 13 April 1936. Typescript, private archives.
28. Ibid.
29. See the memoirs of O. Pokrovsky. Typescript, private archives, Leningrad. A copy of the memoirs is also in the archives at the Pushkinskii Dom in Leningrad.
30 Discussion with P.M. Kondrat'ev in January 1983 in Leningrad.
31. As P.M. Kondrat'ev said, 'the method saves us'.

# Part III
# Literature

# 10 Education and Conversion: The Road to the New Man in the Totalitarian *Bildungsroman*

Hans Günther

Until today the problem of totalitarian literature and art has been looked at almost exclusively from a political point of view. The main focus of interest has been on the mechanisms of 'Gleichschaltung', the forcing into line during the 1930s. In Germany, for instance, it was initiated by the 'Reichskulturkammergesetz' of September 1933 and, in the Soviet Union, by the Central Committee's resolution of 1932 which dissolved existing artists' associations and replaced them by centralised organisations. Consequently, the controlling function of literary criticism and censorship as well as the repression of deviant authors and movements have been considered the most important aspects for scholarly examination. There are, however, hardly any comparative studies of concrete examples, and those which do exist are mainly concerned with art (rather than literature) since parallels between National Socialist works and the Socialist Realism of the Stalin period seem patently obvious there.[1]

The analyses that follow aim at establishing traits of a totalitarian aesthetics and structural correspondences of texts of different ideological provenance. The term 'totalitarian' will not be used in the sense of 'a global theory of totalitarianism', but in order to denote comparable artistic structures and their psychological effects. This, of course, necessitates a complex approach, since differences in the cultural, ideological and artistic situation and tradition, as well as structural and functional similarities, have to be taken into consideration.

Two novels of the early 1930s will be compared: *Der Hitlerjunge Quex* (1932) by Karl Aloys Schenzinger and *How the Steel Was Tempered* (1932–34) by Nikolai Ostrovsky. Both novels represent

early expressions of the norms required in their respective countries. A few years after their publication both were generally regarded as prototypes of their genre. Ostrovsky's novel illustrates the transition from a mainly autobiographical and documentary Five-Year Plan literature to Socialist Realism and its artistic generalisations.[2] It became immensely popular in the Soviet Union after the author's death. Schenzinger's text, which was turned into a successful film in 1933, describes the fighting period of the early 1930s prior to Hitler's coming to power and functioned as an exemplary model of youth literature in the Third Reich.[3]

First of all, I should like to give a brief summary of the plots of the two novels. Schenzinger's hero Heini Völker, a 15-year-old working-class boy from Berlin-Moabit, is modelled on the 'Hitlerjunge' Herbert Norkus, who died in January 1932 in a clash between National Socialist and Communist youth gangs.[4] Revolting against his Communist father and the red environment he is growing up in, the boy, having overcome the fear of his father and the Communist youth gang, joins the Hitler Youth organisation. After the suicide of his mother he feels abandoned and rises to the rank of personal assistant to the group leader. He takes over the command of the Hitler Youth comradeship in Moabit although he has to reckon with the possibility of his former comrades taking revenge on him. In the end he is badly wounded in a Communist attack and sacrifices his life for the movement.

Ostrovsky, on the other hand, who was not a professional writer, based his novel mainly on autobiographical material. Within a few years editorial work on the text changed its form considerably and turned it into an exemplary life-story of a young Bolshevik hero.[5] Ostrovsky's hero Pavel Korchagin, who comes from a working-class family, is forced to earn his living when still quite young. He experiences the injustice of the old system and the atrocity of the Russian Civil War, in which he fights for the Red Army and is seriously wounded. Later he becomes a member of the Communist youth organisation and joins the Party. During the period of the New Economic Policy and the industrialisation of Russia he fights against various deviations and enemies within, such as the workers' opposition, the Trotskyists, demoralising effects of the New Economic Policy, and so on. Due to his failing health – his war wounds gradually lead to blindness and paralysis – he has to give up the fight for a Socialist economy. He suffers a crisis but recovers by writing down his life-story in the service of his Party.

A first glance at the development of the two heroes indicates completely different development periods. The portrayal of Korchagin's life begins in 1916 and ends in the early 1930s. It covers a period of about 15 years, whereas in *Hitlerjunge Quex* all the action takes place during a few months in the summer of 1932. This is not merely a formal difference since it manifests the utterly different paths of development of the two heroes. Pavel Korchagin goes through a long process of learning and education, which leads from spontaneity to Party-mindedness and discipline. Heini Völker, on the other hand, experiences a sudden change, which gives his life a new direction. Pavel's development is influenced by various ideological mentors, who explain the course of events to him. The revolutionary sailor Zhukhrai is Pavka's first teacher: 'The way Zhukhrai spoke was always clear, plain, understandable and based on simple words. There were no unsolvable problems for him. The sailor knew exactly which way he had to go and Pavel began to realise that the whole tangle of different parties with impressive names – Social Revolutionaries, Mensheviks, Polish Socialist Party – were all bitter enemies of the workers and that there was only one revolutionary party which fought unwaveringly against the rich – the party of the Bolsheviks' (Ostrovsky, p. 101).[6]

In Heini Völker's life living examples figure prominently. There is, for instance, the leader of the group, Kass who abruptly changes his adventurous and aimless life after meeting the Führer: 'Hitler spoke to me for half an hour. He actually got out of his car and spoke to me, Egon Kass from Kannerstrasse. Suddenly I knew where to go. Then I went on with the lads. Boy, then I really saw the light!' (Schenzinger, p. 154).[7] Pavel attains self-discipline and ideological growth in a long process of 'tempering the steel'. Already in his boyhood he possesses such positive qualities as courage, a fighting spirit and a sense of justice, but he acts too spontaneously and anarchically. He has to learn his lesson about party-discipline in a long series of conflicts. His development is a process of constant improvement and overcoming of negative character traits. With every test the hero passes he climbs one step up the ladder of consciousness. He soon becomes a teacher himself – first in the Komsomol, then in the Party – and points his comrades in the right direction.

Whereas Pavel Korchagin's development can be described as permanently moving upward, Heini Völker seems to experience an immediate conversion,[8] which becomes the starting point of a radical change in his life. I will quote at some length a passage in which he

leaves the camp of his red gang at night and runs towards a fire of the
Hitler Youth:

> It was a fire! There behind the hill! Distant singing could be heard
> from over there, just audible, a mere wave, it came, faded away
> and came back. What was going on behind that hill? He felt a
> vague longing. [. . .] As he was leaving the camp his steps became
> quicker and quicker, through the forest towards the shining light of
> the fire. Not for a second did he think about what he was doing. It
> felt good to be walking through the night towards this light and so
> he just walked. [. . .] He was blinded by a sudden sharp light,
> quite breathless. He didn't dare to move. He stood and watched.
> Eventually his eyes got used to the light. Around a burning pile of
> wood there were standing a thousand boys, or maybe only a
> hundred, The circle of young people seemed to reach the end of
> the world . . ., 'Deutschland über alles' – a thousand voices rolled
> over him like a hot wave. I am a German, too, he thought, and this
> awareness came over him in a powerful and completely unexpected
> way that he had never experienced in his whole life. [. . .] He
> wanted to join in the singing, but his voice failed. This was German
> soil, German wood, these were German boys, and he realised that
> he was an outsider, alone, helpless, and that he didn't know what
> to do with this sudden great feeling (Schenzinger, pp. 45–7).

The irrational ideology of National Socialism transfers the conflict
entirely to an emotional sphere and a subsequent decision of will. It is
not by chance that 'decision' is one of the key terms of National
Socialist thinking. Interference by common sense is specifically
rejected: 'There was nothing else he wanted to know. He felt that he
wanted to go with these boys . . .' In this and all the other turning
points of the novel important things happen suddenly and unexpec-
tedly as the 'sudden sharp light' which blinds Heini and the 'sudden
great feeling'. Similar to Saul's experience on the road to Damascus,
the conversion is supported by an overwhelming symbolism of light.
The experience produces a 'serious conflict in the heart' of the boy.
The steps he then takes towards the Hitler Youth are based on a
spontaneous decision. This contrasts sharply with rationalistic
Bolshevik determinism, which influences Pavel Korchagin's develop-
ment. His growth consists of an arduous learning process under the
guidance of Party mentors and the attainment of awareness and
understanding of existing necessities.

The different ideological substratum of the two texts determines their structures down to the smallest detail. We have, therefore, two fundamentally different modes of narration. Whereas in *How the Steel was Tempered* the omniscient narrator introduces superior insights and evaluations, the narration of *Hitlerjunge Quex* is largely personalised, that is, it is brought into line with the hero's or another character's point of view. Ostrovsky's narrator knows the laws of history and is therefore able to write sentences like: 'Class warfare raged hard and savagely in the Ukraine' (Ostrovsky, p. 84). He does not hold back from giving his biased judgement: 'The red partisan brigades stormed forward against this rabble of Socialist Revolutionaries and Kulaks'.

In Schenzinger's novel no 'objective' historical situation can be ascertained. The narration is mainly based on the young hero's point of view and conveys his immediate experiences. Internal events are frequently presented by means of indirect interior monologue, as for instance, in the conversion passage: 'Suddenly he saw it all. The comrades were asleep. He could nick a blanket now, he thought, this was a good opportunity. He didn't want to. What was the time? There was a glowing redness in the sky. Was that dawn already? It wasn't the rising sun. The morning sky looked different. It was a fire!' (Schenzinger, p. 45).

Even in numerous descriptions of city life in Berlin the narrator keeps well in the background and delegates his point of view to the collective 'you' of certain social groups: 'This happened literally over night, like all major events in life [. . .]. Who have you been up to now anyway? A nothing, a nobody, just a neighbour, a tenant from Gotzkowskystrasse 86 [. . .]. And now, all of a sudden, you are the centre of public curiosity' (Schenzinger, p. 79). Choosing a point of view inside the hero and other characters – except for the negative ones! – emphasises the experiential and emotional quality of the events. Thus Schenzinger's novel appears to be more modern than Ostrovsky's with its didactic-omniscient narrative mode.

There is an obvious contrast between openly biassed judgements and ideological didactics in Socialist Realist works on the one hand and indirect and subliminal judgements in the National Socialist novel on the other. In *How the Steel was Tempered* the following is said about the sailor Zhukhrai: 'That evening he spoke a lot about the Bolsheviks, about Lenin, and helped them [the youths] to understand what was happening' (Ostrovsky, p. 108). In *Hitlerjunge Quex* all political and ideological aspects are removed and played down. Fritz

Dörries, for instance, concludes his statement about the 'natural community' of the nation and the purity of the blood with the following words: 'You just got to feel it. There's no point in all this blethering' (Schenzinger, p. 63). Heini's experience of conversion leads to an interior conflict, which is described as a victory of courage and a spontaneous decision rather than an ideological insight. Heini knew 'all of a sudden that he would go to Gotzkowskystrasse even against his father's will [. . .], come what may' (ibid., p. 68). Later the group leader Kass tells Heini, who is mourning over his mother's death: 'I don't want you to get into politics. You don't understand what it's all about. [. . .]. You'd better learn how to stop crying when you're told to' (ibid., p. 155).

In the National Socialist novel direct ideological discourse is often replaced by fetishist symbols, which are more or less explicitly decoded in the text. Uniforms especially play an important role. The group leader informs Heini Völker about their significance: 'A uniform is not an ornament or a show piece, my boy. It is the dress of the community, the comradeship, the idea, the integration. [. . .] It makes everyone equal, it gives everyone the same and demands the same from everyone. Everyone who wears such a uniform no longer has a free will, he only has to obey' (Schenzinger, p. 170).

At the beginning of the novel when Heini Völker has not yet joined the Hitler Youth he characteristically admires police and army uniforms: 'They looked so neat, tidy, upright, the leather was shining. They reminded me of the order and discipline one could read about in old stories' (Schenzinger, p. 8). The wearing of uniforms, the 'brown shirt' and so on are motifs which can be found frequently throughout the text. It is a climax in Heini's life when he is accepted as a 'Hitlerjunge' and kitted out with a new uniform – without doubt a heavily symbolic act of ritual initiation.

The symbolism of marching also figures prominently in the novel. It is typical that already before he turns to the Hitler Youth, the young hero feels 'the wish in his heart to join the marching columns' (ibid., p. 8). The essential function of marching in Heini Völker's opinion is revealed much later: 'No longer did he feel lonely. [. . .] He heard the marching steps of the columns and storm troops, commands being shouted, singing; he saw endless platoons marching and masses of people moving, arriving from all directions, they all pressed and pushed forward towards the one goal, he saw the flag, the goal' (ibid., p. 176). Klaus Vondung is right when he describes

the constant mindless and restless movement of National Socialism as an end in itself, since there are 'no concrete goals in evidence; the "permanent movement" is given an irrational ecstatic character'.[9] Heini's Hitler Youth name 'Quex' is derived from the German word 'Quecksilber', which means 'mercury'. It is explicitly linked to the symbolism of movement: 'His activity was movement, movement was necessary for him, a distraction, a soothing, a healing perhaps. He wanted orders, wanted to obey'. (Schenzinger, p. 183). Heini's submission to the movement bears typical features of the authoritarian masochist character with its endeavour 'to escape his unbearable feeling of aloneness and powerlessness'.[10] It is no accident that he takes the final decision to join the Hitler Youth immediately after the severe crisis caused by his mother's suicide. The movement 'heals', or rather represses the mourning for his mother and in fact replaces her.

Finally, I would like to mention the distinctive flag cult in Schenzinger's novel. The flag is highly charged with symbolism since it can stand for a number of other mythical symbols, such as fire, sun or blood.[11] It is not surprising that the blazing red of the flags is emphasised throughout the text. This suggests a closeness to the Communist flag and hints at the temporary collaboration of the two rival parties against the bourgeois state (see Schenzinger, pp. 222–3). The common ground ends when Heini Völker begins to imagine the robbery of the opponents' red flag. On the whole the novel distinguishes very clearly between the two red flags. The Communist one is simply defined as 'red', whereas the red of the National Socialist one very often unfolds in contexts which are connotative and emotionally charged (for instance, camp fires). In the end the fight for the flags between the political enemies is of fateful importance for Heini Völker. In an act of retribution for removing a Communist flag Quex receives fatal wounds. This passage demonstrates the connection between the flag cult and the Nazi myth of 'blood and honour' and emphasises the fetishist significance of the flag. It stands for the empty 'goal' (ibid., p. 176) of the movement. When he is asked what he is fighting for, all Heini Völker can reply is: 'We are fighting for – for a flag' (ibid., p. 206), which earns him scorn and derision from his Communist rival.

Significantly, all Nazi symbols are taken from the military sphere. They indicate that National Socialism does not primarily aim at creating a new political consciousness but at awakening a sense of moral concepts which emotionally already exist. Among them there

are secondary virtues such as order, cleanliness, comradeship, obe-
dience and so on, as well as racial and national instincts, both of
which were excessively glorified during the National Socialist period.

Neither *How the Steel was Tempered* nor any other Socialist Realist
novel shows a comparable tendency to crass fetishism although, for
instance, the red flag figures prominently within the symbolic pool of
Stalinist culture. With regard to the development of the Socialist
novel of education, however, a considerable increase of these tenden-
cies can be seen. The red flag employed by Gorky as a leitmotif in his
description of a workers' demonstration in *Mother* (1906) is an
expression of real Promethean emotion. In Makarenko's *Flags on the
Towers* (1939), on the other hand, the inflationary use of the flag
symbol links up with a military ideology of production and recons-
truction.

In Ostrovsky's novel the dull fetishist symbolism of National
Socialism is replaced by a directly didactic propagation of ideal
virtues as well as political and ideological standards, which clearly
derive from the progressive and emancipatory tradition of Marxist
thinking. Contrary to the National Socialist text, which is based on
emotional appeals, we encounter here a distinctly educational inten-
tion. The development of the young hero involves a number of
exemplary conflicts. Every conflict he withstands leads to an ideal
virtue that is often mentioned explicitly.

Corresponding to Schenzinger's text, the Socialist Realist novel of
education presupposes basic positive qualities for the positive hero.
On this matter Pavel Korchagin's characteristic features are his
proletarian background, his class instinct and hatred of all rich people
as well as his immense determination, his adventurousness, his sense
of justice and so forth. In hard lessons Pavel learns to overcome his
shortcomings, such as his inclination to anarchic behaviour and 'left'
exaggerations. His overall development represents a channelling of
spontaneous impulses in the direction of consciousness. It implies an
increasing narrowing and instrumentalisation of the positive virtues.
This becomes evident when the hero recklessly fights against devia-
tions by enemies of the Party. Despite fundamental differences in
terms of ideological standards and virtues, there is a clear conver-
gence between the two novels: both propagate unconditional dis-
cipline and obedience. Whereas in the National Socialist novel blind
obedience is glorified as a mere end in itself, the Bolshevik variant is
based on the allegedly rational insight into the leading role of the
Party and its knowledge of the 'laws' of history.

A further convergence can be seen in the virtue of 'decency', which manifests itself in the kind of ascetic sexual morality commonly acknowledged as representative of Hitler's Germany and Stalin's Soviet Union. Schenzinger's young hero is repelled both by the loose moral standards of the red gang and at the same time by the 'Hitlerjunge' Wisnewski, whose Slavic name contrasts with Heini's surname Völker (which comes from 'Volk' = 'people') and who later significantly deserts to the red enemy. Heini dreams of Ulla Dörries, the sister of his Hitler Youth comrade, but he prefers to see himself as her heroic protector, without actually daring to approach her.

The strict moral principles of Pavel Korchagin become evident in his relationship with the girl Tonya, who he decides to leave because of her bourgeois individualism.'First of all I will belong to the Party and then to you and all the other relatives' (Ostrovsky, p.91). In a prisoners' camp of the 'whites' he refuses to sleep with the country girl Khristina although she – faced with the prospect of getting raped by the 'whites' – beseeches him to do so. The Komsomol official Rita remains sacrosanct for him despite his difficulty in suppressing 'sinful' thoughts. Later on, the sick Korchagin describes his feelings for his wife Taya Kyutsam. In his view she is a 'pupil and a Party comrade' whom he educates to be a 'new personality' rather than a 'partner and wife' (Ostrovsky, p. 389).

Both novels have martyrdom as a central theme. In *Hitlerjunge Quex* it first appears in the shape of a painting of Herbert Norkus. Wreathed with fresh leaves it hangs next to the Nazi flag in the comrades' home. Later Heini Völker reads with enthusiasm a story about a boy from the Tyrol, who dies during a fight against the French and he feels 'that his life was spilling out' (Schenzinger, p. 214). Also Heini's illusion of two swastika flags with two dead boys lying underneath hints at his own martyrdom. The novel ends with an apotheosis of the sacrificed hero: 'His body was laid out with candles and flags and wreathes. The guard of honour stands there petrified. Outside they are digging a grave right between the dead comrades. The sides of the hole are being decorated with fir branches. [. . .] Behind the bier . . . a hundred flags are flapping and a thousand friends are walking silently to the muffled sound of the rolling drums; everyone knows: he was a good comrade. A few weeks later, again the flags are flapping in the wind, out there in the streets of Potsdam. [. . .] 75000 boys are marching past their Führer with the same flags and with the same song but with beaming faces' (Schenzinger, p. 264). Although it is not stated in so many words, it becomes clear that

the dead Quex experiences a glorious resurrection at the Reichsju-
gendtreffen of October 1932.

As mentioned earlier Schenziger's novel is a variation of the
martyr's legend of the 'Hitlerjunge' Herbert Norkus. In his comment
on Norkus' death Reichsjugendführer Baldur von Schirach pointed
out that there is an automatic connection between ideological martyr-
dom and symbolic immortality: 'This little comrade has become a
myth of a young nation; he is a symbol of the willingness to make
sacrifices which is shared by all the youths who carry Hitler's name.
Many died in the young's fight for the Reich; the name Norkus has
become a byword and unites them all in undying loyalty to the Hitler
Youth. There is nothing that could bind us together as Hitlerjungen
more strongly than the consciousness of our comradeship to this dead
boy; nothing is more alive than this murdered boy; nothing will last
longer than this young life that has just ended'.[12]

It is a well known fact that the motif of ideological immortality
played a crucial role in both the National Socialist and the Stalinist
culture. Stalin, for instance, created a cult of Lenin which was based
on the formula that 'he was more alive than the living'.[13] On closer
examination, however, a fundamental difference between the mar-
tyrdoms of Ostrovsky/ Korchagin and the Hiterlerjunge Norkus/
Quex can be found. The death of Norkus/Quex bears typicals
features of a ritual sacrifice of a boy, which, as stated in a book about
Norkus, was accepted by his comrades, the entire Hitler Youth, the
movement and the Führer.[14]

Contrary to the mythical and archaic form of sacrifice the sacrificial
hero in the Socialist Realist novel represents a kind of ascetic 'heroic
vanquisher' (podvizhnik). He combines quasi-religious ascetic virtues
and features of a Bolshevik hero of war and work. Ostrovsky was
called a saint by André Gide and essential elements of a saint's life
can indeed be found in Korchagin's biography.[15] His development is
a continuous martyrdom in the service of the Revolution. In his
boyhood he has to endure 'many hours of hard labour' (Ostrovsky,
p. 36) and spends 'seven days in sheer agony' (ibid., p. 138) in a
'white' prison. Wounded several times, he comes through the Civil
War in 'pains and tribulation' (ibid., p. 166) and only survives
because of his exceptional 'steadfastness' (ibid., p. 189). During the
building of a railway line he falls badly ill with typhoid. He propa-
gates 'endless endurance' and the type of person 'who can suffer
without letting everybody know' and the type of revolutionary 'for

whom the personal does not count in comparison with the general' (ibid., p. 343). As Korchagin's illness gets worse he progressively becomes a tragic figure. On the verge of suicide, he decides to return to life and write his memoirs. Literary criticism in the Stalin period, however, interpreted the tragic fate of the Bolshevik sacrificial hero in the light of a historical optimism.

To sum up, the following distinctions can be made: whereas Heini Völker experiences a sudden conversion and change, Pavel Korchagin step by step overcomes his anarchic spontaneity and replaces it by awareness. We can distinguish between an irrational decision-making on the one hand, and an allegedly rational determinism on the other. Whereas on the one side the crucial events take place 'abruptly' and 'suddenly', they seem to happen according to the plan of objective reality as understood by the Party on the other side. The personalised mode of narration in the National Socialist novel results in an emotionalisation and depoliticalisation, in contrast to the Socialist Realist novel, where an omniscient narrator presents a comprehensive view of history in which he embeds the plot's characters. In the National Socialist novel ideological discourse is replaced by fetish symbols and secondary virtues, whereas the educational Party-mindedness of the Socialist Realist novel is never concealed.

What are the basic structures of a totalitarian aesthetics in the two novels I am discussing? I would like to look at two aspects in more detail: the recurrent black-and-white schematicism and the development of the heroes. As for the first point, in both novels the constellation of characters is structured according to a dichotomic principle which polarises the characters. In the course of events all characters are assigned to either a positive or a negative group. At the end no-one remains unassigned. The main hero chooses, of course, the positive direction. In *How the Steel was Tempered* polarisation starts during the Civil War and continues in the fight against all kinds of deviants and enemies within the Party. In 'Hitlerjunge Quex' Heini changes over to the 'brown camp' while his mother, who is unable to cross this border, commits suicide.

Both novels show the negative characters only from the outside. They are often presented as members of groups and remain unindividualised. They all share the same negative features as far as their ideology, character and outward appearance are concerned. Heini's opponent Stoppel, for example, does not only support the wrong ideology but is in Heini's eyes also a 'big threatening beast' (Schenz-

inger, p. 19). Ostrovsky describes all political deviants, especially the Trotskyists, as either degenerate creatures or officious bureaucrats. They are never allowed to state their political opinions.

In the Socialist Realism of the Stalin period the black-and-white scheme, which is one of the basic features of authoritarian thinking, was called 'partiinost'. A National Socialist counterpart of this term does not exist, probably because Party-mindedness implies a conscious judgement. National Socialism, however, propagated an instinctive and emotional way of reaching 'decisions'. It already exists in the depth of the racial soul and needs only to be awakened by the movement.

A second point of convergence of the two novels can be found in the parallel development of the heroes. It is a well known fact that the constitutive element of the *Bildungsroman* as a genre is a central hero who passes through a process of self-realisation and social integration in the pursuit of a – more or less clearly defined – goal. This hero is shown as an individual and malleable human being but at the same time he is a model. According to the rules of the genre his inner development is more important than external events.[16] The classic example of this genre in German literature is Goethe's novel *Wilhelm Meisters Lehrjahre*.

The definition of the classic *Bildungsroman* as given above clearly does not apply to the two texts discussed in this essay. The 'new man', a term which is used, significantly, in both ideologies to describe the goal of the development, is not a human being who has matured and gained experience through inner conflicts. In both novels the main emphasis is put on the overcoming of external oppositions. Hitler's motto 'oppositions do not exist to be given in to but to be overcome' makes good sense to Schenzinger's young hero (Schenzinger, p. 57). But the 'triumph of will power' is by no means confined to National Socialism. There is a comparable voluntarism in Stalin's statement that there is no fortress the Bolsheviks cannot take.[17] Spontaneous will power, however, has to be subordinated to the iron discipline of the Party. This is one of the main teachings of Ostrovky's novel.

The path of Heini Völker's conversion to the *Hitlerjunge Quex* as well as Pavel Korchagin's path of education to Party discipline lead to the same goal, namely 'the extradition of the individual to a whole which remains undetermined because it is not legitimised'.[18] Total extradition implies heroic self-sacrifice. As compared to the old one, the 'new man', as a result of conversation and education, has not 'developed' but submitted without reservations to a political organi-

sation and its ideology. 'The new man who was emerging was a man without personality, without a self'.[19] It seems to me that the preference for iron and steel metaphors ('hard as Krupp steel', 'iron discipline', 'steeling of cadres' and the like) which can be found in both Nazi and Stalinist culture as well as in the title of Ostrovsky's book, is highly symptomatic. Experience, education and development are replaced by a process of 'tempering' in terms of ideology and fighting spirit. The final consequence of self-sacrifice and masochistic self-hatred is heroic martyrdom in the service of ideology. In this connection Robert Lifton speaks of 'the inseparable merging of the motif of purity which includes self-denial, self-surrender on behalf of a higher cause, ideological single-mindedness and the urge to eliminate evil with power'.[20] It is no accident that in political religions, which are in competition with the church, quasi-religious martyrs play an important role.

How can we describe the position of the ideological *Bildungsroman* and its specific path towards the development of a 'new man' against the background of its genre? In terms of cultural anthropology, the structure and objective of the genre of the *Bildungsroman* manifest a closeness to initiation rites.[21] Their aim is to make man's passage to a new period of life easier and, once he has passed the test, provide him with an identity adequate to his new status. Compared with literary tradition the ideological novel of conversation and education notably intensifies the elements of ritualisation. A reason for this can be seen in the fact that the original intention of the genre – to demonstrate the self-realisation and social integration of an individual – has been restrained in favour of a gradual submission of the individual to existing organisational ideological structures.

As for the initiation, we can distinguish between collective rituals which are obligatory for everybody and which cause the passage from childhood or adolescence to adulthood, and specific rites which are connected with the joining of secret societies, associations and so on.[22] These forms of initiation can be found in the two novels discussed here. In both texts external events cause an early detachment from the family. The youth is forced to meet the burden of providing his manliness under extremely difficult conditions. Heini Völker revolts against his Communist father, loses his mother and has to assert himself in the fights between political groups in the streets. Pavel Korchagin, too, is forced early on to earn his living and soon gets caught in the turmoil of the Civil War. There are obvious links between premature adulthood and stages in the boys' political

and organisational development. As for Heini Völker this applies to the ritual 'kitting out' as a Hitlerjunge and, later, when he is promoted to the rank of personal assistant to the group leader. Compositionally, both steps of initiation are closely connected with the hero's loss of his mother. The completion of Heini's 'incorporation' (Schenzinger, p. 170) into the movement finds expression in the name Quex, which manifests his new identity.[23]

In Korchagin's development distinctive stages can be established, too. First he works in the Communist youth organisation Komsomol and takes the step from an egocentric to a collective consciousness (Ostrovsky, p. 183) in the red cavalry. For him the act of joining the Party is the 'liquidation of irresponsibility' (ibid., p. 275). It indicates the transition from his role of pupil of the Party to that of teacher which he fulfils in various functions. In both novels the ritualised path of development towards a 'new man' manifests a close connection between an extremely difficult transition from adolescence to adulthood and heroic self-sacrifice in furtherance of the political organisation.

As far as the literary history of the genre is concerned, the two novels discussed here come from fundamentally different backgrounds. At the time Schenzinger wrote his novel in the field of the *Bildungsroman* genre there existed a rather long tradition of splitting up into a trivial line and a high level literature. In the novels of Hesse, Musil, Rilke or Thomas Mann the traditional scheme of organic growth and personal self-realisation is complicated and modified in order to adapt the genre to the new experiences and aesthetic views of the twentieth century. Instead of a continuous growth of the hero these novels are characterised by the introduction of loose mosaic patterns, by elements of disintegration of the personality or of parody. These modifications are obviously due to the insight that this is the only way of coping adequately with the problems of the individual in the twentieth century.

On the other hand one can see an increasing trivialisation of the *Bildungsroman* since the second half of the nineteenth century.[24] The pursuit of harmonious self-realisation and totality leads to simplified teleological constructions. The tension between the growth of the hero and the surrounding reality is abolished in favour of an affirmative solution. It has to be added that the danger of an ideological, harmonising view of the *Bildungstroman* is not only linked with numerous epigonic novels but also with many of the

prevailing normative theories of the genre. Only recent research has contributed to less harmonistic and more adequate picture of the *Bildungsroman*.[25] The widely spread notion that this genre contains, so to speak, a guarantee of the achievement of unbroken totality and harmony explains why the *Bildungsroman* is so often subject to propagandistic abuse.[26]

Apart from being stereotyped and trivialised, the genre developed in the twentieth century a specific form which can be termed a didactic 'novel of demonstration'.[27] Its characters are reduced to weakly individualised models in the service of an ideology. Some of these 'novels of demonstration' are written by conservative authors (for instance, Paul Ernst's *Der schmale Weg zum Glück / The Narrow Path to Happiness*, 1904); others come from a left background like the Socialist worker's biography, which describes the development of the hero on his way towards joining the Social Democratic Party. As Dagmar Grenz points out, the National Socialist *Bildungsroman* emerged in the 1920s from a combination of the trivialised novel of conversion and the didactic novel of demonstration of a left mould.[28]

The Russian author Nikolai Ostrovsky deliberately conceived the portrayal of a young proletarian revolutionary as a counterpart to the *Entwicklungsroman* of bourgeois authors who described 'the picture of young members of this class, their lives, their formation and their ambitions'.[29] Ostrovky's work clearly stands in the tradition of the Russian Socialist novel of education. It started with Chernyshevsky's *What is to Be Done?* (1863), which takes Vera Pavlovna as an example to show how the new men and women can be created. It is followed by Gorky's *Mother*. K. Clark points out that Gorky translates the clichés of the radical intelligentsia into the formulas of the Bolsheviks.[30] Although Gorky's novel has later been canonised as an example of Socialist Realism, it still lacks the teleological features typical of the Socialist Realism of the Stalin period and contains a considerable number of elements of heretical 'God-building' as condemned by Lenin. In the Russian tradition prior to Ostrovosky's novel, the didactic, or perhaps even hagiographic element is obviously much stronger than in German literature, which tried to maintain the pretence of individual self-development.

Despite different backgrounds in terms of generic history and ideology the National Socialist novel of conversion and Stalinist novel of education converge at two points: both novels trivialise the genre in a stereotypic way and, even more important, they pervert the idea

of development. Basically, they are novels of instrumentalisation, which use existing literary forms while reversing the idea of individual growth.

## NOTES

1. See M. Damus, *Sozialistischer Realismus und Kunst im National-sozialismus* (Frankfurt, 1981).
2. A Guski, *Kak zakaljalas' stal'* – biographisches Dokument oder sozialistisch-realistisches Romanepos? *Zeitschrift für slavische Philologie*, 62 (1981), no. 1, pp. 116–45.
3. Cf. P. Aley, *Jugendliteratur im Dritten Reich* (Hamburg, 1967) pp. 153–4; U. Nassen, *Jugend, Buch und Konjunktur 1933–1945* (Munich, 1987) p. 47.
4. See, for instance, A. Littmann, *Herbert Norkus und die Hitlerjungen vom Beusselkietz* (Berlin, 1934); R. Ramlow, *Herbert Norkus? Hier! Opfer und Sieg der Hitlerjugend* (Stuttgart, 1940).
5. Cf. H. Günther, *Die Verstaatlichung der Literatur* (Stuttgart, 1984) pp. 95–106.
6. The quotations refer to the edition N. Ostrovsky, *Kak zakalyalas' stal'* in: *Sobr. soch. v trekh tomakh* (Moscow, 1974/75) t. 1.
7. The quotation refers to Karl Aloys Schenzinger, *Der Hitlerjunge Quex* (Berlin, 1932).
8. H.J. Baden, *Literatur und Bekehrung* (Stuttgard, 1968) p. 14, distinguishes between immediate and gradual conversion.
9. K. Vondung, *Magie und Manipulation* (Göttingen, 1971) p. 189.
10. E. Fromm, *The Fear of Freedom* (London, 1960) p. 130. For the masochist component in Stalinist culture see Igor Smirnov, 'Scriptum sub specie sovietica', *Russian Language Journal* 61 (1987), no. 138–9, pp. 115–38.
11. Cf. K. Vondung, p. 187; H.-J. Gamm, *Der braune Kult*, pp. 43–56.
12. Baldur von Schirach, Foreword in: A. Littmann, *Herbert Norkus und die Hitlerjungen vom Beusselkietz*.
13. See N. Tumarkin, *Lenin lives! The Lenin Cult in Soviet Russia* Cambridge, Mass./London, England, 1983); Ch. Lane, *The Rites of Rulers* (Cambridge University Press, 1981) pp. 210–20.
14 A Littmann, op. cit., p. 129.
15. Cf. note 5.
16. For the structure of the traditional *Bildungsroman* see H. Esselborn-Krumbiegel, *Der Held in Roman. Formen des deutschen Entwicklungs-romans im frühen 20. Jahrhundert* (Darmstadt, 1983) pp. 14–25.
17. For the voluntarism of Stalinist culture cf. K. Clark, *The Soviet Novel. History as Ritual* (Chicago/London, 1981) pp. 136–52; V. Paperny, *Kul'tura dva* (Ann Arbor, 1985) pp. 231–41.
18. D. Grenz, 'Entwicklung als Bekehrung und Wandlung. Zu einem Typus der nationalsozialistischen Jugendliteratur', in M. Lypp (ed.), *Literatur für Kinder* (Göttingen, 1977) pp.123–54, at p. 134.

19. A. Gruen, *Der Verrat am Selbst* (Munich, 1984) p. 132.
20. Cf. R.J. Lifton, *Revolutionary Immortality. Mao Tse-Tung and the Chinese Cultural Revolution* (London, 1969) pp. 45–60.
21. Cf. E.M. Meletinskii, *Poetika mifa* (Moscow, 1976) pp. 282, 313.
22. For this distinction see M. Eliade, *The Quest. History and Meaning in Religion* (Chicago/London, 1969) pp. 112–13.
23. For the problem of changing of name cf. H.-J. Baden, *Literatur und Bekehrung*, p. 12.
24. See, for instance, J. Bark, 'Bildungsromane', in: H.A. Glaser (ed.), *Vom Nachmärz zur Gründerzeit. Realismus 1848–1880* (Hamburg, 1982) pp. 144–62.
25. Cf. M. Swales, *The German Bildungsroman from Wieland to Hesse* (Princeton, N.J., 1978); M. Beddow, *The Fiction of Humanity. Studies in the Bildungsroman from Wieland to Thomas Mann* (Cambridge, 1982); K.-D. Sorg, *Gebrochene Teleologie. Studien zum Bildungsroman von Goethe bis Thomas Mann* (Heidelberg, 1983).
26. Cf. R.Geissler, *Dekadenz und Heroismus. Zeitroman und völkisch-nationalsozialistische Literaturkritik* (Stuttgart, 1964) p. 73.
27. For the term of the 'novel of demonstration' cf. H. Esselborn-Krumbiegel, op. cit., pp. 163–73.
28. See D. Grenz, Entwicklung als Bekehrung und Wandlung, p. 152.
29. N. Ostrovsky, *Sobr. soch. v trekh tomakh*, t. 2, p.244.
30. Cf. K. Clark, op. cit., pp. 52–67.

# 11 Satire under Stalinism: Zoshchenko's *Golubaya Kniga* and M. Bulgakov's *Master i Margarita*
## Jochen-Ulrich Peters

### I

At first sight tthe theme formulated in the title of this chapter may seem to offer little promise, it may even appear far-fetched. For it seems reasonable to suppose that a system as self-contained as that of Stalinism offered so little scope for something like satire that to seek to discover the role and the possibilities for development of such a manner of writing, which is so outspokenly critical of the society of its time, is tantamount to a contradiction in itself. Even if one admits that those satirical texts which can still excite our interest today in fact appeared in the Soviet Union either before the canonisation of Socialist Realism, that is before the end of the 1920s, or not until after Stalin's death, I nevertheless consider the topic proposed of significance for our understanding of Stalinism as a strictly hierarchically organised political, ideological and cultural system, and that for three reasons.

First of all, it is precisely the various official and semi-official debates on satire, partly initiated by the Press Office of the Central Committee itself, which reveal both when and how the transition from the relatively liberal culture and cultural policies of the 1920s to the later Stalinist policies took place, and how ideas on the co-called 'social responsibility' of art and literature, which are only very inadequately described and defined by the label 'Socialist Realism', were changing even during Stalin's reign of almost 30 years.

Then there are the arguments with which Soviet satire was at once emphatically propagated and in certain individual cases equally

sharply criticised and rejected during the Stalinist period, which illustrate with particular clarity the reasons for which and the extent to which even literary and artistic forms of production were subjected to the ideology of the Party and of the totalitarian state and show how far these restrictions remained in force even after de-Stalinisation. Slightly altering Juvenal's well-known phrase on satire to 'difficile est satiram scribere' renders it applicable even to the Soviet satire of the 1960s and 1970s. For, of course, satirists and humourists necessarily continued to be so directly and so persistently affected by the norms and control systems imposed by the Party and the government, which still existed, that even in the last two decades the most important of recent Russian satires, the works of Voinovich, Terts-Sinyavsky and Zinoviev, for example, could only appear as samizdat publications or in the West.

Finally, I should like to try to demonstrate how in their literary works Bulgakov and Zoshchenko, two of the most important and popular satirists of the 1920s, either grappled openly with the official theory of satire or attempted to subvert it in a most subtle fashion using the methods of Aesopian speech. Zoshchenko's *Golubaya Kniga* is a particularly fine example of how as late as the 1930s a satirist succeeded in formally abiding by the aesthetic and ideological postulates of Socialist Realism, while at the same time exposing them to ridicule through such favourite satirical devices as irony, parody and hyberbolic stylisation, thus revealing their absurdity.

After a comparative analysis of the works of Bulgakov and Zoshchenko I shall return in conclusion to the question of the extent to which the differentiation between a so-called official and a so-called non-official culture propounded systematically by M. Bakhtin in his book on Rabelais can also be used to describe the literary process under Stalinism. For even if Bulgakov's novel *Master i Margarita*, which was not published until 25 years after its completion, can certainly not simply be accounted 'carnivalised' literature in Bakhtin's sense, it nevertheless does seem to me to question more consistently than all other works produced during the Stalinist period the authority of the aesthetic, political and ideological norms and postulates which the official conformist satire was supposed to take as its guidelines.

If we first ask ourselves, what those in the Party and the state with responsibility for cultural policy in the first years after the Revolution thought of literary satire, the picture we get essentially corresponds to the course generally pursued during the early 1920s in matters of

literature and cultural policy. While the theorists of the so-called
Proletkult-movement regarded satire after the proletarian revolution
as superfluous or even as harmful, A.V. Lunacharsky, the peoples'
commissar with responsibility for cultural and educational policy,
vigorously defended it. In his programmatic essay 'Budem smeyatsya'
written in 1920, he recommends to young authors not only Gogol'
and Saltykov-Shchedrin, but also Swift and Heine as models who are
still worthy of emulation, and does not even mention the changed
political and social circumstances after the October Revolution.
Furthermore, Lunacharsky propagates the idea of studios and thea-
tres specifically dedicated to satire and in the emphatic style of the
revolutionary period he formulates his expectation that the fools who
told their masters the truth in earlier epochs, while nevertheless
remaining their servants, would now become 'brothers and far-
sighted and eloquent advisers to the proletariat'.[1] For, as he went on
to say, what then mattered was to eradicate the centuries-old
oppression of the knaves and fools initiated by the church and the
state. Accordingly, Lunacharsky views Soviet satire as a 'sign of the
strength' of the new society which had been fundamentally changed
by the Revolution, and unlike Trotsky, for example, he does not even
make any qualifying reference to the decidedly counter-revolutionary
satires and pamphlets, which even as early as the first years after the
Revolution had only been able to appear abroad.

Since even Lenin himself explicitly welcomed Mayakovsky's sati-
rical poem on the new bureaucrats 'Prozasedavshiesya', Russian
satire represented by the works of Bedny, Zoshchenko, Bulgakov,
Platonov or Mayakovsky was able to develop with relative freedom in
the first decade after the October Revolution, as long, that is, as it
did not attack the newly established political system and its ideolo-
gical foundation as a whole – as did Zamyatin in his satirical utopian
novel *My* of 1920. Above all, as L.F. Ershov has shown,[2] more than
40 satirical and humorous newspapers and periodicals were founded,
in which the intensifying political differences and social contradic-
tions arising from the New Economic Policy were discussed with a
surprising degree of openness. Even in a periodical as close to the
Party as *Krokodil* colleagues were being advised as late as 1925 to
work on the following list of topics: classes hostile to the proletariat
(NEP-men, the bourgeoisie); inadequacies and abuses among the
working-class and the peasantry (in every day life, and in the conduct
of their personal lives); abuses in the administrative apparatus of the
state and in the authorities responsible for the economy; the bour-

geoisie abroad and those parties whose attitudes were hostile to the working-class.[3]

If the definitive selection and listing of individual topics and even more the chosen order of the targets for satire were in themselves enough to signal the Party and the state's interest in employing satirical publications for their own political agitation and propaganda, it is clear that Soviet satire in the mid-1920s was still able to direct itself with the same intensity as ever against the enemy abroad and the continuing shortcomings as well as the politically and socially motivated difficulties at home, which had originally been very frankly analysed by Lenin, Trotsky and Bukharin in the articles they had written against the bureaucracy and the petty bourgeoisie.

After the possibilities and limits of satire had formed the subject of a highly controversial discussion at a conference organised by the Agit-prop department of the Central Committee as early as 1923, it would seem that the discussions held in 1927 and 1928 adopted a fundamentally different approach to satire, which led to most satirical and humourous journals having to cease publication towards the end of the 1920s. It is true it was still not possible for those radical critics and cultural functionaries to impose their views who thought that the very concept of the Soviet satirist was just as much a contradiction in terms as the idea of a 'Soviet banker' or a 'Soviet landowner' and who sought to make it the responsibility of the Party, the trade unions and the publications edited by them to reveal 'in an organised manner' those abuses which still existed.[4] The opponents of this position, however, nevertheless felt called upon to defend literary satire, using the argument that satirical texts which did not refer exclusively to particular shortcomings were directed against the 'legacy of the past' rather than against the new Soviet state in any way. Thus, immediately after the removal of Trotsky and the left-wing opposition from power and in view of the ambitious programme of industrialisation and the collectivisation campaign the role of the satirist was already being limited to opposing the external class enemy, the capitalist system as a whole, or the so-called 'vestiges' (*perezhitki*) of the past.

It was inevitable that this restrictive interpretation of the concept of satire would directly affect not only the satirical periodicals but also such popular and respected satirists as Mayakovsky, Zoshchenko or Il'f and Petrov. It is true that Mayakovsky's biting verse satires and his satirical comedies *Klop* and *Banya* were still able to appear in the late 1920s and early 1930s, as were Il'f and Petrov's satirical novels. *Dvenadtsat' stulev* and *Zolotoi telenok*. However, Mayakovsky's

declamatory comedies, with their grotesque style and their hyperbolic presentation of character, no longer accorded with the theory of the so-called 'living man' (*zhivoi chelovek*) postulated by the RAPP, the Russian Association of Proletarian Writers. That it was not individual bureaucrats Mayakovsky was putting on stage and exposing to ridicule in the *Steam Bath*, but bureaucracy itself which he was denouncing as a political and social phenomenon, could no longer be reconciled with the official view of satire. What was required by the RAPP, but by the government and the Party too, was the kind of satire they thought to be realistic, that is satire which would restrict itself to commenting on particular deficiencies or human weaknesses, and which would support the forced pace of industrialisation and collectivisation as well as the so-called cultural campaign of the Party as directly as possible, thereby at least verbally playing a significant role in the struggle against individual bureaucratic deviations and attitudes.

The fundamental aesthetic and ideological problems which arose from such a restrictive understanding of satire, may perhaps be best illustrated from an essay by Georg Lukács, which he wrote while still in Moscow and published under the title 'On the Question of Satire' in the journal *International Literature* in 1932. Lukács, who – like the members of RAPP – also considered satire a 'creative method' characterised by a definite political and philosophical overall intention and whose constitutive principle lay in the *direct* antithesis of essence and appearance, is well aware that comic and satirical texts generally deviate far more radically from historical and social reality than does the so-called realistic manner of writing he generally advocates. Nevertheless, he demands that the satirist, whose working methods are the grotesque and the fantastic, also imbue his works with a 'correct reproduction of the essence of reality' – which is virtually prescribing the satirist – albeit still in Hegelian terminology – a particular ideological and philosophical perspective.[5]

This dogmatic position, which points forward to Socialist Realism, is further sharpened by Lukács' recognition of the 'self-criticism of the class' as the legitimate and indispensable task of satire. Lukács' main concern was, however, to describe its function as a weapon in the class struggle in bourgeois society and to justify it against the prejudices of the idealist aesthetics of Hegel and F.Th.Vischer, so that he does not go into the task of literary satire after the proletarian revolution and in the Soviet Union specifically. Lukács therefore confines himself to the global statement that 'the objective reality of

decaying capitalism produces objects of satire en masse, daily, hourly'.[6] Like the RAPP critics, who were directly supported by the Party, Lukács too thus restricts the satirist to the critical representation of individual deficiencies and offences against the norm, which are either widespread in capitalist society or inherited from the capitalist system, in order both to sanction the existing Socialist order of society by satirical means too and to contribute to its improvement.

I. Éventov's survey of the development of Soviet satire since 1917, published in 1937 under the revealing title *Smekh pobeditelei* or *The Laughter of the Victors*,[7] marks a further step towards the functionalisation and the instrumentalisation of satire by the Party and the state. At the height of the Stalinist terror and with explicit reference to the new, recently promulgated constitution satire, too, was expected to be optimistic and life-affirming. 'Self-criticism of the class' was no longer even mentioned as an object of satire, since the latter's purpose was now solely to impugn and expose the external and internal class enemy, and thus to contribute both to the education and to the improvement of new Socialist man. It is hardly surprising that such a dogmatic concept of satire, which heralded the so-called 'theory of the absence of conflict', meant that few satirists from the 1920s proved still acceptable. The fables of D. Bedny did, however, continue to be regarded as exemplary, since they were supposedly close to the traditions of the people, as were the more optimistic verse satires of Mayakovsky, whose satirical comedies were no longer even mentioned. Zoshchenko's more recent satirical and humorous short stories were also criticised as too pessimistic and too devoid of principle, since social and cultural progress was depicted only through the explanatory commentaries of the narrator and not through any 'realistic' presentation of the characters. Il'f and Petrov's satirical novel *Zolotoi telenok* from the early 1930s, on the other hand, was still widely accepted on account of its overall anti-capitalist tendency. Eventov, however, reproached the authors – not entirely without foundation – with not having invested the new Socialist forms of life and consciousness with the same degree of attractiveness and conviction as distinguished the overtly satirical passages and particularly the central character, Ostap Bender. For all of these reasons, Éventov ceases to recommend that the satirist write comedies, stories or novels, but rather suggests that he turn his attention to the feuilleton and the pamphlet as tactical, small-scale satirical genres, in which criticism of individual human weaknesses and failings may

most consistently be linked with the 'optimistic' presentation of
progress already achieved or to be striven for.

The questions of principle which such a restrictive interpretation of
the concept of satire entailed for the individual satirist were
expressed by Il'f and Petrov writing to Il'ya Erenburg in a mood of
resignation and depression in 1936:

> What are we supposed to write now? The 'great schemers' are out
> of currency. In the newspaper supplements one is allowed to
> portray self-satisfied bureaucrats, thieves and rogues. If the per-
> son's name and exact address are included, that is a 'distorting
> phenomenon'. But if one writes a story, they immediately protest:
> 'You're generalising, that is an untypical phenomenon, it's libel-
> lous'.[8]

Although at a debate organised by the Writers' Union in 1943
specifically to consider the role of satire in World War II, satire was
more actively supported and propagated, since it was viewed as a
particularly effective and militant way of writing, there was hardly a
change in the restrictive definition of its function. And even during
the following so-called Zhdanov era its scope remained exceptionally
limited, as the bitter denunciations of Zoshchenko and of the journals
*Zvezda* and *Leningrad* showed. An article by the writer and literary
critic B. Gorbatov entitled 'O sovetskoi satire i yumore', which was
written to expound the Party's position and published in *Novyi Mir* in
1949, does deplore the remarkably low standard, the lack of audacity
and the recourse to stereotypes this entails. Yet this fairly negative
conclusion does not prevent the writer recalling the Central Commit-
tee's vigorous criticism of *Krokodil's* ideological deviations and the
earlier reproaches directed against the supposed 'pessimism' of Il'f
and Petrov, in order then for his part to lay down the task of the
Soviet satirist in the following way:

> We are living in the land of Socialism and are proceeding full of
> confidence towards Communism. For this reason our satire must
> be life-affirming, optimistic and bright. If we scourge certain
> deficiencies, we know that they can be overcome. If we smash the
> vestiges of capitalism in the consciousness of the people, we
> nevertheless know that these are no more than vestiges belonging
> to yesterday, not to the future. We believe in the strength of the
> truth and the power of our press.[9]

The difference between such a commitment to satire as this, which contrives to be panegyric and restrictive at the same time, and more recent Soviet theory of satire lies not only in the latter's adoption of a very much more restrained rhetoric, which is careful to take account of the negative consequences of the so-called cult of personality. After the so-called 'theory of the absence of conflict' had been officially criticised and rejected at the beginning of the 1950s, the larger satirical genres, such as the rasskaz, the povest' or the novel, were once again explicitly tolerated and encouraged, while a positive solution of the abuses or offences against the norm was no longer required.

Nevertheless the satirical texts officially published in Soviet books, newspapers and periodicals have never regained that sharpness and liberality of comedy and criticism which was available to them in the 1920s and in some exceptional cases even into the early 1930s. Under the programmatic heading 'Smekh – priznak sily', that same Eventov, who had been one of the founders of the Stalinist concept of satire back in 1937, is now explicitly encouraging Soviet writers and journalists to tackle those political and social problems which still exist without their earlier anxieties or the tactical reticence imposed by the cult of personality. However, the explicit reference to Lunacharsky's earlier dictum that satire is a 'sign of strength' does remain highly ambivalent. For Éventov insists on the fact that although the satire of the 1960s must be directed against phenomena typical of modern society, it must not question the 'determining trends of our development, the objective conditions of being'.[10] This formulation of Éventov's marks very clearly the limit which may not be exceeded even by post-Stalinist satire. Not only the leading representatives of the Party and the state, but also the political decisions taken by them are, as a matter of principle, to remain outside the scope of satirical laughter and mockery, since these can at any time be legitimated as the necessary consequences of objective social development, which for political and ideological reasons continues to be regarded and hypostatised as a process which is subject to the law of nature and which for that reason must be placed beyond the reach of the satirist's critical laughter.

## II

How the early functionalisation and instrumentalisation of satire in terms of Stalinist cultural policy actually worked out in literary

practice can be particularly well illustrated from Zoshchenko's *Golubaya Kniga*, the so-called *Sky-Blue Book*. For it was in this cycle of stories, written in the early 1930s and published complete in 1934, that Zoshchenko undertook the highly problematic experiment of adapting his own satirical texts from the 1920s at least outwardly to fit the normative postulates of Socialist Realism. Unlike the earlier collections, in which the satirical sketches and short stories still appeared as separate texts, they are now sorted out – on the basis of a consistent political and ideological perspective – into five subject areas, which taken together are intended to form a 'History of Human Relationships' which is both amusing and serious. In accordance with a suggestion made by Maxim Gorky the effects of money, love, malice and chance accidents are depicted in succession, only to be finally confronted – under the highly significant heading 'Surprising Events' – with the positive effects of Socialist society in the form of changed forms of consciousness and modes of behaviour.

The schematism and the obstrusive moralising and didactic tendency which emerges from this strict division of the separate narrative texts according to particular themes and problems is further intensified by the narrator's once again outlining the consequences resulting or supposed to result from these relatively harmless, anecdotal stories in discursive form at the end of each chapter. Zoshchenko was apparently concerned to limit the reader expresssis verbis to a particular interpretation of the text once again, as well as to protect him in this way from viewing the material problems or the egotistical, petty bourgeois modes of behaviour portrayed as typical deficiency symptoms of Socialist society or as ultimately unalterable constants rooted in the nature of man.

Reading the cycle of stories and the accompanying commentaries more closely, however, it will be noticed that Zoshchenko – apparently with conscious intent – has built so many discrediting factors into the stories themselves and even into the discursive sections that they serve to undermine not only the obtrusive overall tendency of the cycle of stories but also the dogmatic postulates of the official theory of satire itself. Right at the beginning, for example, in a foreword to the whole cycle, the unusual title of the book is explained and justified in the following way:

> The sky-blue book! We have called it thus, because all the other colours have run out . . . With this colour of hope, which from time immemorial has been the colour of modesty, of youth and of

all things good and sublime, this colour of the sky, which is populated by doves and aeroplanes and spreads out above us, we name our amusing, but in parts moving little book. And whatever one may say about this book: in it is more joy and hope than mockery, less irony than genuine, heartfelt love and tender affection for human beings.[11]

Even this emphatic commitment to conformity and to the officially propagated concept of satire may, it would seem, to me, be read ironically. For which of the important works of Russian literature have ever been designated by particular colours and how far can the remaining colour blue be said to signify modesty, youth and 'all things good and sublime', when in Soviet society the colour red ought to have been more appropriate? That Zoshchenko is merely paying lip-service here, so that he can include the earlier attacks of official literary criticism in his satire, is perhaps even more clearly illustrated by the following most ambivalently formulated passage, which is prefaced to the stories about the negative effects of avarice and of wealth and apparently attempts to disarm the widespread prejudices of literary criticism against Zoshchenko's earlier humorous and satirical prose even more directly:

Let's have a look at what kind of little stories these are. But before doing so, we should like to point out, dear Mr Critic, that we intend first of all to consider only negative facts. As far as the positive sides are concerned, we refer you, as one who is entirely devoted to the brighter side of things and who would prefer only to read about good events which are worthy of attention all the time, to the fifth part, situated at the end of our book. There your weary heart will find rest from all this goodness.[12]

Even if the collective 'we', with which the narrator here addresses the critic who is entirely fixated on the good, is doubtless closer to the position of the author Zoshchenko than is the broken narrative style of the *skaz* adopted by the first-person narrator in the separate narrative texts, in this passage too an ironic undertone is hardly to be missed. Much would seem to indicate that here too the reflecting narrator is once again pretending to be more naive and more conformist than the author Zoshchenko ever was, who is possibly seeking to distance himself by means of this apparent declaration of loyalty from the normative postulates of contemporary literary criti-

cism and the poetics of satire. The use of a mask-like ironic form of speech, which is so characteristic of Zoshchenko's satire, once again offers the author the possibility of simultaneously seeming to support and discredit certain tenets and prejudices of contemporary criticism and thus to impart a semantic ambivalence to this text, such as is characteristic of so-called Aesopian speech as a whole. To this extent the thesis could indeed be advanced that in his *Goluybaya Kniga* Zoshchenko was in fact attempting to adapt his work formally to the Stalinist concept of satire and to the authoritative demands of the censorship officials and the literary critics. This did not, however, exlude the book's simultaneously offering the experienced reader of Zoshchenko an opportunity to see through the precepts of contemporary politicians with responsibility for culture and of literary critics as an aesthetic and ideological imposition, which the satirist and the humourist in particular must on no account accept, lest he give up his very self.

It is this very ambiguity or at least the ambivalent semantics which seem to me to be displayed in those texts in which the supposed achievements of Socialist society are portrayed in anecdotal form. We must in any case assume that many readers will have been able to recall the original texts which had appeared in the 1920s very precisely, when they were confronted with the same short stories once again in the *Sky-Blue Book*, albeit in heavily edited form. In the story entitled 'Bugs in festive illumination' Zoshchenko had ironised the concept of electrification initiated and propagated by Lenin by explicitly presenting the disadvantages of this ambitious programme. After all, by the light of a petroleum lamp nobody had ever noticed the impoverished and dirty housing conditions, from which the bugs profited most, so that the first-person narrator's landlady decides without hesitation to restore the previously more comfortable state of affairs by ripping out the newly installed electricity circuit and renouncing the advantages of technical progress. The short story accordingly ends on the first-person narrator's ironical final statement that electrification does have its drawbacks.

The version of this story in the *Sky-Blue Book* reads very differently. Here too it is the jaded wallpaper, the poor furniture, the cigarette ends strewn over the floor and above all the numerous bugs, which electric light reveals first of all. This time, however, the collective decides on a thorough clean-up and renovation of the dwellings, so that all the problems are solved and the residents are able to enjoy the fruits of civilised progress.

If, however, the narrator remarks in conclusion, that as a result of this new achievement one resident has begun to learn French, several others have discovered the joys of reading and chess, and a third tenant has quite unexpectedly gained a nice husband due entirely to the benefits of electric light, then one may conclude that here, too, it is the dogmatic precepts of contemporary literary criticism which are being mocked. For an author as ironic and as sceptical as Zoshchenko is hardly likely to think that the cultural revolution propagated under Stalinism resulted from forced industrialisation in as direct and problem-free a manner as is suggested by the slightly hyberbolised 'happy ending' of the story.

It is interesting to note that the ambivalence or rather the ironic undertone of the *Sky-Blue Book* was apparently not entirely lost on contemporary literary criticism, even if nothing was explicitly said. While one critic concluded with some satisfaction that Zoshchenko's new book had delivered the decisive blow to the petty bourgeois patterns of thinking and behaviour which still existed, others renewed earlier reproaches as to the supposed pessimism and lack of perspective displayed by the author. For Zoshchenko, like Yuri Olesha or Isaak Babel, had not, it was maintained, finally given up the 'ironic stylisation' or 'stylised irony', which no longer accorded with the literary taste and the political consciousness of the Soviet reader.[13] Yet even before the end of the 1920s Zoshchenko had himself frankly conceded and defended the one-sidedness of his satirical and humorous prose, when he explained to young Soviet writers:

> The fact is that my genre, the genre of the humourist, is irreconcilable with the portrayal of improvements. That is the task of a writer with a different direction. Every one in his own way: the dramatic actor plays Hamlet; the comic appears in the *Revizor*. In my opinion every one must express himself in his own way.[14]

That Zoshchenko denied these principles of the humourist and the satirist a few years later, or at least attempted to conceal them, was apparently necessary in order to deceive or at least to pacify the alert censorship authorities and the dogmatic literary critics. Those readers and critics familiar with Zoshchenko's style and literary technique will presumably soon have seen through the procedures which he never ceased to 'expose' and have been able to assess the ambivalence of his apparently so 'optimistic' satire accordingly.

## III

Bulgakov's novel *Master i Margarita*, which was conceived about the same time as Zoshchenko's cycle of stories, displays such different stands of action and levels of presentation which it is difficult to reconcile with one another, that it hardly lends itself to interpretation as a satire which relates precisely to contemporary history. Certainly, some aspects of the novel, such as, for instance, the powerful writers' union accommodated in the Griboedov House, the prejudiced literary critics toeing the Party line, the intimidated and therefore easily corruptible population of Moscow, or the politicians and functionaries whose sole aim is the maintenance of their own power, do refer very directly to the Stalinist dictatorship and its consequences. But the Pilate-action, and certainly the Witches' Sabbath and the love-plot between the Master and Margarita cannot be as directly related to the political and social reality of the 1920s and 1930s, as those English and American historians would have it who attempt to read the text as a satirical *roman à clef*.[15]

It therefore seems much more profitable to me to assign Bulgakov's novel to the genre tradition of the so-called *Satire Ménippée*, which has the effect of shifting its philosophical dimension – the struggle of good and evil, and of truth and falsehood – to the centre of the interpretation. For does not the novel largely meet the criteria which M.Bakhtin has estalished for *Satire Ménippée* and more generally for so-called carnivalised literature in his book on Dostoevsky thematically as well as from the point of view of its structure, its composition? Its characteristic elements are the juxtaposition of philosophical dialogue, high symbolism, adventurous fantasy and the crudest naturalism as well as the conscious destruction of a continuous and unifying space-time structure. And here too the author's feuilletonistic and satirical interest in criticising his age is linked to the serious discussion of supertemporal or religious problems, which for all the work's fantasy plays a central role both in the Pilate action and in the episodes which take place in Moscow. Quite obviously it is this statement of philosophical and ideological problems which links the two most important scenes of the novel's action: the Jerusalem of the time of Pontius Pilate and Moscow during the Stalinist terror. As B. Zelinsky has shown in a comprehensive interpretation of the novel,[16] the eternal struggle of good and evil is modelled at both narrative levels on the baroque world theatre, the grotesque and fantastic alienation of the presentation making the

Soviet Union of the 1930s seem like an 'upside-down world', in which the figures play out their predetermined roles as in a puppet show. Mendacious poets, self-satisfied bletherers, prejudiced liars and informers, mindless bureaucrats and last but not least the mass of the socially conformist and gullible population of Moscow metonymically present a godless and amoral anti-world, which continually refers to Stalinist reality without being able to be identified with it. For, as Lesley Milne has shown,[17] it is not the Pilate action alone which is transformed into a demythologised version of the Biblical story of the Passion. The action which takes place in Moscow is also so grotesquely defamiliarised that there are constant abrupt transitions between the realistic and the fantastic levels of presentation, which make Stalinist reality appear a world dominated by demonic powers, to which rulers and ruled are alike subject.

With this world of evil which, in spite of all the realistic details, can hardly be individually deciphered, contrasting figures are confronted in the shape of the Master, his beloved Margarita, the historian Bezdomny and the historical Jesus, who stand in a more or less abstract fashion for the ideals of art, love, truth and boundless love, and who thereby expose reality as it actually exists together with those who inhabit it as a godless world based on the naked maintenance of power, on conformity and oppression. It is ironic here that it is none other than the devil, in the figure of Voland himself, who supports moral resistance against the power of evil and falsehood and who, at least after their deaths, provides the Master and Margarita with the rest and peace they had never been able to find during their lives. And that is why at the end Voland appears as a second Mephistopheles and – in terms of the epigraph prefaced to the novel – as 'a part of that power, which always seeks evil and always creates good'.

Without wishing to analyse Bulgakov's novel in detail, it can in my view be maintained that its satirical dimension and the effect it seeks to achieve may be situated on two levels, as it were. Beside the critical portrayal of certain vices and human weaknesses which are to be found or at any rate can be imagined in contemporary reality, there is also a 'metaphysical' level to the novel, directed against the ruling materialistic and atheistic ideology of the state, which is most apparent in the interrogation of Pilate and the dialogues between Voland and the Master and his lover Margarita. Bulgakov's special achievement consists, it would seem to me, in the fact that he does not simply cause the complex empire of evil, falsehood and cowardice

to be overcome by the power of love or the truth of authentic art and literature, but explicitly leaves the conclusion of the novel of the Master and indeed the whole question of a fundamental change or negation of the 'upside-down world' open. In this way Voland's much quoted statement 'Manuscripts do not burn' remains more of a paradoxical moral certainty than a promise made good, and the satire approaches that negative utopia in which, of course, the 'ideal norm' likewise appears as an alternative draft, not, however, as a real solution of existing contradictions. It is not the Master alone, but the author Bulgakov, too, who seems to have realised early on that Yeshua's call for unconditional submission to the good, is tantamount to a demand for fundamental social change, which it was possible to propagate neither in Jerusalem nor almost 2000 years later in Moscow.

If one reads Bulgakov's novel today, with the benefit of hindsight, one is almost surprised that it was published – albeit at first in a heavily censored version – in the second half of the 1960s, whereas Zamyatin's novel *My* or Platonov's *Chevengur* have only now appeared in the Soviet Union. For Bulgakov's novel, written at the height of the Stalinist terror, is much more than a relentless attempt to come to terms with that art and literature which was condemned to silence or corrupted by Stalinism and with those representatives of state power who were reponsible for their decline. It is the most comprehensive and unrelenting retort to the so-called official culture dominated by the Party and the state, such as – if only indirectly – M. Bakhtin analysed and condemned in his book on Rabelais written about the same time. Only in Bulgakov it is no longer the people and the culture created by them who function as the bearers of democratic collectivity and cultural continuity. From Bulgakov's point of view it is rather the individual intellectual, first and foremost the writer and the artist, whose task it is to expose official culture as a world of falsehood, opportunism and an unfoundedly optimistic belief in progress, and in so doing to question it radically.

As in his early prose written in the 1920s, Bulgakov opposes to this a decidedly pessimistic concept of history, in which history appears as the constant recurrence of unchanging events. In this way the Master, his lover Margarita and his pupil Ivan Bezdomny oppose the claims of the authoritarian state with the same relentlessness and selflessness as Yeshua displayed in opposing the reason of state embodied by Pilate 2000 years before.

It is in this scepticism towards all self-contained, future-oriented philosophies of history as well as the conscious recourse to the grotesque and the fantastic in the literary portrayal of political and social reality that Bulgakov's novel seems to me to anticipate the aesthetic credo, which Abram Terts-Sinyavsky formulated in his later rejection of Socialist Realism and official Soviet satire and theory of satire in the following words:

At present I place my hope in an art of phantasmagoria with hypotheses in place of an aim and of the grotesque instead of the realistic description of everyday life. These correspond best to the spirit of our times. May the abstract hyperbolic images of E.T.A. Hoffmann, Dostoevsky, Goya and Chagall and of the really Socialist Mayakovsky and of many other realists teach us how to be truthful with the aid of an absurd imagination.[18]

# NOTES

1.  Cf. the essay 'Budem smeyat'sya', now in: A.V. Lunacharsky, *Sobr. soch. v vosmi tomach*, vol. 3 (Moscow, 1964) pp. 76–9, at p. 78.
2.  L.F. Ershov, *Sovetskaya satiricheskaya proza 20-ch godov* (Moscow and Leningrad, 1960) pp. 5–85.
3.  Quoted from Ershov, op. cit., p. 58.
4.  Quoted from Ershov, op. cit., p. 48, which prints the various comments by authors and critics in a very abridged form.
5.  G. Lukács, 'On the Question of Satire' (Zur Frage der Satire), quoted from B. Fabian (ed.), *Satura. Ein Kompendium moderner Studien zur Satire* (Hildesheim and New York, 1975) p. 438.
6.  Lukács, op. cit., p. 449.
7.  I. Eventov, 'Smekh pobeditelei. Dvadtsat' let sovetskoi satiry', in *Literaturnyi sovremennik*, 1937, no. 7, pp. 223–42. Cf. the similarly formulated article by Eventov (Puti pamfleta) *Zvezda*, 1938, no. 9, pp. 201–25.
8.  I. Erenburg, 'Lyudi, gody, zhizn', in Erenburg, *Sobr. soch. v devyati tomach*, vol. 9 (Moscow, 1967) p. 16.
9.  B. Gorbatov, 'O sovetskoi satire i yumore. Zametki pisatelya', *Novyi Mir*, 1949, no 10, p. 221.
10. I. Eventov, 'Smekh – priznak sily (Zametki o satire)', *Voprosy Literatury*, 1962, no. 7, p. 34.
11. Here and below quoted from M. Zoshchenko, *Izbrannoe v dvuch tomach*, vol. 2 (Leningrad, 1978) pp. 7f.
12. Ibid., p. 32.

13.  Cf. a short selection of statements by literary critics in M.F. Arnold, *Problems of Satire in Soviet Prose Fiction*, PhD (Berkely, 1964) pp. 310–12.

14.  Quoted from R.A. Domar, 'Die Tragödie eines Sowjet-Satirikers. Der Fall Zoshchenko', in E.-J. Simmons (ed.), *Der Mensch im Spiegel der Sowjetliteratur* (Stuttgart, 1956) p. 255.

15.  Cf., for example, D.G. Piper, 'An Approach to Bulgakov's *The Master and Margarita*', *Forum for Modern Language Studies* VII (1971), pp. 134–57.

16.  Barbara Zelinsky, 'Bulgakow. Der Meister und Margarita', in Bodo Zelinsky (ed.), *Der russische Roman* (Düsseldorf, 1979) pp. 330–53.

17.  L. Milne, *The Master and Margarita – A Comedy of Victory* (Birmingham, 1977).

18.  A. Terts, 'Chto takoe sotsialicheskii realizm', in *Fantasticheskii mir Abrama Tertsa* (New York, 1967) p. 446.

# Part IV
# Architecture

# 12 Moscow in the 1930s and the Emergence of a New City

## Vladimir Paperny

## MOSCOW IN THE 1930's

*In The City in History*[1] Lewis Mumford summarised what various scholars had found about the birth of the ancient city. Among other factors, he mentioned the following:

(1) A city develops around a tomb or a cemetery as the meeting place of a tribe;

(2) The first broad street of an ancient city is laid out for sacred processions and marching soldiers, rather than for moving vehicles;

(3) The emergence of a city involves the transition from universal participation in village rituals to a distinction between the city actors (the king and his staff) and the non-participating, but applauding city audience;

(4) The city is associated with the enslavement of the agricultural population and with forced labour.

Surprisingly enough, all these factors could be found in the great rebuilding of Moscow in the early 1930s.

## Lenin's Tomb

Lenin died in January 1924, and at that time it was decided to build a temporary crypt 'in order to give everybody, who will not be able to arrive in Moscow by the day of the funeral, an opportunity to bid farewell to their beloved leader'.[2] Aleksei Shchusev hastily designed the crypt, and within weeks it was built out of wood on Red Square.

In 1924 the Soviet transportation system was still in a state of total disarray, and such a farewell trip to Moscow from a remote place, for

instance, Siberia, could easily take months. Therefore, the temporary crypt was almost immediately replaced with a more durable one, built by the same architect on the same spot out of the same material and having almost the same shape. Eventually, however, the idea of a temporary shelter was transformed into the idea of a shrine for a new saint. Lenin's remains were carefully mummified, and in 1930 the wooden crypt was once again rebuilt, this time as a permanent stone structure coated with marble, granite, porphyry and labradorite tiles.

The creation of a permanent crypt was in a sense a symbolic answer of the new culture of the 1930s to the blasphemous attempts to open saints' relics in the early 1920s. The People's Commissariat of Justice was publishing detailed accounts of such happenings: 'Silver sepulchers, shining with precious stones, contained either decayed, reduced to dust bones, or imitations made of iron structures wrapped with cloth, stockings, gloves, cotton balls, or cardboard painted with flesh colours, and so on'.[3] Ten years later, as Lenin's body began to deteriorate, some of the little tricks of mummification had to be learned again.

The creation of the permanent Mausoleum was, in effect, the seed from which the replanning and rebuilding of Moscow sprang. One of the very first steps in this process was the creation of an enormous square between the Manège building and the 'Moskva' hotel. This area, originally known as 'Okhotnyi Ryad', had been the busiest shopping district in Moscow. It was razed to the ground to accommodate the huge columns of official demonstrators coming from various districts of Moscow twice a year, on 7 November and 1 May. In accordance with the new ritual, these demonstrators would be re-arranged by specially trained personnel, their banners and slogans once again checked, and only then would they be allowed to enter Red Square in an orderly fashion. There they would reach their final destination: Lenin's Mausoleum, the meeting place of the new tribe, with the Party Politbureau members solemnly standing on top of it.

## Sacred Processions and Moving Vehicles

In June 1931 the Plenum of the Communist Party Central Committee passed a resolution to make Moscow a 'separate economic and Party unit with its own government and budget'.[4] Among other things, the Plenum emphasised housing, food services, the water supply system (including the excavation of Belomoro-Baltiiskii and Moskva-Volga

canals), public transportation, especially the building of the Moscow metro, and the 'Five-Year Plan' for the development of Moscow. This plan, the General Plan for Reconstruction of Moscow, was officially approved only in July 1935, but its implementation started at the very beginning of the 1930s, reaching its peak after the Party congress of 1934, 'the congress of the conquerors'.

In November 1934 Moscow looked and sounded like a battlefield. Buildings were blown up, rammed, and moved 24 hours a day, seven days a week. 'Unforgettable was the night on the eve of the Seventh of November', wrote Lev Nikulin, a writer and a future Stalin Prize winner. 'Right before your eyes disappeared the wall which used to separate Kitai-Gorod from the rest of Moscow. The ugly jut of an old squat building on Mokhjovaya street disappeared. Brick and metal scrap were everywhere, walls and corners of buildings collapsed and disappeared like theatre sets. On pavements and driveways stood startled passers-by. They were watching the disappearance of the wall which they had remembered from their childhood. These were wonderful Moscow nights'.[5]

The official explanation of this hectic activity was that a contemporary industrial city with its urgent transportation problems needed wide asphalted streets. However, automobile traffic in Moscow in the 1930s, 1940s, and even 1950s was so insignificant[6] that the real reason for widening streets and razing whole business districts may be explained in Mumford's terms: room was being made 'for sacred processions and marching soldiers, rather than for moving vehicles'.

Another part of the General Plan – the Belomoro-Baltiiskii canal – also seeemed to serve some other purpose than just solving transportation problems. The canal was built between 1931 and 1933. It was publicised not only as a major construction project but also as a re-educational endeavour: the majority of the workers there were prisoners who by participating in it were supposed to turn into 'conscious builders of Communism'. In other words, the use of forced labour was presented not as an economic but rather as an educational necessity. The massive scale of this project could be illustrated by the resolution of the Central Executive Committee of August 1933, which triumphantly announced the completion of the canal, naming the leaders of the building team. Eight of the OGPU[7] supervisors were decorated with the Order of Lenin, 12 484 of the prisoners were parolled, 59 516 of them received reduced terms, 500 were completely pardoned, and 15 of the prisoners were decorated with the Order of the Red Banner.[8] It appeared to have been a total victory

on both the transportation and education fronts. However, when Alexander Solzhenitsyn visited the canal in 1966 he discovered that it was too shallow for any serious navigation, and his conclusion was that nobody had ever intended it to serve any practical purpose.

The Belomoro-Baltiiskii canal, in contrast to the new broadened Gorky street, was not used for sacred processions, but it too demonstrated some of the features of an archaic city. As in the ancient 'hydraulic' societies, 'water' was perceived in the 1930s as a sacred and powerful element, as the basis of existence. The 'cult of water' could be seen in the numerous ponds and fountains that mushroomed all over Moscow during these years, in the provision of the General Plan to concentrate major architectural objects on the banks of the Moscow River, and even in the famous musical film of the 1930's, 'Volga-Volga', with its popular refrain: 'Potomu chto bez vody i ni tudy, i ni sjudy' (because without water you can't get anywhere).

### City Actors and City Audience

The question has been asked repeatedly: who were the spectators of the pompous parades and demonstrations of the 1930s?[9] In the pre-television age, who could see them but a few Party leaders standing on top of Lenin's Tomb? The Mumford model, however, introduces a reversed perspective: the leaders were not the audience, they were the actors, while the demonstrators acted as audience. For technical reasons (the limited size of Red Square) the 'non-participating, but applauding' audience was 'hauled' in front of the stage to give everybody a chance to see the 'king and his staff'. This may explain the obvious 'façadism' and theatricality of the Soviet architecture of the 1930s to 1940s.

In both of the rival Soviet architectural schools of the 1920s – constructivism and rationalism – the term 'façade' had mostly negative meaning. For both of them 'façade' and 'façadism' signified the ornamental, decorative approach to architecture, typical of pre-revolutionary Russia. Instead the emphasis was on 'plan' (the horizontal projection of a building), which connoted structure, construction, function and rationality. Plan was the 'programme for the organisation of urban life and a weapon of social creativity'.[10]

However, in 1934 constructivist Moisei Ginzburg was forced to come to the bitter realisation that 'today you cannot speak of the plan

of a building as you would not speak of rope in the house of a hanged man'.[11] In theory façadism was still a crime (even in the 1940s and 1950s) but, in practice the only architectural element that really mattered was the façade. A building, as well as a city plan, now had to be 'rendered', 'depicted', or 'drawn', and it is not surprising that there were so many exhibitions of architectural drawings in the 1930s to 1940s (even in besieged Leningrad in 1942 there was an exhibition of drawings by architects). When a well-known German architect, Bruno Taut, visited Moscow in 1932 he was appalled by the façadism which he rightly associated with the Russian architectural tradition. 'Czarist Russia', he wrote, 'has not created an architecture that could overcome the separateness of "façade". Architecture, in this way, has become the art of theatre sets'.[12]

Russian architecture of the 1930s returned to its tradition of theatricality. Paradoxically, the more heated the battle with façadism grew (reaching its apogee in the postwar years), the more noticeable became the real rift between the voluptuousness of the façades opening onto the main driving routes of the leaders and the scruffiness of the inner courts.

Long before the American architect Robert Venturi discovered Las Vegas and proclaimed its 'decorated sheds' to be a model for Western architecture,[13] his Soviet colleagues had already broken with the 'form-follows-structure' axiom of constructivism and made the separation of the architectural 'skin' from the 'bones'. The structure now had to be 'dressed-up' or 'coated' with architectural decorations. This architectural 'coat' could be applied to any structure; thus all major constructivist building in Moscow underwent redecoration in the 1930s.

The most striking example of such redecoration was the hotel 'Moskva'. It was designed and built by Savel'ev and Stapran, and in 1933 Aleksei Shchusev was commissioned to apply the new, non-constructivist coat. According to legend,[14] the lack of symmetry of the façade was the result of a misunderstanding. When Shchusev was making a rendering of the façade he divided it in half and produced two variants, so that Stalin, Kaganovich and other leaders could decide which one they liked the best. According to one version of the story, Shchusev was not allowed into Stalin's office and was not able to explain that there were two variants, and Stalin, not looking closely at the board, signed it. According to another version, Stalin realised that there were two variants, but deliberately signed the board right in the middle. Whatever really happened, nothing could

be changed after Stalin had signed the rendering; hence both variants had to be built as part of one structure.

This story suggests that the role of the actors was a complicated one: they were actively involved in the approval of the sets, and consequently in some situations were acting as audience. Very often renderings and models became more important than the actual buildings, because they were intended for an immediate contact with the leaders. This sometimes led to architectural solutions that could be perceived only on paper. At least two buildings had perfect five-point stars in their plans: the Theatre of the Red Army (Alabyan and Simbirtsev, 1934-40) and the Arbatskaya metro pavilion (Teplicky, 1934-35). These stars could not be seen from aircraft, since no aircraft traffic was allowed in Moscow airspace in the 1930s, and they definitely could not be seen from street level. These stars were intended to impress the leaders, which they obviously did. In terms of relations to the building's function, structure or organisation, these plans were no different from the façades.

## Enslavement and the Border

The war against the peasantry was declared in 1929 in the form of coercive collectivisation. It resulted in what Robert Conquest calls 'the terror-famine',[15] one of the worst famines in Russian history. To place the Moscow 'wonderful nights' of 1934 in proper context one has to to keep in mind that in the countryside these nights were accompanied by cruelties and sufferings of almost biblical proportions. In a village in Dnepropetrovsk oblast' an observer was told that 'all the dogs have been eaten. We've eaten everything we could lay our hands on – cats, dogs, field mice, birds. When it's light tomorrow, you will see that the trees have been stripped of the bark, for that too has been eaten'.[16]

The hunger created a mass-migration of rural population into large cities and especially in Moscow. Some measures were taken, however, to prevent the peasants from entering the cities. 'Special road blocks were set up on the roads leading into major cities to stop starving peasants from coming and begging for bread. When an American worker in Samara saw an old woman and two children who had eluded the guards and were lying close to death in the street, a Red Army soldier warned him off, saying, "These people do not want to work. They are kulaks. They are enemies of the Soviet Union"'.[17]

The man-made famine in the countryside and artificial building boom in Moscow were possible to maintain only by having road blocks and border guards. Thus, the border and the border guard became important cultural symbols in the 1930s.[18] The border of the state began to acquire some additional significance as early as the late 1920s. In 1926 special tests in civics were established 'for Soviet citizens, graduated from foreign universities and returning to work in the RSFSR'.[19] A decree in 1927 was directed to a 'sharp curtailment of business travel abroad'.[20] In 1928 the committee for exhibitions of foreign technology was done away with.[21] That same year a special committee was created 'to regulate the hiring of workers in the arts from abroad for work in the USSR and in the USSR for work abroad'.[22] The border gradually took on the meaning of dividing line between Good and Evil, which is evident in the following resolution of the Presidium of the Central Executive Committee of 1929: 'The refusal by a citizen of the USSR . . . working abroad to a suggestion from the organs of state authorities to return to the USSR will be construed as desertion to the camp of the enemy of the working-class and as treason'.[23] A resolution in 1934 added that such a refusal would be subject to 'the highest measure of criminal punishment – execution with confiscation of all property'.[24]

In the 1930s the territory of the Soviet Union consisted of a series of concentric circles separating areas of different value. The state border (as well as the fences around labour camps) separated 'the camp of the enemy of the working-class' from the 'empire of Good'. The borders of Moscow protected Muscovites from kulaks, 'enemies of the Soviet Union'. And the walls of Kremlin, to which no ordinary person had access, divided the 'sacred' and 'profane' space. Those who lived in the 'profane' part of Moscow (and other cities) were subject to a series of rulings aimed at restricting their free movement. These decrees regarding the 'liquidity of labour' and on the *propiska* (a special stamp in the internal passport indicating the place of residence which could not be changed voluntarily) paralleled the decrees concerning state borders. In 1928 engineers, technicians and agronomists were entered in a special registry.[25] In 1930 measures were taken in the 'struggle against the drain of labour' and among them were penalties for the 'enticement of workers and administrative-technical personnel'.[26] In 1935 a 'personal dossier' was opened on every student in the Soviet Union.[27] In 1938 workmen's passports (*trudovye knizhki*) were introduced.[28] In that same year the departure of kolkhoz workers from co-operative farms was finally

prohibited[29] which finalised the enslavement of the agricultural population. And in 1940 workers were forbidden to quit their jobs,[30] which in effect expanded the use of forced labour to the whole country.

## THE EMERGENCE OF A NEW CITY

Has there ever existed a city in the Western sense in Russia? This question has a long tradition.[31] Russian historians of the nineteenth century, struck by the apparent differences between Russian and West European cities, claimed that Russian cities were 'cities in name only', 'big villages', 'government fantasy', or 'coercive accidents'.[32] The medieval Western city was defined by the Belgian historian Henri Pirenne as 'an island of freedom in a sea of serfdom'.[33] According to Max Weber,[34] the Occidental city (as opposed to the Oriental ones, which he believed included Russian cities) had to have certain basic elements: (1) a fortress; (2) a market; (3) community or 'collective legal personality' with related forms of association (such as guilds). The merchants' economic interests necessitated the removal of feudal restrictions on trade and property. The city in the West became the byword for personal freedom: 'city air makes man free'.

Russian cities, which were fortresses and had markets, never had the 'association of urbanites in contradiction to the countrymen'.[35] Even in the nineteenth century many of the city dwellers were engaged in agricultural activities, or maintained psychological or legal affiliation with their villages.[36] Russian cities rarely were islands of freedom, and their air hardly made anybody free. Very often it was the other way around: cities provided a smaller degree of freedom than did the fields and forests outside. It was partly because the state 'saw the Russian population only in terms of services and taxes'.[37] Therefore throughout Russian history, the efforts to build and reinforce walls and borders have often coincided with attempts to tie down the population (as we have seen in the 1930s). For example, the white-stone walls of Moscow were erected under Ivan the Terrible in 1586–93, at about the same time the Czar's decree of 1597 gave the landlords the right to chase and catch runaway peasants for up to five years, and the decree of 1607 declared escape from a landlord to be punishable as a crime against the state.

Until the 1930s the Russian city had not really severed its ties with agriculture, but the war against the peasantry finally did create a border between the city and the village; as a result, some sort of urban culture, as distinct from traditional countryside values, emerged in Moscow. Yet the city that appeared in the 1930s still was not a Western city because in no sense did it have a collective legal personality; rather, it was an archaic city as described by Lewis Mumford or Henri Frankfort.[38] In terms of economic development, the new city also lacked some of the important characteristics of the Occidental city as described by Max Weber. Its economic versatility was not based on market (a dramatic decline from the pre-revolutionary times) but rather on what Weber called 'princely estate'.

The 1930s was a time of unprecedented urbanisation in Russian history. The rate of urbanisation between 1930 and 1940, as some scholars indicate, was 'perhaps the highest rate ever experienced in human history'.[39] The contemporary Soviet society was to a large extent formed in the 1930s. Here is a brief list of some important elements of the Soviet culture that emerged at that time:
- the physical shape of Moscow, Kiev and some other major Soviet cities,
- the agriculture based on de facto forced labour,
- the notion of the state border as a dividing line between Good and Evil,
- the system of holidays and rituals (including parades and demonstrations),
- the idea of an internal passport with mandatory *propiska*,
- workmen's passports (their format remains unchanged)
- the relationship between the government and the Party, and so on.

That was the time when the foundation of a new type of Russian civilisation was laid: the first Russian archaic city.

## NOTES

1. Lewis Mumford, *The City in History. Its Origins, Its Transformations and Its Prospects* (Harcourt, Brace, Jovanovich, 1961).
2. *Sobranie uzakoneniy i rasporyazheniy rabochego i krest'yanskogo pravitel'stva RSFSR*, 1924, no. 29–30, st. 272.

3. Ibid., 1920, no. 73, st. 336.
4. *KPSS v rezoluciyakh i resheniyakh s"ezdov.* v.II (Moscow, 1953) pp. 660–5.
5. Lev Nikulin, 'Chetvert' veka v Moskve', in *Moskva (sbornik)* (Moscow: Rabochaya Moskva, 1935).
6. All available photographs of Moscow of the 1930s to 1950s show almost no traffic.
7. OGPU – Ob"edinennoe gosudarstvenno-politicheskoe upravlenie (later KGB) – was in charge of all major building projects which involved prison labour.
8. *Sobranie zakonov i rasporjazheniy raboche-krest'yanskogo pravitel'stva SSSR*, 1933, no. 50, st. 593.
9. See Rosalinde Sartorti's chapter 3 in this volume.
10. Professor G. Dubelir in 1918, in *Iz istorii sovetskoi arkhitektury. Dokumenty i materialy*, vol. 1 (Moscow, Nauka, 1963) p. 16.
11. 'Uroki maiskoi arkhitekturnoi vystavki', *Arkhitektura SSSR*, 1934, no. 6, p. 12.
12. Bruno Taut, 'Kak voznikaet khoroshaya arkhitektura (1936)'. Russian translation in Tsentral'nyi gosudarstvennyi arkhiv literatury i iskusstva SSSR (TSGALI), f. 674, op. 2, edn khr. 21, 1. 267.
13. Robert Venturi *et al.*, *Learning from Las Vegas* (Cambridge, 1977).
14. S.O. Khan-Magomedov told the author that Shchusev himself partly confirmed this legend.
15. Robert Conquest, *The Harvest of Sorrow. Soviet Collectivization and the Terror-Famine* (Oxford University Press, 1986).
16. Geoffrey A. Hosking, *The First Socialist Society. A History of the Soviet Union from Within* (Harvard University Press, 1986) p. 167.
17. Ibid.
18. Cf. Katerina Clark, *The Soviet Novel. History as Ritual* (University of Chicago Press, 1981) p. 114.
19. *Sobranie uzakoneniy i rasporyazheniy rabochego i krest'yanskogo pravitel'stva RSFSR*, 1926, no. 88, st. 645.
20. *Sobranie zakonov i rasporyazheniy raboche-krest'yanskogo pravitel'stva SSSR*, 1927, no. 24, st. 265.
21. Ibid., 1929., no. 2, st. 13.
22. Ibid., 1928, no. 11, st. 100.
23. Ibid., 1929, no. 76, st. 732.
24. Ibid., 1934, no. 33, st. 266.
25. Ibid., 1928, no. 31, st. 275.
26. Ibid., 1930, no. 60, st. 641.
27. Ibid., 1935, no. 47, st. 391.
28. Ibid., 1938, no. 58, st. 329.
29. *Sobranie postanovleniy i rasporyazheniy pravitel'stva SSSR*, 1938, no. 18, st. 115.
30. Ibid., SSSR, 1949, no. 16, st. 358.
31. Lawrence N. Langer, 'The Historiography of the Preindustrial Russian City', *Journal of Urban History*, vol. 5, no. 2, February 1979.
32. M.G. Rabinovich, *Ocherki etnografii russkogo feodal'nogo goroda* (Moscow: Nauka, 1978) p. 53.

33. Henri Pirenne, *Medieval Cities. Their Origins and the revival of trade*, translated by Frank D. Halsey (Princeton University Press, 1925).
34. Max Weber, *The City*, translated and edited by Don Martindale and Gertrud Neuwirth (Glencoe, Illinois: Free Press, 1958).
35. Ibid., p. 81.
36. A good example could be found in Chekhov's story 'Muzhiki'. A butler in a Moscow restaurant gets sick and decides to 'go home, to his village'.
37. Lawrence N. Langer, 'The Historiography of the Preindustrial Russian City', *Journal of Urban History*, vol. 5, no. 2, February 1979, p. 211.
38. Henri Frankfort, *Kingship and the Gods. A Study of Ancient Near Eastern Religion as the Integration of Society and Nature* (University of Chicago Press, 1968).
39. Robert A. Lewis and Richard H. Rowland, 'Urbanization in Russia and the USSR, 1897–1970', *The City in Russian History*, ed. by Michael F. Hamm (University Press of Kentucky, 1976) p. 208.

# 13 The Ultimate Palladianist, Outliving Revolution and the Stalin Period: Architect Ivan V. Zholtovsky

## Adolf Max Vogt

The generally accepted view of the architectural development from the Russian Revolution (1917) until Stalin's death (1953) is simple enough: *first*, a true revolution of the concepts of space, that is, a purity of 'modernity' that surpasses and outshines all Western endeavours of this kind ('Bauhaus', 'neues bauen', 'CIAM') and also quite often antecedes them chronologically; *Then*, a fatal twisting of the arguments under Stalin that results in a blown-up version of 'Cake Decorators' Baroque'. The *watershed* between these two contradictions is generally seen as occurring in the decisions at the Competition for the Palace of Soviets, which was drawn out over several phases from 1930 to 1935. Already in 1931–32, the jury of this international competition begins to give prizes to names which promise little, measured by the expectations of the European avant-garde. One of these names is Ivan Vladislavovich Zholtovsky, born 1867 (12 years before Stalin), who died in 1959 (six years after Stalin). In 1931–32 he receives a First Prize, next to the two additional First Prizes for the Russian Yofan and for the American Hamilton. In the third phase (1933–35), 'the project of comrade Yofan' is qualified 'as the basis', and as partners to Yofan are added the architects Shchuko and Gel'freich.[1] This short sketch of the events between 1917–53 is not a 'terrible simplification', yet it needs to be supplemented and made more precise – especially because the documentation of the events is by no means completed and each new publication triggers new corrections of the total profile.

Apart from this: how did Soviet artists and architects themselves explain the contradiction between the Stalinist 'People's Baroque' or 'Mass Baroque' on the one hand, and revolutionary Constructivism

240

on the other? In Milan Kundera's novel *Life is Elsewhere* (1973) is to be found the description of an art debate, which does not touch upon architecture but which seems typical for the alternative which dominated Russia and the satellite countries for a long time. From this debate, which takes place in Prague, I quote:

He [Jaromil] invoked Marx's idea that until modern times mankind had been living in prehistory, and that its real history began only with the proletarian revolution, which was a leap from the realm of necessity into that of freedom. In the history of art, a comparable decisive turning point was the moment when André Breton and other surrealists discovered automatic writing, revealing a hidden treasury of the human subconscious. It is symbolically significant that this occurred at about the same time as the socialist revolution in Russia. The liberation of the human imagination entailed the same leap into the realm of freedom as the liberation from economic thralldom.

At this point, the dark-haired man entered the debate. He praised Jaromil for defending the principle of progress, but expressed doubt that one could link surrealism so closely with the proletarian revolution. He stated his belief that modern art was decadent and that the epoch in art which best corresponded to the proletarian revolution was socialist realism. Not André Breton, but Jiří Wolker – the founder of Czech socialist poetry – must be our model! . . . the only art which is modern is the art that helps in the struggle to build a new world. This could hardly be said of surrealism, which was incomprehensible to the masses.[2]

What in Kundera's novel is discussed as a contradiction between Surrealism and Socialist Realism in the context of literature, would, when translated into the context of architecture, stand for the contradiction between avant-garde (ill. 10) and Stalinist monumentalism (ill. 11). What was brought about under Stalin – through the exclusion of the avant-garde groups and the levelling of the professional organisations into a uniform union, the SSA, in 1932 – was carried out under the formula 'proletarian in content, national in form'. But, as becomes increasingly clear through the new material that has become accessible,[3] Zholtovsky never submitted to this formula, even though the suspicion that he did is sustained by the fact that he received the Stalin Prize in 1950. A late recognition, for at that time he was 83 years old.[4]

To be sure, Zholtovsky belongs in the same group as Fomin and Tamanyan, but he certainly is not an ally of Mordvinov and Tzapenko. This dividing line should be observed and it is to be explained as follows: the Neoclassicist Fomin from Petersburg/Leningrad and the Regionalist A. Tamanyan, who defended the architectural cultural heritage of the Armenians and wanted to develop it further, constituted together with the Palladianist Zholtovsky an influential defensive formation against the avant-garde – but these three architects are no architectural propagandists for Stalin's dictatorship as was the theoretician M. Tsapenko[5] and as was the zealot A. Mordvinov, who laid before the Congress of the Architects Union of 1939 the following resolution: 'The true architect is the Party: the idea proposing verticality does not stem from the architects but from the Party'.[6]

What Tsapenko and Mordvinov had in mind in terms of theory and what often fully developed as a model in the propagandistic pathos of his project for the Palace of Soviets (ill. 25), Zholtovsky quite probably – even if he did not do so openly – held to be a 'degrading monumentality'. Because to the convictions and doctrines of Zholtovsky belonged also the view that an 'elevating monumentality' (for instance, that of the Parthenon) has to be distinguished from a 'degrading monumentality' (for instance, that 'of the old Roman architecture with its heavy elements and its huge entablature').[7] What was unusual in Zholtovsky's position – and this holds true of his long life of over 80 years – is the fact that he sustained a resistance not just against one, but even against two sharply distinct architectural periods. For his resistance was turned against the avant-garde of the so-called Russian constructivists (represented here for instance by Leonidov, (ill. 10) just as against Stalinist architecture later on (moulded first by architects such as Yofan (ill. 23 and 25) and later by others like Rudnev (ill. 11). No wonder, that in his exceptional life, which showed him highly successful as a pedagogue yet a complete loner as a designer, the two aspects of the force of resistance present themselves in a strange mixture: resistance as a strength of character and resistance as a sheer obstinacy. Only by dint of this mixture could he save and sustain his own 'Third position' over the course of more than half a century in the midst and beyond the eruptive heat of the Revolution and the paralysing cold of the dictatorship.

Admittedly, in this he was aided at the onset by the political constellations. For the most powerful figure of the Revolution, Lenin himself, took up a stand regarding the arts that came astonishingly

close to Zholtovsky's intentions, and this fact evidently served Zholtovsky as a source of support throughout his life. In my book, *Russische und französische Revolutionsarchitektur 1917/1789* (Cologne, 1974), I have tried to show that in his cultural policies Lenin increasingly was pulled into an ever more distinct dichotomy between avant-garde and tradition. On the one hand, he shows an astonishing openness toward the experiments of the avant-garde painters, that interest him as much as they irritate him – and on the other hand, he decidedly gives a great importance to the taking over and reprocessing of the traditional values by the Marxist-oriented state, and that is by the proletarian class recently come to power. In the above mentioned book I attempted to point out this ambivalence in the role Lenin played as a patron of architecture:

As is well known, Lenin ruled the young Soviet state at first from Petersburg, called Petrograd at the time. As the Government Residence had been chosen the former educational institution of the aristocracy, the Smolny Palace. Here Lenin was active 1917/18, and then came the move to Moscow. In order to emphasize the significance and the memorable character of this first seat of the government – presumably also in the sense of Lenin's call for 'monumental propaganda' – in 1922 was erected along the front approach a double colonnade of Doric columns by the architects Shchuko and Gel'freich (ill. 12).

These two architects conceived their task in a strictly conservative sense. They placed a row of five Doric columns on each side along the axis leading to the Ionic façade of the building. Thus they simply wanted to confirm the former educational institute in regard to its form, and evidently, are thus far from daring to attempt a confrontation, say, by setting avant-garde forms in opposition to the neo-classic building so as to make it perceptible that in this conventional aristocratic building had happened highly unconventional and unaristocratic events. Inconceivable, that they did this in 1922, in the very period of blazing fervor for the new goals of a new art.

Since in 1922, before his stroke, Lenin actively exercised his powers, it is hardly imaginable that he had not personally given his assent to this symmetrical neo-classical portal. This shows as a matter of fact that about 1922/23 not only the constructivism and functionalism holds sway that we see coming into the fore in the

designs of the brothers Vesnin. On the contrary, an opposite movement is in existence and sets in Smolny its first counterpoint.[8]

Lenin's ambivalent attitude, or more precisely: his tendency to assign to architecture a more conservative part and to painting a more experimental part (ill. 13) is mirrored in the decisions of his secretary of cultural affairs Lunacharsky (Director of the People's Commissariat of Education). Lunacharsky maintained that 'the future belongs to classical architecture' whereas 'the leftist search' has to remain the domain of painting, as 'for architecture such daring experiments are not salutary'. When in the third year of the Revolution tensions surfaced between 'the leftists and the classicists', Lunacharsky abruptly created a clear situation by dividing the architecture group from the art group and entrusted the leadership of the first of the two to Zholtovsky. Hence, 'in the first years of Soviet rule the classicists dominated building practice over certain periods of time'.[9]

However, the appointment of the then 52-year-old Zholtovsky stirred the younger avant-garde architects into an uproar and they proceeded to found under the plausible title of 'Synskulptarch' (short for: Synthesis/Sculpture/Architecture, in keeping with the predilection for word truncations at that time) a first association for new architecture, to which belonged Ladovsky and Fidman, for instance. This founding action was expressly registered as a protest against the person of Zholtovsky.[10]

Such events and developments call for a comparison and they also raise the question of their legitimation, or lack of it, from the side of Marx. Starting with the comparison: it is interesting to note that the avant-garde theoreticians in the West set up at this period a different art theory than that of the Marxists in the East. While, as noted above, Lenin and Lunacharsky assign to architecture the 'classic' and to painting a 'leftist search', in the West, particularly the Bauhaus circles under Gropius developed a kind of 'theory of precedence' for the arts which puts painting ahead in the position of pilot (and thus also of a search, but aimed in a general sense at the 'new') while architecture – as the more encumbered art, because dependent on industry – receives the function of a follower (facing up nevertheless to the considerably difficult task of having to transpose the 'new pictorial space' into the 'new real space').[11]

The second question, the point whether Marx himself endorsed the classicists or the leftist searchers as his true followers, I have

specifically pursued in respect to Lunacharsky and Marx in the above mentioned book, and here I can only refer the reader to the relevant passage.[12]

Our thesis that Zholtovsky's work offers a counterpoint against two different periods of Russian architecture can best be demonstrated by contrasting his position with works of other architects done in the same year. We have to limit ourselves to eight designs only, of which five were actually built. A modest, but as I hope, nevertheless a significant portion of an oeuvre that deserves a full documentation (if only because the persistence of an architect in presenting a counterpoint to the trends of his time is an astonishing case in our century).

Zholtovsky was 42 years old in 1909/10, when he built the House Tarasov (ill. 14) and therewith put down a card on the table marked with one single name, namely Palladio's. Already here one feels compelled to ask: can an architect in all seriousness want to take the city houses by Palladio from the terra ferma in Venice and transport them across over three-and-a-half centuries and the distance of three-and-a-half thousand kilometers of space-time to the North-East, from a mediterranean to a continental climate? To be sure, Fomin, Zholtovsky's rival in Petersburg apparently answers this question in the positive with his Villa Polovtsev (ill. 15) built two years later. Yet Fomin avoids Zholtovsky's completely literal and faithful adherence to the original, and stays within the framework of that freely variable Neo-Classicism which since the Eighteenth century had remained applicable in the Scandinavian countries, in Russia, and likewise in North America. While Fomin later attempted to react to the revolutionary changes by proclaiming his slogan of 'The Red Doric',[13] with his design for the bridge over the Moskva (ill. 16), Zholtovsky shows himself as totally immune and immutable, who by 1921 had certainly lived through four dramatic years of revolution yet kept his gaze unerringly on the fixed star of Palladio. Did he feel the Smolny colonnade (ill. 12) that Lenin had just erected as a renewed legitimation of his own attitude? And did he feel his own stand further legitimised by the decision reached jointly by Lunacharsky and himself in 1919 proposing to view the 'leftist search' justifiable for painting but inadmissible for architecture? As soon as one sets some nearly contemporaneous work next to Zholtovsky's Bridge, say, Tatlin's Tower of 1919 and the Publishing House by the brothers Vesnin of 1924 (ill. 17), one feels dazed or transported as by a dream – either from anger or by magic.

The building of the State Bank in Moscow (ill. 18) was erected in the year of Leonidov's design of the Lenin Library (ill. 19) on the hills over the bend of the river (that is, for the same site on which the Lomonosov University (ill. 11) was later erected. While in his bridge design Zholtovsky appeared a dreamer, now he appears a philistine, whose Renaissance gesture falls flat. In fact, in these years he seems to have gone through his only one deep crisis of loyalty towards his Upper-Italian master and paragon. That ends up in his recognising, at least for industrial architecture, the right to a 'harmonised constructivism', that is, the right to a new vocabulary. The boiler house of the Electric Power Station near Moscow (ill. 20, 1927) is proof of this single concession, and at the same time a proof of Zholtovsky's mastery of his art.

One almost feels tempted to assume that he now approximates the younger avant-garde architects such as Barshch and Vladimirov, who achieved in their communal housing unit (ill. 21), designed at the same time, the most pregnant version of this new species of housing. Yet this approximation happened in the opposite sense: Barshch attests that shortly after he began working on his commune design he began regularly to attend Zholtovsky's lectures.[14]

Zholtovsky's first design of the Palace of Soviets (ill. 22) has for a long time been read by Western observers as the breakthrough that opened the field for the escalation into the coarsely colossal mode that Yofan brought to a final realisation in 1933–35 (ill. 23). However, if one takes into consideration Zholtovsky's second design (ill. 24, third stage, 1933), one is inclined to read it differently. For it becomes obvious that, on the contrary, he is trying to avoid the colossal, and though piling up massive building units he undertakes everything to preserve the articulation of slenderness. This second design is not only a tour de force imposed on him against his will, it is also a veto aimed against Yofan (ill. 25). With the so-called 'Intourist' Building (ills. 26 and 28) Zholtovsky takes back his literal word for word adoption of Palladio that he practiced before the outbreak of the Revolution (ill. 14). For this is a motif copy of the Loggia del Capitaniato built by Palladio in 1571 in Vicenza (ill. 27). I am saying motif copy and not a total copy, because out of the three storeys he makes five, or respectively, seven storeys. But the most prominent motif: the violently projecting corbelled entablature with the superimposed balcony has been reproduced so pronouncedly that a striking mirror effect is achieved – that almost makes one forget the

weakening of the motif of three arches down to a single plain central door entrance.

It is again Leonidov who acts as Zholtovsky's most important opponent in the same years (ill. 29), this time with a design which sums up something like a Postmodernism of the Russian constructivists, as we today might tentatively call this phase of Leonidov's. For in it he has left the geometric purism of the Lenin Library of 1927 behind (ill. 19) yet by no means abandoned it. He opens himself for historical perspectives, which, with a sure hand, he magnificently combines with the modern constructivist language of steel and glass. The small tower, on a circular ground plan (right) is namely a paraphrase of the two famous light-houses on top of the Strelka in Leningrad and their platforms (shaped as a ship prow) – a motif that occupied Fomin as well.[15]

Even against this second masterpiece Leonidov's Zholtovsky persists in what we have called a counterpoint position, although the two opposing camps seem to force each other into an escalation. Zholtovsky had used quotations – now Leonidov, too, begins to use quotations; the first of the two, as ever, Palladio; the second one, and this is totally new for his camp, de Thomon. If Leonidov learned from Zholtovsky the use of quotation, he also immediately surpassed him at it.

Our last example from the noteworthy series of Zholtovsky's work, the City Hall in Sochi on the Black Sea (ill. 30), at first reminds one of the City Hall in Winterthur (Switzerland) by Gottfried Semper. But the interconnections go back much farther, and demonstrate a very strange theory of Neo-Classicism, which I have not come across in this form. However, it remains to be examined, whether in East Europe and Russia can be found antecedents with similar ideas or whether influences from theories on language can be discovered. We have a case here of a 'parallel action' (a concept I am borrowing from Robert Musil) to Western Neo-Classicism. The side gables of Sochi (to be seen on the left in ill. 30) are namely so-called broken pediments as they occur prominently in Late Antiquity in Baalbek. A comparison with the reconstruction of the Adytum in Baalbek (about 150 AD) (ill. 31) shows the origin of the borrowing clearly enough. And Baalbek lies, as the map shows (Ill. 32), almost exactly south from Sochi. In other words: to the Rome of Western Europe and the Athens of Middle Europe Zholtovsky counterposes a Baalbek of Eastern Europe. The barely 60-year-old architect of the City Hall of

Sochi begins thus to reclaim for Russia its own geograpically apposit-ive specific zone of Neo-Classicism. Does he see himself in this as a Lord Burlington of the East – or is he adapting to the ever-present nationalism and compulsion for legitimation of the Stalin era? If the second supposition carries more weight then we have to grant Zholtovsky quite a different appeal, in contrast to M. Mazmanyan's deportment, who a year later, in 1937, is said to have exclaimed before the Architects' Congress: 'Although the Akropolis is located on your territory, we are its true heirs'.[16]

## NOTES

1. Cf. Anatole Kopp: *L'architecture de la Période Stalinienne* (Grenoble, 1978) Chapter, 'Concours du Palais des Soviets'.
2. Milan Kundera, *Life is Elsewhere* (New York, 1985) pp. 115–16.
3. Cf. especially Selim O.Chan-Magomedow, *Pioniere der sowjetischen Architektur* (Dresden, 1983).
4. The strikingly late bestowal of the Stalin Prize to Zholtovsky leads one to distrust the assertion that he has had a direct influence on Stalin's architectural judgement. Anatole Kopp in *L'Architecture de la Période Stalinienne* (Grenoble, 1978), however, cites the architect Hans Blumen-feld, who worked in Moscow from 1930 on: 'Joltovski a eu une grande influence sur Staline. C'est lui qui l'a initié à l'architecture' (p. 404). Is there a legend in the making here?
5. M. Tsapenko was the author of the following resolution at the Congress of the Architects' Union in 1937: 'The creative method of Social Realism has its origin in the great scientific discovery of comrade Stalin which says that Soviet architecture has to be proletarian in content, national in its form'. A. Kopp, op. cit., pp. 352–3.
6. Anatole Kopp, op. cit., pp. 276–7.
7. Anatole Kopp, op. cit., p. 404, statement to Hans Blumenfeld.
8. A.M. Vogt, op. cit., pp. 233–4.
9. See Chan-Magomedow, op. cit., pp. 23 and 24.
10. See Chan-Magomedow, op. cit., p. 68.
11. The later summary and elaboration of this theory was achieved by Sigfried Giedion in *Space, Time and Architecture* (Cambridge, Mass., 1943).
12. A.M. Vogt, op. cit., pp. 235–7.
13. Cf. Vogt, op. cit., p. 131, and Chan-Magomedow, op. cit., p. 23.
14. Anatole Kopp, op. cit., record of a conversation with Barshch, p. 381.
15. Cf. Vogt, op. cit., Chapter 16, 'Die Strelka in Petersburg', pp. 130–2; also W. Pekut, *Das Ende der Zuversicht. Architektur in diesem Jahr-hundert* (Berlin, 1983) pp. 150–1.
16. Anatole Kopp, op. cit., p. 314.

# Part V
# Film

Part V
Film

# 14 From the Avant-Garde to Socialist Realism: Some Reflections on the Signifying Procedures in Eisenstein's *Stachka* and Donskoi's *Raduga*

Brenda Bollag

Twenty years and vastly divergent socio-political contexts separate the two films which I shall discuss here. *Stachka* (1925), Eisenstein's first feature-length film, was made in the Soviet Union at a time when an exceptionally euphoric vitality and unprecedented innovativeness was observable in all walks of artistic and intellectual life. Despite their turbulence and extreme material hardships, these first years of Soviet power were the scene of an exuberant rupture with old values and of an attempt to redefine art in such a way that it would correspond to the needs of a new and more just society. The theatre of Meyerhold, the poetry of Mayakovsky, and the plastic art of the Constructivists are among the most well-known examples of this ardent desire to break with the past. For the cinema, the revolution brought about changes which were perhaps even more substantial than those which occurred in the other arts. Nationalised in 1919, and declared by Lenin to be 'the most important of all the arts', the cinema found itself propelled virtually overnight from a side-show attraction to a major form of national culture, important not only as a powerful tool of political propaganda on the one hand, and means of artistic expression on the other, but as a medium in which the two could be synthesised into a truly political form of art.

Parallel to these developments in the field of artistic production, highly original approaches to the analysis of art were being advanced by theoreticians. The Formalists began looking at the artwork as a structured ordering of elements and sought to explain its specificity in

terms not of its content, but of its formal characteristics (or 'structure'). Although they lacked a sufficiently solid base of conceptual tools to be able fully to achieve their goals, the Formalists developed a line of questioning which effected a major break with content-oriented descriptive analyses and which provided the groundwork for much subsequent research in the semiology of the arts. Bakhtin, simultaneously critical and appreciative with regard to the Formalists, analysed literary artworks in terms which surely would have met with the approval of Eisenstein himself. In his well-known work on Dostoevsky, for example, he stresses the importance of counterpoint, of the weaving of divergent – or even contradictory – elements into a polyphonic discourse, of character construction based on the personification of abstract ideas, and of a type of composition which he called 'carnivalesque' and which brings strongly to mind Eisenstein's principle of a 'montage of attractions'.

In the theory and practice of ordinary linguistic communication similarly original developments were taking place. Here again, the name of Bakhtin is central: the first to explicitly attempt to apply the principles of Marxist thought to the analysis of language, he construed the sign as an arena within which contradictory 'indices of value' confront each other. It is this 'internal dialectic', he maintained, that 'renders the sign alive and mobile, capable of evolution'.[1] The new government's language policy, aimed at giving each Soviet citizen the right to communicate publicly and privately in his or her own language, was an attempt to put the egalitarian ideals of the Revolution into practice. Faced with a largely illiterate, ethnically heterogeneous population speaking over a hundred languages, of which relatively few had written forms, the Soviets 'expended considerable time and effort on the  . . . provision and development of literacy in these languages, and on the provision of educational and other cultural facilities in a wide range of [them]',[2] even going so far as to create written forms for certain languages with as few as several thousand speakers.

By the time that Donskoi shot *Raduga* in 1943, more than a decade of bureaucratic repression of the strictest and most tyrannical kind had ravaged the artistic and linguistic situations. Bakhtin was arrested in 1929 and exiled to Kazakhstan. His dangerously anti-dogmatic theories were banished from the universities and replaced by Marr's mechanistic and imprecise attempt to apply Marxism to the study of language, which was to be imposed for over 20 years. Formalism had become a crime; Meyerhold and many other of the

best talents of the so-called 'Heroic Epoque' had already met with brutal liquidation. Artistic activities of all types were submitted to rigid centralised control and strict censorship. Because of the elaborate apparatus required by the nature of their art, deviation from the rigorously imposed aesthetic dogma of Socialist Realism rapidly became a structural impossibility for film-makers. 'Vitality began to vanish from motion pictures' write the Liehms, 'to be replaced by brochure illustrations, posters of May Day slogans and official rosy-hued optimism'.[3]

The war would have the effect of loosening this control somewhat. With the transfer of cinematographic production to outlying provinces (*Raduga* was shot at the Mosfilm studios in Alma Ata), censorship became far less effective and technical difficulties and the lack of adequate facilities forced film-makers to improvise and innovate in ways which would have been impossible in the 1930s. 'In addition', note Liehm and Liehm, 'as a result of the horrors of the war, Soviet film regained some of the rights of which the Socialist Realism of the late 1930s had stripped it: the right to depict death, the right to show suffering, misery, hunger, misfortune, and grief'.[4]

At the level of their overall goals and thematic concerns, Eisenstein and Donskoi had much in common. Both were guided by an unfailing commitment to revolutionary ideals and saw the arts as a powerful means of furthering these ideals, as 'one of many instruments used on the battlefront of the class struggle and the struggle for socialist construction'.[5] Both considered agitation, propaganda, and elevating the level of political consciousness of the masses to be among their most important tasks as film-makers (Eisenstein: 'The Soviet cinema aims primarily to educate the masses';[6] Donskoi: 'We must acquire the great art of educating mankind'[7]). Both were strongly critical of the bourgeois cinema's thematic orientation: addressing himself to the 'masters of occidental cinema', Donskoi proclaims himself to be 'nothing less than indifferent to your art . . . in which the alcove disputes between a prostitute and her pimp have become . . . the central conflict',[8] while Eisenstein denounces 'the bourgeois cinema ['s] . . . class taboos', citing the New York City Censorship Board's list of 'undesirable thematic attractions' upon which "relations between labour and capital" appears alongside "sexual perversion" [and] "excessive brutality" '.[9] In choosing the anecdotes which can be considered as constituting – in the sense referred to above – the 'meaning' of their films, Eisenstein and Donskoi adhered to the very general tendency among both avant-

garde and Socialist Realist film-makers to treat contemporary or historical conflicts such as wars, political upheavals and their aftermaths, economic struggles, in clearly partisan terms. But although they were involved in the transmission of very similar types of meaning, little was similar about their conceptions of the series of luminous images which would correspond to them. Eisenstein and Donskoi were both firmly committed to making political films; but Eisenstein, to use Godard's expression, wanted to 'make political films politically'.

Barely older than Eisenstein himself, the cinema had already institutionalised a set of standardised procedures for the construction of an anecdote by the time he began making films. The little filmed sketches lasting no more than a few minutes which had characterised the cinema's beginnings were before long being strung together to form the episodes of somewhat longer films and, by around 1915, the cinema had already found its essentially modern format: a single, elaborate story line, built around a small number of highly developed characters, lasting for about an hour and a half. The cinema had already adapted many of the conventions of theatrical naturalism to its own needs (for example, by framing action from the perspective of a movable 'missing fourth wall'), and the rudiments of 'invisible' editing (that is, classical Hollywood montage which reduces the shock of disparate images coming together through the use of schemas such as the 'shot/counter shot' or the 'long-shot/mid-shot/close-up') had already been established. Eisenstein, convinced that a revolutionary message could not be conveyed with the same types of signifying procedures that the bourgeois cinema used to inculcate the masses with escapist fantasies, set out not only to transmit a different kind of meaning to the spectators, but to restructure the way in which various elements would be assembled into a filmic signal corresponding to it. In 1940, in an article entitled 'More Thoughts on Structure', Eisenstein recalls his position at the time of the making of *Stachka*: 'A story sharper than the American ones? What could be sharper than to reject "story" altogether? . . . What if we should turn our backs on all that and build with quite different materials?'[10] But, in fact, Eisenstein would not 'abolish' or 'reject altogether' the story: in contrast to Dziga Vertov's *Chelovek s kinoapparatom* (1929), which verges on the non-narrative, Eisenstein's films all contain easily discernible, essentially straightforward 'story carcasses' around which the film's elements are assembled in ways which often defy normal narrative expectations. But, unlike Donskoi, who synchronised all

the film's elements into harmonised support of a unified, emotionally engaging plot line, Eisenstein played on the conflict between such elements, retaining only enough of a story to assure the coherence of the polyphonic 'montage of attractions' into which he assembled them. The audience's so-called 'identification-projection' mechanisms – through the manipulation of which Donskoi so skillfully succeeds in eliciting visceral feelings of personal involvement in the drama of *Raduga's* characters – are barely solicited in any of Eisenstein's films. He attempts, rather, to use the cinema's powerful emotional intensity as a means of inducing spectators to reflect analytically about the forces shaping their world, and thus 'To restore sensuality to science. To restore to the intellectual process its fire and passion. To plunge the abstract reflective process into the fervor of practical action'. 'Where is the abyss', he asks, 'between tragedy and essay?'[11]

For Vertov, Eisenstein did not go far enough in breaking with conventional illusionistic cinematography; for others, he went too far, and in 1934, ever ready to adapt his film-making to the better service of the Revolution, he called for a revalorisation of the story: 'In 1924, I wrote with intense zeal: "Down with the story and the plot!" Today, the story which then seemed to be almost "an attack of individualism" upon our revolutionary cinema, returns in fresh form, to its proper place'.[12] Try as he would, however, Eisenstein never succeeded in making a truly Socialist Realist film. Even in *Alexander Nevsky* (1938), his most fervent attempt in this direction, he persists in violating the fundamental laws for constructing a conventional realist narrative. Despite the considerable stylistic differences which separate the four films which Eisenstein made during the 1920s (*Stachka*, *Bronenosets Potëmkin*, *Oktyabr'*, and *Staroe i novoe*) from his two later works (*Nevsky* and *Ivan Grozny*, many of the 'signifying procedures' introduced in *Stachka* which we shall attempt to describe below continued to be used throughout his career. By the term 'cinematographic signifying procedures', we refer to the means through which a link is created between the moving spots of light projected onto the screen on one hand, and a given meaning on the other, in such a way that the former 'stands for', 'represents' or 'signifies' the latter.

CHARACTER CONSTRUCTION

For Eisenstein, character construction, like so many other aspects of film form, was an acutely political problem. Holding the conventional cinema's tendency to structure all action around the personality of the hero as 'an operation born of an individualistic conception of the world which is incompatible with our conception of "class cinema" ', he sought 'to push into the dramatic center the masses as the basic *dramatis persona*, those same masses that heretofore had provided a backdrop for the solo performances of actors'.[13] Yet in *Stachka* and *Raduga* alike we see images of crowds and images of individuals; we see heroic actions undertaken both collectively and individually. How is it then that we unhesitatingly identify the 'real hero' of *Stachka* as the masses and the 'real heroines' of *Raduga* as Olga, Olena and Fedossia? How does Eisenstein manage to transform an animated element of the decor into a visually and dramatically autonomous character?

The most immediately striking differences between Eisenstein's and Donskoi's representations of the masses are of a quantitative order: the crowd in *Stachka* is much larger than the crowd in *Raduga* (several hundred extras in the former film as opposed to several dozen in the latter) and much more frequently on the screen. In *Raduga*, the crowd serves to provide us with details about the context within which the principal protagonists are operating; we see it either crammed into or passing through spaces which are essentially theatrically-conceived and adapted to the proportions of the film's three individual heroines. In *Stachka*, on the other hand, the camera is pulled back to a vantage point from which Eisenstein can create an enormous visual field adapted to the dimensions of the crowd itself. The screen thus becomes a colossal expanse within which the crowd can be made to move about, to rise up and to pulsate as a single living being.

In their treatment of individuals, the contrast between *Stachka* and *Raduga* is equally sharp. Donskoi begins with the rather original premise of making a war film in which the major protagonists are women and then procedes to develop them in accordance with the conventions of naturalistic narrative representation. Each heroine reappears at numerous points throughout the film, variously framed in long-shots, mid-shots and, especially, close-ups; each is shown engaged in a diversity of activities and is incarnated by a skilled professional actress trained to convincingly imitate a wide range of

facial expressions. Clearly, they are crucial elements around which the film's action turns.

When images of individual workers appear in *Stachka*, it is on the contrary in the form of little self-contained sketches which function as 'close-ups' of fragments of the crowd. The individual tragedy, for example of the worker who hangs himself following the ruinous theft of his micrometer, is presented to us without lingering close-ups of the realistically expressive faces of actors. Before we have time to become sentimentally involved in the plight of the individual victim, the reappearance of images of the crowd reminds us that this is potentially the tragedy of a thousand workers.

For Eisenstein, naturalistic 'method' acting, which would – under the successive guidance of Konstantin Stanislavsky at the Moscow Art Theatre and Lee Strasberg at the Actor's Studio in New York – acquire a firm and still unrelinquished hold on the cinema, held little interest. He sought a way of bringing together 'the montage method and the sphere of the *inner* technique of the actor'[14] in such a way that through 'the assembly and juxtaposition of deliberately selected details . . . nuance of feeling is added to nuance of feeling, and from all these the image of hopelessness begins to arise'.[15] He enthusiastically cites a technique of 'disintegrated' acting which he discovered in the Kabuki theatre: the actor 'depicting the dying daughter in *Yashao* (*The Mask-Maker*) performed his rôle in pieces of acting completely detached from each other: acting with only the right arm. Acting with one leg. Acting with the neck and head only. (The whole process of the death agony was disintegrated into solo performances of each member playing its own rôle)' and writes of the 'rhythms' with which the actor can 'fully grip the spectator' when he is 'freed from the yoke of primitive naturalism'.[16] For most roles, Eisenstein did not use actors at all, but non-actors who were cast on the basis of a 'principle of typage' with which he had already begun experimenting in the theatre. He saw his task not as that of 'looking for creative revelations of talent' but of finding 'the right people . . . the correct physical appearances'[17] and he would sometimes spend months scouring the general population until he found just the right 'type' for a given role. The principle of typage, Eisenstein insisted, did not simply mean 'a face without make-up, or a substitution of "naturally expressive" types for actors'; rather, it was part of a 'specific approach to the events embraced by the content of the film', an approach which allowed for the development of 'definite affinities to real life through the camera'.[18] Eisenstein's method is based on the

one hand on ancient theatrical traditions, and on the other on the shooting conditions offered by a modern Socialist state. The stock characters in *Stachka* representing 'the honest worker', 'the greedy boss','the depraved informer' and so on are compared by Eisenstein himself to the figures of the *Commedia dell'Arte*, and the integration of masses of ordinary people into the dramatic action was one of the features of medieval 'mystery cycles' and morality plays which called upon the audience to play the role of the common man. Sometimes – as in the shooting of the taking of the Winter Palace for *Oktyabr'* for which 4000 workers were mobilised – people who had themselves participated in the events which would be depicted on the screen re-enacted their involvement in them before the camera. 'Such a filming method is possible in Russia where each and every matter is a government matter' wrote Eisenstein in 1926, clearly not foreseeing the monumental difficulties which this government interest would soon bring him, 'If we are making a naval film, the whole fleet is at our service; if a battle film, the whole Red Army'.[19]

While its hero is clearly the masses, the villains of *Stachka* appear in the form of individuals. Yet, unlike Kurt Werner, the commander of the German troops occupying the village in *Raduga*, and his traitorous Russian mistress, they bear little resemblance to 'real people'. To account for this difference between Eisenstein's and Donskoi's characters, Charles Sanders Peirce's famous tripartite system for classifying signs may be of help to us. Peirce, insisting that his typology concerned not mutually exclusive sign types but dimensions which often co-exist within a single sign, distinguished between the *icon*, which is characterised by a relationship of resemblance between the signal (signifier) and its referent (signified), the *index*, in which there is an 'existential bond' between the signal and its referent and the *symbol*, in which the signal is linked to its referent solely by virtue of an arbitrary convention or contract.

Cinematographic images are by nature highly indexical (because the referent – or a simulacrum for the referent– must be placed before the camera and thereby made physically to intervene in the process of the signal's production) and highly iconic; their symbolic aspect – which manifests itself, for example, in the traditional colour-coded use of attire for the hero and villain of cowboy films – is generally far less important. However, the iconic, indexical, and symbolic dimensions may assume widely varying proportions in different types of films. In documentaries, it is clearly the indexical – that is, the physical bond between the images on the screen and the objects and people that they represent – which predominates. 'Rea-

list' fiction films such as *Raduga* tend rather to emphasise the iconic and to be built around psychologically believable portraits of cha- racters who have names and private lives, and who are shown eating, speaking and expressing diversified human emotions and who, visually and audibly, resemble real people. The characters in *Stachka*, on the other hand, although they too are partially iconic, are strongly symbolic as well; they can thus be classified, along with the Christian cross and the scales of justice, as 'emblems'. The image of the factory boss, for example, does not function simply as an iconic representation of a human being,but also as a symbol of the larger, more abstract notion of 'capitalist oppression'.

In 1937, in the atmosphere of censure and virulent criticism which surrounded his disastrously abortive attempts to make *Que Viva Mexico!* and *Bezhin Meadow*, Eisenstein would reconsider his earlier position concerning actors and characters. After submitting the 'exaggerated generalisations' and 'donquixotesque deviations' of his early works to public 'self-criticism', he embarked on the making of a film about an individual, rather than collective hero. 'For the first time', writes Amengual, 'Eisenstein integrates into his art the art of the actor'.[20] Yet neither the demands of officially imposed Socialist Realist aesthetics, nor the constrainst of the biographical genre, nor the extraordinary acting talent of Nikolai Cherkasov could compel Eisenstein completely to abandon his earlier conception of character construction and to create a truly convincing 'realist' hero. 'His initial idea', writes Barna, 'was to endow him with superhuman qualities – with the colossal strength, for instance, to rip apart an apparently indestructible fishing-net'.[21] Although the idea was eventually aban- doned, Eisenstein's representation of *Nevsky* retains a heavily sym- bolic, archetypal quality and it remains in many ways closer to the emblematic caricatures of *Stachka* than to the more subtly differen- tiated portraits of individuals presented in *Raduga*.

## THE USE OF WORDS

Before the advent of sound, words presented little danger for the cinema. Because they were visually cumbersome and markedly distinct from the cinematographic images themselves, and because they were poorly adapted to the presentation of lengthy texts, intertitles – containing either succinct explanatory remarks or lines of dialogue – tended to be used as sparingly as possible in silent films.

When words could finally be heard rather than read, the iconic nature of the cinematographic image was reinforced: the signal now resembled not only the visual, but also the audible aspects of the referent. Words were now actually part of the image, and the ease with which they could be used to convey information of all sorts gave rise to the danger that notions which the film-makers had previously been obliged to express visually would now be simply told to us through the dialogue.

In their well-known 'Statement on the Sound-Film', published in 1928, Eisenstein, Pudovkin and Alexandrov laid out the premises upon which they believed sound could be made to assume the status of a creative element in film rather than remaining a gimmick of which the 'use will proceed along the line of least resistance', restricted to 'a naturalistic level, exactly corresponding with the movement on the screen, and providing a certain "illusion" of talking people, of audible objects, etc.' They proposed a 'contrapuntal use of sound' and proclaimed their intention to use sound in 'distinct non-synchronisation with the visual images'.[22] Already in *Stachka*, Eisenstein had explored the possibilities of using words in ways which went beyond – or even which contradicted – their normal role as carriers of information. In violation of the rule which stipulates that words be used as economically as possible in silent films, Eisenstein occasionally repeats an intertitle. Or, he shows us an intertitle which is then directly contradicted by the information conveyed by the images, as when an intertitle stating that 'At the factory all is calm' is followed by an image of the frenetic activity of men and machines. And, in a particularly remarkable sequence, the Russian letters forming the word 'HO' (=but) on an intertitle are detached from their symbolic linguistic meaning and transformed before our eyes into the shapes constituting the mobile iconic representation of workers in a factory. According to Lotman, this 'permanent interaction' and 'continual interpenetration' between symbolic and iconic signs (that is, between the word and the image) which 'constitutes the artistic base of the cinema' is part of a much older tradition 'determined by the dialectical opposition between the two fundamental types of signs' which embraces certain types of Ancient Egyptian mural painting as well as comic strips.[23]

Curiously, in his sound films, although Eisenstein brilliantly applied the principle of audio-visual counterpoint to the use of music, he employed words in a conventional synchronised fashion. In *Alexander Nevsky*, for example, as in *Raduga*, words appear in the

context of straightforward naturalistic dialogue. However, while language is used in an essentially realistic capacity in both films, both film-makers were willing to sacrifice the precision of their realistic historical depictions for the sake of linguistic unity. 'Doubts sometimes assailed me' writes Eisenstein: 'Should the Grand Master of the Teutons be made to converse in standard contemporary Russian with Tverdila, the felonious mayor of Pskov, without the aide of an interpreter who could translate from 13th-century German (hermetic to the spectator) into Russian of the same epoque (roughly as incomprehensible)? 'What is more important to the spectator', he asks, 'the exotism of the rhythms and sounds of an unknown language with explanatory subtitles? Or that the spectator finds himself plunged directly, with a minimal expenditure of energy, into the tragedy of these betrayals and atrocities?'[24] Eisenstein would, of course, opt for the second solution. The realistic looking Germans in *Raduga* likewise address each other in Russian (which is somehow more unrealistic than the fact that the Ukrainian villagers speak to each other in Russian). Donskoi, however, retains a touch of the 'exotism of an unknown language' by having them occasionally bark an authentic German word of a highly stereotypical variety.

## MONTAGE

In Eisenstein's work as a director and as a theoretician, no problem received more attention than that of montage and it is surely in this domain that his contributions have been the richest and most innovative. Whereas classical 'Hollywood-Mosfilm' montage of the type used in *Raduga* tends to prevent us from perceiving the images before us as consciously-ordered series of discrete elements, Eisenstein's 'collision montage' was aimed at intensifying precisely this perception. Instead of creating an illusion of spatio-temporal unity, it underscores the shock caused by the juxtaposition of independent shots.

Here again, the notions of conflict, opposition and contradiction are fundamental. And here again, antecedents can be found in Eisenstein's work in the theatre. There, through the use of the technique which he called the 'montage of attractions', he began experimenting with the fragmentation and juxtaposition of dramatic elements. Thus, in his 1923 production of Ostrovsky's *Enough Simplicity in Every Sage* (also known as *Even a Wise Man Stumbles*),

for example, he divided the stage into two parts in order to present 'an intertwined montage of two different scenes'. The scene in which Mamaev tells his nephew Glumov what to do was played downstage, while the one in which Glumov carries out his instructions with his aunt took place on a raised platform off to the side. 'Instead of changing scenes, Glumov ran from one scene to the other and back – taking a fragment of dialogue from one scene, interrupting it with a fragment of dialogue from the other scene – the dialogue thus colliding, creating new meanings and sometimes word-plays.'[25] Among the sources of his method of montage, Eisenstein cites the films of D.W. Griffith, of course, but also Flaubert's *Madame Bovary*, in which a dialogue between the future lovers Emma and Rodolphe is 'cross-cut' with the speech of a politician being pronounced in the square below them, and the poetry of Mayakovsky and of Pushkin, noting with reference to the latter's *Poltava* 'the juxtaposition of three almost "documentarily" selected representations' of three detail incidents from the episode [of Kochubei's execution]:

'Too late' someone then said to them,
And pointed finger to the field.
There the fatal scaffold was dismantled,
A priest in cassock black was praying,
And onto a wagon was being lifted
By two cossacks an oaken coffin . . .

'It would be difficult', he writes, 'to find a more effective selection of details to convey the sensation of the image of death in all its horror'.[26]

In montage, Eisenstein saw wondrous new possibilities for the cinema. Like language, he wrote, the cinema 'allows for wholly new concepts of ideas to arise from the combination of two concrete denotations of two concrete objects'.[27] The way in which this principle of 'associative montage' functions is well illustrated by the sequence at the end of *Stachka* in which images of the massacre of the workers by the Czarist police are cross-cut with images of a bull being butchered in a slaughterhouse. 'Though the subjects are different' writes Eisenstein, "butchering" is the associative link. This made for a powerful emotional intensification of the scene', an intensification in which the 'homogeneity of gesture plays an important part'.[28] Through this juxtaposition, writes Barna, Eisenstein 'was to convey

not two disparate actions, but the single idea of the savagery of the Czarist police'.[29]

Although this sequence would continue to enjoy celebrity as the prototypical example of Eisensteinian montage, and although its bloodiness was considered so strong that it was cut out by the Crimean censor, its effectiveness would be called into question by Eisenstein himself. Certain working-class audiences, he reported, were not at all shocked by 'the usual "bloody" effect of the slaughterhouse sequence: among these workers the blood of oxen is first of all associated with the by-product factories near the slaughter-house! And for peasants who are accustomed to the slaughter of cattle this effect would also be cancelled out'.[30]

Donskoi too sung the praises of 'contradictions'. 'Let us pity those whom contradictions frighten', he wrote, 'Everything is contradic-tion: intellectual passion, the suffering of the heart, love, struggle, encounters, separations. Life is contradiction'.[31] But, unlike Eisen-stein, Donskoi did not see montage as a way of bringing contradictory forces into confrontation. For him, montage was rather a means of intensifying the illusion of reality by restoring the mobility of the eye to a series of images created by a heavy, unwieldy machine. Thus, conversations are rendered through the familiar shot/counter-shot schema (which is perceived as being far more 'natural' than the uncut image created by a camera panning back and forth between two conversants); 'establishing shots' (that is, long-shots), which allow us to place a sequence within an appropriate narrative context, precede close-ups depicting dramatic action. When Donskoi does play on the clash between contradictory elements, it is rather between elements appearing on different planes within the same shot. For example, in an otherwise classic establishing shot which shows a small group of soldiers approaching the village, a pair of feet are seen in close-up dangling into the screen from above. In *Stachka*, a close-up of a pair of dangling feet appear as the unequivocal focus of attention of the shot, which informs us that the worker to whom they belonged has committed suicide. Here, on the other hand, the emotional impact of the image of a corpse's feet is initially undermined – but ultimately perhaps strengthened – by their peripheral position within the shot. This curious emplacement, together with the movement of the unconcerned soldiers below them, create a disquietingly off-handed image of death.

The conclusions which can be drawn from the foregoing compari-sons are in fact not conclusions at all, but rather, further questions

about the validity of categories such as 'avant-garde' and 'Socialist Realist' and about the ways in which such concepts might profitably be applied to the analysis of films. To what extent can Socialist Realist films be identified as such on the basis of their content, or on the basis of biographical information about their creators? To what extent do these films employ a specific set of signifying procedures? In which ways do these signifying procedures differ from those used in the Hollywood cinema? Is it really true, as Wollen maintains, that "Realism" has always been the refuge of the conservative in the arts'? Did not the Italian neo-realists and the early Solzhenitsyn (proclaimed by Lukács to be among the most promising of Socialist Realist writers) employ realism to break with the conservative? The precise nature of the relationship between individual 'Socialist Realist' artworks and artists and the state apparatus headed by Stalin remains another great murky area. Clearly, all manner of submission to – and surreptitious rebellion against – the instances of official control must be taken into account. Perhaps, as Cervoni claims, 'Donskoi was never in any way the man of Stalinist academism'; perhaps he constituted 'on the contrary one of its strongest and most courageous contradictions'.[32] Let us not forget that Donskoi too was hounded by the censors and that after the making of *Alitet ukhodit v gory* in 1950, he would remain for six years without making another film (with the exception of the sports documentary *Nashi chempiony*, likewise made in 1950).

## NOTES

1.  V.N. Volochinov (= M. Bakhtin), *Le marxisme et la philosophie du langage* (Paris, 1977) p. 44.
2.  B. Comrie, *The Languages of the Soviet Union* (Cambridge University Press, 1988) p. 28.
3.  A. and M. Liehm, *The Most Important Art: Soviet and Eastern European Film After 1945* (Berkeley: University of California Press, 1977) p. 41.
4.  Ibid., p. 43.
5.  S. Eisenstein, 'Soviet Cinema', in *Film Essays* (Princeton: Princeton University Press, 1982) p. 25.
6.  Ibid.
7.  Quoted in A. Cervoni, *Mark Donskoi* (Paris, 1966) p. 111.
8.  Ibid., p. 101.
9.  S. Eisenstein, 'The Method of Making Workers' Films', op. cit., p.19.
10. Quoted in op. cit., p. 97.

11. S. Eisenstein, 'Perspectives', op. cit., p. 44.
12. S. Eisenstein, 'Through Theater to Cinema', in *Film Form* (New York, 1949) p. 17.
13. S. Eisenstein, 'More Thoughts on Structure', in *Film Essays*, p. 97.
14. S. Eisenstein, *The Film Sense*, ed. and trans. by Jay Leyda (New York,1942) p. 36.
15. Ibid., p. 42.
16. S. Eisenstein, 'The Cinematographic Principle and the Ideogram', in *Film Essays*, p. 43
17. S. Eisenstein, 'A Personal Statement', ibid., p. 16.
18. S. Eisenstein, 'Through Theater to Cinema', in *Film Form*, p. 8.
19. S. Eisenstein, 'A Personal Statement', in *Film Essays*, p. 16.
20. B. Amengual, *Que Viva Eisenstein* (Lausanne, 1980) p. 314.
21. Yu. Barna, *Eisenstein: The Growth of a Cinematic Genius* (Boston,1973) p. 208.
22. S. Eisenstein, 'A Statement on the Sound Film' (with Alexandrov and Pudovkin) in *Film Form*, p. 258.
23. Yu. Lotman, *Sémiotique et esthétique du cinéma* (Paris, 1977) p. 22.
24. S. Eisenstein, *Réflexions d'un cinéaste* (Moscou: Les Editions du Progrès, 1958) p. 42.
25. S. Eisenstein, 'Through Theater to Cinema', in *Film Form*, p. 10.
26. S. Eisenstein, *The Film Sense*, p. 47.
27. S. Eisenstein, 'A Dialectical Approach to Film Form', in *Film Form*, p. 60.
28. Ibid., p. 57.
29. Y. Barna, op. cit., p. 75.
30. S. Eisenstein, 'The Method of Making Workers' Films', in *Film Essays*, p. 18.
31. Quoted in Cervoni, op. cit., p. 112.
32. Ibid., p. 19.

# 15 The Annexation of History: Eisenstein and the Ivan Grozny Cult of the 1940s

## Bernd Uhlenbruch

With the appearance of his study about the historical novel in the journal *Literaturnyi kritik* in 1937,[1] George Lukács demonstrated a near prophetic talent and a distinct feeling for the processes of totalitarian development of power, which were just concluding in the Soviet Union. In addition to the primary level of interpretation of the sociological description of the phenomenon of the historical novel, Lukács outlined a second interpretation in his work which was clearly adapted to the Soviet reality of the period. Lukács outlined a number of rather pathological circumstances in the historical novel, which became evident not only in the past of the bourgeois nineteenth century, but also in the works of progressive authors termed as 'anti-fascist human' by Lukács.[2] On the one hand, Lukács determined the cult of the exceptional individual as being one variant misunderstood within the formulation of historical narration, which, as in Flaubert's *Salammbo*,[3] misused the historical folio, in order to expose the colourful exotic and excentric psychopathology. On the other hand, contemporary literature makes use of the genre of the historical novel, in order to conduct a basic discussion in a tone of 'intellectual generalisation' on the enduring virulent problems of human existence, a concern which Lukács sees in Lion Feuchtwanger's *Jud Süss*.[4]

The people, as protagonist, and the question concerning the means of articulating their voice play a central role for Lukács in the novel. In a nearly provocative way, he refers to models of bourgeois novelists, in particular to Scott and Tolstoi, who had both ideally solved the problem of the people and the individual protagonist. They brought the depicted individual destinies and the fate of the people into accord, among which the individual protagonists are ideal voices of opinions, feelings and needs of the people, regardless of

whether they belong to the bourgeoisie or the nobility.[5] The shape of the people's destiny, not from the viewpoint of the people, then manifests itself in the historical novel, when it is a novel about leaders, a novel with a historical leader as its main focus, but also, when it presents the people as an object, which is unable to express itself.[6] According to Lukács, leaders should only play a minor role in the historical novel.

The intensity with which Lukács hit a sensitive nerve of his times is reflected in the criticism in the journal *Krasnaya Nov'* (April 1940), in which, among other things, Lukács' postulate of the leaderless historical novel was attacked at a time when the Stalin cult was beginning to take form, and Stalin began jealously to observe Hitler's aura.[7]

Lukács wrote his work in a period, during which Soviet culture was preparing itself to put the relationship of history 'from below' and history 'from above' into a proper perspective. Consequently, the history of collective action and the history of individual leaders' accomplishments were to be harmonised according to the demands of Soviet reality.

Lukács based his work on the Hegelian concept, whereby, according to Hermann Lübbe, history is 'a process without a subject . . . which, would actively bring this process to an end, while ruling it and focussing on its goal'.[8] Lukács' historical ideal heroes are representative individuals, affected by history, not history-making heroes.

Cultures of totalitarian systems, which conceive themselves as being a fulfillment of time and history, giving history a final 'ratio', try to claim legitimacy for themselves through 'the origin and future of the course of history, which has allegedly been grasped'.[9] The 'horror vacui'[10] of totalitarian systems in view of 'blanked out periods' of history, which cannot be interpreted in a clear-cut fashion as items in a history of salvation, allow special mechanisms to come into play. These mechanisms, in turn, cause an impression of absolute absurdity, when viewed superficially; however, instructive results are provided regarding the formation of cultural signs, when viewed in a semiotic context. Above all, the interpretation of revolutionary mass movements of the past stood in the forefront of historical interest after the October Revolution. This interpretation was there to prove that the Revolution of 1917 was the completion of a long chain of historical events and that Lenin was able to avoid the mistakes of unsuccessful historical revolutions by correctly interpreting the course of revolutionary history. The history of rulers and

leaders, history from above, was rewritten, to be sure, from the context of class antagonism; however, the writing of a history about 'revolution from above' was taboo well into the 1930s. It is naturally understandable therefore that Soviet historians rewrote sixteenth-century Russian history from the standpoint of Marxist philosophy, but nevertheless still characterised the leading figure of the second half of the sixteenth century, Ivan IV, in accordance with the bourgeois historical accounts along Karamzin's lines.

Numerous factors met to stimulate the rigorous rewriting of sixteenth-century history, which proved shocking to critical observers in the late 1930s and early 1940s, as witnesses later admitted.

According to later statements,[11] 19 March 1941 was the day on which the mass Soviet public learned from *Izvestiya* that henceforth they would have to live with a new image of Ivan Grozny and his era. In 1924 Platonov had still been able to present Grozny's early activities as reforms in his history course for secondary schools, while portraying Grozny's later phase as one of physical and mental decay.[12]

The 1941 *Izvestiya* article, written by the novelist Valentin Kostylev, sketches an exclusively positive portrait of Grozny.[13] Kostylev was recognised as a competent expert on the subject. He was the author of a historical novel on Grozny, which was later expanded into a trilogy. The novel which he was either writing, or had just completed in 1941, as the first part of the later trilogy, carries the title *Moskva v pokhode*.[14] From this novel, it becomes clear, that the revision of Grozny's image was evoked by various types of stimuli. The Stalin cult was certainly one stimulus, another was the interpretational deficiency of historiography, which was perceived as oppressive helplessness in the face of a 'blotted-out spot' of history. A third stimulus was surely the so-called 'typos-formation', a tendency immanent to closed cultural systems, which understand themselves as being the highest stage of development in history. The semiotic principle of this typos creation is familiar to us from the New Testament exegesis.[15] This concerns the attribution to Old Testament persons and events of a prefiguring of the salvation offered in the New Testament: Melchizedek, the priest in the Old Testament, is a positive 'typos' for Christ, just as 'old' Adam is a negative figure. Abraham's sons, one from a free woman, the other from a slave, are New Testament 'typos' for the Jews, who live according to the law, and the Christians, who are free from the law (Galatians 4:21ff.). The biblical exegesis generated hundreds of such figures, which certainly

cannot be handled here individually. It is decisive that cultures which consider themselves to be periods of fulfillment, search the history of an earlier, unfulfilled world, crying out for redemption, in a sense for 'typical' preliminary formulations. Incidentally, this is also true in the case of the Nazi era.

A significant piece of evidence for the typological workshop of the Stalin Era is Kostylev's novel *Moskva v pokhode*. The last stimulus resulting from the new Grozny reception, which has remained unnamed up to now, can be derived from this novel: the events surrounding the annexation of the Baltic states of Estonia and Latvia by the Soviet Union, which needed historical legitimisation. Kostylev's novel portrays Ivan Grozny's Livonian campaign in such a manner that references to the events of 1939 are apparent to everyone.

Kostylev's novel is devoid of conflict to an almost grotesque degree, because it was written after the annexation of the Baltic States, and in a period during which the Hitler-Stalin Treaty was still valid, at a time when Stalin was doing his utmost to court Hitler, and because it was designed to create 'typoi'. In Kostylev's novel, Grozny's historical war rivals, the German citizens of Dorpat, Reval and other cities of the Baltic, wish nothing more for themselves than Russian rule, in order to play slave to their Russophile inclinations. The true opponents of the Germans *and* the Russians, the 'villains', are colourless 'knights', who exercise foreign rule over the German and Baltic peoples. Whenever the Commander-in-Chiefs negotiate in Kostylev's novel, the people's heroes again and again have the time and opportunity to fraternise with half-starved and impoverished Latvians who wish nothing more than to become Russian subjects. Such episodes are occasions for Kostylev to unfold and insert the full spectrum of folklore of the times. In one passage in the novel, the Russian heroes are told a mythical legend, in which the Estonians at one time lived in a paradise-like state and according to which their gods prophesied the return of this state to Russian rule.[16] Grozny's Livonian war, as presented by Kostylev, was an operetta war: on the one hand, he depicts the construction of the Russian artillery in an overdone fashion; on the other hand, the only duty of this artillery is to shoot some roofs to pieces; for nowhere is force used against symnpathisers. Even the few opponents are allowed to retreat.

There is no doubt that Kostylev was commissioned to write this article in *Izvestiya*. One must thus wrestle with the problem as to why exactly a mediocre novellist would be given the task of introducing

the Grozny cult of the Stalin era. Stalin initiated a new phase and tactic in Soviet foreign policy with the annexion of the Baltic States, in that he allowed staged revolutions to take place outside of the Soviet Union, and consequently direct aid from Moscow was sent. It was necessary to historically legitimise this new tactic. At the same time, the phase of the great purges, the trials in the years from 1936–1938, the elimination of Lenin's followers and the army's command and the centralisation around Stalin also required historical legitimacy. However, it was not the fact of the trials against supposed Party enemies alone which provoked the comparison between Stalin's methods and Grozny's annihilation of entire peoples, but also the manner of persecution and the methods used against innocent family members, friends and acquaintances of the accused. This comparison had to be refuted. In the beginning, Stalin was under pressure to legitimise his actions. He was forced to justify his actions historically, because historical parallels could be used against him by his opponents. The outstanding achievement of Stalin's cultural politics was due to the fact that he was later able to turn criticism into affirmation, and reverse criticism founded in historical parallels to that of his own self-stylisation. His own autocratic style of rule and the developing Stalin cult of the 1930s provided a point of departure from which history had to be rewritten. Kostylev paved the road brilliantly: now it was the time for historians to add the finishing touches. Vipper, who submitted his Grozny biography in 1922 (quickly forgotten due to its amateurish style), was allowed to republish his book in 1942 and 1944, enriched with patriotic phrases and quotations from Stalin.[17] In 1947, the publishing house for foreign literature even published an English edition.[18] In Vipper's book, the complete works on Grozny of past centuries, beginning with the first documents of sixteenth-century contemporaries and going up to the works of Soviet historians, were exposed as the works of enemies of Russia. Vipper wanted to show that the Grozny image originated in a centuries-long conspired campaign and was based on reports by professional traitors 'of the most dubious political and moral character'.[19] In another passage, Grozny's disqualification as a tyrant arose from the forced reduction of his achievements as a statesman.[20] Because of Stalin's autocracy and system of denouncement, mass arrests, but also including the annihilation of the kulaks and agricultural collectivisation and resettlement, memories were evoked in the population of Grozny's *oprichnina*. This unique phenomenon of ancient Russian culture had to be rigorously sup-

pressed or distorted. Kostylev had already marginally hinted that the *oprichnina* was purely and solely a counterweight to be used against the aristocracy, but never against the people. Vipper disputes the physical annihilation of the entire population of Novgorod in 1570 in a massacre lasting several weeks, one of the darkest points in Grozny's historical rule, accusing the chroniclers of exaggerated partiality to their own city.[21] The massacres up to 1572, following the genocide of Novgorod, were depicted by Vipper as being actions carried out by a disorganised *oprichnina* unit without Grozny's consent.[22] One need not thoroughly analyse further attempts at justification by historians of the 1940s, because they are based merely on the same grounds. In 1944 I.I. Smirnov submitted a grandiose apology for the blossoming of Russian culture under the conditions of a centralised, autocratic state, in his book on Grozny.[23] Likewise, S. V. Bakhrushin's publication, which first appeared in 1942, then in 1945, and once again in 1954 with editorial comments, followed the same path.[24] The arguments in favour of this entire justificatory campaign were the following:

(1) The sources from abroad used up to then by historians, were defamations which were meant to interfere in Russian affairs.
(2) The Boyard Opposition was a clique, organised and funded from abroad.
(3) Russia was surrounded by enemies on all fronts, and consequently could not tolerate internal enemies.
(4) The Baltic peoples readily aligned themselves with Russia. The entire Western world was astonished at the humane treatment of the Baltic population.
(5) The reunification of Russia and the prevalence of the *samoderzhavie* was a progressive act.
(6) The *oprichnina* was a radical re-organisation of the Russian state and a necessary condition for a 'unified, centralised national state'.[25] They aligned themselves solely against the feudal aristocracy.
(7) The factually documented *oprichnina* massacres took place without the Czar's knowledge or consent.

The historians Vipper, Smirnov and Bakhrushin provided Stalin with a model for the historical legitimacy of his domestic and foreign policies of the 1930s. One must now ask, why 400 years of past events had to undergo a new interpretation. Was it just in order to still

rumours of Stalin being the second Ivan Grozny? Certainly not.
Moreover, it seems plausible that the rigorous shaping of the entire
culture around one centre point, could leave no sphere untouched. In
a phase in which the texts were completely rewritten, such an
important branch as historiography could not be omitted. In this
context, the similar but problematic parallels between the Nazi's
historical interpretation and that of the Stalin era should be touched
upon. At no time did the writers of history during the Nazi era have
difficulties identifying with the history of a 'Führer'. The definition of
the 'Führernatur'. the 'Führerauslese', the legitimacy of the idea of
leadership resulting from a historical and racial viewpoint, an ideo-
logy of the German people as a people, that needed and still needs a
charismatic leader to develop fully,[26] made it easy for the Nazi
theorists to classify their own actions *into a historical* continuum. The
circumstances were different in the Soviet Union. A culture which
was decidedly written down in a revolutionary tradition could not be
satisfied with only a slightly modified interpretation. For his interpre-
tation of history, Stalin needed a total reversal of traditional defini-
tions of values. Grozny's rule and the *oprichnina* had to be redefined
as a positive element of class struggle and as a necessary transitional
period of Russian history. There are no indications that Stalin wished
to be redefined in a mythical manner as a second Grozny. The
correction of the Czar's image always took place with the claim of
historical correctness. Others made the comparison, while Stalin
consented to this, but personally saw to it that correspondences to the
past were maintained. In the Stalin era we do not find absurdities
such as those of the Nazi era, where Hitler was pictured as the
charismatic leader in shining armour, or where Himmler thought
himself to be the authentic reincarnation of Kaiser Heinrich I.[27]
Much subtler strategies were used during the Stalin era to create
models of identification. The historians' and authors' descriptive
styles rival the ritual flowery phrases of the official Stalinist pane-
gyric: however, the similarity is intended. Vipper characterised
Grozny as 'one of the greatest diplomats in the history of all time',[28]
after Kostylev in his novel had already clearly hinted at codes of
presentation of Stalin: the fashion cult built around the modestly
dressed Grozny, the art of communication, the blissful-sounding way
of dealing with subordinates, the idyllic conversations, in which
Grozny wisely gave advice and history later proved him to be
correct,[29] must have reminded the reader of the official iconology
surrounding the presentation of Stalin and of the rhetorical form of

Stalinist panegyric. The artistic adaptations of the Grozny theme following the historical revision prove that the revised version of Grozny's rule was not halfheartedly propagated, and even more, that the historical description of the Grozny epoch was always to be understood as a self-description of the Stalin culture. After a thorough criticism of the way history had been written in the nineteenth century, that literature, which had created a dreadful, repugnant image of Ivan IV, had to be placed in opposition to a positive concept in the Stalinist vein.

Before dealing with the great difficulty surrounding the prominent artistic adaptation of the theme, Eisenstein's film *Ivan Grozny*, I would like to use briefly an example to show that the supposition surrounding the revision of Grozny's image as a large-scale, targeted self-stylization of Stalin is no pure hypothesis. Aleksei Nikolaevich Tolstoi called attention to the Grozny subject matter within the context of his research on Petr I in the 1930s and completed a Grozny drama in 1943. In 1942 he prepublished 200 copies of his drama. He received the edition for revision and explained simultaneously that he would not complete his work, originally intended to become a trilogy. The drama remained a work in two parts. Even the Stalinist interpreters had been unable to find a plausible interpretation for Ivan's last years, namely, the phase of his spiritual and mental decay. Another noteworthy fact, however, proves how strictly even marginal events in the Grozny biography were interpreted already at the beginning of the 1940s. In the first part of Tolstoi's drama there is a scene which shows Kurbsky before fleeing to Poland. In the first draft of the play Kurbsky declares, just before his escape, that he has delivered a part of a Russian unit into the hands of the Poles 'by a stroke of bad luck'. He is told by a colleague that after his escape, people in Moscow will accuse him of purposely sacrificing the army to the Poles. Kurbsky energetically denies this. The escape motive in the first version of the drama is limited alone to wounded pride and fear of punishment. In the 'corrected' version, published in 1943, Kurbsky intentionally sacrificed the army in order to ingratiate himself with the Polish king.[30] The frame-catalogue adaptation above had to be adhered to completely, in order to publish an artistic adaptation of the Grozny material as this literary-historical note shows. As is well known, one of the accusations in the show trials declared that the accused had been working for foreign intelligence services since the first days of the Revolution.[31] The historical parallels had to be exactly correct item for item. A general depiction

of Grozny's epoch, the general statement that there was an organised opposition in general sympathising with foreign powers, was seen as insufficient. Stalin's thesis stated that opposition had existed from the very beginning and had infiltrated even the highest levels of the power apparatus. Thus, the historical parallels had to be designed according to the scheme. Kurbsky, one of Ivan's earliest collaborators during the years of reform, became a prototype for Trotsky. Also historically, the impossible became true – prominent associates of Lenin had eyed the destruction of the Soviet system from the beginning.

In January 1941, two months before Kostylev's *Izvestiya* article on the rehabilitation of the Grozny regime appeared, Sergei Eisenstein was commissioned by Mosfilm to film the material. He seemed to be the ideal director following the success of *Aleksandr Nevsky*. At the end of 1941 the scenario was ready. Filming began in April 1943. The first part of the film appeared on the screen at the beginning of 1945. These dates alone reveal that Eisenstein produced his film synchronically to a phase in the writing of history in which the entire Grozny image was reduced to a few typical episodes with a fixed meaning. Initially, the appeal to the system of culture with its fixed semantics makes the highly complex deciphering of the Grozny film recognisable as an interpretational problem. Levels of almost too exacting affirmation overlap with phases of explicit denial to accept the new interpretation of the Grozny image in Eisenstein's film. Exactly these phases in which Eisenstein distances himself from the official interpretation lead one to believe that, whenever he behaves strictly dogmatic, he has a parody in mind. The all too strict citing of official opinion helps him to uncover the Grozny cult which is perceived as being hypocritical and at the same time unmasking the perversion of historical concepts of values in the Stalin era. Eisenstein understands the Ivan material from a perspective of tragedy. Evidently Pushkin's *Boris Godunov* and Shakespeare's tragedies served as primary models for his access to history.[32] While historians dissected Grozny's life into a chain of episodes of which every single one had to serve as an explanation for the theorems of the present, Eisenstein wanted to show the 'tragedy of absolute power'.[33] He approached his material just as selectively as the official history writers, but with a totally different intention. During the filming, Eisenstein wrote: 'When I create Grozny's image in the conception of our time, then I choose those episodes from his biography, out of which my conception and my understanding are formed, that is, those facts which I consider to

be "characteristic", for "characteristic" is not a fact as such, but rather 'exists in the conception of a historical understanding and an illumination of the facts through a certain historical conviction'.[34] Eisenstein toys with the term 'historical conviction'. Naturally, he observed the dogmatic fixation, the authoritarian codification of the contents of historical consciousness which appeared around him, and of course he knew what the official historians canonised as being 'characteristic'. Nevertheless, he is able to bring his individual interpretation into play. The document cited here is a private writing by Eisenstein which was not meant to be published and was first cited in the commentary to his six-volume works. In his official writings Eisenstein conceals his true artistic plans and seems to conform to official opinion. In *Izvestiya* on 30 April 1941, that is, one month after receiving the commission to make the Grozny film, Eisenstein appeared before the Soviet public seeming to comply to public opinion. His *Izvestiya* article repeats the new slogans delivered by Kostylev about the falsely depicted Czar whose image was misrepresented by malicious foreigners, by agents, who, encouraged by Grozny's generosity, prepared the way for an invasion of Moscow by hostile, foreign armies, in the interest of foreign powers. Further, his image was distorted by the *oprichnina*, a positive counterweight to the Boyard Opposition, and by the heroic *oprichniki* father and son Basmanov.[35] In the following we will see how Eisenstein's two-facedness became his doom.

Let us first examine the other side of Eisenstein's encounter with dogmatism, the side of his voluntary-involuntary affirmation of fixed scholastic opinions which were so pronounced and show that an ironic intention on his part cannot be excluded. In this respect, the staging of the campaign against Kazan' in the first part of the film is significant. The scene preceeding the actual Kazan' sequence, Ivan's arguments against the Kazan' envoys, evoked parallels to the breach of the Hitler-Stalin Treaty. In Eisenstein's script, Ivan declares, 'God knows we did not want war. But those days are gone forever when impudent foreigners could penetrate unpunished into the Russian state'.[36] The Kazan' envoy had already proclaimed to Ivan: 'Kazan' ends its friendship with Moscow and dissolves its ties with Moscow'.[37] In the following scene, the actual siege of the city of Kazan', Eisenstein shifts this newly proposed semantisation: Kurbsky pleads, in a seemingly rambling manner, for the use of the cavalry, while Ivan relies on his artillery:

(Kurbsky):
'Trenches and gunpowder – the Czar's follies!'

(Grozny):
'Do you not trust my gunpowder?
Would you rather ride upon mares, gallantly attired,
upon stallions, equalling George the Dragon Slayer?'

Ivan is angered.
Kurbsky is enraged.
Mockingly, the Czar looks to the Prince.
This heightens Kurbsky's rage.[38]

The allusion to the 1918 historical dispute between Trotsky and Stalin in Tsaritsyn where Trotsky delivered his famous words, 'Proletarians to your horses!' must have been understood by contemporaries. For those contemporaries who had forgotten this historical note, in 1940, a colonel Boltin was allowed to propagate the basis of Stalin's strategic wisdom, in *Novyi mir,* where it was fully described. The main point was stated as being that in static warfare, heavy artillery takes precedence over the cavalry.[39] The canon fervour in Kostylev's novel and in Eisenstein's film was clearly rooted in the strategic writings of Stalin.

In the Kazan' scene, Kurbsky forces Tatar prisoners to demand that their countrymen surrender the city. In response to this, the Kazans kill their own people in front of the city walls with arrows. This allowed Eisenstein the opportunity to cite the medieval and baroque Sebastian iconology. Ivan strongly reprimands Kurbsky for this arbitrary act: the topos of mild treatment of the indigenous population on the part of Ivan, the topos presented in the Livonian war, that Ivan alone always called for restraint, is inserted here in the complex association with 'Kazan'.[40]

Eisenstein attempted to approach the Ivan material with a critical study of the sources. This was a time in which historical research had been degraded to schematic historiography and many contemporary sources had been disavowed as a large-scale propaganda campaign. It was a phase of fixed meaning in which a historical-critical study of sources was taboo and an established meaning was assigned to the sources, which was unchallengeable. His draft of the script could only be realised in a radically shortened version in the film. His script is a splendidly structured epos with numerous allusions to the historical

correspondence between Grozny and Kurbsky, to the ancient Russian satirical tales of the doubles, Foma and Erema, to the lives of the *yurodivye*, to *byliny*, to folk songs, to ecclesiastical hymns, to the Daniil Zatochnik, to contemporary chronicals, as well as writings by Machiavelli. Marie Seton states that Eisenstein referred to research records which he had collected for a film project about the history of Moscow in 1933.[41]

If one observes Eisenstein's *Ivan* film against the background of the Soviet 1940s, then it is clearly a document of refusal and rebellion. According to official scholarly opinion, autocracy was to be understood as progressive and was considered to be a necessary historical stage. Artists had done their utmost to portray Ivan as a strong-willed reformer. In addition, they sketched a picture of a charismatic Czar of the people, who is misunderstood and opposed by the Boyard Opposition, whose historical mission, however, is recognised by the people. Eisenstein adheres to these norms of perception, but questions them from a tragic point of view. Ivan's separation from his family and the old Boyard class, the replacement of the hereditary nobility by a new class of serving nobility, the establishment of the *oprichnina* unit which was interpreted in the Stalin era as being progressive, is presented by Eisenstein as a tragic moment in the life of Ivan Grozny. Ivan does not found the *oprichnina* as he should have, as historically-teleogically correct, but rather opportunistically. He is not prepared, as is shown in the film, to wipe out the 'oak forest of Boyarddom' in order to create room for a 'weak aspen forest'.[42]

The Party censorship and Stalin could not give the film proper attention due to the circumstances of the war. Eisenstein's critical attitude towards fixed models were pardoned in the first part of *Ivan Grozny*. The 1953 memoirs of the leading actor who played Ivan, Cherkasov, provide much insight in this vein. He takes no pains to hide the fact that the criticism made of the second part of the film was also meant to include its first part. According to Cherkasov, Eisenstein was overly fascinated with the graphic setting. He ignored the effects of the plot during staging. He was obsessed with the details, an unmasked accusation of formalism. As Cherkasov says, Eisenstein 'worsened' his mistakes in the second part of the film.[43] To worsen mistakes that have already been made is something different from making mistakes. Cherkasov, as an expert of the scene, makes it plain that the resolution of the Central Committee of the Communist Party of the Soviet Union on 4 September 1946, should also apply to

the first part of *Ivan*. This resolution deals with the prohibition of the
film *The Great Life* (directed by Lukov). In the resolution, Lukov's
film is subjected to annihilating criticism and it is furthermore stated
that the Central Committee of the Communist Party establishes that
the Ministry for Cinematography (Comrade Bol'shakov) has pro-
duced a series of unsuccessful and faulty films: Part Two of the film
*Ivan Grozny* (Director, S. Eisenstein). *Admiral Nakhimov* (Director,
W. Pudovkin), *Simple People* (Directors, G. Kozintsev and L.
Trauberg). The resolution reports further: 'The director Eisenstein
revealed his ignorance of the presentation of historical facts in the
second part of the film *Ivan Grozny*, when he represents the
progressive *oprichniki* army as a degenerate band cast in a mould of
the American Ku-Klux-Klan, and Ivan Grozny as characterless and
weak-willed, a kind of Hamlet'.[44]

The Party waited longingly for the presentation of that epoch in
which Ivan pushes through to the Baltic sea in a glorious campaign.
Kostylev successfully placed this episode at the beginning of his
novel. Eisenstein, on the other hand, delayed this triumphant
moment further and further in order to display 'dirty family
washing'[45] as formulated by Grigory Aleksandrov in a conversation
with Marie Seton. In addition to the complicating of Ivan's psyche,
the resolution of the Central Committee mentioned the marginal
detail, that Eisenstein (by the way, historically correct) portrayed the
*oprichniki* in a type of monk's cowl with hoods. But there was
another doctrine unutterable for Zhdanov and his assistants: after the
victory over Hitler, it was historically proven that Stalin had suc-
ceeded in completing Grozny's work. Instead of now creating a
historical parable of the apotheosis of Stalin, Eisenstein filmed, in the
second part, a cryptogram of the internal state of the Party in the
1930s and 1940s. In the scene about the *oprichnina* feast, Ivan
intoxicates the Boyard candidate to the throne, Vladimir Staritsky.
He then elicits the Boyard murder plans, crowns him the Fools' Czar,
sends him off dressed as a czar to a gloomy cathedral where he is
murdered by the assassin who had been waiting for Ivan. It was
certainly this cryptogram, the parallels to the staged murder of Kirov,
the circumstances surrounding the deaths of Frunze and Ordzhoni-
kidze, the parallels to all those who were made Stalin's fools in order
to be later liquidated, which made the second part of the Grozny film
unacceptable.

In the culture of the 1940s, in which the history of Ivan IV was
typically interpreted, it was fundamentally impossible to present this

epoch as different from that of the set clichés. The public expecta-
tions and that of the censors was pre-established: everything that was
shown and said could be interpreted from the very beginning in a
two-fold manner. There was no historical event which could remain
purely historical. Eisenstein breached this chain of one-to-one illus-
trations, in that he disappointed the expectation of the 'typos' in a
manner which undermined the historical system. Below are several
examples:

Malyuta Skuratov, an allegedly positive *oprichnina* leader of the
people, is already reduced in a close-up in the first part of the film to
an all-knowing, all-seeing eye, doubling Christ's eye in the fresco on
the wall. In the second part of the film, Skuratov is the one who
accepts responsibility for the execution of the Boyards. Festively
dressed, he carries out the executions. The viewer is reminded of
Ezhov, Beriya, and the NKVD from the viewpoint of the type of
material shown.

A further example: among other things, Kazan' could be decoded
as a cryptogram resembling Hitler's Germany, which had broken its
treaty. Subsequently, in an unusually complex manner, Eisenstein
conceives of the forming of the image of the 'external enemy' and the
'internal enemies', with whom he is allied. In the scene 'At Sigis-
mund's Court', [46] which is in the first part of the script, which,
however, introduces the second part of the film, the viewer again
encounters Kurbsky, who in the meantime has emigrated to Poland
(Trotsky living in exile?). In the script, a certain sympathy is clearly
felt for Kurbsky, who is teased by Polish court jesters, and to whom it
is prophesied (incidentally, historically correct) that he will have
difficulties managing his estate in Kovel'.[47] By looking back at
historical facts, a personality profile emerges of an emigrant and
traitor to his country, for whom the viewers still feel a certain
sympathy. In the film version, Kurbsky is only a loyal, submissive
vassal to the enemy, that is, King Sigismund. The problem of
Kurbsky's image is made even more complicated through the deve-
lopment of the concept of an 'external enemy'. In the written copy of
the script, Eisenstein allows King Sigismund to call for a 'new crusade
of all Christian rulers' (krestovyi pokhod vsekh khristianskikh gosu-
darei)[48] and remains within the boundaries of historical facts. In the
film the same passage is updated, but the historical references have
obviously been clearly twisted to such an extent that even a viewer
without previous background knowledge would notice the contradic-
tions and missing parts in the film. In the film Sigismund speaks of a

Russia, blessed with natural resources and dominated by barbarians who must be driven back into the Asian steppe.[49] A fight for living space ('Lebensraum'), a 'Drang nach Osten' is what has become of the historical motive of the religious crusade. The typology is turned upside down. Nazi ideologemes of racist living space ideology ('Lebensraumideologie') are delivered by a Pole. The Soviet Union should have aligned itself with Poland, so that both countries would not become a victim of precisely this ideology. Instead of this, Stalin aligned himself with Hitler, divided Poland with him, and made the wrong side his enemy.

In the course of the film, Eisenstein neutralised his original sympathy for Ivan. In the second part it remains an open question as to where his sympathies lie: for the opposition, or for Ivan. Everything that the church representatives and the Boyards bring up against Ivan can be understood as an indictment against the Stalin regime.[50] The boundaries in the second part between positive and negative are no longer perceptible: for quite some time now Eisenstein is not longer interested in a 'good' Czar and 'deranged' saboteurs. He is interested in presenting a game of power: the Boyards hire a murderer who is supposed to be sacrificed after Ivan's murder. Was not Nikolaev also sacrificed, after he had committed the murder of Kirov, in December 1934, as commissioned by Stalin? And was not Nikolaev considered an instrument controlled by 'foreign powers'? And furthermore, one must ask, is not the *oprichnina* bacchanal with its bloodthirsty song in the second part of the film an allegory of the times?[51] Eisenstein understood the mechanisms of the 'typical' and played with them.

His second series, *Ivan Grozny*, was banned. However, this prohibition did not release him from the duty of ritual self-criticism. Eisenstein's self-criticism is, however, an ironic-rhetorical sweep of genius and an act of self-assertion:

> It is difficult to imagine a sentry who gets so lost in contemplation of the stars that he forgets his past. It is difficult to imagine a tankist eagerly reading an adventure novel while going into battle. It is difficult to believe there could be a foundry man who, instead of giving all his attention to the mass of molten metal flowing in prepared forms, turns aside from his work to contemplate a pattern of his own fantasy. They would be a bad sentry, a bad tankist and a bad foundry man. Each would be a bad soldier. In our Soviet army and in our Socialist production there are no bad soldiers. It is even

more difficult to realise that during the stern accounting caused by demands of our Soviet reality such bad and unworthy soldiers are discovered in the front lines of literature and art.[52]

Eisenstein defeats the propaganda with its own weapons. According to official accounts, there could be no-one who had been purposely forgotten. Even in the decree on the film *The Great Life* one could read how perfectly the economy functioned and that any portrayals of shortcomings had to be untrue. Juridical rhetoric calls Eisenstein's manner of argumentation 'adynaton' and defines it as being 'something which cannot be, because it is not in the nature of the thing'. As Eisenstein continues with his alleged self-criticism, he tediously lists accusation after accusation and everything that the Central Committee and the Party-conformist historians had previously practiced is painstakingly enumerated:

> We know Ivan the Terrible as a man with a strong will and firm character. (. . .) Ivan (was) the creator of a new, powerful, united Russian power. (. . .) The private, unimportant and non-characteristic shut out the principal (. . .) I have portrayed him as weak and indecisive, somewhat like Hamlet. I am a victim of bad upbringing and have been corrupted by Aleksei Konstantinovich Tolstoi's *Knyaz' Serebryanny*.

The rhetorical climax of Eisenstein's self-criticism is the following sentence:

> Works of classics of Marxism on questions of history have illustrated and made available to us the historically correct and positive evaluation of Ivan's progressive lifeguards.

This is certainly the most burdening point in the self-accusation. But, neither Marx, nor Engels, nor Lenin expressed their opinions on the positive role of the *oprichnina*. None of the aforementioned Soviet historians could refer to such a quotation. Eisenstein's self-criticism ended with the promise of only wanting to produce films which are worthy of the Stalin era. A comparison to Eisenstein's reaction in a similar situation, which arose after the prohibition of his 1937 film, *The Bezhin Meadow*, proves that his self-criticism on the occasion of the condemnation of *Ivan* was a rhetorical masquerade. At that time Eisenstein had taken the duty of self-criticism seriously and had

actually shown his innermost self, as was expected. At that time he had accused himself of not having taken part in the course of stormy history and of having crawled into the 'shell' of private feelings.[53]

In order to save his film, Eisenstein did the only thing he could do: confident of his authority, he turned in writing to the highest judge of art in the country, Stalin, for help. On 24 February 1947 Eisenstein, Stalin, Cherkasov, Zhdanov and Molotov met for a conversation. Cherkasov made an exacting report in his memoirs, which is revealing in two respects. On the one hand, it shows the banality of Stalin's thought, and on the other hand, Stalin's true fascination with the aura he was capable of exercising over intellectuals, too. Cherkasov's report is full of the typical topoi of Stalin praise: the simple, hearty Stalin, who is highly knowledgeable on the subject matter being discussed, who gives valuable advice, who gives the one being taught a lesson the chance to contribute to the discussion. Cherkasov was personally never attacked. On the contrary, in the Central Committee's resolution on the film *The Great Life*, the directors' misuse of the actors is discussed. Nevertheless, in the discussion with Stalin, Cherkasov takes part of the responsibility, speaks of '*our* mistakes' and names himself as an accomplice to Eisenstein. In their conversation with Stalin, Eisenstein and Cherkasov admit completely different mistakes than those they are accused of by the Central Committee. The film had become too long, and those events which were supposed to be portrayed in the film, the 'Livonian Campaign', were delayed until the third part of the film. We should note that it was never mentioned beforehand that the Livonian war and the penetration to the Baltic Sea should be a central theme in the film, as in Kostylev's novel. The demand remained unsaid, but left its marks on the final version of the film, as can be seen. In the so-called prologue, Ivan is shown as a child, who was only intended to assume a figurehead role as delegated by the ruling Boyard parties. These same Boyards buy trading rights in the Baltic from the Hansa Cities and from the German knights. Ivan destroys this transaction in a first decisive act. In the script, the prologue is at the beginning of the film, and with this, Eisenstein wanted to pick up on Kostylev's thematic guideline. In the second part, he later inserted the prologue scenes as flashbacks. But he did so in phase of historical development, when the topic of the Livonian war ideologically no longer played a role worth noting for the Soviet Union.

Consequently, Eisenstein had ignored official expectations throughout the entire production period. It must at least be touched upon at

this point, what sort of strategies the artist of the Stalin era had at his disposal to act subversively, while under the constraints of non-critical affirmation. Eisenstein's films and his self-criticism are excellent examples of such techniques of subversion. In the film itself, it is the refusal of a second interpretation, the questioning of motives by which the viewers and censors are irritated. This does not allow a clear one-to-one correspondence between historical material and the present. In his self-indictment Eisenstein expresses himself subversively, in that he mechanically repeats the critical objections of the censors without expressing his views on anyone of them. He admits nothing, but rather reports the statements of others. In Cherkasov's portrayal of the conversation with Stalin, there is one passage which one can equally interpret as being praise or criticism of Stalin. Cherkasov persistently preserves the decorum of the day, but nevertheless succeeds in unmasking Stalin.

> Iosif Vissarionovich remarked, with reference to Ivan Grozny's mistakes, that one of his mistakes lies in the fact that he did not succeed in liquidating the five remaining aristocratic lines, that he did not successfully end his fight against the nobility. If he had succeeded, there would not have been the time of *smuta* in Russia. And then Iosif Vissarionovich added humourously that God interrupted Ivan. Grozny liquidated a line of nobility, a Boyard family, and then repents for a year, shows remorse, and prays because of his sin, instead of advancing with more resolve.[55]

Eisenstein promised Stalin to refilm an acceptable conclusion to the third part of the film and to shorten the completed second part. In 1945 it was recorded that Eisenstein would film a trilogy on Stalin's life entitled, *Caucasus*, *Moscow*, and *Victory*.[56] The second part of *Ivan Grozny* was declared by Soviet authorities to be missing or destroyed for ten years until 1958. The version which then became famous was missing the scene 'Last Judgement'. Instead, a short exaggerated phase was refilmed, in which Ivan Grozny justifies his actions. In the third part, there are said to have been a scene of Ivan's remorse and some phases of the Livonian war, which, however, must remain as having been destroyed.

Eisenstein's case occurred in a phase of Soviet cultural history, in which historiography and the genre of the historical novel as such had reached a crisis point. After the victory over Hitler's Germany, the immediate past had much artistic material to offer. The system had

legitimised itself internally and no longer needed historical parallels. Isaac Deutscher comments on this: 'From 1941 to 1943 Stalin may have felt flattered, whenever one compared him with Peter the Great, and he was perhaps proud of the parallels which were made between both of the Great Patriotic Wars in 1812 and 1941. He gained in prestige, by being hoisted onto the shoulders of his predecessors. However, as the victor of this war, he no longer needed all that. The Peters, Kutuzovs and Alexanders were now all dwarfs, compared to Stalin'.[57]

Consequently, it is only natural that the narration of historical material was subjected to vigorous criticism in 1946. A whole group of novelists had realised that they could evade the pressure of the affirmative bias of schematic literature relatively easily through historical works. In a collective review of the journal *Molodoi Bol'shevik* this apparent escapism is severely denounced.[58] Whoever retreats into the distant past in order to flee from the present is not able to create works rich in ideas. This is the one side of the coin 'history'. The other side is, as in the past, the so-called problem of historical correctness. The critic of the *Molodoi Bol'shevik*, Lenobl', shows in his scathing review of the novels *Dikoe pole* by Petrov (1946), *Korabli vkhodyat v more* by Yakhontova (1945), *Varyag* by Sergeev and of the historical novels by Sergeev-Tsensky, that an author of historical novels finds himself in a general state of helplessness. If he chooses to glorify heroes of the past, then he must overlook their role as oppressors and their class status. On the other hand, he is forced to present the respective revolutions, which are to be interpreted as being progressive, in a negative light. Lenobl's explanations allow one to surmise that he would like to suggest that no historically correct depiction of past history is possible in literature.

The dilemma of history, into which the Stalin culture had manoeuvred itself during the years of foreign policy conflicts, becomes clear after the end of World War II. As seen from the chronology of events, Eisenstein's fight to save his Ivan Grozny is an outdated battle retreat. A true, vital interest was evident in the first part of the film, whose mistakes could be easily pardoned. The second part had to disappear into the archives, not only because of its mistakes, but also due to official indifference. The Stalin cult in the post-war period no longer needed a historical metaphor. In films such as *The Battle of Stalingrad* and *The Fall of Berlin*, Stalin himself appeared on the screen.

After the victory over Hitler's Germany, the historical dualism could be abandoned in which Soviet history and its perfecter, Stalin, had positive prefigurations in the past history of Russia. The model of the early 1940s was discarded after 1945. If past history up to that point was to have been read as a result of prerequisites, which one could interpret 'ex post' as prophecies of redemption – in the Old Testament too there were nearly redeemed persons – then Soviet culture found itself now, after 1945, in a state without history, focussing on the present and on the latest war events. As paradoxical as it may seem, the facts produced positive results for the science of history. Already in 1951, Lur'e and Likhachev could submit a critical publication of the works of Ivan Grozny.[59] Their commentaries are certainly lacking in acute critical appreciation, but they relinquish to the same extent the superficial generalisations of the early 1940s.

Just as with other scattered phenomena of the culture of the Stalin era, the Grozny cult was condemned after the 20th Party Congress as being anti-Marxist. In the journal *Voprosy istorii*, S.M. Dubrovsky in 1956 restored the Grozny image which had been valid up to around 1940, and showed in a detailed manner the internal contradictions of the epoch of Ivan IV, which had been levelled by Vipper, Smirnov and Bakhrushin.[60]

Was the Grozny Cult just another one of those many irrational curiosities produced by the Stalin era? In 1945 the historian Veselovsky, had written a rebellious book about the *oprichnina* which went against the Zeitgeist of that time. The book appeared first in 1963, posthumously. The appearance of this work gave the writer Efim Dorosh the opportunity to portray Stalin's Grozny cult in *Novyi Mir* as more than just a curiosity for intellectuals of the 1940s.[61] For all those engaged in literature, who always stood on the side of those historical heroes, who rebelled against Ivan, the rehabilitation of tyranny under Stalin was, according to Dorosh, 'a moral agony', a significant case of the reversal of good and evil.

## NOTES

1. G. Lukács, *Der historische Roman* (Neuwied and Berlin, 1965).
2. Ibid., p. 344.
3. Ibid., p. 222.
4. Ibid., pp. 352f.
5. Ibid., p. 348.

6.  Ibid.
7.  H. Günther, *Die Verstaatlichung der Literatur. Entstehung und Funktionsweise des sozialistisch-realistischen Kanons in der sowjetischen Literatur der 30er Jahre* (Stuttgart, 1984) pp. 154f., especially p. 162.
8.  H. Lübbe, 'Geschichtsphilosophie und politische Praxis' in *Geschichte-Ereignis und Erzählung*, ed. R. Koselleck and W.-D. Stempel (München, 1973) (Poetik und Hermeneutik V) p. 227.
9.  Ibid., p. 223.
10. Ibid., p. 244.
11. Ya. S. Lur'e, 'Perepiska Ivana Groznogo s Kurbskim v obshchestvennoi mysli drevnei Rusi', in *Perepiska Ivana Groznogo s Andreem Kurbskim*, ed. Ya. S. Lur'e and Yu. D. Rykov (Leningrad, 1979) p. 216.
12. S.F. Platonov, *Uchebnik russkoi istorii dlya srednei shkoly. Kurs sistematicheskii*, no. 1 (Prague, 1924) p. 148f.
13. 'Literaturnye zametki', *Izvestiya*, 19 March 1941.
14. Edition used here: V. Kostylev, *Ivan Grozny. Kniga 1: Moskva v pokhode* (Moskva, 1949).
15. See *Lexikon für Theologie und Kirche*, vol. 10 (Freiburg, 1966) p. 422f; item 'Typos in der Schrift'.
16. Kostylev, p. 374.
17. R. Ju. Vipper, *Ivan Grozny* (Moscow, 1922); (Moscow (?), 1942); (Moscow-Leningrad, 1944). S.M. Dubrovsky, Protiv idealizatsii deyatel'nosti Ivana IV, *Voprosy istorii*, no. 8, 1956, p. 121–9, especially p. 123.
18. *Ivan Grozny* by R. Wipper, trans. J. Fineberg (Moscow, 1947).
19. Ibid., p. 244.
20. Ibid., p. 231.
21. Ibid., p. 127.
22. Ibid., p. 128.
23. I.I. Smirnov, *Ivan Grozny* (Leningrad, 1944).
24. S.V. Bakhrushin, *Ivan Grozny*, 1942; 1945; later republished: S.V.B., *Nauchnye trudy, t. II: Stat'i po ekonomicheskoi, sotsial'noi i politicheskoi istorii russkogo tsentralizovannogo gosudarstva XV-XVIII vv.* (Moscow, 1954) pp. 256–328.
25. Ibid., p. 300.
26. K. Schreiner, 'Führertum, Rasse, Reich. Wissenschaft von der Geschichte nach der nationalsozialistischen Machtergreifung', in *Wissenschaft im Dritten Reich*, ed. P. Lundgren (Frankfurt a. M., 1985) pp. 163–252, especially p. 172.
27. Ibid., p. 206, with quotation from J. Ackerman, *Heinrich Himmler als Ideologe* (Göttingen,1970) p. 60, note 112.
28. Quoted from Dubrovsky (see note 17), p. 124.
29. Cf. The scene of the first meeting of heroes from the people and Ivan Grozny in *Moskva v pokhode*, pp. 69f.
30. A.N. Tolstoi, Sobr. soch., vol.IX (Moscow, 1960) pp. 781f.
31. I. Deutscher, *Stalin - Eine politische Biographie* (German edition: Stuttgart, 1962).

32. S. Eisenstein, *Izbrannye proizvedeniya v shesti tomach,* t. VI (Moscow, 1971), quoted as *Works VI* (Commentary to *Ivan Grozny*).
33. Ibid.
34. Ibid.
35. Eisenstein, 'Fil'm ob Ivane Groznom', *Izvestiya,* 30 April 1941.
36. *Works VI,* p. 241.
37. Ibid., p. 240.
38. Ibid., p. 246.
39. (Polkovnik) E. Boltin, 'Lenin i Stalin – organizatory Krasnoi Armii i vdokhnoviteli ee pobed', *Novy Mir,* nos. 2–3, 1940, pp. 274–85.
40. *Works VI,* pp. 248–9.
41. M. Seton, *Sergei M. Eisenstein* (revised edn, London, 1978) p. 410.
42. *Works VI,* p. 346.
43. N.K. Cherkasov, *Zapiski sovetskogo aktëra* (Moscow, 1953) p. 135.
44. Translated from the German edition: *Beschlüsse des Zentralkomitees der KPdSU (B) zu Fragen der Literatur und Kunst (1946–1948)* (Berlin, 1952) pp. 21f.
45. Seton, op. cit., p. 429.
46. *Works VI,* pp. 277f.
47. I. Auerbach, *Andrej Michajlovič Kurbskijs Leben in osteuropäischen Adelsgesellschaften des 16. Jahrhunderts* (München, 1985).
48. *Works VI,* pp. 280f.
49. During my analysis I used a film copy broadcast by the 'Zweites Deutsches Fernsehen', which seems to me to be a correct version of the original.
50. See, for example, *Works VI,* pp. 328f.
51. Ibid., pp. 344f.
52. Seton, op. cit., p. 460f.
53. Cf. Eisenstein's essay 'Oshibki *Bezhina luga*' in S.M. Eisenstein, *Izbrannye stat'i* (Moscow,1956) pp. 383–8, especially p. 387.
54. Cherkasov, op. cit., pp. 379–81.
55. Ibid., p. 380.
56. Seton, op. cit., p. 447.
57. Deutscher, retrans. from German edn. op. cit., p. 591.
58. G. Lenobl', 'Protiv idealizatsii proshlogo', *Molodoi bol'shevik,* no. 7, 1946, pp. 55–9.
59. *Poslaniya Ivana Groznogo,* ed. D.S. Likhachev and Ya. S. Lur'e (Moscow-Leningrad, 1951).
60. See note 17.
61. E. Dorosh, 'Kniga o Groznom Care', *Novyi Mir,* no. 4, 1964, pp. 260–3. (Review article on S.B. Veselovsky, *Issledovaniya po istorii oprichniny,* Moscow, 1963).

# Index

Aesopian speech, 211, 220
Aestheticisation of reality, 143
AKhRR (Assotsiatsiya
    Khudozhnikov revolyutsionnoi
    Rossii), 101–2, 131–3, 139
American Wave, 157
Anti-egalitarianism, 88
Anti-religious propaganda, 53
Arvatov, Boris I., 185
Avant-Garde
    and Socialist Realism, 122–48,
        178–87
    other references, 112, 119
Averbakh, Leopold L., 103

Bakhrushin, Sergei V., 271
Bakhtin, Mikhail M., 19–21, 211,
    222, 224, 252
Bard movement, 31
Beautiful in art and life, 137
Bedny, Demyan, 215
Belomoro-baltiiskii canal, 231–2
Beskin, Osip, 178
Bildungsroman, 204–8
Brecht, Bertolt, 18
Brik, Osip M., 185
Brodsky, Isaak I., 172
Bulgakov, Mikhail M., 222–5
Carnival
    and Komsomol, 51
    and literature, 211
    other references, 20, 41–72, 86
Central Holiday Commission, 50–1,
    62
Cesarec, August, 97, 101
Chagall, Marc, 183
Cherkasov, Nikolai K., 259, 277,
    282–3
Chernyshevsky, Nikolai G., 69, 207
Christian iconography, 142, 173
Civil War, 79, 83
Clark, Katerina, 152, 160, 207
Classicism, 132, 186, 244–8

Collective creativity, 57–61
Collectivisation, 234
Communal movement, 89
Consciousness, ideological, 200
Constructivism, 129
Craven, Thomas, 157–8
Cult of personality, *see* Stalin
Cultural revolution of 1928–31, 28,
    83–5
Cultural symbolism
    Stalinist, 235
    Stalinist and Nazi, 198–200

Decadence, 105
Deineka, Aleksandr A., 182
Deutscher, Isaac, 284
Dmitrieva, N., 130, 136–7
Donskoi, Mark S., 251–64
Dorosh, Efim Ya., 285
Dostoevsky, Fedor M., 104–5
Drevin, Aleksandr D., 182
Dunham, Vera, 65
Dzhabaev, Dzhambul, 32
Eclecticism, 138, 144–6
Egalitarianism, 88
Eisenstein, Sergei M., 25, 251–64,
    266–85
'Engeneer of human souls', 130,
    133, 139
Ershov, Leonid F., 212
Eventov, Isaak S., 215, 217

Façadism of Stalinist Architecture,
    232–3
Family law, 24
Farner, Konrad, 156
Fedorov-Davydov, Aleksei A., 132
Filonov, Pavel N., 184, 187
Fitzpatrick, Sheila, 35, 82–3
Five-Year Plan, 3–9, 61, 64, 78, 81,
    85
Folklore, 28–32
Formalism, 165–6, 178, 252

Fotografiinost', 167

Gan, Aleksei, 128, 185
Gel'freich, Vladimir G., 240
Ginzburg, Moisei Ya., 232
Grenz, Dagmar, 207
Gerasimov, Aleksandr M., 152, 167, 170–2
God-building, 87
Gorky, Maxim, 28, 34, 104–5, 166, 168, 200
Gramsci, Antonio, 19
Gray, Camilla, 179
Grotesque, 225

Heroic realism, 133
Hitler-Stalin-Treaty, 269, 275
Holidays
 Religious, 46
 Socialist, 41–72

Iconoclasm, 86
Il'f, Il'ya and Petrov, Evgeny, 213, 215–6
Illiteracy, 4
*Illyustrativnost'*, 150
Immortality, ideological, 202
Impressionism, 165–7
Iofan, Boris M., 118, 240, 242, 246
Irrationality of Nazi ideology, 196–9, 203
Ivan Grozny, 268–85

Kaganovich V., Lazar M., 81
Kandinsky, Vassily, 180
Kasatkin, Nikolai A., 166
Kerzhentsev, Platon M., 48, 53, 60, 67
Kirov, Sergei M., 280
Klutsis, Gustav, 182
*Komitet po delam iskusstv,* 165
Korzhavin, Naum, 181
Kostylev, Valentin I., 268–70
Kozhinov, Vadim V., 181
Krleža, Miroslav, 98
Krupskaya, Nadezhda K., 174
Kryukova, Marfa, 29, 30
Kundera, Milan, 241
Kurbsky, Andrei M., 273–7, 279

Kurella, Alfred, 133

Laktionov, Aleksandr I., 153, 169
Larionov, Mikhail F., 186
LEF (Levyi front iskusstv), 129, 130, 132, 136, 140
Lenin
 and architecture, 243–4
 and Stalin, 117, 142–3, 152–3, 171–3
 and theory of two cultures, 144
 cult of, 24, 229–30
Leonidov, Ivan I., 242, 246–7
Life-building (zhiznestroenie), 126, 128
Lifshits, Mikhail A., 112, 181
Lifton, Robert, 205
Lukács, Georg, 103, 214–15, 266–7
Lunacharsky, Anatoly V., 47–8, 58, 97–8, 183, 212

Makarenko, Anton S., 200
Malevich, Kazimir S., 125, 127, 130, 133, 180, 183
Mandelshtam, Nadezhda Ya., 10–11
Mandelshtam, Osip E., 99
May Day celebration, 54–5, 61, 65–6, 69
Mayakovsky, Vladimir V., 99–101, 134, 179, 212
Meyerhold, Vsevolod E., 97–8
Millenarianism, 83
Montage, 261–4
Monumentalism, 241–2
Mordvinov, Arkady G., 242
Moscow
 as archaic city, 237
 in the 1930s, 91, 229–37
 reconstruction of, 143, 231
Mumford, Lewis, 229, 237

Narodnost', 17, 102, 158
Nationalism, 25
Nazi art and culture, 112–16, 160, 193, 272
Nedoshivin, German A., 137
Neo-Classicism, *see* Classicism
New Man, 139–40, 145–6, 193, 204–5

Norkus, Herbert, 194, 201–2

*Oprichnina*, 270–2, 275, 277–9, 281, 285
OST (Obshchestvo stankovistov), 101, 132
Ostrovsky, Nikolai A., 26, 193–207

Palace of the Soviets, 118, 240, 246
*Partiinost'*, 160
Peasants' culture, 82
*Peredvizhniki*, 123, 125, 143, 157
Philosophy in the 1930s, 135–6
Piotrovsky, Boris B., 55–6
Political liturgy, 116–17
Popular culture, 15–37, 65
Productivism, 129, 131
Proletarian Culture, 17
Punin, Nikolaj, 142, 178
Purges, 34

RAPP (Rossiiskaya assotsiatsiya proletarskikh pisatelei), 103, 214
Revolution from above, 60
Ritualisation, 205–6
Rodchenko, Aleksandr M., 182, 184, 187
Roh, Frank, 115

Sacrificial hero, 202
*Samodeyatel'nost'*, 42, 53–4, 59, 67
Satire, 210–25
Schenzinger, Karl Aloys, 193–207
Science Fiction, 88
Serov, Vladimir A., 187
Sevost yanov, E.I., 133
Shchuko, Vladimir A., 240
Shchusev, Aleksei V., 229, 233
Smirnov, Ivan I., 271
Socialist Realism
  and avant-garde, 122–46, 178–87, 264
  and the beautiful in life, 113
  and Nazi art, 156
  as institutional practice, 159–77
  as style, 153
  norms of, 105, 163
Sots Art, X, 126

Stakhanov movement, 9
Stalin, Iosif V.
  and architecture, 233
  and Lenin, *see* Lenin and Stalin
  and utopianism, 80
  as 'architect', 'artist' and 'creator', 137–8, 146, 155
  cult of, 11, 23, 92, 268, 282–4
  portraits of, 114, 177, 168–74
  portraits of Stalin and Lenin, 142–3
  Prize, 113–14, 150
Stalinism, 80
Stalinist culture
  dying out, X, 110
Stalsky, Suleiman, 31
Strievsky, Konstantin K., 5
Suetin, Nikolai M., 182

Tamanyan, Vladimir F., 242
Tatlin, Vladimir E., 182, 184, 186
Taut, Bruno, 233
Terts, Abram (= Sinyavsky, Andrei S.), 225
Theory of the absence of conflict, 217
Tolstoi, Aleksei N., 98, 273
Totalitarian
  aesthetics, 115, 193, 203
  art, 118–19
  culture, XX, 110–20, 267
Tretyakov, Sergei M., 185
Trotsky, Leo, 47, 50, 274, 276, 279
Tugendkhol'd, Yakov A., 133, 141–2
Tumarkin, Nina, 24
Tsapenko, Mikhail P., 242

*Uravnilovka*, 91
Utopianism, 78–92

Vertov, Dziga, 255
Vesnin, Aledsandr A. and Viktor A., 244–5
Vipper, Robert Yu., 270
Volkovinskaya, Zinaida, 173
Voluntarism, 204

Weber, Max, 236–7

Working–class culture, 3–14, 17, 97

Yaroslavsky, Emelyan N., 52
Yuon, Konstantin F., 101–2

Zamyatin, Evgeny I., 89, 90, 92, 213, 224

Zhdanov, Andrei A., 216
Zhdanovshchina, 167, 216–17, 277–8
Zholtovsky, Ivan V., 240–8
Zinov'ev, Aleksandr A., 110
Zoshchenko, Mickhail M., 210–21